# Praise for L

"*Loot* does an excellent job of exploring the political underpinnings of the contest over antiquities. . . . [Waxman's] critical distance allows her to see both sides of this tangled story. . . . *Loot* is an engaging and informative read."

—*Art + Auction* magazine

"Sharon Waxman has written a compelling page-turner about the world of antiquities and art-world skulduggery. She manages to combine rigorous, scholarly reporting with a flair for intrigue and personality that gives *Loot* the fast pace of a novel. I enjoyed it immensely."

—TINA BROWN,
author of *The Diana Chronicles*

"A journalistic tour de force—an exhaustively researched, even-handed compendium of the disputes roiling museums and source countries."

—LEE ROSENBAUM at CultureGrrl.com

"Sharon Waxman's *Loot* is the most instructive as well as the most intelligent (and the most entertaining) guide through the labyrinth of antiquity and the ways in which the claims of the departed intersect with the rights of the living."

—CHRISTOPHER HITCHENS,
author of *God Is Not Great* and
*The Elgin Marbles: Should They Be Returned to Greece?*

"I devoured *Loot*. . . . The first merit of Waxman's book, the best on its subject, is her verbatim account of conversations with everybody who matters in the antiquities trade."

—KARL E. MEYER, *Truthdig*

"*Loot* is a riveting foray into the biggest question facing museums to-day: Who should own the great works of ancient art? . . . Vivid, witty, and delightful, this book will beguile any reader with an interest in art and museums."

—DOUGLAS PRESTON,
author of *The Monster of Florence*

"This is a fabulously well-written book full of outrage and shady intrigue. When you blend a fine journalistic style with a postgraduate degree in Middle East studies, you have a person who can write entertainingly about one of the modern world's most divisive artistic problems."

—*Sydney Morning Herald* (Australia)

"Sharon Waxman approaches her subject with the passion of a great journalist and the rigor of a scholar."

—LUCETTE LAGNADO,
author of *The Man in the White Sharkskin Suit*

"*Loot* is hip to the politics underlying the whole repatriation craze. . . . This book's title is absolutely true."

—*Newark Star-Ledger*

"[An] insightful new exploration into cultural plunder."

—*The Dallas Morning News*

"A lucid and intelligent investigative report into the dilemma of what the great museums of the world are to do in the face of demands to return signature artifacts to the countries of origin."

—*Toronto Star*

"A remarkable book . . . After reading [*Loot*] you will never again view an antiquity in a museum in the same light."

—*King Features Syndicate*

"Evocative . . . *Loot* reveals that there is no easy solution to the centuries-old problem of stolen antiquities. . . . As the battle continues, enlightened readers and art observers will be among the victors."

—*Bookpage*

"This is a great read. There is enough here to have a history buff nosedown for a few solid hours and enough mystery and intrigue to keep a conspiracy theorist in a dinner-party conversation for months."

—*The Courier-Mail* (Australia)

"A measured, detailed and accessible history of cultural custody cases, bringing the ages-old quandary up to date."

—*The Kansas City Star*

"This is an even-handed exploration of a fraught topic."

—*Saudi Aramco World*

"Exposes hypocrisy on all sides of the debates."

—*The Roanoke Times*

"Skillfully blending history and reportage . . . Waxman's account is animated by interviews with museum curators, accused smugglers and government officials, putting a human spin on the complex cultural politics before arriving at a middle ground that strives for international collaboration in preserving a broad global heritage."

—*Publishers Weekly* (starred review)

"Comprehensive and revealing . . . Waxman is a congenial, globe-hopping tour guide through cramped offices, dank tomb sites, and sleek, art-filled palaces."

—*Booklist*

ALSO BY SHARON WAXMAN

*Rebels on the Backlot:*
*Six Maverick Directors and How They Conquered*
*the Hollywood Studio System*

# LOOT

# LOOT

## THE BATTLE OVER
## THE STOLEN TREASURES OF
## THE ANCIENT WORLD

## SHARON WAXMAN

TIMES BOOKS
HENRY HOLT AND COMPANY
NEW YORK

*To Art Buchwald, Sparky Schulz,*
*Joan Goodman, and William Paris—*
*mentors who are greatly missed.*

Times Books
Henry Holt and Company, LLC
*Publishers since 1866*
175 Fifth Avenue
New York, New York 10010

Henry Holt® is a registered trademark of Henry Holt and Company, LLC.

Library of Congress Cataloging-in-Publication Data

Waxman, Sharon.
    Loot : the battle over the stolen treasures of the ancient world / Sharon
Waxman.—1st ed.
        p.   cm.
    Includes bibliographical references and index.
    ISBN 978-0-8050-9088-8
    1. Art thefts.   2. Archaeological thefts.   I. Title.
    N8795.W39 2008
    709.01—dc22                                                  2008015575

Henry Holt books are available for special promotions and premiums.
For details contact: Director, Special Markets.
Originally published in hardcover in 2008 by Times Books
First Paperback Edition 2009
Designed by Meryl Sussman Levavi
Printed in the United States of America
1   3   5   7   9   10   8   6   4   2

*I watched the rafts, until they disappeared behind a projecting bank forming a distant reach of the river. I could not forbear musing upon the strange destiny of their burdens; which, after adorning the palaces of the Assyrian kings, the objects of the wonder, and may be the worship, of thousands, had been buried unknown for centuries beneath a soil trodden by Persians under Cyrus, by Greeks under Alexander, and by Arabs under the first successors of their prophet. They were now to visit India, to cross the most distant seas of the southern hemisphere, and finally to be placed in a British Museum. Who can venture to foretell how their strange career will end?*

—the archaeologist Austen Henry
Layard, upon sending to Britain in
1849 a giant winged bull and winged
lion from the Assyrian palace near
Mosul, in modern-day Iraq

# CONTENTS

PART THREE

# LORD ELGIN'S LEGACY

PART FOUR

# ROUGH JUSTICE

# ILLUSTRATIONS

In an insert following page 192:
Zahi Hawass
The Egyptian Museum in Cairo
Graffiti in the tomb of Seti I
The Temple of Hathor in Denderah
The plaster replica of the zodiac ceiling
The interior of the tomb of Amenophis III
The missing head of Amenophis III
The hippocampus of the Lydian Hoard
The counterfeit hippocampus
The column from the Temple of Artemis at Sardis
The Euphronios krater
The new Greek and Roman galleries at the Metropolitan Museum of Art
The Elgin Marbles
Dimitrios Pandermalis on the top floor of the New Acropolis Museum
The Getty wreath on a museum catalog and back in Greece
The bronze Ephebe of Marathon
Roger and Bertrand Khawam
The Getty villa in Malibu

# LOOT

# INTRODUCTION

IT WAS JUST LIKE ZAHI HAWASS TO TOSS A BOMB INTO the middle of someone else's well-laid plans. On a bright, breezy day in June 2006, dozens of reporters and news crews, cameras, and microphones were lined up at the Field Museum in Chicago for a pleasant and entirely noncontroversial news event: the opening of an exhibit of the treasures of King Tutankhamun, on loan from Egypt for the first time since 1977.

Sitting in the front row, Hawass, the charismatic secretary-general of Egypt's Supreme Council of Antiquities, was braced for a fight. As he listened to remarks by Randy Mehrberg, a spokesman for the show's corporate sponsor, a billion-dollar electricity corporation called Exelon, he felt himself grow increasingly incensed. Extolling the wonders of ancient Egypt, Mehrberg mentioned that Exelon's CEO, John Rowe, was an avid Egyptophile who kept the sarcophagus of a mummy in his office. Hawass, dapper in a suit and tie, wasted no time. He strode to the podium and went straight for the jugular. "No one has a right to have an artifact like that in their office or in their home," he declared indignantly, kicking the exhibit's benefactor in the gut and stunning the museum's officials. "How can he sponsor an exhibit like

King Tut and keep an artifact like this in his office?" Rowe should sur-
render the sarcophagus to a museum, Hawass said, or send it back to
Egypt. If he didn't, there would be consequences.

What kind of consequences? Hawass had plenty in mind. Never
mind that the sarcophagus—a 2,200-year-old wooden coffin with
painted designs and hieroglyphs—was Rowe's private property. Never
mind that it had been purchased legally from a reputable dealer.
Never mind that Rowe ran one of the biggest utilities in the country
and had been a major contributor to President George W. Bush, with
whom he was touring power plants on the day of the museum news
conference. In this case, none of that mattered. For the next two days,
Hawass turned up the pressure; he threatened to pull out of the exhibit,
and he warned that he would cut Egypt's ties to the museum and its
partners if Rowe didn't relinquish the sarcophagus or withdraw Exelon's
sponsorship.

Within the museum, panic ensued. The exhibit was about to open to
an expected audience of 1 million visitors, and the story had taken up
residence on the *Chicago Tribune*'s front page. By the end of day two, John
Rowe blinked. He agreed to loan the piece—an artifact of middling
value, not really worthy of the Field Museum's galleries—indefinitely.
You could practically hear the museum administration breathe a sigh of
relief: "This has been a very, very happy resolution for everyone," said
a spokeswoman. "We're very pleased." Added an Exelon official, "John
loves the Field Museum and is happy to share the piece." Hawass, at
last, was mollified. At a dinner for the opening that night, he was all
charm and smiles. "Mr. Rowe is a very nice man," he said. "To accept
that the coffin be given to the Field Museum, this will finish the
process and make peace with everybody."

Peace? How nice. A sharing kind of word. But peace and sharing
are not at all what is in the air around museums these days, nor in the
countries that were home to the great civilizations of the ancient
world. Instead it has been lawsuits and criminal prosecution, public em-
barrassment, and bare-knuckled threats. Of late, it's been much more
like war, a tug-of-war over who should own the ancient artifacts that
represent the heritage of humankind. Over the past two hundred
years, antiquities and monuments have been ripped from the ground

and shipped across the world, and many of these pieces now reside in the vast collections of the great museums of the West. Should they stay where they are—at the Louvre, the Metropolitan Museum of Art, the British Museum, and elsewhere—exhibited and preserved with care, accessible to avid crowds of visitors from around the world? Or should they return to their countries of origin, whose demands for restitution have grown ever more vociferous, a chorus of dissatisfaction from across the ancient world?

In April 2007 Zahi Hawass announced that Egypt would seek the loan (though he has also said he seeks the permanent return) of five iconic pieces from museums in Europe and the United States, including the Rosetta Stone and the famed bust of Nefertiti, even as he raises hell over minor pieces such as John Rowe's. With Greece preparing to open a modern museum at the base of the Acropolis in Athens, its government has renewed its demand for the return of the Elgin Marbles, the sculptures removed from the Parthenon in 1802 by the Earl of Elgin and kept at the British Museum. Italy has waged a sustained campaign against museums, dealers, and collectors for the return of artifacts it claims were illegally excavated and smuggled from the country. That culminated in the two-year criminal trial of the American curator Marion True and, in August 2007, in the agreement by True's former employer, the J. Paul Getty Museum, to return forty artifacts from its permanent collection.

Is THIS HISTORIC justice, the righting of ancient wrongs from the age of imperialism? Or is it a modern settling of scores by the frustrated leaders of less powerful nations? And why now, all of a sudden, has the issue taken hold with such force? The battle over ancient treasures is, at its base, a conflict over identity, and over the right to reclaim the objects that are its tangible symbols. At a time when East and West wage pitched battle over fundamental notions of identity (liberator or occupier; terrorist or freedom fighter), antiquities have become yet another weapon in this clash of cultures, another manifestation of the yawning divide. And ironically, it undermines the very purpose of cultural exchange, of building bridges and furthering mutual understanding.

In some sense, the battle over antiquities is part of an epochal shift. Once upon a time, these objects were tied to the national identity of Western empires. From the sixteenth century forward, European culture became the dominant force in the world, sweeping across continents and destroying past civilizations, while claiming ancient history for itself. "Never before had one culture spread over the whole globe," writes the historian J. M. Roberts. This cultural shift was a one-way process. "Europeans went out to the world, it did not come to them," he adds. Except for the Turks, non-Europeans did not enter Europe. And after conquering foreign cultures, Europe brought back home the trophies that it desired, along with slaves, spices, treasure, and raw materials. The imperial age, beginning in the eighteenth century, culminated in the appropriation of ancient cultures for the glorification of European power. First, classical history—ancient Greece and Rome— were adopted as symbols of refinement and taste, their monuments sought and imitated in the battle for supremacy among competing empires. Then with the dawn of the nineteenth century and the rediscovery of ancient Egypt by Napoleon Bonaparte, mummies and pyramids were the new, must-have status symbols, and this fascination fueled the rise of scientific inquiry into the past. The uncovering of ancient Mesopotamia and its myriad civilizations followed in subsequent decades, with treasures and monuments brought to the halls of the Western cultural temple—the museum. The twentieth century expanded Western holdings to include the treasures of Asia, Latin America, and Africa.

Today, we live in a different age. As once-colonized nations seek to stand on their own, the countries once denuded of their past seek to assert their independent identities through the objects that tie them to it. The demand for restitution is a way to reclaim history, to assert a moral imperative over those who were once overlords. Those countries still in the shadow of more powerful empires seek to claim the symbols of antiquity and colonialism to burnish their own national mythmaking.

To those who love museums, who cherish history and are fascinated by antiquity, these arguments may seem strange. Who cares about national mythmaking? What about the artifacts themselves? Doesn't the past belong to all of humanity? Aren't museums there to exhibit

the great achievements of art and human civilization? Well, yes. Of course.

But as cultural politics change, museums change with them. Today museums must look hard at their missions and their guiding ethos. Western museums once could argue that they were necessary to protect ancient artifacts from being destroyed in the poor or unstable countries of their origin. In some cases—like Afghanistan or Iraq—this is still true, and Western museums remain essential custodians of the past. But many developing countries with ancient civilizations beneath their soil feel ready to step up and take full charge. Perhaps it is time to allow them to do so, and to return some or all of the artifacts to their care.

FOR THE BETTER part of the past two centuries, this issue has lurked beneath the surface of the gleaming exhibits in the great cultural shrines of the West, untroubled by public discussion. I used to wonder: Do only ignorant laypeople gaze on the colossal bust of Ramses II at the British Museum and ask themselves how it ended up there? Is it only the unschooled visitor who looks at the soaring column from the Temple of Artemis at the Met and questions why it exists in this place? As a student, I visited the glorious Pergamon Museum in Berlin with its Altar of Zeus and marveled at its beauty, while wondering why an entire building from central Anatolia in Turkey had ended up there. (And for that matter, how did Egyptian obelisks find their way to plazas at the Vatican and in central Paris?) Amazingly, in almost no cases do the museums volunteer the information. They are veritable black holes when it comes to illuminating the nineteenth- and twentieth-century histories of the ancient objects that they shelter.

Still, the debate over the Elgin Marbles has raged publicly for nearly two hundred years, stoking the flames of nationalism on either side. The trustees of the British Museum have continually dismissed the request of successive Greek governments for one overriding reason: precedent. If the British Museum were to give up the Elgin Marbles, its trustees fear, museums would soon be emptied of their ancient treasures. This very fear partly drove the museum to cover up its own mistakes in caring for the sculptures in the 1930s. It is a fear that permeates the world of museums today, with increasing legitimacy.

The modern restitution question first arose in the 1970s, as archae-
ologists, enterprising journalists, and public officials realized that loot-
ing was not a thing of the past. The growing market in the West for
antiquities as vast and varied as Cycladic sculpture, Mayan stelae, Bud-
dhist temple carvings, and Greek vases was fueling rampant destruc-
tion of archaeological sites in places as far afield as Guatemala, Costa
Rica, Cambodia, Greece, Italy, and Turkey. The hunger for ancient
beauty was destroying history, and Western museums were contribut-
ing to this loss of knowledge by feeding demand for the objects. In his
landmark 1973 book *The Plundered Past*, the journalist Karl Meyer
brought up most of the issues, and at least a few of the case studies,
that still define the problem today: collusion among museums and an-
tiquity dealers; the failure to demand proper provenances for the ac-
quired artwork; the winking and nodding as dubious provenances are
accepted as valid; the chain of actors in the process of smuggled antiq-
uities, from the tomb robbers to the anonymous middlemen to the re-
storers to the upscale dealers, who collaborate with auction houses or
sell to wealthy collectors; the lack of clear international laws to regu-
late all of this.

But the world has evolved over the past three decades, as public
awareness has grown more sensitive to the issue of cultural differ-
ences of all kinds, including the notion of cultural plunder. In 1970,
UNESCO—the educational, scientific, and cultural arm of the United
Nations—adopted a convention banning the illegal export and transfer
of cultural property, a convention adopted by many countries in order
to stop the smuggling of contraband antiquities. The United States
signed on in 1983. The rising culture of political correctness has served
to tweak the conscience of many in the archaeological and museum
worlds over demands for restitution, with some in these camps eager
themselves to expiate the sins of the nineteenth and twentieth cen-
turies. Meanwhile, restitution of stolen art was a topic that was com-
ing into its own. In the late 1980s and early 1990s, survivors of the
Holocaust and their heirs became bold in demanding the return of
paintings and other artworks that had been confiscated by the Nazis
during World War II. Some of those paintings had ended up in na-
tional museums in Austria, France, the Netherlands, or the United

States, or were in the hands of private collectors willing to acquire works with suspiciously thin provenances. The ownership was successfully challenged in lawsuits and received widespread discussion in the press. Paintings were removed from museum galleries and presented to descendants of the persecuted in a bid to offer some justice for murdered victims. Countries that had been plundered of their antiquities took note.

And finally, global politics have played a role. The shift in the world after 9/11 has contributed to the rise of restitution as a political hot button. East and West are divided not only in their worldviews but in their cultural perspectives. The rift between powerful and powerless is expressed not only in the violence of suicide bombs but also in strained exchanges over objects of ancient beauty. A reaction to American political and military supremacy can be felt in the restitution battles, just as the vestiges of anger over European colonialism are evident in the conflict. Similarly, the responses of the Western nations have often betrayed an arrogance that has served to stoke the flames of resentment over trampled national dignity.

BUT THERE ARE no easy answers here. No clear right and wrong as there was in the case of looted Nazi art. Context matters. Details matter. The broad brushstrokes of polemic end up distorting the picture rather than clarifying it. For one thing, it must be asked: is it fair to view events that date back two hundred years through modern eyes? Is it appropriate to use words such as *stolen* and *plundered* for things taken when archaeology was in its infancy, and when pioneering explorers did what they believed was best? Looting, after all, did not begin two hundred years ago. Grave robbing is almost as old as the tombs of the pharaohs themselves. It is only in our modern age that the notion of "spoils of war" has taken on a negative connotation; this was once a reasonable outcome in the wake of hostilities. And for those interested in balancing the scales of justice, where does it end? The ancient Romans stole obelisks from Egypt, to which Renaissance sculptors added their own adornments. Should these be dismantled to return the obelisks to Egypt? Should the four bronze horses on the roof of the church of San Marco in Venice be returned to Constantinople, whence they were

taken in 1204 during the Fourth Crusade? Or should they be returned to Rome, since they supposedly adorned the Arch of Trajan before they were carted off to Constantinople? Or should they go back to the Greeks, who are believed to have originally made them in the fourth century BC? Those who would unravel the tangled skein of history will quickly confront such riddles. As the restitution debate evolves, new brain twisters emerge. Like this one: in 2007 American deep-sea explorers in international waters off the coast of Spain found a Spanish galleon that had been sunk by a British warship in 1804. On the ship, the explorers found gold and other treasures worth $500 million. Claiming that this was its "cultural heritage," Spain immediately asserted ownership of the shipwreck and filed a federal lawsuit in Tampa, Florida, to press its claim. But Peru then intervened to ask what seemed to be a relevant question: wasn't this gold stolen from the Peruvians' Incan forebears? And if so, shouldn't they be the ones to whom restitution is made?

It is possible that at the end of this journey, the reader will find more good questions than good answers. The subject tends to bring out hyperbole among right-minded activists, and even the most nobly intentioned observers can be wrong. In 1973 Karl Meyer wrote in the introduction to *The Plundered Past*, "Given the present tempo of destruction, by the end of the century all unexplored major archeological sites may be irrevocably disfigured or ravaged. We are witnessing the equivalent of the burning of the library at Alexandria by the Romans, the catastrophic bonfire in which much of the wisdom of antiquity was consumed in flames." Well, no; rampant smuggling continued through the end of the century, but somehow archaeological sites still exist. There is posturing and counterposturing on every side. There are lies and distortions and prevarications by the most solemn authorities and institutions, all in the service of making the argument that suits them best. Museums are expert at selective history. Until recently, it has been sufficient to state that Europeans were out to save the crumbling, neglected, and vandalized monuments of Egypt; that they were rescuing the Parthenon sculptures from savages like the Turks and inventing modern archaeology as they went; that American museums were buying artifacts that would otherwise disappear from public

view. Those arguments cannot stand the test of contradictory facts: the evidence of nationalism and greed that fueled the collection of antiquities; the blind eye turned by curators and museum officials to the provenance of artifacts that they knew well enough were probably looted.

At the same time, the countries that demand restitution must face some serious facts of their own: museums in their countries are woefully underfunded and disorganized. Proper curating and even basic inventories are often nonexistent. In many cases the countries are not capable of securing the monuments and treasures that are already under their control. Corruption may be rife; artifacts may be stolen; looting continues. And what's more, across the ancient world, museums are often empty of visitors. The rhetoric of source countries is often many years ahead of their abilities to effectively protect antiquities and disconnected from the interest of the local population.

For the purposes of addressing so vast a subject, I focused on those countries that have aggressively pursued demands for restitution of antiquities: Egypt, Turkey, Greece, and Italy. In parallel, I focused on the major museums of the West whose antiquities collections have been called into question and which have faced the most high-profile restitution requests: the Louvre, the Metropolitan Museum of Art, the British Museum, and the J. Paul Getty Museum. In travel through a dozen cities in eight countries, in scores of interviews and many hours of research, I have sought to get at the truth behind the accusations and claims made by museums and source countries—not as an art historian or archaeologist, but as a journalist with a passion for foreign cultures of all kinds and a love for the museums that first kindled that passion.

The issues raised in these conflicts illuminate the broader themes that affect cultural exchange around the world. How did we get to this crossroads, and how do we proceed from here? The answers may not be simple but they are critical to the survival of the artifacts that represent our common human heritage.

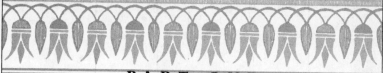

# PHARAOHS
## *and*
# EMPERORS

# ZAHI RULES

THE MAN HOLDING COURT AT THE ABOU ALI CAFÉ AT the Nile Hilton Hotel, a calm outdoor space with wicker furniture and attentive waiters in floor-length caftans just behind the Cairo Museum, was not ready for a break. It was a Saturday in July and one hundred degrees in the shade, but the words *weekend* and *heat wave* held little meaning for Zahi Hawass, the secretary-general of Egypt's Supreme Council of Antiquities and the country's leading agitator for all things pharaonic.

Handsome, his thick hair combed neatly in tight waves, dressed in a crisp orange button-down shirt and jeans, Hawass was in an upbeat mood. He had just come from a television interview about Hatshepsut, the great pharaoh-queen whose mummy he said he had identified based on a newly discovered tooth found in a long-neglected sarcophagus. He had been milking this news for a week, doling out bits and pieces, CT scans and DNA results, ahead of a television program called *Secrets of the Lost Queen of Egypt,* to be broadcast on the Discovery Channel a few days later. The great pharaonic queen, it turned out, was obese and had both diabetes and cancer.

Hawass claimed to be in hiding at the moment, having turned

down most of his media requests for today. Three outlets buzzed futilely on his cell phone: Al-Jazeera cable news, Orbit news from Saudi Arabia, and a popular local program, *Beiti-Beitak*. They all wanted to know what Hawass thought about the results of a new contest, to be announced the following day, to name the modern-day Seven Wonders of the World. Hawass had stepped into this promotional maelstrom weeks earlier by indignantly withdrawing the pyramids from this bake-off. The pyramids have been a wonder of the world since ancient times, he said, and had no need to compete for contemporary legitimacy against the likes of the Eiffel Tower or the giant Jesus of Rio de Janeiro. Instead, the organizer—a Swiss tour promoter—gave the pyramids honorary status, though Hawass declined to acknowledge this fillip. Ignoring the contest turned out to be an ingenious media strategy, giving the pyramids central billing whether they were named to the list or not, and guaranteeing Hawass more ink on the day of the announcement, whether he commented or not. (Strangely, the Greeks similarly withdrew the Parthenon from the contest, but no one seemed to notice.) As it turned out, he gave instructions to one of his assistants on what precisely to say on the 9:00 news. "Why am I the only one they want?" he mused disingenuously as the cell phone bounced on the café table. "Because I know how to talk. I send my assistants all the time. But God gave me this gift. I never asked to be on TV in my life." His cell phone rang. "*Aiwa, ustaz*," he said. ("Yes, sir.") Interviews and meetings don't keep the good doctor from answering his cell phone.

Zahi Hawass is one of the most formidable Egyptians to emerge in modern times. He is articulate, Western-educated (he holds a doctorate from the University of Pennsylvania), and media savvy in a way that is rare in his field, rare in his culture, and endlessly irritating to his rivals. His allies, too. He is the loosest cannon in the Egyptian government. No one in the culture ministry ever knows what Hawass is apt to say. And yet, almost single-handedly, he has awakened Egypt from a cultural torpor in regard to its pharaonic treasures and created renewed excitement abroad for Egypt's past. He is a man who gets things done: he succeeded in getting the Egyptian parliament to reverse a law, thus permitting the King Tut treasures to travel abroad for the first time in

twenty-six years, while at the same time negotiating terms for a multi-city exhibit that brought tens of millions of dollars in profit back to the country—something that had never been done before.

Zahi Hawass has done this with an innate gift for self-promotion and a sharp instinct for finding the news hook that will give him world-wide headlines. His instinct about the West's vulnerability to the romance of pharaonic Egypt is a matter of bemusement in antiquities circles and among Egypt's more sophisticated observers, especially when major "discoveries" occur just before a television special airs about those very discoveries. This is precisely what happened with the news about the identification of the mummy of Queen Hatshepsut in June 2007, mere weeks before the air date for *Secrets of the Lost Queen of Egypt*. The news was the subject of a prominent article in the *New York Times*, followed by a host of other stories on television and in print. Six months later, however, scientists were still attempting to definitively confirm the identification of the mummy from the evidence so roundly hyped by Hawass. But some in the press were beginning to get wise to his game; when Hawass announced in August 2007 the discovery of what might be "the oldest human footprint ever found," possibly 2 million years old, reporters weren't biting. This time he rated only a brief comment in the *Washington Post* and no word at all in the *New York Times*.

Hypemonger or not, Hawass has nonetheless catapulted Egypt to the forefront of international cultural consciousness, giving the country exposure for something other than corruption, poverty, or fundamentalist Muslim terrorism. Doing so has made him many enemies, including those who say Hawass grabs all the credit for the work of others, rivals who complain that he unfairly denies excavation permits, and others who call him a tool of the Americans. Hawass does not pay his critics any attention at all. He has the support of the president, Hosni Mubarak, who seems to recognize that promoting pharaonics abroad is an intelligent way to boost the lucrative tourism trade.

But lately Hawass has found another path to promote his cultural agenda: demanding the return of Egypt's lost treasures. It is the larger issue motivating him these days, and the reigning undercurrent of his quest for recognition of Egypt as a grown-up country, culturally

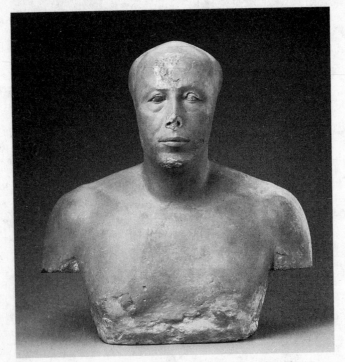

*Bust of Ankhaf, the architect of the second-largest pyramid at Giza.*
(Photograph © 2008 Museum of Fine Arts, Boston)

speaking. In April 2007 Hawass began seriously to press his demand that five iconic objects that originated in Egypt be returned from the West for a temporary loan: the Rosetta Stone at the British Museum; the famed bust of Nefertiti in the Egyptian Museum of Berlin; the zodiac ceiling of Denderah in the Louvre; the life-size statue of Hemiunu, the architect of the great pyramid, in Hildesheim, Germany; and the sculpture of Ankhaf, architect of the second-largest Giza pyramid, at the Boston Museum of Fine Arts. Each of these objects left Egypt at different moments and under different circumstances. The Rosetta Stone dates back to the Napoleonic invasion in 1799 and was handed to the British after the French lost to them in battle. The Nefertiti bust was granted to Germany as part of the "partage" system of dividing

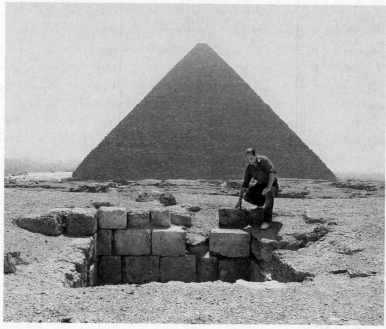

*The findspot of the sculpture of Hemiunu, the architect of the great pyramid at Giza,
pictured in the background.* (Photo © Sharon Waxman)

archaeological finds in the 1920s by the German archaeologist Ludwig
Borchardt. Hemiunu was discovered in 1912 by the expedition of
Hermann Junker and taken legally on behalf of the German collector
Wilhelm Pelizaeus, who was financing the excavation. Ankhaf was
found in his tomb near Giza by archaeologists led by George Reisner
excavating for Harvard University and the Boston museum in 1925,
and Boston was awarded the statue under partage. And the zodiac ceil-
ing at the Louvre was violently hacked from the ceiling of a magnifi-
cent temple during the nineteenth-century steeplechase for treasures
among the European powers.

The differences in provenance don't matter much to Hawass. He
considers these five monuments to be exempt from any international
agreements or from protection because of legal purchase; they are in-
tegral parts of the Egyptian cultural heritage, he argues, and need to

be in Egypt. Hawass sent letters to the five museums asking for the three-month loan of the objects in time for the opening of the Grand Museum, a $350 million structure being built beside the pyramids, scheduled for 2012. He was waiting for all of them to reject his request, which would be occasion to fulminate further in the public arena, though none had been so dense as to take this bait.

"What do they say? What do they say?" he asked excitedly at the Abou Ali café, after I told him that I had been to the Louvre and the British Museum and the Met to ask them about Egypt's request for the loan of ancient masterpieces. "What does Philippe de Montebello say? Does he like me?" he asked, referring to the director of the Met.

Why did he care? This was hardly a popularity contest, and if it were one, Hawass wouldn't win. His approach in the fusty world of museums has been to huff and puff, to embarrass Western museums, generally breaking every rule of decorum and tact. He challenged the British Museum to return the Rosetta Stone in a speech at the museum during a gala dinner where he was a guest of honor, saying that the great pharaoh Ramses II had come to him in a dream and asked him to bring home the Rosetta Stone. He tossed out the demand for Nefertiti to the Germans in an unscripted moment at a news conference in front of Mubarak and the German president, Horst Köhler, at the opening of an exhibit of "Egypt's Sunken Treasures" in Berlin in 2006. And he threatened the Europeans and Americans with an embargo on digging permits and museum cooperation if they didn't comply. Often he would wink or smile in the wake of these performances, fully aware that he was performing for effect.

For the moment, the museums were taking a cautious route, even if the overall sense they gave in interviews was one of extreme suspicion. They regarded the request of a loan as a kind of a publicity stunt—and they were right about that—and as a first gambit in a process seeking the objects' permanent return. They were right about that, too.

Hawass was particularly annoyed by the response of the Roemer und Pelizaeus Museum in Hildesheim, Germany, which houses the statue of Hemiunu. "Hildesheim wrote that they'll give it to us," he said, "but they want masterpieces of the Old Kingdom for an exhibit in return. I gave them many exhibits before without asking for anything

in return." Boston replied to Hawass's letter; it was looking at the question. The British Museum responded that it would take the request to the board of trustees, and the Louvre was taking the matter under advisement.

"They have no right to say no," he said, sucking energetically on a hookah, an Egyptian water pipe burning fragrant tobacco. "The Louvre will be in trouble if they don't lend us the zodiac. I will stop all French excavations in Egypt and any scientific relationship."

Only Berlin had indicated that a negative response was likely, saying that the bust of Nefertiti—undoubtedly the most recognizable, iconic figure of them all—was too fragile to travel. Hawass scoffed at this. "The piece has been shown elsewhere. We sent them fifty Tut objects, some not in good condition. But we believe people should see these pieces. Nowadays you can pack anything fragile and it can go anywhere," he said. "What is their objection? Are they afraid I won't give it back? We are not the Pirates of the Caribbean."

Several Egyptologists who are generally on Hawass's side have suggested that his punitive approach is self-defeating. Does he really want to bar the French from bringing their knowledge and financial resources to work in Egypt? Doesn't he need all the funds he can get? Hawass was impatient with all of this, and indeed only had a few more minutes of attention to spare on this issue at all before picking up a cell phone call. "It's only three months," he said, the soul of reason. "I open my country to discoverers, to researchers to write books, articles. We send our best artifacts to their museums. To say no is not fair."

Anyway, he couldn't care less, he said, if further excavation continued. "It's not good for us, not at all. Conservation is what's good, site management. Excavation doesn't help me. What helps me is to preserve what we have. I don't need their discoveries. It's better off in the ground. Christiane Ziegler [a curator at the Louvre] finds mummies in Saqqara and has to keep them in the shafts there. It's better to have them in the ground. Excavation is more for the glory of Ziegler than the glory of Egypt."

By the end of the year, Hawass had made some progress: Hildesheim had dropped its conditions and agreed to the loan. But the Louvre had sent a negative response, saying the zodiac ceiling could not be moved

without damage, and that Hawass should choose another piece to borrow. For a similar reason, Boston turned him down; Ankhaf could not travel in its current condition. The British were still mulling things. This sent Hawass into a paroxysm of invective. "This is all bullshit," he raged in a phone call. "I'm going to make this museum's life especially miserable," he said of the Museum of Fine Arts. "They're assholes. They get every exhibit. Everything—they get for free. They should be punished. I will ban them from working in Egypt completely, officially."

I mentioned to Hawass that the British seemed skeptical about the idea of a loan, since what Hawass really seemed to want was a permanent return. He laughed. "I happen to like dancing with the English," he said. "I thought I should dance with them first, before I kiss them. Before I fuck them."

IN THE FIVE years since he has taken over the Supreme Council of Antiquities, Hawass has changed much about Egypt's attitude toward its antiquities. And he wants to change much more, as quickly as possible. First, he banned further excavations in upper Egypt (the archaeological region along the Nile area to the south of Cairo) and confined new digging to the far-less-explored Nile Delta, a move that greatly reduced the amount of new digging in Egypt, though excavations that had begun before the ban continue. He instituted a program to train new archaeologists, sending promising scholars abroad for study and bringing known experts to Egypt to nurture greater expertise. He started a children's program at the Cairo Museum to cultivate young interest in pharaonic history and persuaded the education ministry to require more serious study of ancient Egypt in elementary school. More important, he ordered a full inventory of the museum's vast holdings for the first time, a task not undertaken since the early twentieth century. He initiated site management plans at Egypt's overcrowded and largely abused tourist sites, such as in the Valley of the Kings. All of these measures won widespread admiration in the worldwide archaeological community.

But much remains on the drawing board. In an interview he spoke about Egypt's ambitious $500 million plans, already in progress, to

build twenty-two new museums around the country and fill them with masterpieces, a plan that seems overambitious, to say the least. He also proposed laws to stiffen penalties for dealing in stolen antiquities, to permit Egypt to sue people abroad and to copyright monuments like the pyramids as national intellectual property.

Hawass's ideas and plans flow a mile a minute, and it is true that he is a man in a hurry. He is trying to make up for one hundred years of indolence, bureaucratic inertia, and colonial elbowing-out of local interests. It is no small matter to accomplish his goals in a country that remains one of the poorest in the world. With a population of 80 million, Egypt is the largest country in the Arab world, where a third of its adults remain illiterate, and a third of the population is under the age of fourteen. Egypt's per capita GDP is $4,200, about one-tenth of that in the industrialized West, and just barely ahead of Cuba and Syria. The government budget for preserving monuments is a relative pittance. For anyone trying to change the system, the task might seem impossible, and logically depends on the millions of dollars sent by foreign governments and related museums and the billions from foreign tourists. But Hawass is willing to bite the hand that feeds him. He is a born entrepreneur, a lightning-fast decision maker who knocks off a series of tasks with the efficiency of a bottom-line thinker. Hawass is often found with a cell phone to one ear and the office phone to another, signing off on myriad documents, barking orders in Arabic and English. In between he works on academic research, writing the introduction to a new book in large, longhand Arabic on a legal pad.

Hawass's style is far more American than it is Egyptian, and it is probably no accident that he loves the United States and spends most of his time out of the country there, rather than in Europe, which he regards as hidebound and stiff. On a typical day, a small army of Egyptian secretaries, ensconced in the waiting room outside his office, keeps his domestic work schedule flowing. At the other end of his office, in a small anteroom, the "*khawaga* brigade"—a host of young, female American art history and archaeology graduates (*khawaga* means "foreigner" in Arabic)—keeps a dozen balls in the air. The various assistants parade in from alternate doors, a blonde Barnard student with a response to a letter he dictated, and any number of Egyptian women—one with pigtails,

another in full veil—announcing the next visitor, getting a signature, or sending for tea.

His office looks nothing like one might expect of the chief of antiquities in a country as rich in archaeological treasures as Egypt. The Supreme Council of Antiquities is housed in a stone building on the island of Zamalek in the middle of Cairo, with a few objects in glass vitrines in the lobby. Strangely enough, one of the pieces is a life-size copy of the yearned-for bust of Nefertiti, odd since Egypt has no end of authentic pieces it could choose to show. Upstairs, Hawass's office is a drab, wood-paneled space similar to that of other bureaucrats—with heavy furniture in the colonial King Farouk style, a few black-and-white photos on the wall, and the obligatory photo of President Mubarak. There are no antiquities visible anywhere in the office. There are only file cabinets and bookcases, and on one of them there is a golden statue of an Emmy, which Hawass won for his work with a local Los Angeles reporter on a news feature. The message: this is a work space, not a showcase.

Hawass's pace would be fast for any Western organization, particularly governmental. In Egypt it is something close to the speed of light. Hawass presides over a bureaucracy of thirty thousand civil servants, none of them as qualified as he to make the changes he has demanded, and plenty overeager to act without the necessary know-how and planning. Can Egypt live up to his vision? Already he is facing difficulties, many of them related to the simple weight of the groaning bureaucracy he inherited and a history of institutional gravity over personal initiative. Hawass says he works with a dedicated core of eighty-five trained people, but it is obvious the country requires far more than that. And he is reluctant to acknowledge that to truly accomplish the tasks before him, he relies heavily on the help of Americans, especially, and Europeans.

"I think of Zahi as Sisyphus," said Janice Kamrin, Hawass's right-hand assistant. "He's made significant progress. But it's such a daunting task." She added, "But I wonder what happens after Zahi leaves. I worry a lot about that. All we can do is train people to take over." An attractive brunette in her late forties, Kamrin is the chief of the *khawaga* brigade, an archaeologist by training who moved to Egypt in

2003 at Hawass's request, to dedicate herself to his plan to drag Egyptian Egyptology into the twenty-first century. She is a no-nonsense New Yorker, a former opera singer who first met Hawass in 1988, when she volunteered at the museum at the University of Pennsylvania and Hawass was a graduate student. At the time, she was gluing pots from a dig in the Levant, and he was dealing with responsibilities back in Giza, home of the pyramids, where he was the chief inspector. "He was yelling at people on the phone all day, and we got to be friends," she recalled. "He taught me my first hieroglyphs."

Kamrin is Hawass's hands and eyes and ears, and his reality check. She is omnipresent in Hawass's operation, his secret weapon—and they both like to keep her invisible, to protect her from Egyptian critics who might not like the hand of an American present so prominently in Egyptian affairs. "The pride of Egyptians wouldn't allow a foreigner to tell them what to do," Hawass explained. "So I don't want them to hate her." Kamrin's main project is the creation of a computerized data bank of the Cairo Museum collection, a massive undertaking that she leads with insufficient funds and as many volunteers and laptops as she can muster. Her own paycheck is covered by an American grant.

Significantly, she is uninterested in Hawass's quest to win the return of the Rosetta Stone and the other iconic pieces. "I don't think it's a battle we can win," she said. Referring to the statue at the Museum of Fine Arts, she observed, "Ankhaf was a gift to Boston. I don't think it's going to fly. The only chance is Nefertiti. And these are not pieces that interest me, frankly. What interests me are the alabaster duck vessels taken from Saqqara." She was referring to four duck-shaped artifacts from the Middle Kingdom stolen recently from the storehouses at Saqqara, near Cairo. One appeared at Christie's in 2006; another turned up at around the same time at the Rupert Wace Gallery in London. An expert from the Metropolitan Museum in New York alerted Hawass's office to their existence. And she was upset by the purchase of the ancient funeral mask of Ka Nefer Nefer by the St. Louis Art Museum, which Egypt can prove was looted, since the mask was logged in a storage catalog in the 1950s. (Two of the ducks were returned by the fall of 2007, and the St. Louis museum says that there is no evidence the mask was stolen.) These and other problems are much

more immediate dangers facing Egyptology, she said, not the Nefertiti standoff. "It's a battle I'm not interested in. We are doing real inventories of the magazines [warehouses] and the museums. We don't know what's missing." Kamrin rattled off a list of more serious problems going on within Egypt. "Egypt tends to be a couple of decades behind in various things. Collections management is a new concept. The staff is badly trained and incredibly underpaid." A senior curator, she says, earns three hundred Egyptian pounds per month, about sixty dollars. New staff starts at half that amount. "That's ludicrous," she said. "And the guards don't know enough to stop people from climbing on the monuments."

Hawass's quest for these five iconic pieces is "a political, a media thing," she said. And she said she's skeptical that Hawass will really suspend cooperation with the French over the zodiac ceiling, whereas the St. Louis museum, with its recently looted mask, will certainly be punished. "They can forget it," she said, referring to any cooperation with Eygpt.

People love Zahi Hawass or they hate him. Often both. They worry among themselves about his tactics, but not his motivation. For all his flaws, corruption—rampant in this part of the world—is not one of them. This seems to be a matter of unspoken understanding among archaeologists and even museum curators, who are convinced that an ulterior motive of the foot stomping is a fierce desire to save the monuments. That is why they treat Hawass with a mix of fascination and wariness. What is his game, really? they wonder. They can't quite tell if he is serious in his threats to the West. And as Kamrin's comments suggest, there is an ongoing debate among Egyptologists over whether Hawass's headline-grabbing quest makes sense in a world of limited time and resources, and while Egypt faces so much work on the domestic front with the antiquities it already has.

"Four days a week we get on well; three days a week we're ready to throttle each other," said Kent Weeks, a leading American archaeologist who has lived and worked in Luxor for more than forty years. "I just don't see that returning the objects for the sake of returning objects is that critical a deal." Weeks has written about a dozen books on Egyptology and was responsible for designing new plans to limit tourists in the

Valley of the Kings, the hillside across from Luxor where the pharaohs are buried, and which draws millions of visitors every year. "I think it's a PR ploy," he said. "And I applaud him for that. But if it's to get the objects back, I don't see the point."

Weeks understands better than just about anyone else why it is important to Hawass to raise a ruckus and to win attention for archaeological treasures that continue to deteriorate rapidly. Pollution has corroded the monuments everywhere in Egypt, especially the Sphinx and the pyramids, while tourists have devastated some of the irreplaceable treasures in the Valley of the Kings. "Zahi is trying," Weeks said. "He often goes in with a heavy-handed approach, when something more subtle might work. He's very much a showman, and a lot of what he's doing in terms of the return of objects is just that: showmanship. But to an extent it helps him better control antiquities in Egypt. And to the extent it allows him to show Egyptians what their patrimony is, that's wonderful." In other words, the battle makes sense not for the objects themselves but in order to make Egyptians feel better about their heritage. This is not an argument likely to sway the Louvre.

Betsy Bryan, an archaeologist from Johns Hopkins University who is Hawass's longtime friend, felt differently. "He knows why he does what he does. Underneath it is a core that's very real," she said. "He sees the need for improving modern Egypt's self-image by means of embracing its antiquities." To her, Hawass was also pointedly reminding the West of its sins of the past. Egypt bears the scars of the greed of Western collectors, who pranced through Egypt in the nineteenth century and took things as if the country were Europe's playground. "If I were in Zahi's position, I would do the same," she said. "It's an effective tack. It wakens people to the simple message of what the nationalistic competition of the nineteenth century ended up doing. As it created the great museums in the West, it created a strange, odd blank in Egypt and other countries. When you go to Denderah, you see an absence of the ceiling. In the Temple of Satis, there is a wall missing. I mean, it is strange and odd. This nationalistic competition by European powers was about getting the biggest, most noticeable stuff. So it's hard not to notice it. He has gotten people to pay attention to this. I am a complete supporter of the view that if you make people feel ashamed, they will stop."

But then again, Hawass often contradicts himself. On some level, he acknowledges that his demand for the five iconic pieces is a stunt to make a point. Over dinner with Hawass, Betsy Bryan mused, "I don't think the Rosetta Stone is worth returning." She pointed out that there were three other pieces in the Cairo Museum with inscriptions that essentially represented the same significance. Hawass responded, "I agree with you. But it's an icon."

For the most part, it was hard to find people who would speak openly about Hawass in general and restitution in particular. He is a dangerous man to have as an enemy; Hawass dispenses the excavation permits and controls what comes and goes from Egyptian museums. People fear him. Typical of this position was Gerry Scott, the director of the American Research Center in Egypt (ARCE). "I am not in a position to have an opinion" about restitution, he said. "It's vital for us to get clearances for our clients in the field." The ARCE is a nonprofit consortium of museums like the Met, the Brooklyn Museum, the Boston Museum of Fine Arts, the Los Angeles County Museum of Art, and universities like the University of Chicago, the University of Pennsylvania, and the University of Michigan. It represents the academics and curators seeking permits to excavate, even as it provides significant resources—money and expertise—to Egypt to conserve its monuments.

There is a certain addictive element to Hawass's constant seeking of the limelight and poking in areas of conflict. The international attention he has gotten as an archaeological enfant terrible has pleased him a little too much. At this point it seems he can't resist the idea that Egypt can follow Italy's lead and begin suing foreign institutions in the local courts for having taken things from the country illegally. Never mind that Egypt is not exactly an evolved democracy with a transparent judicial system. Never mind that the courts are even more confused and open to political taint than in Italy. Never mind that, according to Amnesty International, Egypt holds political prisoners in detention for years at a time without charging or trying them or that civil and criminal trials typically drag on for years, often without clear resolution. To Hawass, the idea of a show trial is too good to pass up. Ed Johnson, a Los Angeles–based lawyer and part-time archaeologist, is working on the new Egyptian law that will permit such prosecutions.

(The old law barred prosecution if the person did not maintain a presence in the country.) To him, there is no contradiction between the fact that Egypt does not have a firm grip on the antiquities in its own borders while it intends to begin suing collectors outside the country. "If I steal from you because I can take better care of something, does that give me the right to steal?" he asked testily. "I reject that out of hand." Johnson seemed eager to get on with the legal route. Tops on his and Hawass's list to target was the St. Louis Art Museum, along with several individuals who participated in the unveiling of the Gospel of Judas, an early Christian codex translated in 2006 that has an unclear provenance.

ON THE EVENING of our meeting at the Abou Ali café, Hawass was surrounded by paparazzi and well-wishers at the elegant residence of the French ambassador, across the street from the five-star Four Seasons Hotel in Giza, an upscale neighborhood of Cairo. The Louvre notwithstanding, France had chosen to bestow one of its highest honors, the Officer of the Order of Arts and Letters, on Hawass. After a brief ceremony with the pinning of the medal, the necessary speeches, Hawass moved comfortably among the dignitaries, wearing the new green enamel starburst with a matching grosgrain ribbon. "He's an undeniable personality," observed Philippe Coste, the French ambassador, admiringly, as Hawass conducted interviews nearby. "He's a partner of France." Well, sometimes. But what did the ambassador make of Hawass's threats toward the Louvre? The ambassador was diplomatic. "The problem comes from a difference in class, in economic level," he said. "If we were all equal, we would not have this problem." But like many, Coste seemed unsure whether Hawass was serious in his threats or playing some kind of game. "It's something between the two," he observed, when probed on this question. A photographer approached to take a picture of the honoree with the ambassador and other diplomats. Hawass eyed me standing nearby. "Well, never mind about the zodiac ceiling," he quipped, looking down at the medal, as if he were toying with the French.

Alex Sorrentino, the French cultural attaché, was openly admiring of Hawass's attitude. "Everyone hates him," he said, as waiters passed

around silver trays of petit-fours and champagne and juice. "They're scared of him. He's like the godfather. He imposes himself, like an immovable object. He can say yes, or no, or fuck you." Sorrentino has been around—South Africa, Israel, Egypt—and he's seen a foreign fulminator or two. "We know for sure he's never sold antiquities on the side. . . . He's one of the few who is honest," he said. "He's good on the ground, and he's good in the politics."

Later, the embassy's operations manager gave me a tour around the building, a magnificent Islamic-style palace built in 1937 from the rescued interiors of Ottoman-era structures that were torn down to make way for a modern-day Cairo. The ceilings, twenty feet high, are of intricately carved wood, and the walls inlaid with marble mosaic, most from the fifteenth and sixteenth centuries. But the most magnificent and rare pieces in the embassy were its front doors, two massive bronze pieces of work, intricately cast and carved in the thirteenth century. Zahi Hawass wants the French to give them up, he told me, to put in the Islamic Museum in Cairo.

STILL, IT IS not enough to define Hawass as a publicity hound. He has a profound sense of his own time and place and a personal connection to the great civilization that he has studied. He is justifiably worried about the survival of the monuments in his country. His is a desire to drag Egypt out of its miasma, to give Egyptians a tangible sense of their tie to a great pharaonic past. At the same time, he has cause to shame the West into recognition, at the very least, of its actions in despoiling Egypt of its monuments, along with the discovery and conservation of other monuments as well. And he has plenty of allies in the West who would like to help him in this quest.

Seen from this angle, Hawass's militant approach is a survival strategy for antiquities and for Egypt itself. The posturing, finger wagging, and indignation are not merely for the purpose of feeding his own ego but also serve to rally ordinary Egyptians to claim ancient Egypt as their own. Cultural nationalism is a wedge, perhaps, that may separate nations. But in this case, part of Hawass's genius is his ability to use it as a lever to hoist Egyptians from a state of utter apathy toward the treasures in their possession. Every nation needs a cause, and Hawass instinc-

tively knows that pointing the finger at the big, bad West is the quickest path to winning the hearts and minds of the Egyptian masses. "Behind his big persona is a desire to reach people, to get people in Egypt— especially in Egypt—to be passionate and fascinated with antiquities," said Janice Kamrin. If that passion is lacking, no UNESCO, no amount of foreign aid, institutes, foundations, or archaeology conferences will be enough to keep these treasures intact. "If future generations do not buy into Egypt as part of their patrimony, then the monuments will disappear," said Gerry Scott of the ARCE. Scott was sitting in the lobby of the Sheraton Hotel in Luxor, overlooking the Nile, where a half dozen massive tourism cruise ships lined the shore. Increasingly, upper Egypt has become a popular destination for European tourists, who pay three hundred euros for a package trip to be carted around by the busload and descend on the monuments en masse, taking a terrible toll. Egypt's plan is to aggressively raise the numbers of visitors, clearing out Luxor's small merchants and residents to make way for expanded sites. The plan worries many archaeologists. "The tourism numbers are frightening," Scott continued. "They will end up destroying the monuments. The Egyptian people have to understand that this is a unique resource they've been given."

In other words, the antiquities have to mean more to Egyptians than a touristic meal ticket. Yet in conversation after conversation, educated Egyptians repeated that the average Egyptian cared little and knew less about the pharaonic past of their country. Hawass's thirty-one-year-old son, Sherif, said so, too. "Not a lot of people are really interested in antiquities, at all," he said. "Here, they're not a really big thing for a normal Egyptian." Indeed, ancient Egypt does not feel particularly organic to contemporary Egypt. Modern Arabic bears no trace of hieroglyphics, traditional Islam flatly rejects pharaonic polytheism, and the modest, traditional dress of today bears no resemblance to the body-conscious loincloths of ancient statuary and murals. Some would argue that modern Egyptians are Arabs and therefore not the actual forebears of the ancients who lived on this land. It is not an argument worth pursuing; the Egyptians officially claim ancient Egypt as their past. They live on the land and among the monuments. Practically speaking, it does not matter whose genetic heirs they are. But clearly,

there is a cultural gap. It is striking indeed to see young Egyptian women as tour guides, more often than not their faces wrapped in the Islamic veil and covered from head to toe, earnestly explaining the distant past before a contrasting tableau of beautiful women in scant clothing.

Some educated Egyptians, wise to Hawass's game, wish he would focus on fixing what's wrong at home before raising a hue and cry in the West. "Let's start with taking care of what we have," said Ahmed Badr, a well-spoken tour organizer for Abercrombie & Kent, Egypt's leading upscale tour company. "They installed a security guard post at the pyramids. Have you seen it? It looks like two pieces of cardboard and some string. Why can't we make something decent there? And the road to the pyramids, can't we pave a street so two buses can pass one another without one having to pull over to one side? It's ridiculous." Badr and his wife, Azza, a public relations executive who works with Google Egypt, are disgusted by what they see as Hawass's self-aggrandizing media pronouncements. "I have not been to the Berlin Museum, but I've seen pictures of where they display the bust of Nefertiti," said Badr. "It's in a huge hall, its own room, with special lights on it. You go there—you feel the greatness of the pharaohs. Have you been to the Cairo Museum? That place is an antiquity in itself."

But accusing the West as a foil to boost Egyptian ownership of its antiquities does actually work. Hawass has made progress in awakening an Egyptian sense of ownership. With the same breathless fervor that animates his Western television specials, he is constantly on Egyptian television with some find or another, or to decry another outrage. He uses a weekly column in the *al-Ahram* newspaper to rally people to cultural issues—against looters, to promote laws that will clamp down on smuggling, and to explain why the Rosetta Stone needs to come back home. "I now have children who say to me, 'Why did you steal the Rosetta Stone?'" said Nigel Hetherington, a young British expert in cultural heritage, who has worked with Kent Weeks on reorganizing the Valley of the Kings. Hetherington agreed with the children, though in addition to the Rosetta Stone, he'd like to see the return of a piece of the Sphinx's beard, now at the British Museum, along with a famed

alabaster sarcophagus of Seti I, now at the Sir John Soane's Museum, a postcolonial clutterfest in London.

In the absence of any great emphasis on Egypt's antiquities in the public school system, what ordinary Egyptians know may well be from Hawass's frequent television appearances, where he recounts stories of ancient Egypt at length. Applications to join the archaeology faculty at Cairo University have soared since Hawass took over the Supreme Council of Antiquities. Before, it was a sleepy corner of the university system. In my travels in Egypt I met perhaps a half dozen young, dynamic Egyptian archaeologists now working for the SCA, all recent graduates of domestic programs, good English speakers, and utterly professional in their conduct. They regard Hawass as their model and their mentor, and he is counting on them—indeed, he desperately needs them—to transmit his passion to the Egyptian masses. They and others worry what will happen when Hawass's mandate expires, in 2010. At least one young archaeologist told me that he is likely to go back to being a tour guide when Hawass steps down, rather than deal with the business-as-usual bureaucracy.

The most moving display of a new connectedness between average Egyptians and the pharaonic treasures among which they live came in the summer of 2006, when Hawass had to move a colossal statue of Ramses II from in front of the Cairo train station in the center of the capital. The pollution of the city was causing the three-thousand-year-old, 125-ton statue to disintegrate, and Hawass made a fateful decision to move it ten miles, out of central Cairo, toward the pyramids. Moving it was a feat of engineering and care. A special cage was built around the statue to carry it, upright, on two flatbed trucks, accompanied by a convoy of archaeological specialists and 1,500 armed soldiers. The operation took all night. And all night long, tens of thousands of Cairenes lined the road that the statue traveled, standing silent vigil as their Ramses, trussed and padded, went to a new home.

# FINDING ROSETTA

*The French are true Musselmans.*

—Napoleon Bonaparte, 1798

On the fifteenth of July, 1799, a French soldier was digging a foundation for a fort near the Egyptian town of Rosetta.

It was a year, almost to the day, since the army of the thirty-year-old French general Napoleon Bonaparte had landed in Egypt to rescue its people from the tyranny of the Mamluks, the Ottoman military rulers. It was also a year since Napoleon had crushed the Mamluks at the Battle of the Pyramids outside of Cairo. And it was just a month before he would desert his army, run a British blockade, and flee for France.

The town was about forty miles from Alexandria, due east along the mouth of the Nile, where the river spilled into the Mediterranean from its four-thousand-mile meander north. The air was aching hot. After a year as foreign occupiers, the soldiers were exhausted, disliked by the natives, hungry, thirsty, and missing the company of women. Napoleon, in no coddling mood, had ordered that wives and mistresses be left behind on this campaign. And Muslim women were hardly accessible to the Europeans.

The French were digging in. Having quickly taken the port of Alexandria in July of the previous year, Napoleon swiftly moved to the

other port cities, Damietta and Rosetta, which easily surrendered. Napoleon himself was just back from fighting the Ottomans in Syria, pushing farther into the land he hoped to conquer and seeking a way to avoid the British, hot on his heels. Meanwhile General Jacques Menou, his commander, was eager to reinforce the coastal towns and gave orders to his soldiers to begin work on the ruined Fort Rashid at the edge of Rosetta. Surrounded by children and goats, and by the nomads who had taken up residence in the shade of the fortress, Menou's soldiers took up pickaxes and set to work on the mud-brick walls. It was Captain Pierre-François Bouchard who felt something solid beneath the sun-baked rubble: a hard rock, of quartz and feldspar and mica, dark gray with a delicate vein of pink.

The Rosetta Stone.

Measuring forty-seven inches tall and thirty-two inches wide, weighing 1,680 pounds, the stone had writing on it, three different kinds. Bouchard recognized the ancient Greek, and he understood that the two other languages—one the mysterious, figure-based text that was found on ancient buildings all over this country—were probably translations. He quickly saw the importance of his find: it was a key of some kind to the civilizations of the past, a code that might be deciphered. The stone was presented immediately to the French scholars, called savants, who had accompanied Napoleon and established the Institut de l'Egypte, dedicated to studying the finds of the invasion. They too immediately recognized its significance.

Dated to 196 BC, the Rosetta Stone was written in the wake of the Punic Wars between Carthage and Rome, at a time when the Ptolemaic pharaohs, of Greek descent, ruled Egypt. The stone was akin to a public billboard, publishing a decree by a council of priests that affirmed the royal cult of Ptolemy V on the first anniversary of his coronation. The decree repealed certain taxes and issued instructions relating to the priests and temple life and was inscribed three times in two different languages: Greek (the language of Ptolemy) and two forms of ancient Egyptian—hieroglyphics and demotic, the more common cursive script used for administration. The savants, of course, could read the Greek. "In the reign of the new king," it began in a blast of praise to the ruler,

> who was lord of the diadems, great in glory, the stabilizer of
> Egypt, and also pious in matters relating to the gods, Superior
> to his adversaries, rectifier of the life of men, Lord of the
> thirty-year periods like Hephaestus the Great, King like the
> Sun, the Great King of the Upper and Lower Lands, offspring
> of the Parent-loving Gods, whom Hephaestus has approved,
> to whom the Sun has given victory, living image of Zeus,
> Son of the Sun, Ptolemy the ever-living, beloved by Ptah . . .

It went on to invoke the Egyptian gods and issue instructions in the
name of the gods and the ruler and his relatives, in fourteen lines of
hieroglyphics.

Napoleon Bonaparte, the man who would fancy himself France's
modern-day pharaoh (and Caesar and Alexander the Great), had come
to Egypt on a quest not just to "rescue" the Egyptians from the Mam-
luks but also to challenge France's bitter rivals, the British. Bonaparte
had already swept through northern Italy in a brilliant campaign and
was the talk of Europe. Now his aim was to find the soft underbelly of
the British Empire. With their formidable navy, the British had domi-
nance of the oceans. Egypt, though it was ruled by the Ottoman
Mamluks, was within the British sphere of influence, and it was the
road to India, British territory. In the wake of the French Revolution,
the irrepressibly ambitious general told his leaders that he would find the
glory of France and demonstrate the ideals of the revolution by con-
quering Egypt. "The day is not far distant when we should appreciate
the necessity, in order really to destroy England, of seizing Egypt," he
wrote in a letter to the Directory of Five, the remaining leaders of
the revolution who headed the country. "Europe is a molehill," he
wrote. "We must go to the Orient. All great glory has always been ac-
quired there." In dreaming of Egypt, a place where very few Europe-
ans had ventured for centuries, Bonaparte hoped to duplicate the exploits
of Alexander the Great, the Macedonian conquerer, and he avidly read
the accounts of rare travelers to the region, such as the Abbé Reynard, in
preparation for his future triumph.

But Napoleon also possessed a very real desire to export the ideals
of the revolution—liberty, equality, fraternity—however distorted this

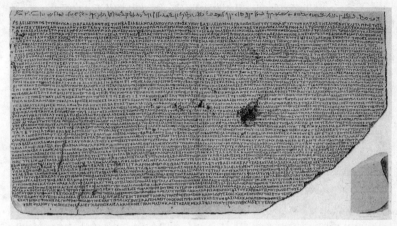

*The Greek portion of the Rosetta Stone, as drawn by one of Napoleon's savants. A sketch of the entire stone can be seen at the lower right.* (Courtesy of the Dahesh Museum of Art)

would become through the prism of European superiority and conquest. Egypt had been ruled for the previous five hundred years by a handful of corrupt Ottoman beys, supported by a class of ferocious warrior elites, the Mamluks. They lorded their power over the mass of Egypt's impoverished and uneducated population, the *fellahin* (peasants). The French leadership approved of Bonaparte's notion; in their view, as the world's most progressive society they had a mandate to free the Egyptian peasantry and to bring some prosperity to the descendants of one of the earliest known civilizations. Napoleon had a singular way of communicating this as he marched his way through Egypt, scattering leaflets with the message that he embraced the Muslim prophet, in a kind of eighteenth-century charm offensive.

> Inhabitants of Egypt, where the Beys tell you the French are coming to destroy your religion, believe them not! It is an absolute falsehood—believe it or not. Answer these deceivers, that they are only come to resque [revoke] the rights of the poor from the grasp of their tyrants, and that the French adore the Supreme Being, and honor the Prophet and his Holy Koran.

All men are equal in the Eyes of God. Understanding, tal-
ents and science alone make a difference between them. As
the Beys do not proffer any of these qualities, how can they
be worthy to govern this country? The French are true Mus-
selmans.

The announcement went on to caution that any village that resisted
Napoleon's army "shall be burned to the ground."

There was another entirely unique aspect to Napoleon's campaign.
Along with his expedition of thirty-eight thousand men (including
infantry, cavalry, gunners, horsemen, artillerymen, foot soldiers, guides)
and three hundred women (who were cooks and laundresses), the
general brought scientists. No fewer than 167 intellectuals, men of let-
ters and science, experts in their various fields, the savants included
painters, engineers, geographers, botanists, mathematicians, and histo-
rians. They included Dominique Vivant Denon, a French engraver,
painter, and writer who would also become one of the first archaeol-
ogists, as well as an early master planner of the Louvre; Nicolas Jacques
Conte, a balloonist; Baron Dominique-Jean Larrey and Costaz Des-
genette, who were doctors; the poet François Parseval-Grandmaison;
C. L. Berthollet, a chemist; Etienne Geoffroy Saint-Hilaire, a zoolo-
gist. They would accompany Bonaparte and his soldiers onto the bat-
tlefield and record, sometimes under fire, everything they saw. (French
soldiers assigned to protect them would take to shouting in the midst
of a skirmish, "Donkeys and scholars in the middle!") It is thanks to
them—and to Bonaparte's visionary decision to bring them—that we
have a vibrant contemporary record of Egypt at that time, an early
record of ancient Egypt, and the start of modern Egyptology. It was no
small irony that Napoleon's military goals in Egypt failed. But as one
scholar noted, his intellectual goals "succeeded wildly, and ironically
have endured through the centuries . . . in laying out before an amazed
Europe an exotic living landscape for study and the arts."

BONAPARTE AND HIS fleet sailed forth from France in May 1798,
evading the British commander Horatio Nelson, while conquering
Malta along the way. Napoleon landed at Aboukir Bay and prodded

his men onward without rest or water, heading to Alexandria. As he watched from a pile of masonry known as Pompey's Pillar, the French troops stormed the fort on the outskirts of Alexandria and—driven mad by thirst—decimated the town's defenses in a few hours. They moved on with little resistance to Damietta, and they occupied Rosetta on July 8. Taken by surprise, the Mamluks finally roused themselves to defend Cairo, to the south. At the famous Battle of the Pyramids (recorded in a glorious contemporaneous painting), 4,000 mounted Mamluks, in their desert costumes with headdresses flying, along with 15,000 fellahin, took on the modern French army of 25,000. The local leader, Ibrahim Bey, tried to recruit fighters with this specter: "The infidels who come to fight you have fingernails one foot long, enormous mouths and ferocious eyes. They are savages possessed of the Devil, and they go into battle linked together with chains." Napoleon, under the gaze of the Sphinx, grasped the historic significance of the moment and famously exhorted his troops: "Forward! Remember that from those monuments yonder forty centuries look down upon you." The battle was a rout and the beginning of the end of Mamluk rule in Egypt.

But Napoleon's success was short-lived. Even as the Corsican enjoyed this victory in Cairo, his British nemesis, Rear Admiral Horatio Nelson—blind in one eye, missing his right arm, a royalist, and a national hero—was preparing for Napoleon's ignominious defeat. Ten days later, on August 1, 1798, Nelson sailed into Aboukir Bay and neatly cut off the French soldiers, a mile inland, from their ships anchored far out in the waters by sailing in between the two. He then summarily destroyed the French fleet. Nelson was awarded a barony for his victory at the (misnamed) Battle of the Nile.

Now cut off from France, Napoleon's forces soldiered on for another two years. It was not an easy occupation. Napoleon had planned on his troops' living off the land, as they had done in Italy and elsewhere. But here, the land had little to give. On this arid, bleak landscape, their food rations were biscuits. The men did not find the granaries and could not make bread. Village wells were filled in by angry Bedouin tribesmen. The heat was unbearable, and soldiers succumbed to mirages. Hundreds of French troops died of hunger, thirst, malaria, sunstroke, or exhaustion. Napoleon's attempts to adapt to the local culture were

equally unsuccessful. Local villagers resented his insistence that they fly the French tricolor flag from mosque minarets and were not eager to be bestowed with tricolor sashes and cockades. The early notion that Napoleon and his army might adopt the Muslim faith quickly foundered over the issues of circumcision and the ban on alcohol.

But the work of the savants was a success. The Institut de l'Egypte was created in August 1798, with sections for mathematics, physics, political economy, and literature and arts. They held weekly meetings, which Napoleon frequently attended. The role of the institute was to transmit modern technology to Egypt and "to advise the government on the various problems put to it"—a think tank of sorts, headquartered in the Mamluk palaces of Qassim Bey. Among the many beneficial projects brought to Egypt by the savants was a reorganization of the government administration, reducing corruption. The country was set up as a French system of departments ruled by a local notable, a system that has remnants to this day. The savants set up hospitals in Alexandria, Cairo, and elsewhere, and studied local diseases. They instituted sanitary regulations and quarantined ships when necessary. They erected street lanterns every thirty yards in Cairo and organized proper rubbish disposal.

But the most extravagant and beautiful accomplishment of the savants was the discovery, or the rediscovery, of ancient Egypt. As they came across one monumental wonder after another, the savants were visibly moved and inspired. It must be remembered that these sights— the great pyramids, the Sphinx, the temples of Philae, Karnak, and Luxor—had been unseen by European eyes for centuries. Raised on the fussy splendor of rococo architecture and baroque design, instructed by the latest knowing trend that celebrated the ancient Greeks, French soldiers and savants saw the distinctive style and towering monuments of ancient Egypt as a stunning revelation. Those who came across the monuments were dazzled in ways that the modern traveler, who has seen these things in photographs, cannot be.

Fifty-one-year-old Vivant Denon marched with the troops into battle, sketching as he went. Upon seeing the Temple of Denderah, north of Luxor, Denon wrote: "Pencil in hand, I passed from object to

object, drawn away from one thing, by the interest of another. . . . I felt ashamed of the inadequacy of the drawings I made of such sublime things." The soldiers began by mocking the scholar but ended up helping him as they discovered the sights of ancient Egypt along with him. "The soldiers, overwhelmed, served me as a table, their bodies as shade," Denon wrote as he sketched the Temple of Karnak in Luxor, once the capital of ancient Egypt. The drawings by the savants served as a basis to publish the massive *Description de l'Egypte*, a government-funded project showing the wonders of Egypt as recorded by the savants, in twenty-three oversized volumes. The *Description de l'Egypte* took many years to complete and emerged in fits and starts, but it is a grand feat of publishing skill; eleven of the folios, those with the engravings, are massive—three and a half feet tall and two feet four inches across. It takes two people to lift one of them. The magnificent, detailed, lovingly rendered engravings of the antiquities discovered by the French scholars tell the story of their awestruck gaze. One original drawing of the Temple of Denderah by Gaspard-Antoine Chabrol is a carefully wrought tableau in pencil of hieroglyphs and figurines of an imagined scene from antiquity—women in elaborate headdress, men in textured, wrapped tunics, a vision by the artist of beauty and grandeur. Michel-Ange Lancret, a scholar, was shaken by what he saw on the island of Philae: "I reflected with a mighty excitement, pleasure and apprehensives [*sic*] that I was in one of the most extraordinary places on the earth, amid places that partake of the fabulous and by means of which, recited since childhood, have assumed gigantic and almost magical significance."

Among other monuments, the savants drew the fallen colossus of the pharaoh Ramses II, also known by the Greek name of Ozymandias. Made of granite in 1250 BC, it was the largest statue ever carved in Egypt, measuring fifty-two and a half feet tall. The engraving by André Dutertre depicts a fallen head on the right of the drawing, with the small pillars and smaller statues that remain from Ramses II's mortuary temple. It seems likely that it was this image that inspired the British poet Percy Bysshe Shelley to write his famous poem "Ozymandias" in 1817.

> I met a traveller from an antique land
> Who said: Two vast and trunkless legs of stone
> Stand in the desert. Near them on the sand,
> Half sunk, a shatter'd visage lies, whose frown
> And wrinkled lip and sneer of cold command
> Tell that its sculptor well those passions read
> Which yet survive, stamp'd on these lifeless things,
> The hand that mock'd them and the heart that fed.

Shelley never visited Egypt, but thanks to the savants he could feel as if he had.

Napoleon's campaign and the images sent back by the savants set off a wave of Egyptomania in Europe, a decided precursor to the many succeeding cycles that would grip the West, including the Tut-mania that took hold of the United States in the 1970s with the museum show of the boy king. In 1802 Vivant Denon published his *Voyage in Lower and Upper Egypt During the Campaigns of General Bonaparte*, a two-volume best seller, complete with engravings, translated into English and German and reprinted in forty editions. In France architects began building palm-topped columns, obelisks, and sphinxes. Everywhere, ladies of style adopted Egyptian iconography as the vanguard of chic, taking to wearing crocodile ornaments. The Sèvres porcelain factory made Egyptian inkwells and a series of knickknacks with Egyptian motifs—hieroglyphs, sphinxes, and a lion—while Napoleon ordered from the porcelain maker an Egyptian tea service for his empress, Josephine. For her part, Josephine kept an actual mummy on display at her home in Malmaison. Britain, too, was besotted with Egyptian style, creating porcelain curios by Wedgwood with pharaohs and hieroglyphs. There was an "Egyptian Hall" in London's Piccadilly Circus. Furniture designers produced boat-shaped couches with crocodile feet, and across Europe architects built Egyptian-inspired libraries, gates, bridges, tombs, and gardens. The Antwerp Zoo built an Egyptian temple to house its ostriches.

No surprise, then, that the first image of what became known as the Rosetta Stone is by Alire Raffeneau-Delile, one of the savants. Copied in careful Greek, with a three-dimensional scale of the stone

*The Ramasseum, the mortuary temple for the great pharaoh Ramses II, as drawn by the savant André Dutertre and published in the* Description de l'Egypte. *The head of the pharaoh lying tumbled in the sand is believed to have inspired Percy Bysshe Shelley's poem "Ozymandias."* (Courtesy of the Dahesh Museum of Art)

in the lower-right corner, the image is measured in decimeters and *pouces* (thumbs). There were three such pages in the *Description de l'Egypte*. But the stone itself would not remain in the hands of the French for long. Two years after the discovery, as the French army capitulated to the British in 1801, the treaty stipulated that all the savants' specimens and research were to be handed to the British. The French did not want to relinquish the stone. Indeed, General Menou—who had converted to Islam—stated that the Rosetta Stone was his personal property. The savants were devastated. Etienne Geoffroy Saint-Hilaire threatened to destroy the works rather than hand them over. "Without us this material is a dead language that neither you nor your scientists can understand," he told a British diplomat. "Sooner than permit this iniquitous and vandalous spoliation we will destroy our property; we will scatter it amid the Libyan sands or throw it in the sea. We shall burn our riches ourselves."

He was exaggerating. General John Hutchinson ultimately allowed much of the savants' collection to go with them. They were allowed to

take their magnificent drawings and valuable research and went on to complete the *Description de l'Egypte*. But not the stone. General Menou yielded his treasure, unhappily. "You can have it," he wrote. "Since you are the stronger of the two of us." And of course no one asked the Egyptians what they thought. In due time, the objects were handed over, and the Rosetta Stone was sent to London in 1802 to take up permanent residence in the British Museum. The French had made wax copies of the stone and were permitted to take those to France. They became the basis of a twenty-year quest to successfully crack the code of the hieroglyphs, a story that aptly illustrates the blessings and the curses visited on Egypt by the arrival of Europeans.

WITHOUT THE FRENCH, there would be no Egyptology today. More specifically, without Jean-François Champollion, the quirky, brilliant, and socially awkward scholar who worked on cracking the hieroglyphic code for two decades, we would have little of our current insight into the lives of the ancient Egyptians. We all owe him a debt of gratitude, Egypt first and foremost.

Used as a written language for some 3,000 years, hieroglyphics had been dead for more than 1,400 years by the time of Napoleon. In Roman times, a few priests still understood it. In the second century AD, the Roman emperor Hadrian called it "the language of the dead." The last recorded instance of hieroglyphic writing is in AD 394. After that it disappeared. Scholars since the Renaissance had tried to decode it, without success.

Born in 1790 in the town of Figeac, in central France, Jean-François Champollion was a young polymath, a prodigy and autodidact. He had to be self-taught as teachers were not to be found. It was just after the revolution and the subsequent reign of terror when ideological dogma—a dictatorship of virtue—had descended, condemning not just libertines and atheists but the clergy and educators, too. The guillotine had claimed the lives of many mathematics, chemistry, and philosophy scholars. Revolutionary leaders were seeking to reinvent education and train educators imbued with the proper revolutionary ideals. There were hardly enough of those, and by the time young Jean-François was ready to be educated, their ranks were painfully thin.

Champollion's father was a bookseller whose home was filled with books, and he took in a monk from a monastery that was being ransacked by a mob; in return, the monk secretly taught Jean-François and his older brother, Jacques. He would tell Jean-François ancient stories, including the biblical tale of Belshazzar, the evil Babylonian king who held a feast using the sacred vessels from the Hebrew temple destroyed by his father, Nebuchadnezzar. Suddenly a hand appeared, the tale went, and wrote these words on a wall at the feast: *Mene, mene, tekel, upharsin.* A Hebrew boy named Daniel was brought in to translate the mysterious words: "You have been weighted in the balance and found wanting." Jean-François dreamed about this story for years. But in the dream it was he, and not Daniel, who was called upon to translate the strange words. Unschooled though surrounded by books, Jean-François struggled to teach himself to read. He would draw the alphabet as if he were sketching pictures. His imagination drew him deep into the ancient world, fed by the stories of the Olympic games told by his brother Jacques.

Jacques had an extraordinary memory and focus, and studied most of the ancient works, but worked in a cloth shop to survive. He taught himself Greek, Latin, and Hebrew, and he taught his younger brother, too, reciting to him in Greek. But it was Jean-François who was the true linguistic prodigy; he easily remembered languages that Jacques worked hard to learn. Jacques decided to finance Jean-François's studies, sending him to Grenoble, where as a teenager the younger Champollion learned an astounding number of tongues: Hebrew, Arabic, Chaldean, Latin, and Greek. By age twenty he spoke well over a dozen languages, including Coptic, Sanskrit, Syriac, and Farsi. But Jean-François ached to unlock the hieroglyphics, the secret language of Egypt that held untold tales of wonder. The prefect of Grenoble visited Champollion's school and was taken by the young man's linguistic skill and knowledge of Egyptian history. Champollion was made an assistant professor of history in Grenoble, then appointed to a chair at the Royal College of Grenoble, where he concentrated on deciphering the Egyptian language and archaeology, for he was obsessed with the Rosetta Stone. In 1815 Napoleon—a recent escapee from Elba—showed up in Grenoble in his bid to challenge the restored Bourbon

*Jean-François Champollion, the decoder of the hieroglyphs.* (Mansell/Time & Life Pictures/Getty Images)

monarchy. Champollion came to the mayor's office to pay his respects; the fallen emperor and the obsessed linguist talked late into the night about the failed attempts to decipher the Rosetta Stone.

Champollion was not the only man trying to crack the code. Wax impressions of the stone circulated in several European countries, but scholars continued to fail to pierce the mystery. They worked on the demotic text, which looked more like an alphabet, rather than on the figure-based hieroglyphs. And they erred in seeking to translate the hieroglyphs as individual ideas, rather than sounds. Notably, a British physicist and amateur classicist, Thomas Young, worked on the demotic text. He believed it to be alphabetic, too, and by 1814 had translated that portion of the Rosetta Stone. He continued to study the hieroglyphs, also as an alphabet.

But it was not. Over time, Champollion came to understand that. Instead, he conjectured, it was a kind of rebus, in which the picture signified the sound. Or, it might be acrophonic, where the picture signified

the first letter of the word (a rabbit for *R*; a door for *D*). Thus it depicted the sound of the language, not the meaning. In 1822 Champollion deciphered his first hieroglyphic word: *Ptolemaios,* the name of the pharaoh, which was enclosed in a cartouche on the Rosetta Stone. Champollion realized that this was a name, and a foreign name, rendered phonetically. From there, he realized that all the cartouches, the oblong circles often found on tombs and inscriptions, were names. He discovered a cartouche from Abu Simbel in which he could identify the name of Ramses. Upon making this breakthrough, he rushed from his apartment, found his brother, cried, "*Je tiens l'affaire!*"—"I've got it!"—and dropped into a dead faint. In a letter dated September 27, 1822, Champollion wrote of his discovery to the Royal Academy of Inscriptions and Letters. And within two years he completed a *Précis du Systeme Hieroglyphique*, showing that the script was a mixture of ideographic and phonetic signs.

In 1824 Champollion traveled to Turin, which had one of the first collections of Egyptian antiquities—statues, papyri, and jewelry—purchased by the king of Sardinia from Bernardino Drovetti, the French consul-cum-antiquities smuggler. Drawn to the stacks of papyri—which had been badly shredded during their transport to Italy—Champollion proceeded to unlock the mysteries of the documents and read them for the first time in the modern era. He spent many months there, and with appropriate awe wrote his brother, "I have seen roll in my hand the names of years whose history was totally forgotten; names of gods who have not had altars for fifteen centuries."

Four years later, Champollion fulfilled a lifelong dream by visiting Egypt. It was an electrifying experience; he could actually read the inscriptions on the great temples and understand the long-buried significance of some of the oldest monuments in the world. He spent seventeen months in the Nile Valley, including three months in the Valley of the Kings. His trip, ostensibly to record material, was marred by an episode of looting: he took two vivid wall sections from the tomb of Seti I that were mirror image scenes. One is now in the Louvre and one is in the museum of Florence. Champollion returned to Paris, where he died of a stroke in 1832, while preparing to publish the results of his expedition. He was forty-two years old.

In 1973 the Rosetta Stone was finally exhibited at the Louvre. It has never been back to Egypt.

HE WAS A strongman. A weight lifter. A sideshow carny.

Giovanni Belzoni came from his native Italy to seek his fortune in London in the early nineteenth century. And he found it. Six foot six, the handsome muscleman known as the "Patagonian Samson" came up with an extraordinary act, which he performed at the Sadler's Wells theater in London. He would place an iron frame weighing 127 pounds, fitted with ledges, on his shoulders. Then twelve members of the theater company would clamber up onto the frame and perch there, while Belzoni strode around the stage, waving two flags in his hand. That was 1803, and for a while he was a star, touring Europe with the act. By 1813 or so, seeking new audiences, Belzoni and his wife, Sarah, made their way to Turkey. There they met Captain Ishmail Gibraltar, an agent sent by the pasha ruling Egypt to recruit experts who could improve Egyptian life.

Belzoni was no expert, but he was no mindless mass of brawn either. He was inventive and endlessly curious, and he had a natural gift for the mathematics of practical design. He also had a flair for writing and drawing. Egypt was in the air; Europe was enchanted by the images and stories brought back following Napoleon's foray into the country, and Belzoni had heard them like everyone else. Europeans of means were beginning to travel to the country to explore this ancient playground—a trend that would have both salutary and disastrous results for the antiquities buried there for millennia. Belzoni would be in the vanguard of those exploring the ancient sites and uncovering its hidden treasures. Among his discoveries were the Temple of Abu Simbel, the magnificent tomb of Seti I, and the entrance to the second pyramid at Giza. His extraordinary life is a testament to the best and worst of those enraptured by ancient Egypt in the nineteenth century. Belzoni was an archaeologist and a thief. He was an intrepid discoverer and a covetous collector. A preservationist and a tomb robber. He is a prime example of the conflicting effects on Egypt caused by the arrival of Europeans.

Approached by the pasha's agent in Turkey, Belzoni had an idea for a waterwheel that he believed could revolutionize the Egyptian economy.

*Giovanni Belzoni, the great discoverer of ancient Egypt and sometime looter.* (National Portrait Gallery, London)

His invention would use a single ox to turn a waterwheel, instead of many. He was determined to convince the pasha that he could change Egyptian agriculture with mechanization. Belzoni came to Egypt, took up residence in Cairo, and built a prototype. The innovation was never adopted, but in the meantime Belzoni became enchanted with Egyptian antiquity. He was in good company. The Egyptomania craze set off by Napoleon's discoveries coincided with the rise of the national, public museums in England and France and, later, Germany. A race began between these great empires to fill the halls of their cultural temples with the treasures of Egypt.

In these early years, it was the diplomats themselves who led what amounted to the wholesale looting of ancient Egypt: Henry Salt, the British consul general, and Bernardino Drovetti, the consul for France, led the charge, a pattern that would be followed elsewhere in the ancient world, including Turkey and Greece. At the time, the Albanian-born Ottoman ruler of Egypt, Mehmet Ali, was more interested in currying

favor with the West in order to modernize Egypt than in exploring the past. To him, the antiquities were a convenient bargaining chip to induce Westerners to invest and take an interest in his still-backward country. The pasha gave them as many *firmans* (exit permits) as they desired, and Salt and Drovetti were rapacious. As the historian Brian Fagan details in his book *The Rape of the Nile*, "They reached an unspoken gentleman's agreement . . . to carve up the Nile Valley into spheres of influence. Other acquisitive visitors were forced to beware, for both Salt and Drovetti were so influential that they could arrange for the denial" of the exit permits. They did not hesitate to smash things up if a piece was too large or too heavy to transport. Later travelers found the detritus of their work—fragments of obelisks and colossi with the heads missing—from men in a hurry to take what they wanted and send it abroad. This was the start of what became an outrageous free-for-all. Egypt's Nile Valley became a veritable marketplace for antiquities, blithely lifted by Europeans for their own purposes, some scientific, some aesthetic, some nationalistic, but ultimately commercial.

Belzoni, whose talent was in finding things rather than selling them, worked in concert with Salt. In Cairo he learned of the famous colossal bust of Ramses—the fallen Ozymandias—still lying in the sand in the Ramasseum, the pharaoh's mortuary temple, on the west bank of the Nile. Others had recognized the bust's pristine beauty, and the French had tried to remove it earlier, without success. In 1816 Belzoni determined to bring it to England. (This was not the colossal head from the fifty-two-foot statue but a smaller one from the same temple.) Henry Salt got the *firman,* the permit, from the pasha, striking a business partnership with Belzoni that would last for some years. Belzoni traveled down the Nile and, arriving at Luxor, he was transfixed: "It appeared to me like entering a city of giants who, after a long conflict, were all destroyed, leaving the ruins of their various temples as the only proofs of their former existence," he wrote.

Drovetti did his best to obstruct the British project. Along the Nile, Belzoni found that the local Arabs refused to work; boats, materials, carpenters were all suddenly unavailable, the local bey could not grant permits, and the timber on which to drag the head was impossible to find in the desert. Belzoni persisted. Many bribes and several frustrat-

ing days were needed before work could begin. His plan was to drag the bust to the edge of the Nile and wait for the river's annual flood to float it northward on a boat. He heaved up the weight of the bust with four levers, placing two large rollers under a carpenter's platform. (Belzoni painted an evocative watercolor of this exercise, showing dozens of men pulling the car on its four rollers.) He had to break the bases of two columns in the Ramasseum to get the piece out. They moved a mere hundred yards a day, then had to detour around a sandy patch. All along, Belzoni was plagued by work stoppages arranged by his political rivals; eventually the strongman lost his temper. In an attempt to block his work, the local chief drew his sword, but "I instantly seized and disarmed him, placing my hands on his stomach and making him sensible of my superiority, at least in point of strength, by keeping him firm in a corner of the room," Belzoni wrote. Five more days, and the bust was at the bank of the Nile, awaiting the flood season.

Looking for a new challenge, Belzoni continued up the Nile to Abu Simbel, the site of two massive statues mostly covered in sand. This area of the Nile was Nubia, populated by black Africans who lived in the villages along the river, far from the reach of Cairo. In these remote places, there was no money, and the people had absolutely no interest in the soaring antiquities around which they lived. (When Drovetti had offered the locals three hundred piasters to open the temple, they returned it, having no use for cash.) It was another explorer, the Swiss Johann Ludwig Burckhardt, who had discovered the tips of the colossal frieze, peeking above a sandy incline. Belzoni was determined to uncover it and find what he believed—correctly it turned out—to be a temple below.

Inspecting the site, Belzoni was daunted by the task before him, as well he should have been. The scale in this part of ancient Egypt was massive, beyond European imagination, far bigger than similar statues and monuments from ancient Greece and Rome. Belzoni got the locals to work for him, finally, by paying in food—corn rations—rather than cash. He made early progress, uncovering twenty-five feet of the temple, by clearing away sand and planting palm trees and saplings along a palisade of the upslope to keep new sand from pouring into the excavated area. He then left, determining to return to finish the job.

This was, perhaps, an esoteric quest. Belzoni could not bring Abu Simbel with him, and he did not necessarily expect to find treasures there. Along his path, Belzoni managed to unearth more treasures and sent many of them to the British Museum. But the greed that seemed to ultimately overwhelm the better instincts of those who were dazzled by ancient Egypt came to characterize Belzoni's quest. He found an object, he coveted it—he took it.

So it was with an obelisk on the island of Philae. "If brought to England, [it] might serve as a monument in some particular place, or as an embellishment to the Metropolis," Belzoni wrote, as if he were shopping in a High Street gallery. In a small temple on the island he found twelve carved stone blocks, which, assembled, showed the god Osiris on his chair, with an altar before him. The blocks did not stay on the island. Too bulky to fit on Belzoni's boat, they were sawed down for later shipment from his base in Aswan.

He then moved back to Karnak and commenced digging. These sites were so untouched that almost anywhere one dug there were treasures to be found. Within a few days, he found near the Temple of Mut a group of black granite statues of the goddess Sekhmet, the lion-headed wife of the god Ptah. Over dinner with Calil Bey, the Turkish ruler of the province and a relative of the pasha, Belzoni had spiced mutton and got his *firman*. The statues are now in the British Museum.

Then came the final move of the Ramses head, poised near the bank of the Nile. After finally winning permission from the local authority, Belzoni built a dirt causeway from the ledge, eighteen feet above the Nile where the head sat, to the river's edge. A contingent of 130 men dragged the head to the water and placed it carefully in the middle of the boat to prevent it from capsizing. One could easily imagine that the colossal Ramses could have ended up at the bottom of the Nile. To everyone's amazement, it did not. Twenty-four days later, the bust arrived in Cairo, along with a spectacular load of antiquities nabbed by Belzoni, and continued on to Alexandria. The bust of Ramses debuted at the British Museum in 1817 and was an immediate sensation.

Returning to Luxor and Karnak, Belzoni came across the people of Qurna, peasants who lived at the mouths of the tomb entrances, among the mummies. These were subsistence farmers who had dwelled

among the tombs of the ancient nobles for centuries, and who persisted in their way of life until about 2006, when the Egyptian government finally began moving them to new housing, far too late to salvage any of the tombs. By the second decade of the nineteenth century, the peasants of Qurna had abandoned their farming in favor of grave robbing, which had become a far more lucrative pursuit. They took Belzoni into the dry caves and burial chambers, packed high with hundreds of mummies, where they crawled on their bellies through a foot-high opening in search of papyri to steal from the very embrace of the ancient dead. "The purpose of my researches was to rob the Egyptians of their papyri," he admitted, "of which I found a few hidden in their breasts, under their arms, in the space above the knees, or on the legs, and covered by the numerous folds of cloths." Ever welcoming, the Qurnese cooked chicken for Belzoni in an oven heated with pieces of mummy cases, "and sometimes with the bone and rags of the mummies themselves," he wrote. "It is no uncommon thing to sit down near fragments of bones. Hands, feet or skulls are often in the way, for these people are so accustomed to be among the mummies that they think no more of sitting on them, than on the skins of their dead calves. I also became indifferent about them at last, and would have slept in a mummy pit as readily as out of it."

He returned to Abu Simbel in the summer of 1817, and when the locals could not be induced to continue, Belzoni determined to dig out the temple himself. Stripped to the waist, he and his crew dug each morning from before dawn until 9:00 a.m., when the heat became unbearable. Throughout, they were threatened and robbed. The locals offered assistance at a price, but fistfights and drawn swords were frequent. On the last day of July, the diggers came upon a broken upper corner of a doorway: the entrance to the temple. The next day, as they prepared to enter, again arguments, demands, and complaints rang out, until one of Belzoni's crew slipped into the temple, and the others followed. For the first time in a thousand years, human eyes gazed on a pillared hypostyle hall, with eight huge figures of Ramses II facing one another across a central aisle. The air was foul and heavy with humidity. Behind the statues, square pillars were decorated with brilliant reliefs of the pharaoh and other gods. Beyond this first hall came a

chamber, an antechamber, and a sanctuary, with figures of seated gods. Belzoni recorded this in a watercolor, and navy engineers sat down and drew the temple to scale. He took the few portable treasures that were there.

The Temple of Abu Simbel is one of the most important finds of antiquity, and it must be credited to Belzoni's extraordinary efforts. He then returned to Luxor, to the Valley of the Kings, where there were rumors of undiscovered royal tombs. Belzoni, now experienced in the field of Egyptian antiquity, headed to a minor tomb he had found earlier, the tomb of Ai. He set his men to work at a spot where he noticed some surface irregularities; after two days' digging, his men found the entrance to a passage, thirty-six feet long, whose walls were painted with intricate scenes. It led to another passage, then to a pit, with a small hole made by previous tomb robbers. Squeezing through that hole, Belzoni found himself in a richly decorated hall with four pillars, adorned with figures of a pharaoh. Beyond that came other passages and halls and then a translucent alabaster sarcophagus, nine feet long and only two inches thick. It glowed when he placed a light inside it, and the interior was decorated with hundreds of delicate, inlaid figures. Belzoni had found the burial chamber of Seti I, the father of Ramses II, who had died in 1300 BC. The mummy itself was long gone, having been removed for safekeeping by royal priests and hidden in another tomb. (The mummy was later recovered.) This was one of the most important tombs in the Valley of the Kings and probably the most beautiful. The walls were decorated with thousands of hieroglyphs and beautiful scenes of the pharaoh and the gods, with a curved, soaring ceiling painted in midnight blue. A delegation of British dignitaries, led by Henry Salt, soon arrived to witness this spectacular find.

Then Belzoni discovered the entrance to the second pyramid at Giza. By this time the British consulate in Cairo looked like a "catacomb," as one visitor noted, so full was it of statuary and found treasures. The French traveler Edouard de Montule, journeying up the Nile at this time, was struck by the rapid dislocation going on at these sites, so many thousands of years old. He wrote: "If any perfect tombs exist, I sincerely wish they may escape the research of the curious antiquary. To them the learned are become objects to be dreaded as Cambyses [the Persian con-

querer], for the sarcophagus's and mummies which they contained would inevitably take the road to London or Paris."

But Belzoni was not nearly as clever a businessman as he was a budding archaeologist. Struggling to make money off his discoveries, he decided to sell the alabaster sarcophagus of Seti I and to create an exhibit of the tomb with which to tour Europe. He hired an Italian artist to make wax impressions of the carvings on the wall of Seti's tomb; the artist reproduced 500 hieroglyphs, 182 life-size figures, and 800 smaller figures. The exhibit opened in 1821 in London, in a building called Egyptian Hall in Piccadilly, and was a ringing success. The show contained a full-scale model of two rooms from Seti's tomb, a model of Abu Simbel, and a cross-section view of the second pyramid. As for his partnership with Salt, they tried to sell the sarcophagus to the British Museum and meant to split the proceeds. Negotiations dragged on for months, until finally the trustees of the museum rejected the piece. It was sold instead to John Soane, a famed architect and antiquities collector. Belzoni got none of the money. The sarcophagus can be seen today at the Sir John Soane's Museum in London.

For what it's worth, Salt never made the fortune he expected from his looting enterprise either. He sought a huge sum for the many artifacts he sold to the British Museum, but had to settle for two thousand pounds—a fraction of what he wanted. Drovetti sold his collections to the king of Sardinia; to King Charles X of France, who passed it to the Louvre; and to the German scholar Richard Lepsius, who put the objects in Berlin. Drovetti died in an insane asylum in 1852.

Restless in London, Belzoni set out again in 1822, this time to explore the Niger River in West Africa. He caught dysentery in Benin and died in a week. His burial site is unknown, an obscure end to a notorious life.

SHE IS THE most famous of the Egyptian queens. Her name, Nefertiti, means "The Beautiful One Has Come." What did she look like? Everyone knows: the swanlike neck, the dark, doe eyes, the high, noble forehead on a delicate featured head, crowned by a towering blue headdress—all of that is familiar because of a limestone sculpture found in 1912. Except for the pyramids and the Sphinx, the bust of

Nefertiti is the most recognizable icon of Egyptian antiquity. The image has inspired artists and seekers of beauty, lovers of Egypt. She is shorthand for Egypt itself, even though she is no longer in Egypt. The bust is the image superimposed on the landing card that every visitor to the country fills in at Egyptian passport control.

Today, she resides in the Egyptian Museum of Berlin, displayed majestically in a neoclassical building on the city's museum island. Visitors surround and gaze at her in a huge, dramatically lit glass case in a soaring stone hall. (Nefertiti is in the Altes Museum while a new home is prepared for her at the nearby Neues Museum.) Berlin does an excellent job of exhibiting the bust of Nefertiti. But she came to Berlin under legal circumstances that sound suspiciously like smuggling; it is no wonder Zahi Hawass wants her back.

Much about Nefertiti, the historical figure, remains a mystery. She may have been a princess from central Mesopotamia. Many believe she coruled with her husband. Then she disappeared, and no one knows whether she was banished, retired, or died early.

This much is known: Nefertiti was the beloved chief wife of the eighteenth-dynasty pharaoh Akhenaten (also known as Amenhotep IV or Amenophis IV), who ruled from 1353 to 1336 BC. She did not descend from royalty, and apparently Akhenaten did not follow the royal tradition of marrying his eldest sister in choosing her. She had more power than almost any other wife in ancient Egyptian history and early on was named an adviser to the king. Theirs was an unusual love story. In inscriptions found from the reign of Akhenaten, the pharaoh wrote tributes of devotion to Nefertiti, such as this, found on a funerary stone.

> And the Heiress, Great in the Palace, Fair of Face, Adorned with the Double Plumes, Mistress of Happiness, Endowed with Favors, at hearing whose voice the King rejoices, the Chief Wife of the King, his beloved, the Lady of the Two Lands, Neferneferuaten-Nefertiti, May she live for Ever and Always.

Many reliefs show Akhenaten and Nefertiti in loving, family compositions, surrounded by their children (they had six daughters to-

gether), with Nefertiti sitting on Akhenaten's knee or even, as in one example, showing the king riding with her in his chariot, kissing her in public. In other scenes they participate in ritual events. The queen is frequently shown at the king's side and is always represented wearing her tall, blue, flat-topped crown, a headdress that was clearly unique to her, as it is unseen elsewhere in Egyptian art.

Nefertiti and her husband founded a cult of one god, the sun god, Aten. In his bid to overturn the worship of the traditional gods and create a religion devoted to the sun, Amenophis IV changed his name to Akhenaten and moved his capital from Thebes, today's Luxor, to a city he founded 150 miles to the south, a capital he called Akhetaten, known now as el Amarna. The cult, a radical departure from the polytheistic Egyptian religion, is an early form of monotheism, worship of a single god, in this case the life-giving sun, a universal, omnipotent, and supreme force. The king imposed his religious doctrine on many aspects of society, especially artistic ones. The new style was characterized by naturalistic representation of plants, birds, and animals, and extolled the joy and beauty of life. Yet in the art, bodily features were elongated and distorted. Nefertiti can be seen in numerous reliefs and inscriptions, including on some blocks that were dismantled and used in temples for later pharaohs, reconstructed by archaeologists with computer models, and the images are not nearly so elegant as the bust. The figures on wall reliefs tend to be in the Amarna style, with widened hips and overly broad lips. This too makes the bust, in vibrant color and entirely lifelike, unique. The Cairo Museum has a beautiful stone sculpture of Nefertiti that much resembles the bust in Berlin, but it is incomplete, and work on it appears to have been stopped in early stages of its sculpting. Some speculate that the bust in Berlin was a study for that final version, made of a finer brown quartzite.

The revolution effected by Akhenaten and Nefertiti was eradicated by the reactionaries who came after them and abolished much of the evidence of their cult. It was not until the early decades of the twentieth century that real work on this period began when Ludwig Borchardt, the founder of the German Archaeological Institute in Egypt, was given permission to excavate at Tell el-Amarna. He was funded by James Simon, a merchant and museum patron. Digging began,

and Borchardt quickly found many treasures. But his digging in the work studio of Thutmose, an ancient Egyptian sculptor, turned up an unexpected cache of unique objects. Thutmose's style differed from the stiff, flat portraits typical of Egyptian art at that time. Pieces from his workroom were striking and lifelike, and none more so than the bust of Nefertiti. In his diary, Borchardt could not keep his excitement from seeping through the methodical language of the scientist.

> After my lunch break on December 6, 1912, I found a note by Prof Ranke who was the supervisor, in which he asked me to come to House 47, 2. [The workshop of Thutmose.] I went there and saw the pieces of Amenhopis IV's life-size bust, which had just been discovered right behind the door in room 19. . . . Slowly but surely we worked our way through the debris, which was only about 1.10 meters high, towards the east wall of room 19. . . . About .2 meters from the east wall and .35 meters from the north wall, on a level with our knees, a flesh colored neck with painted red straps appeared. "Life size colorful bust of Queen" was recorded. The tools were put aside and the hands were now used. The following minutes confirmed what appeared to be a bust: above the neck, the lower part of the bust was uncovered and underneath it, the back part of the Queen's wig appeared. It took a considerable amount of time until the whole piece was completely freed from all the dirt and rubble. . . . We held the most lively piece of Egyptian art in our hands. It was almost complete. Parts of the ears were missing, and there was no inlay in the left eye. The dirt was searched and in part sieved. Some pieces of the ears were found, but not the eye inlay. Much later I realized that there had never been an inlay.

Borchardt's excavation was an authorized one, and the terms of his digging were set under the system of *partage,* French for "division," from the verb *partager,* "to share." The excavator would share his finds with Egypt in a process conducted by an "Egyptian" official who was, in fact, French. Egyptian authorities would have first choice and could

rule out as national treasures anything they deemed too important to leave the country. But actual Egyptians had little part of this process. At that time, the antiquities authority in Egypt was headed by a Frenchman, Gaston Maspero. The reason for this was simple: Egypt produced no archaeologists of its own. There was a reason for this, too: Egyptians were not allowed to study Egyptology.

The Western attitude of the time may require some explanation, but it is reflected fully in the comment by a nineteenth-century traveler to Egypt: "France . . . earns the right to the thanks of the learned of Europe, to whom belong all the monuments of antiquity, because they alone know how to appreciate them." Egyptians were considered too primitive to study such a sophisticated science. The French dominated Egypt's archaeological institutions for the better part of a century, fending off other Europeans and giving no thought whatever to including Egyptians. The Antiquities Service was founded in 1835 by Auguste Mariette, a brilliant French Egyptologist, who also founded the Egyptian Museum in Cairo. Mariette opposed teaching archaeology to the Egyptians, for reasons that were clearest to him. A school opened to teach archaeology to promising young Egyptians, but a hostile Mariette closed it in 1869. Mariette's successor, Gaston Maspero, denied excavation permits to Egyptians because, he asserted, they were motivated only by the desire to find treasure, not by "scientific passion." (This may even have been true, but the way to rectify that situation was to train and educate Egyptians.) Lord Cromer, the British consul general in Egypt at the turn of the century and an unabashed imperialist, stated outright that Egyptians were not "civilized enough" to look after their antiquities. The situation had not improved much by 1923 when Ahmed Kamal, the first Egyptian to be fully qualified as both an Egyptologist and an archaeologist, proposed comprehensive training for Egyptian Egyptologists. His efforts resulted in the opening of the first proper school to do so, but it was not until 1952, after the nationalist revolution by Gamal Abdel Nasser, that Egyptians took full control of the Antiquities Service (now the Supreme Council of Antiquities) and of the nation's museums.

This must be considered what it is: a blunder born of racism. But it was also a shortsighted strategy by the Europeans in power, with the

cost borne by the antiquities themselves. Egypt's most important monuments are under the stewardship of Egypt, and the country ignored and neglected them for decades. If Egypt has taken too long to claim ownership of its past, and to expend political and financial capital to preserve it, it is partly because Egyptians were actively excluded from the process of discovery and knowledge.

And so it was Maspero's deputy, Gustave Lefebvre, a French papyrologist and epigraphist, who conducted the partage of Thutmose's workshop on January 20, 1913. Lefebvre was not in his area of expertise. Either he did not notice the importance of the bust, or—as Egypt maintains—Borchardt purposely hid it among less important objects. Borchardt himself admitted that he did not clean the bust but left it covered in mud during the division of artifacts. Either way Lefebvre failed to recognize its importance and ceded it to the Germans.

Shipped to Germany, the bust was given to Borchardt's benefactor, the wholesale merchant James Simon, who donated it to the Berlin Museum in 1920. It was unveiled in 1923 before an astonished public, and—to no one's surprise—it rapidly became one of the favorite attractions of the Egyptian Museum of Berlin.

Egypt felt hoodwinked. Officials there were unaware of the statue before its unveiling. Now that its beauty was obvious, they demanded its return. This dust-up occurred against the backdrop of Howard Carter's discovery of the tomb of King Tutankhamun in 1922, the same year that Britain conceded limited independence to Egypt and a new, semicolonial era in the country's politics began. The discovery of so many intact treasures in Tut's tomb, and the fervor of independence, led to a public outcry over applying partage to this discovery. This led to the abolition of partage, and the subject was in the air as Nefertiti was unveiled in Berlin. In 1925 Egypt refused to grant excavation permission to German archaeologists unless Nefertiti was returned, or at least until discussions were opened on the question. Germany declined, saying the statue was part of a legal division of spoils. In 1929 Egypt offered some valuable pieces in its collection in exchange for Nefertiti. Germany declined.

Then in 1933, after Adolf Hitler's rise to power, Egypt renewed the request yet again. Hermann Goering, who was the premier of Prussia

along with being Hitler's leading military henchman, suggested to King Fouad of Egypt that Nefertiti might be sent back home. Hitler at first agreed to do so. But after he examined the statue, he adamantly refused. "Do you know what I'm going to do one day? I'm going to build a new Egyptian museum in Berlin," Hitler wrote to Egypt in rejecting the request. "I dream of it. Inside I will build a chamber, crowned by a large dome. In the middle, this wonder, Nefertiti, will be enthroned. I will never relinquish the head of the Queen."

In 1939 German museums were evacuated because of the war, and the bust was sheltered in a salt mine in Thuringia. After Germany's defeat in 1945, the bust was shipped to the U.S. central collecting point in Wiesbaden by the U.S. Army Monuments, Fine Arts and Archives branch, and was returned to West Berlin in 1956. The East Germans tried in vain to recover the sculpture, as it had been exhibited in the part of the city that became East Berlin. For forty years there was an inter-German debate over "Who Owns Nefertiti," a discussion that ended when the Berlin Wall came down in 1989.

Little happened to change this situation until Zahi Hawass rose to prominence. An opportunity for indignation presented itself in 2003; he and his colleagues took offense when two Hungarian artists, András Gálik and Bálint Havas, incorporated the bust of Nefertiti into a piece of sculpture for the Venice Biennale international art show. Gálik and Havas sculpted a bronze nude body, brought it to Berlin, and placed the bust of Nefertiti on the body, making a videotape of the event for display at the Biennale. The bust was on the body just for a few moments, but no matter—the Egyptians were insulted and outraged. "The moral and scientific responsibility of the Egyptian Museum is at stake here," fumed the Egyptian ambassador to Germany, Mohamed al-Orabi. "It contradicts Egyptian manners and tradition. The body is almost naked, and Egyptian civilization never displays a woman naked." Egyptian newspapers took up the call, and the cultural insult was officially deep. (Al-Orabi might be interested to read Zahi Hawass's book about women in ancient Egypt, in which he writes: "The ancient Egyptians were not disturbed by nakedness in either sex. . . . Women are shown bare-breasted and servant girls frequently wear nothing but a girdle of beads.") Farouk Hosni, the Egyptian culture minister, warned

absurdly that the sculpture was "no longer safe in German hands." Whether or not Hosni really cared about this subject—his home in Cairo is filled with contemporary and other European art, and very little of ancient Egypt—and regardless of the fact that Egyptian women are very nearly nude in countless ancient images, the incident had clearly hit a raw nerve. The Hungarian artists had waded into an international cultural minefield, even if they believed they were doing what artists have done for centuries, paying homage to the art that preceded them.

The opportunity for cultural outrage served the Egyptians perfectly well. Their requests for the bust's return had been ignored since the 1920s, and it was a logical step from here to renew their demands, which Zahi Hawass did just a couple of years later. During a speech in 2006 before Egyptian president Hosni Mubarak and German president Horst Köhler, Hawass asked for Nefertiti as a three-month loan and said that Egypt would offer something valuable in exchange. He went on to make formal requests of the Berlin Museum, which responded that the bust was too fragile to travel. Hawass had a bitter history with the director of the Berlin museum, Dietrich Wildung, who was banned from excavating in Egypt in 2003, when Hawass claimed to have a tape in which Egyptian antiquity smugglers talked about selling objects to him. Wildung denies the accusation and has not been charged with a crime. Regardless, by early 2008, Berlin had backed down a bit on the Nefertiti request: a joint Egypt-German commission would examine the bust and decide if it were capable of traveling.

The Egyptians were not the only ones making self-serving arguments as to whether Nefertiti should return. In 2007 the *Berlin Zeitung* threw its weight behind the decision to leave Nefertiti where she was: "The bust has been above ground and visible in Berlin for much longer than it ever was in Egypt," said the newspaper, in a twist of strained logic. "She has become the epitome of slimly modern beauty, the ideal of self-confident modern womanhood." Which apparently was why she needed to stay in Germany.

Should Nefertiti be returned? The arguments for and against were dissected by lawyers in a conference in 2004 that debated the question of restitution. The lawyer arguing in favor of return, Kurt Siehr, stated that it should leave Germany because Egypt was not aware that it had

allowed its export in 1913. Moreover, Egypt had been a British pro-
tectorate until 1922 and was not in control of its own fate. Siehr cited
a German law barring "unjust enrichment," but noted that its thirty-
year statute of limitations had expired. Arguing the other side, Stephen
Urice, the director of the Project for Cultural Heritage Law and Pol-
icy, observed that partage had been done according to Egyptian law;
therefore there was no wrong to be righted. In addition, he said, the
bust's presence in Berlin made it accessible to a large audience. Finally,
Urice rejected the idea that Nefertiti was part of Egypt's basic cultural
identity. "The cultural connection between Nefertiti's Egypt and con-
temporary Egypt is attenuated at best," he wrote. "The former was pa-
gan; the latter is predominantly Muslim; the former was a monarchy, the
latter is a democratic state; and so on. . . . There is no evidence that the
bust is essential for contemporary Egyptians to understand who they
are and the values their culture currently holds in esteem."

In these matters, it seems that legal arguments cannot prevail. Do
the Egyptians need to possess the bust of Nefertiti? Do they deserve it?
The sculpture may well have been smuggled out of the country but,
given the chaotic state of Egyptian museology, that might well have been
a blessing. Today, the politics of possession leads the discussion, while it is
a culture of exchange that would serve the public—and history.

# THE LOUVRE

*Rome n'est plus dans Rome*
*Elle est tout à Paris.*
*(Rome is no longer in Rome / She's all in Paris.)*

—EIGHTEENTH-CENTURY FRENCH VAUDEVILLE DITTY

IT WAS A MISERABLE DAY AT THE LOUVRE. BENEATH A SKY thick with clouds, the drizzle drew a moist curtain over the curved, courtly flourishes of the seventeenth-century palace, whose galleries seemed to stretch endlessly into the mist. Alain Pasquier, chief conservator of Greco-Roman antiquities at the museum, was in a foul mood. For starters, he was behind in editing the proofs to the catalog for an upcoming exhibit on Praxiteles, an influential sculptor in ancient Greece, which was set to open at the museum in eight weeks. Praxiteles, long admired by art historians, was a master technician and an artistic provocateur, the first to sculpt nude women in ancient Greece, whose style was copied by other sculptors for hundreds of years after his death. Pasquier had stayed up late the night before to close the catalog and was likely to be staying up late again tonight to get his proofs done in time for a hard deadline. He was also under pressure to finish assembling a group of antiquities that were to be sent on loan to a new Louvre museum being set up in Abu Dhabi, in the Persian Gulf. The Louvre had agreed to curate a new museum in the tiny emirate—a kind of satellite branch—loaning for a period of years a fair number of pieces from its vast collection. But that project was

turning out to be a magnet for all kinds of unexpected criticism from France's museum and art establishment, who had taken the view that the Louvre—the most important and oldest museum in the world and the one to which Pasquier, a year from retirement, had consecrated his life's work—was whoring itself out to a country of nonmuseum-going Bedouins in exchange for a fat check.

Idiots, he thought. The Louvre sucked up $300 million a year in expenditures, and the French government had been tightening the screws every successive year. The galleries were in desperate need of updating, and the Louvre had no tradition whatsoever of raising money from private donors. Taxpayers and tourists paid the bill for himself and his sixty-five fellow curators, not to mention the several hundred employees at the museum. The catalogs cost a fortune, conservation cost a fortune, the building cost a fortune, and if the Arabs were willing to fork over $1.3 billion for the privilege of having the Louvre's imprimatur on their building, why not? Perhaps the cultural snobs who were whining in *Le Monde* about the loss of the "French patrimony" had a better idea for coming up with some cash?

But those critics weren't his problem. What was his problem was that two weeks earlier Greece had suddenly threatened to pull out of the Praxiteles exhibit, protesting the inclusion of a stunning, life-size bronze statue of a young Apollo. The armless, fourth-century bronze, nick-named "Sauroktonos," Greek for "the lizard slayer," was being sent from the Cleveland Museum of Art and was an early version of a marble Apollo from the later Roman era—complete with arms and a lizard crawling up a trunk—which was owned by the Louvre. Both sculptures were very rare; the Cleveland Apollo was the only known bronze of its kind in the style of Praxiteles. The Louvre owned one of only two Roman-era marble sculptures like it, with the other in the Vatican. The Cleveland piece was a perfect example of the early influence of Praxiteles, and Pasquier had planned to exhibit the two statues side by side for the first time ever.

Without warning, Greece had announced that it had a problem with the Cleveland statue. The culture ministry said that it was unsure of its provenance and would withdraw its loan of a half dozen key sculptures if Sauroktonos were included in the exhibit. "They never

mentioned this to the Cleveland museum. They've never asked for the sculpture to be returned," Pasquier grumbled to me, as he canceled our scheduled meeting.

The Cleveland museum had bought the statue in 2004, and its curators were unsure of how and where it was originally found. But they rejected the Greeks' claim that the bronze had been underwater and had been fished by an Italian vessel in international waters between Italy and Greece in the 1990s. Instead, the Cleveland museum said it was bought from two well-known dealers, Ali and Hicham Aboutaam, who owned the Phoenix Ancient Art Gallery in Geneva, and had come from a collection held in East Germany from before World War II. Cleveland's curators said they had spent a year investigating the provenance before buying the sculpture. In truth, the exact chain of ownership was unclear: from East Germany it was sold to an unidentified Dutchman in 1994, who sold it to another collector, who sold it to the Aboutaams in 2001 with the understanding that he would remain anonymous. Cleveland's experts said the statue had never been underwater. And anyway, since its place of origin was unknown, why should the Greeks have a claim? Nonetheless, it was a diplomatic tangle of the kind that was taking up more and more time for the Louvre's curators. Pasquier had just returned from Athens, where—reluctantly—he was forced to give his agreement to drop the Cleveland sculpture from the exhibit. Without the half dozen Praxiteles sculptures from Greece, the entire exhibit didn't have much of a point.

And so it was going in that particular week in January 2007 at the Louvre, a venerable institution with incalculable treasures, long accustomed to calling the shots in the world of museums and antiquity.

From the outside, the Louvre was as popular as ever, visited by 8.3 million people in 2006 alone, most of them foreign visitors who came from all over the world to see the Mona Lisa, the Venus de Milo, and the Winged Victory of Samothrace. The runaway best-selling book *The Da Vinci Code*, and the blockbuster movie that followed, had brought with it a new wave of popularity for the museum's collection, and the Louvre had cleverly capitalized on the iconic image of the Mona Lisa from the movie poster to mount its own informational campaign.

But from the inside, the mood did not seem so self-confident. Things were changing in the world of art and antiquity, and those changes were beginning to have an effect on the Louvre, and on the morale of its staff. Within the museum, a new dynamic was taking hold, as the institution changed a long-held policy of curatorial tenure. Until 2004, the post of museum director was a lifetime appointment, as were the heads of the various departments. This had led to a near paralysis in the administrative structure, for it was impossible to remove a department head who was abusing his or her power or falling down on the job. The new rule filled positions for three years only, to be reconfirmed or changed at the end of that time. That reform set the complacent scholars at the Louvre on edge.

And outside the Louvre, the supremacy of its judgment—and indeed its mission—was being questioned. Every day it seemed another demand for restitution arose. Every day some journalist threw questions at a Louvre official over one object or another, asking whether it would be fair to consider the return of some of the Louvre's prized possessions to their countries of origin. It was becoming unmanageable.

The hardworking officials at the Louvre found these developments confusing. Never before had they been asked to justify themselves in this way. The Louvre was unaccustomed to being refused loans of pieces they requested for exhibits. They were thrown off balance by this new atmosphere of suspicion and, frankly, disrespect.

"You end up thinking we're all a bunch of looters, thieves, exploiters, that we're some kind of criminals," said Aggy Lerolle, the Louvre's chief press attaché. The Greeks may feel indignant now about the provenance of this or that statue, she said, "but who would be interested in Greek sculpture if it were all in Greece? These pieces are great because they are in the Louvre."

The same was true for the media drumbeat created by Zahi Hawass in Egypt. Lerolle did not deign to call him by name. "The Egyptian keeps coming to ask for more things, through the media," she said. "Legally he has no right to ask for anything before 1983," when Egypt banned the export of antiquities unearthed after that date.

In her offices—an aluminum, three-story prefabricated structure in one of the Louvre's many courtyards, a temporary home while the

permanent offices were undergoing renovation—Lerolle and her team were juggling a barrage of inquiries, in addition to their regular work. Already she and her staff were overstretched, often working until 8:00 p.m., with the Abu Dhabi project heavy in the news and set to open in a matter of months. But the restitution issue would not go away. A writer from the British publication *Art Newspaper* had called earlier in the day to ask about a Turkish request for the return of a panel of colorful tiles from the sixteenth century, part of the museum's Islamic art collection. The panel had come from the tomb of an Ottoman sultan, Selim II, located in the Hagia Sophia complex in Istanbul. In this case, it appeared that the panel had a history and a provenance; a French restorer had received the panel in 1895 in exchange for restoring numerous other panels from the same tomb, and had made copies at the time for Istanbul to have in its place. The restorer sold the panel to the Louvre upon his return to France. The Turks were, apparently, crying foul nonetheless; the Louvre was convinced the entire business was nonsense, but wading into the details took valuable time. In internal e-mails over the latest set of requests, the Louvre officials were dismissive, with one writing to another with ill-concealed exasperation: "The Islamist press launched the whole thing."

These challenges came as a kind of culture shock to the Louvre, an arm of the French state and a pillar of France's own national identity. Forged in the fervor of revolutionary zeal, the Louvre was meant to embody the very essence of the humanist ideals that led to the overthrow of the French monarchy and the creation of a representative democracy. Art was not to be hoarded by the rich; it was to be shared. Knowledge was for all. Human achievement was not restricted to a single class, and great beauty, accessible to all, could elevate any citizen. It was a social message that the Louvre could represent within its walls, simply by existing. To take the palace of France's kings and transform it into a public temple, where all French people could enjoy the royal art collection and other artistic treasures of the world, was a symbolic act that resonates with perfect clarity even today. The building was first opened to the public as a museum on November 8, 1793, amid the French Revolution. The early collection was made of the crown jewels of France

and illustrated vases collected by an abbot to the crown. The Crown Furniture Repository came to the Louvre in 1796, along with other so-called revolutionary seizures, mainly royal.

Over time, the egalitarian ethic of the revolution has come to run deep in the veins of the French body politic, evident in the widespread consensus today that the government should not just pay for health care, education, child care, and public transportation, but also actively support the arts. France spends fully 1.5 percent of its national budget on culture—more than $4 billion a year (approximately 3.1 billion euros)—including allocating about $500 million to museums.

But hand in hand with France's egalitarian ethic comes a parallel, if contradictory, elitism. Art is for all, if you are French. Enlightenment is of a particularly Western variety. In coming to the Louvre to view the art of the world in a universal museum, gathering all the great artistic achievements of humankind, you pay homage to the supremacy of this glorious museum and the culture that created it. The Louvre opened its doors to art that was gathered, bought, looted, and appropriated from other places, without much thought to the consequences or concerns of those places of origin. From 1794 onward, France's revolutionary armies rounded up artworks from across Europe, with the aim of filling the halls of their new public palace. They brought pieces that were considered to be the very pinnacle of artistic beauty: the Apollo Belvedere, and the Laocoön group, taken from the papal collection in the Vatican; the Dying Gaul, snatched from Rome's Capital Museum; the four horses from the San Marco cathedral in Venice. These arrived in Paris with great celebration. The rise of Napoleon Bonaparte and his conquests across Europe invited yet another wave of looting, foremost from Italy, where he won battles in 1797 and 1800. The despoiling of Italy was an act of national pride, enshrined in paintings that depicted caravans of artwork being carted off to Paris. The vast treasures brought from Italy led to a grand restoration and completion of the Louvre—new galleries were built along the rue de Rivoli—and its renaming as the Napoleon Museum in 1803. For a short period, northern Europeans were able to see the finest of classical sculpture without traveling to the Mediterranean.

None of this history is mentioned, however, on the Louvre Web site under the heading "How the Collection Was Formed." That digest leaps from the acquisition of art belonging to the crown in 1796 to the purchase of a medieval collection in 1825. Like most of the great Western museums, the Louvre has chosen the history that suits it. Regardless, led by the esteemed savant Vivant Denon, who became the museum's director in 1804, the Louvre continued to grow through purchase—including forced purchases, such as part of the Borghese collection of sculpture—and appropriation, which was sometimes reversed. The collections shrank by about two thousand paintings when almost all the wartime acquisitions (including the bronze horses from San Marco) had to be returned after Napoleon's final defeat at Waterloo in 1815.

The elitist strain that is built into the Louvre has an explicitly nationalist component. No object that has become part of the French museum system can ever be sold, since it has officially become French patrimony. To someone who comes from Greece, this must seem like a strange concept: the Parthenon frieze in the possession of the Louvre has become, ipso facto, French. The building of a national collection was central to creating the narrative of French greatness, of the power and the glory of its empire. Like so much in French culture, the Louvre is organized around the unspoken principle that the French are a great nation with a mandate to instruct and lead the world in all matters of human progress, whether art, history, philosophy, politics, science, or food. Over the centuries, that elitism has become an integral part of its identity, as much a part of its essence as the populist ideals of the revolution. Indeed, it is this mix of egalitarianism and elitism that is so peculiar to the French, and that to them poses no contradiction. The filling of the Louvre is a perfect example: the French colonized foreign countries and taught the natives to read their language, while shipping off the local treasures to the Louvre for the edification and wonder of the European masses. Deep in the DNA of the institution is this passionately held belief—valid, perhaps, but not unanimously believed—that the world should be grateful that the Louvre preserves and displays the great art of the world. How that art came to be at the

museum is not a question that the curators or other officials actively consider. And why should they? It is, after all, *the Louvre*.

THE FIRST INESCAPABLE reality of the Louvre is its mind-boggling size. I have seen many museums in my life. I have seen scores of Egyptian, Greek, Mesopotamian, and other ancient artifacts. I have been to the Louvre many times. But in all my years of visiting this imposing palace, whether to see the new glass pyramid or to stroll through the eighteenth-century sculpture garden, I never quite grasped its scale. When, for the first time, I went through all the rooms displaying antiquities, they seemed endless. Not just the Venus de Milo or the dramatic Winged Victory of Samothrace. Not just the nine rooms—rooms—of Greek vases. Not just the display of mummies, with the row of stone sphinxes and rearing baboons that originally stood alongside the obelisk on the Place de la Concorde but were moved indoors by nineteenth-century prudery (the baboons' genitals can be seen). Long after most of the visitors had gone, I continued to wander through the halls of the Egyptian collection, past the spectacular rooms that most visitors see, with the matching reliefs of Ramses II, the two massive red granite sphinxes, and the colossal foot from the statue of Amenophis III in Thebes. When it all sinks in, the visitor cannot help but be overwhelmed by the totality of this grandeur and by a sense of gratitude at the opportunity to see so much, so beautifully displayed.

And yet there are dirty secrets in the Louvre's collecting past. Its Egyptian collection, dating back to 1826, is as breathtaking as it is oblique in revealing its origin. Jean-François Champollion, the famed decoder of the hieroglyphs, was the Louvre's first curator of Egyptian art, and the collection is a cornerstone of the Louvre, a symbol of its revolutionary, Enlightenment purpose. Indeed, the collection was part of the very creation of modern Egyptology. All the more notable, then, that the monumental pieces on display in the Louvre have no apparent past other than that in antiquity, and that they came to the museum with no previous owners. They do have a past, of course, just not one that is evident from visiting the museum or its bookstore— most of it was taken from Egypt during decades of unchecked looting

in the nineteenth century. Thus Champollion pulled together a dazzling collection of nine thousand objects in just a few years. Some, though not most, came from Napoleon's expedition; much more came from the rapacious collectors in later decades who were working to dismantle monuments in Egypt as quickly as possible.

Some have interpreted this dismantling as a desire to save the monuments from extinction, because Egyptians were reusing the materials for new construction. That view, from today's vantage point, is overly convenient. While it is true that many of Egypt's rulers were prepared to dismantle ancient temples to build factories (Egypt's modernizing leader Mehmet Ali was even prepared to use the stone from the pyramids in construction, but budding Egyptologists like Giovanni Belzoni convinced the pasha this was a bad idea), what mainly drove the European collectors was greed and national pride. They wanted to gather as many pieces for their national collections as possible, before their British or French or German rivals could do so. Thus, Champollion bought 4,000 pieces from the collection of Henry Salt, the British consul in Egypt who found the British Museum less inclined than the Louvre to pay his prices. He bought 500 pieces from the collection of Bernardino Drovetti, the French consul in Egypt, who was in a pitched race with Salt to despoil the country. The Louvre had earlier acquired 2,500 pieces from the collection of Edme-Antoine Auguste Durand, another collector-adventurer. Toward the end of his life, Champollion went to Egypt himself and brought back another 102 pieces, including two bas-reliefs ripped from the tomb of Seti I. Three painted reliefs of Amenophis III were bloodlessly cut out of his tomb by an unknown nineteenth-century adventurer and cataloged at the Bibliothèque Nationale, before ending up at the Louvre. "At that time, there were no rules, except to please Champollion," remarked Roger Khawam, an eighty-five-year-old, Egyptian-born antiquities dealer who sold many pieces to the Louvre, as did his father and grandfather before him. "The Egyptian law didn't forbid commerce. And it was conceived to please Champollion."

The French Egyptologist Auguste Mariette, who later became the first director of Egypt's monuments and the founder of Egypt's Cairo Museum, went to Egypt in 1850 and began excavating in Saqqara,

where he discovered catacombs of Apis bulls, the Serapeum. (In his account of the discovery, Mariette describes blowing up the vaults with gunpowder.) Over a four-year period, operating under a partage agreement with Egypt that he instituted, Mariette sent some 6,000 objects to the Louvre, including one of the most famous statues in the Egyptian department, the seated Scribe. Today it graces the cover of one of the Louvre's Egyptian catalogs. Another 2,500 pieces collected by a French physician, Antoine Clot (who traveled to Egypt to help modernize the country's health services in the 1850s), went to the Louvre as well. At the time, the Antiquities Service was run by the French; the Egyptians themselves had no say in what could leave the country.

The Louvre's antiquities holdings went through another major expansion during the reign of Napoleon III, as French explorers pushed into Asia Minor and Mesopotamia. Paul-Emile Botta, the French consul general in Mosul in 1842, which was part of the Ottoman Empire at the time, set out to find the biblical city of Nineveh. Instead he found Khorsabad, the remains of the Assyrian palace of King Sargon II, and the dazzling winged bulls that were its entrance. For the next few decades, the French government dispatched archaeological missions— either directly or through French institutes in Athens, Cairo, Rome, and the Ottoman Empire—led by budding explorers who excavated and sent home artifacts fresh from the ground: Assyrian, Phoenician, Sumerian, Babylonian, Mesopotamian, Persian. These missions filled the museum, taking objects from countries mainly under the control of a European empire under the rules of partage, or, in some cases, with permission to take everything.

But there is a reason for not revealing the origin of so many pieces from the Egyptian collection: the tales would embarrass the Louvre. And to the average visitor, it would undoubtedly mar the experience of reveling in the treasures of the ancient world to know how they arrived in this place, in this condition. Where the museum offers hints, more questions are raised than answered. Two priceless pieces of art and of history are tucked away in a niched hallway in the Louvre, just off the main room that houses most of the mummies. You could easily miss them; I nearly did. The first, the Chamber of Kings, is a floor-to-ceiling account of the history of Egypt's royal families, covering

three walls, rendered in colorful, sculpted bas-reliefs and hieroglyphic cartouches of the kings' names. Built under Thutmosis III (1472–1425 BC), the chamber is made of stone blocks and covers eleven centuries of pharaonic history; it is inscribed with sixty-one names, including those of many pharaohs. It is one of only five known chronological lists of royal names; thus, its historical value cannot be overstated. But the piece, on closer inspection, has been badly damaged. More than half of the inscriptions are done in trompe l'oeil, painted on instead of sculpted. How could that be? The explanation is suggested, barely, if you read between the lines of the legend to the left of the chamber, which tells you that the chamber was found and dismantled by the explorer Emile Prisse d'Avennes in 1843. "It was a ruin in Karnak when Prisse d'Avennes dismantled it," the Louvre tells us. The legend goes on to explain that "elements" were "lost in transport" by a broken case, but luckily Prisse d'Avennes had made plaster casts of the walls before he removed them, so they could be reconstituted on arrival.

This is prevarication of the first order, a selective telling that is rather shocking for an institution dedicated to preserving history. Prisse d'Avennes was a half-heroic, half-tragic figure, who devoted forty years of his life to discovering and understanding ancient civilizations, especially Egypt. He was a gifted artist who made hundreds of sketches, papier-mâché impressions, and plaster casts of thousands of inscriptions and reliefs that covered the tombs and temples in Egypt, a critical record of monuments that were in the process of being excavated, looted, or otherwise irretrievably altered in the nineteenth century. But he stole the Chamber of Kings, also known as the Table of Kings, for the purpose, he said, of its preservation. Even the most celebratory history of the Louvre, a glossy account by Nicholas d'Archimbaud, notes that Prisse was actually in a race to snatch the bas-relief before the Germans could do so. He had settled near the ruins of the Temple of Karnak in ancient Thebes, and according to one account was increasingly disturbed by the demolition of ancient monuments, which were being used as stone quarries to build factories. Without the necessary *firman*—the permission of the Ottoman authority—he removed the bas-reliefs under cover of night, using a few men and basic tools. He also took several stelae, with domestic scenes dating back to 4,000 BC,

*Emile Prisse d'Avennes, artist, explorer, and looter.* (Image from
*Who Was Who in Egyptian Archeology*)

and several priceless papyri. He bribed the local governor and begged
his way to getting the reliefs into twenty-seven packing cases that were
placed on boats to Cairo. From Cairo, they moved to Alexandria, and
in 1844, a full year later, he finally escorted the cargo to France. But,
again, nationalism was a motivating factor; the French *Revue Archeolo-
gyae* thanked Prisse for saving the chamber "from vandalism . . . and
from being removed by the Prussian Commission . . . and above all,
for having refused to sell it to England."

Tragically, the French state did little to appreciate or to properly
preserve this find. The walls of the Chamber of Kings needed to be
reconstructed and were meant to be displayed in the Bibliothèque
Nationale in an exhibit designed by Prisse. But in his absence, workers
applied a hot varnish to the walls rather than a colorless shellac, which
destroyed the paint that colored them. Even Prisse's son and biogra-
pher later noted, "An object which 35 centuries had left unharmed
has been destroyed by indifference and ignorance." Is Prisse the hero

of this story or the villain? Perhaps Prisse did save the monument, though most of the Temple of Karnak remains. The trompe l'oeil was made possible by his original sketches. But the paint-over was necessitated because he removed the sculptures from their place of origin. None of this can be imagined by reading the explanation beside the Chamber of Kings in the Louvre today.

The same holds for the wondrous object that occupies the other end of the niche in the same room, one of the five pieces that Zahi Hawass has demanded be returned to Egypt. The zodiac ceiling of the Temple of Denderah would easily be missed by the average museum visitor, so tucked away is it from the busier byways. This treasure was ripped from the building that housed it by the French collector Sebastien Louis Saulnier and his agent, Jean Baptiste Lelorrain, in the early 1820s. The temple was familiar to early Orientalists, as it was among the objects described by a wonderstruck Vivant Denon, the French savant who was among the first Europeans to lay eyes on this temple as Napoleon's army pushed south in 1799. The ceiling is in every way sublime, though it will probably never again be seen in its entirety, as Denon saw it. The zodiac ceiling is a dense kaleidoscope of intricate images and symbols from Egyptian astronomy, with recognizable symbols from astrology still in use today. As a historical document, the ceiling documents the Egyptians' deep knowledge of the astral movements of the sky—of planets, eclipses, and constellations. The ceiling gives us a precise notion of the state of the cosmos 2,050 years ago. One inscription actually records a solar eclipse that occurred on March 7 in the year 51 BC at 11:10 a.m. Other carvings show the position of the constellations from June 15 to August 15, in 50 BC. Sculpted into the ceiling are a big dipper, a little dipper, a bull, Cassiopeia, Orion, a scorpion, Sagittarius—all familiar symbols to this day. It is magnificent. Saulnier, a former police commissioner in Lyon under Napoleon who had been thrown out of power after the restoration of the monarchy, decided that such a remarkable piece should belong to France.

According to the Louvre's documentation, Saulnier succeeded in gaining "the express permission of Mehmet Ali," the ruler of Egypt, to take it, though the museum makes no mention of what inducement was necessary for such a feat. The engineer Lelorrain had forged special tools

in France to do the deed. Working on the rooftop of the Denderah temple, Saulnier hacked and gouged at the zodiac ceiling over the course of twenty-two days, trying to drag it down using chisels and saws. But when more than three weeks of hacking did not succeed in removing the ceiling, Lelorrain turned to gunpowder in specially drilled holes to dislodge it. The explosions finally did the trick, destroying a nearby sculpture of Isis. The masterpiece was then dragged on special wooden rollers down from the rooftop, toward a waiting boat, but the rollers wore out because it was so heavy. Lelorrain had to resort to levers and, again, brute force. When the ceiling reached the river, there was a further drama when it slipped off the sloping planks and fell into the soft mud. This still sounds horrible, at a distance of nearly two hundred years. At the time, the mutilation of the temple caused outcry even among the nationalistic French. The savant Edme Jomard protested, as did Jean-François Champollion. Henry Salt protested, but for a different reason. He had been planning to make off with the zodiac ceiling himself, to sell to the British Museum, but Saulnier had beaten him to it.

I asked the Louvre's chief Egyptian curator, the gentle Christiane Ziegler, pale of skin and hesitant of voice, about the brutal removal of the zodiac ceiling. She said simply, "How else would you remove a stone ceiling?"

Unlike the Chamber of Kings, this artifact survived its extraction and shipment to France and was treated better once it got there. On its arrival in Paris, the zodiac ceiling was sold to King Louis XVIII for 150,000 francs. He placed it in the Bibliothèque Nationale, where it remained until 1919, when it was moved to the Louvre. Today, the Louvre visitor is given a detailed analysis of the carvings on the ceiling. But there is not a single word about how this remarkably important artifact came to be removed from its place of origin.

THERE IS A DAZZLING, encyclopedic quality to the Egyptian galleries of the Louvre. Room after room depicts every imaginable aspect of ancient Egyptian life: cooking, furniture, jewelry, farming, accounting, sewing, sex, and of course the intricate funerary process. Their quantity is matched only by the amazing, intact state of most of these pieces, with brilliant color and intricate detail. There is one entire

room of ancient Egyptian hand mirrors. There is a glass display case devoted to what the curators call *claquoirs*, a kind of Egyptian castanet, and another display case filled with chesslike board games. But almost none of them offer information about how these objects came to be in the halls of the Louvre. The first major piece greets visitors as they enter the Egyptian wing, a large sphinx of red speckled granite. In pristine condition, except for the same hacked-off nose visible on so many Egyptian sculptures, probably courtesy of overzealous early Christians or Muslims, the sphinx is noted to have been "found in Tanis," though most viewers probably do not know where that is. (It is in the northeast Nile Delta.) There is no clue as to how this massive piece of stone was moved thousands of miles from there to the basement of a French palace. In the same room, matching reliefs of Ramses II, adoring the Sphinx of Giza, adorn the walls. The legend reads: "This relief was found, with the one facing it, between the feet of the grand sphinx of Giza." Fascinating. But who took it? How? And when? For the visitor to the Louvre, an enduring mystery, worthy of the Sphinx itself.

When I was sure I was nearing the end, I turned a corner and found myself before an entire row of life-size seated gods, Sekmets, from the reign of Amenophis III. I counted seven in a row, all black. And then, more still: the sarcophagus of Ramses III, an eighteen-ton mass of stone, covered in intricate script and scenes, discovered and hauled here from the Valley of the Kings.

Finally, darkness had fallen and the museum was nearly closed, and still I wandered through new rooms of Egyptian artifacts, discovering new treasures. It was quiet, deserted, dim. Suddenly, I was stopped in my tracks by a sight both familiar and strange. Tucked against the wall of an obscure, paneled room painted orange, perched high on a pedestal with a spotlight and little else to distinguish it, was the sculpted stone head of Akhenaten, the renegade, revolutionary pharaoh. It is one of the most famous images of the monotheistic king. The legend beside Akhenaten's bust reads simply that Egypt donated the Akhenaten head to the Louvre. No date. No reason. I learned later that it was a major gift—the sort of piece Egypt no longer allows to leave the country—in the wake of the heroic efforts of a French archaeologist and Louvre

curator, Christiane Desroches Noblecourt, to save the Temple of Abu Simbel in southern Egypt. The story is one of those typically grand dramas of which Egypt seems to have an endless supply. In the 1960s the completion of the Aswan High Dam, created as a public project by the nationalist Egyptian president Gamal Abdel Nasser, threatened to submerge the monument. Desroches Noblecourt successfully rallied UNESCO to save Abu Simbel, but she could not convince the organization to save a lesser shrine, the Temple of Amada. In time-honored French tradition, Desroches Noblecourt swore that "La France le sauve!"—France would save the temple!—and persuaded an otherwise uninterested President Charles de Gaulle to do exactly that. This was an ambitious undertaking that meant cutting the stone temple into pieces, placing it on rails, and transporting it several miles away and 180 feet above its original site. Once again, none of this gripping backstory is offered in the quiet anteroom where Akhenaten resides.

The massive stone sculpture is missing much of the skull, and from head-on it looks thin, diminished. But from the side view, the face, with its graceful features in the elegant, elongated style of the Amarna era, is intact and stunningly beautiful. The pharaoh is smiling.

BEHIND THE SCENES, the Louvre is very different from the ornate rooms of state that display the jewels of the museum's collection of 350,000 objects, only about 10 percent of which are on permanent display. The offices of the staff of the museum are unadorned, except for a framed poster or two in a narrow corridor. And all the offices seem well worn, badly in need of a coat of paint. Modern office chairs fill the office spaces beneath elaborate plaster moldings along the ten-foot ceilings, but they are no longer gilded, and the ancient wood floors creak.

The back alleys of internationally renowned museums could themselves be the subject of an investigation. No matter how gleaming and magisterial the courtyards and exhibition halls may be, the museum back rooms usually resemble the fire escape of a regional theater. They are often draped with fabric and are stacked high with clutter—no, not of second-rate Monets, chipped marble busts, or the watercolor landscape of some now-forgotten nineteenth-century painter, but with

cardboard boxes filled with catalogs and brochures, with ladders and toe motors and those hydraulic contraptions that scissor their way up toward the ceiling. The back rooms of newer museums, like the Getty, are brighter, wider, and equipped with giant-sized elevators for transporting oversized artwork. But even there the whole thing smacks of the back-stage of a traveling circus, with spackle paste and piano wire and nary an objet d'art to be seen.

"What's the greatest museum in the world?" asks the introduction to the Louvre catalog in 2004, written by former director Michel Laclotte. It is a disingenuous question, but he answers diplomatically: "Hard to say. But few other museums have developed, in the same place, as bal-anced and representative a collection of artistic accomplishment, from the 3rd millennium BC to the middle of the 19th Century." The subti-tle in the catalog is similarly subtle: "The Museum, Triumphant."

The great museums of the West by now have their own legends and myths, and the Louvre burnishes its version with evident care, ex-plicitly so in a multiroom exhibit at the entrance to the Sully wing with a formal history of the institution. It is, perhaps, a bit different from other museums, if only because of the size of the place, and the fact that the building dates back, originally, to the fifteenth century when it was a hunting lodge, and then a castle. Some say the Louvre collections are the most valuable gathering of art to be found in any one building in the world. Shunted off in a forgotten corridor, you might find an entire series of marble sculptures of past leaders of the museum, or the revolution, or the counterrevolution. And while the Louvre is a public institution—indeed, an international one—the cul-ture of the place is hardly transparent. The French approach informa-tion as something to be guarded zealously, not necessarily shared with the undeserving masses. Unlike the British Museum, the Getty, or the Met, the Louvre does not have archives that are accessible to the pub-lic. Attempts to extract even the most banal information about the origins of the acquisition of major pieces—say, how did the Venus de Milo end up at the museum?—are met with a blank stare and the ad-monition that it is only the curators who hold such information.

But the true identity of the museum, its personality beneath the legend and the official story, is to be found elsewhere. You learn much

more about how the museum views itself merely by paying attention to the pieces as they are exhibited throughout the museum, and in reading the catalog entries. In fact, what is often most interesting about the antiquities collections at the Louvre is what the museum *doesn't* tell you. The catalog takes care to explain the partage system, by which European archaeologists split their finds with the country of origin. "Thanks to this policy, the Louvre obtained beautiful pieces from excavation," the catalog reads, in a breathtakingly selective account of how it built the collection, ignoring entirely its history of expropriation. The catalog points to the Louvre's greatest pieces, such as the Code of Hammurabi, the Babylonian stele that is the earliest known legal code in human society. The code displays 282 crimes and punishments carved into the stone—including the famed reference to "eye for an eye" justice—the aim of which was to illustrate the laws that created a uniform social code and a verifiable legal system nearly four thousand years ago. The catalog notes that the stele, dated between 1792 and 1750 BC, was taken from Babylon in modern-day Iraq to Suse, an Elamite city in modern-day Iran, as war booty in the twelfth century BC. Five centuries after that, in 646 BC, the king Assurbanipal of Assyria destroyed the Suse acropolis, burying the stele. The account makes no mention of how or when the code came to be in a French museum.

In fact the Code of Hammurabi was unearthed in 1901 during a dig conducted by Jacques de Morgan, a respected French archaeologist who was the director of the Persian Delegation, an appointment made by the French ministry of public education and fine arts. At the time, the Iranian leader Naser ed-din Shah had signed a treaty granting to France a monopoly on archaeological exploration in his country. De Morgan focused his interest on Suse, most particularly on a one-hundred-foot-high mound of earth, known as "the citadel," beneath which lay layers of successive prehistoric civilizations, built one atop the other. De Morgan, though, was most interested in the oldest layer. The dig, which began in 1897, yielded spectacular finds: Elamite metal works and Babylonian pieces taken as war booty. In 1901 the Hammurabi code was found, not long after the next shah, Mozaffar-ed-Din, had signed a new treaty granting all antiquities discovered at Suse to France. Broken into three pieces, the Hammurabi code went to France

in 1902 and was restored. The stele was subsequently deciphered by the French Orientalist Jean-Vincent Scheil, a Dominican priest who conducted archaeological expeditions in Egypt and Persia, and made the code the focus of the rest of his career. It was Scheil who entrusted the stele to the Louvre.

None of this backstory is to be found in the Oriental galleries of the Louvre, where the smooth totem of black basalt on which Hammurabi inscribed his harsh system of justice stands naked, unprotected by glass, in a room that overlooks the bustling cacophony of traffic on the rue de Rivoli. The room itself is rather obscure, not well marked, and the display seems almost offhand, as though the code is just another in the Louvre's many thousands of priceless works from history rather than a unique, fundamental clue in the puzzle of early human civilization. The accompanying legend explains the significance of the Code of Hammurabi, with its sculpted relief of the ruler bending before his sun-god, Shamash. It offers nothing at all about its provenance in recent centuries.

It is worth noting that the Hammurabi code is actually a part of Babylonian, not Persian, history. A copy of the stele is to be found in the dimly lit basement floor of the Baghdad Museum, so famously ransacked in the days following the fall of Saddam Hussein in 2003. What would have happened had the original been there at the time? Perhaps it would have been untouched. Perhaps it would have been damaged. An estimated 4,000 objects remain missing from the Baghdad Museum, though far fewer than the 170,000 pieces (the sum total of the collection) that were first reported. Today, the copy remains, accompanied by an explanation that the original is in France, leaving the viewer with the unavoidable feeling that this is a strange state of affairs.

The vast majority of items in the sprawling antiquities collections of the Louvre are just like the Code of Hammurabi and the zodiac ceiling; they would appear to have landed in this French palace by chance or, perhaps, divine intervention. In the Greek-Rome-Etruscan halls, many pieces are marked simply "Bought 1807." Others note that they came from a "royal collection" before that time. When the provenance has a clear line through European channels, it is duly noted. Beneath a

marble statue of Athena, for example, there is this: "In Mattei collection; 1808–1815 Cardinal Flesch; Bought by Louis XVIII in 1821, given to the Louvre." But in the room where the Venus de Milo stands alone, surrounded by hundreds of curious tourists—who loudly gawk and wonder what makes this piece of Greek sculpture so different from dozens of others—a sign behind the statue reads, "Discovered April 1820," and explains that the piece came from the island of Melos in the Greek Cyclades. No further details are volunteered. The Louvre does not tell you that the Venus de Milo, considered one of the finest examples of Greek sculpture, was found by a peasant named Yorgos, who was tilling his field on the lonely island of Melos, near the ruin of an ancient theater, according to the *Manual of History of Art of the Ancients*, published in 1847. Another account states that a French sailor, Dumont d'Urville, was present and helped excavate the statue. A Bavarian prince with property on the island bought the sculpture. More nationalist maneuvering ensued: it was coveted by the French and by the Venetian prince Morosini. At one point the statue was loaded onto Morosini's ship; the weather kept the ship from sailing, and only frantic diplomacy turned events in France's favor. The Marquis de Riviere, the French ambassador to the Ottoman Empire, succeeded in acquiring the statue; he shipped it to France and gave it to Louis XVIII, who gave it to the Louvre in 1821. The lack of information does not banish the question of provenance from the mind of viewers. On one of the many days I visited the Venus de Milo, an American visitor perused the map of the Cyclades on the wall and muttered to himself, "They're telling us where they stole it."

The Louvre is equally cryptic about the small piece of the Parthenon frieze displayed nearby. It was taken by French agents before Lord Elgin could spirit it off with the rest of the marbles he took starting in 1801. The signage gives no hint of the British-French rivalry over antiquities at the time, which was at the heart of its being in Paris rather than London, or Athens. "Revolutionary seizure, 1798," it reads.

When it suits the Louvre, the museum may offer in great detail the story of how an object came to be within its walls. The most striking example of this is the Winged Victory of Samothrace, one of the museum's three most famous artifacts. It sits dramatically on the landing

*The Winged Victory of Samothrace, in the Louvre.* (Photo by Scott S. Warren/Aurora/Getty Images)

at the top of the Daru staircase, just before the entrance to the Etruscan collection. The statue, which dates from 190 BC, is a glorious example of Greek sculpture, though its creator is unknown. It is a six-foot marble winged woman alighting on the prow of a massive stone ship. Her head is missing, as are her arms, but the movement of Victory's draped robes as she lands gracefully on the ship makes her seem thrillingly alive. The Louvre explains the sculpture's complete history on handy cardboard panels laminated in plastic and translated into a half dozen languages beside the sculpture. The interested visitor will thus learn that it was found by Charles Champoiseau, the vice-consul of France in Adrianople, the second capital of the Ottoman Empire, in March 1863. Champoiseau, a twenty-seven-year-old amateur collector, had searched the island of Samothrace and discovered

the statue in pieces. The laminated legend does not mention that Champoiseau was a young striver who was eager to win favor with Napoleon III and knew how much the new emperor loved antique objects. It does not make mention of any *firman* from the Ottoman authorities. But apparently the French felt free to take the pieces, for the island was basically empty of inhabitants; the Turks had massacred several thousand of the Greek residents in 1821 in what is known in Greek history as the "Great Massacre of Samothrace" and took most of the rest into slavery. (Samothrace would not be taken by Greece until 1912 and was annexed shortly thereafter.) In a letter dated April 15, 1863, Champoiseau wrote to the Marquis de Moustier, the French ambassador in Constantinople, that he had found something wonderful.

> Today I have just found, in my excavations, a statue of winged victory (or so it appears), in marble and of colossal proportions. Unfortunately, I have neither the head, nor the arms, unless I find them in pieces in the area. The rest, the part between the breasts and feet, is nearly intact and made with an artfulness that I have never seen surpassed in any of the great Greek works that I know, not even in the bas reliefs of the Aptere Victory, or the Caryatides of the Erechtheion on the Parthenon.

Over the next fifteen years, he continued to seek out any remaining pieces of the statue, while struggling to understand what purpose it served. He surmised that the statue greeted ships as they entered the harbor of the island. Champoiseau was no archaeologist; when the pieces arrived at the Louvre, they were a mess. They arrived, a curator wrote at the time, in a dozen bags, broken into 200 pieces, including 118 for the torso alone. In a triumph of modern archaeological perseverance, curators and experts at the Louvre slowly put the statue together over those fifteen years, filling in pieces that were missing, and, after discovering the base of the statue in 1879, adding the ship's huge prow to the piece. The piece was first displayed in the museum's Salle des Caryatides. Reconstructed, the inspiring piece of sculpture was

installed in 1884 on the upper landing of the Daru staircase, where it remains today, hugely popular with visitors. This information goes a long way toward understanding why this piece became so famous. In this instance it is because the Louvre played a significant, salutary role in finding and restoring the sculpture, and displayed it in a spectacular way, where its impact is clear for all who pass through this section of the museum. Were it not for Champoiseau, the piece might still be in pieces, underground. No wonder the Louvre is so eager to tell visitors about it.

CHRISTIANE ZIEGLER, IN the process of retiring from her position as head of the Egyptian department at the Louvre, received me in her cramped museum office, one that is entered from just off the Cour Carré, the Louvre's elegant square courtyard, behind the main esplanade containing the glass pyramid. Ziegler had spent thirty-five years—most of her career—at the Louvre, conducting research and running the department, which included a vast renovation and reorganization of the Egyptian galleries in 1997 and 1998. A pale, blonde woman with light blue eyeshadow and a delicate complexion, Ziegler studied history at the prestigious Institut de Science Politique and at the Sorbonne, and started out as a high school teacher. She had been at the Louvre since 1972 and had conducted archaeological research at a dig in Saqqara since 1991.

But Ziegler had surprisingly little to say about the question of restitution and museums. Indeed, she seemed to be ill at ease speaking about the subject. Perhaps this was the instinctive self-protective response of a government servant. Even so, Ziegler said the first she had heard of any desire by Egypt to claim an object was "fifteen days ago," when she read in the press about Zahi Hawass's request for the bust of Nefertiti from Berlin. And before being told about it in this interview in May 2007, she was completely unaware of the request for the Louvre's zodiac ceiling. "It's the first I've heard of it," she said, though it had been reported in the international press on several occasions. She knew Hawass, of course. But "we've never talked about it," she said. "We met years ago; we were both young, so we maintain the relationship of Egyptologist to Egyptologist."

What was her view about the notion of restitution? At first she demurred. "It's really not up to me to say," she said, rather curiously. Finally, she threw up her hands. "I'd rather not go into it," she said. "These are sensitive matters." After a moment's pause she continued: "The Egyptians didn't feel that they were the heirs to this great civilization. Islam was the religion. And these are idols." In other words: modern Egyptians are not related to these great ancestors who lived on the land before them. "There are other ways to respond, besides giving back wealth and returning objects," she continued. "If they want to promote Egypt, they should do the opposite. They should loan out some of the pieces they have in their reserves or sell some of those pieces; they have far too much. It's innumerable. There are finds every week. If I were Egyptian, I wouldn't worry about restitution. These objects are ambassadors. They inspire people to go and see other objects in the country." As for seeing things out of context, she said, "If that's the case, then we should put everything back in the tombs and leave it in the dark. At its extreme, that argument is absurd. These objects were not made to be seen."

Finally, she came back to the point that it was to Egypt's advantage to have these pieces dispersed. "The problem of Egypt is to have such a rich patrimony, such a huge amount to maintain," she said. "Egypt is rich enough in masterpieces. I think it would be an advantage to have pieces outside of Egypt that entice people."

Françoise Cachin, the former director of the National Reunion of Museums, the French government's museum authority, also expressed bewilderment at the idea that source countries would have some kind of claim on artifacts held in the Louvre for many decades. "We don't have this sort of thing in France," she said at first, when I asked her about it. I brought up the Parthenon Marbles in England and made reference to the fact that the Louvre has a Parthenon frieze of its own, taken from the Acropolis. With some prodding, it became clear that she believed the Europeans were best situated to be the caretakers for antiquities that originally came from the Near and Middle East. "I'm divided about it," she said, when she finally grasped the question about the frieze. "I believe if it would have stayed there, it would have been destroyed. You have to think about that. And it's up to the Turks to

apologize. They were using [the Parthenon] for gunpowder storage."
She was referring to the explosion in 1687 that left the Parthenon in
its current parlous state. But actually, the Venetians were the ones who
lobbed explosives at the Turks. "The second argument is, if the entire
world knows the Elgin Marbles, it's because they were saved by the
British."

Then I asked her about Egyptian antiquities at the Louvre. "Come,
you really have to be a bit serious about all this," she retorted, dismiss-
ing the subject. "There's an enormous number of things that were
taken from France, taken when France was poor." She gave her own
parallel: France, in her view, should never have sold Georges Seurat's
pointillist masterpiece *A Sunday Afternoon on the Island of La Grande
Jatte* to the Art Institute of Chicago. "It should never have been allowed
to leave the country. It should be in France," she said. "But I would not
ask for it back. We have to be responsible for our own past." This is not
an exact parallel, by a lot. Egypt never sold to France the pieces that
make up its collection; the pieces were taken under the permission of a
distant authority. Still, Cachin wasn't swayed. "They have to take re-
sponsibility for their own history," she said, despite the fact that most of
the countries whose antiquities were taken under imperialism were not
the masters of their fate at that time. From the position of possessor
speaking about dispossessed, it is a convenient argument to make.
Clearly Cachin believes that Europe saved antiquities from the degrada-
tions of the developing world. It is not an uncommon view. And not an
entirely illegitimate one. But it is entirely self-serving, as so many argu-
ments in the restitution debate are.

Meanwhile the formerly dispossessed continued to fight back. In
early February 2007, the curator Alain Pasquier had finished his catalog,
just in time for more stomach-churning news. On the first Monday of
the month, he received a fax from the Greek culture minister, Giorgos
Voulgarakis, informing him that the exquisite bronze sculpture of a boy,
"Ephebe of Marathon," which Pasquier had intended to be a center-
piece of his exhibit, would not be loaned to France from its home in the
National Archaeological Museum in Athens. Greece had decided that
the Ephebe was on a list of objects "that cannot leave the territory."

# DENDERAH

*Paris has a zodiac from Denderah, so Denderah should
have a zodiac from Paris.*

—LINE FROM A NINETEENTH-CENTURY FRENCH COMEDY

IN THE STILLNESS BEFORE DAWN ON THE LAST DAY OF THE
ancient Egyptian calendar, the sandstone Temple of Hathor at Den-
derah soars silently in the dark as the Nile laps at her entrance. Seen
in the rising half-light, the sixty-foot-tall edifice, painted pale blue,
glows like a distant ghost. Inside the temple, her priests gather toward
the rear, waiting for the high priest to bring Hathor from her resting
place in the holy of holies for the annual ceremony of the new year.

The ritual lands in the summer season, in the modern month of
June, timed to greet the emergence of the star Sirius and to herald the
start of the flooding season. Here it is a time to celebrate the goddess
of joy and music, one of many celebrations that have brought Egyp-
tians to the door of this temple with blessings and prayers, long, long
before the notions of Abraham, Moses, or Christ came to the world.
Hathor is a beloved deity, her face an image of serenity and compas-
sion. She draws to her women who seek remedy from childlessness or
relief from malady. She represents joy, and the priests who serve her,
both men and women, embody her message. She inspires musicians,
and in many of her images she holds an instrument, the sistrum. There
is music and laughter in the halls of her great temple.

Carefully the high priest removes Hathor from her perch and, keeping the statue hidden inside a curtained cloister box, brings her down a corridor to those who wait to honor her in a state of patient excitement at the back of the temple. In the niche where they stand, Nut—the goddess of the sky—oversees the ceremony from the ceiling, where she is painted in golds and dark blues, her body tracing the path from east to west, offering up the orb in the morning and swallowing it again by evening.

Then the procession begins. In his great caftan and with a towering headdress, the high priest leads the way through the temple's side chambers to the staircase, past the imposing hypostyle hall, with its intricately carved columns and its ancient calendar represented by eighteen boats around the rim of the ceiling. He begins the long climb to the roof. Behind him, the priests carry offerings of fowl and fruits. They carry the standards of the regions around Denderah, represented by other gods. In the dim of dawn's approach, up the narrow stone stairs they ascend, around the outer edge of the temple higher and higher, sixty feet up, until they reach the rooftop.

On the roof is a small, open-air chapel, adorned by Hathor's smiling visage at the top of a series of pillars, arranged in a square. And in the center of the space, the ceremony begins with a chant, and singing, and dancing. "Thou art the Mistress of Jubilation, the Queen of the Dance, the Mistress of Music, the Queen of the Harp Playing, the Lady of the Choral Dance, the Queen of Wreath Weaving, the Mistress of Inebriety Without End," they sing to the goddess who inspires both men and women to serve in her shrine. The ceremony is timed to the minute. As the first rays of the morning sun break, the high priest draws back the curtain, and the goddess is bathed in the first light of the first day of the new year.

So began the annual calendar in ancient times at the Temple of Hathor, a majestic temple to their pagan goddess on the foundations of one that had served her since the Old Kingdom, more than a thousand years before. Tradition holds that there were more festivals in her honor than for any other deity, and one annual holiday paired her with her god-husband, Horus, for a full fifteen days. No wonder, then, that

in the time of the Ptolemaic pharaohs, some 2,100 years ago, she was the inspiration for this magnificent structure.

The temple rises like some ancient Notre Dame out of the flattened wheat fields of Denderah, a wonder of architectural grace and artistic skill. On its facade are six colossal statues of Hathor herself, the faces now missing. The front hypostyle hall is filled with twenty-four columns, each twenty feet tall, and six feet in diameter, carved with hieroglyphs and scenes of the goddess. The original colors of this hall, now in the process of restoration, are still visible—the same pale blue from the outside of the temple, along with red and white and gold. The larger hall leads to a smaller hall of worship, which leads to another, and another, back to the smallest room, the holy of holies where Hathor's goddess-statue resided. Built over the course of 150 years—which is about the same time it would take to build the famed Gothic cathedral in Paris—the temple was a center of worship for barely one hundred years before it became a target of the rising force of Christian radicals. Believers in the young cult of Christianity who had taken refuge in the temple hacked off the noses and chins of Hathor on the massive front pillars as a protest against polytheism and took chains to the elegantly carved scenes of Ptolemy offering the sistrum to the goddess. They hacked as high as they could go, which still left intact scenes twenty feet above the ground. Yet even with all the mutilation, the temple's elegant design and intricate detail still inspire awe. Today it remains the most complete, and probably the best preserved, temple in all of Egypt.

But there is one glaring blot on the Temple of Hathor, a literal black spot, that has not survived the mutilations of the past. Just a stone's throw from the rooftop chapel that held the annual New Year's Day ceremony, a sandstone room carved heavily with hieroglyphs stands in the shadow of a black plaster ceiling, an unsightly, heavy square with barely discernible markings: the zodiac ceiling. The original, as we know, is in the Louvre, tucked away in a corner where it is barely seen and where there is no explanation of how it came to be removed from its place of origin. The plaster replica looks like some kind of tumor. Beside it is a similarly ugly outstretched figure of the goddess Isis, her

arms aloft, also rendered in muddy black plaster, a replacement for the graceful original, which was destroyed by Jean Baptiste Lelorrain's gunpowder. The effect is a blight on the otherwise beautiful room.

This is the sore where the zodiac ought to be.

But what is the proper path to right this wrong? How do you repair historic damage, while at the same time valuing where the ceiling is today, a place that offers up history to a multitude of people, in a setting where it can be preserved and admired?

A couple of points are worth making. With or without the ceiling, the temple of Denderah is a breathtaking experience. The ceiling is a small, if important, detail in a very big structure—imagine if someone had removed the bell tower of Notre Dame—and while the ceiling is important to historians, astronomers, and of course Egyptologists, it is doubtful that its absence changes the experience of Denderah for the average visitor. Second, Denderah is far off the beaten trail even for the dedicated tourist. On the day that I visited, in the height of the summer tourist season, there were only two other people who joined me at this enormous complex, a mother and her young daughter. To get to Denderah, you must join a convoy of buses and police cars that leave Luxor at a set time of the morning. (There are no hotels here to stay overnight.) And I could only spend two brief hours before having to leave, because I had to rejoin the convoy as it went back to Luxor, again at a set time.

The fear of terrorist attacks means that tourists may not visit Denderah independently. And the fear, of course, is fully justified. In November 1997 radical Islamic terrorists descended on the Temple of Hatshepsut in Deir el-Bahri near Luxor, guns blazing, knives sharpened, and commenced a horrific bloodletting. In the end, sixty-two tourists were massacred—Swiss, Japanese, British, German, and French. The attack set back Egypt's efforts to develop a robust European and American tourist trade and had a ripple effect on foreign travel throughout the region. That was further affected by the attacks of 9/11. As part of a concerted campaign to woo tourists back and to convince tour companies that their visits would be secure, Egypt instituted a series of security measures designed to ensure no recurrence of what everyone cryptically refers to as "the accident." (As in, "Since *the accident*, we have

new security requirements.") Among the measures are a suspension of cruise ships from Cairo down to Luxor to prevent their vulnerability to attack and a ban on an Egyptian traveling in a car outside of Cairo with a foreign woman who is not his wife. This elaborate convoy system is also meant to ensure security, while it limits access to the monuments.

Still, in the case of Denderah, access is not the only thing that is limited. So, apparently, is interest. Most of the vehicles in my convoy leaving Luxor sped right past Denderah, buses packed with tourists on their way to the beach in Hurghada, on the Red Sea. Most of them had spent a day or two in the Valley of the Kings, and they'd had enough of tramping around ancient monuments in 110-degree heat.

But let us return, for a moment, to Denderah. Having the ceiling in the Louvre allows scholars and students and average people to study the piece up close. Let us also note that King Louis XVIII bought it for a very large sum of money in its time—150,000 francs—in good faith. Its importance as a historical artifact is beyond doubt. The Denderah zodiac is one of only four known representations of the cosmos from ancient Egypt, a wondrous image of the sky two thousand years ago that tells us much of what the ancient Egyptians, and the Greeks who came to Egypt, knew about the heavens. The ceiling features four standing figures of the sky goddess Nut and eight of the kneeling earth god Geb holding aloft the dome of heaven in their upraised arms. Within the star-dotted sky are astrological characters that we easily recognize from our own daily horoscope predictions, including Taurus, the bull; Libra, the balance; Leo, the lion; the scorpion, the ram, twins, the fish, and the water bearer.

But after two hundred years in France, the zodiac now has its own history there. The ceiling first appeared in Paris in the form of a sketch by the savant Vivant Denon in the years just after the 1799 expedition. It set off an immediate wave of interest and articles and salon chatter, speculating on its meaning. The speculation led to wild estimations of when it had been carved—"four thousand years ago!" "seven thousand years ago!"—which related to the debate in postrevolutionary France over the relative level of knowledge in ancient Egypt versus Greco-Roman culture. A camp of ardent Egyptophiles wanted to prove that this pagan civilization knew far more about the cosmos than was known in their

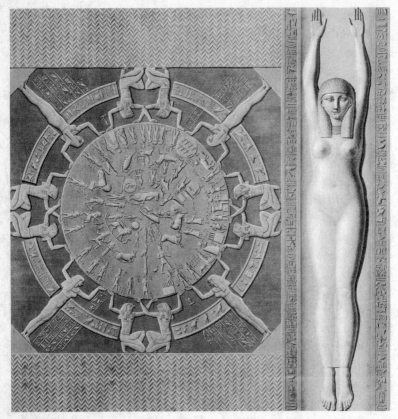

*The zodiac ceiling from the Temple of Hathor, as drawn by a savant before it was blasted out of the ceiling and taken to France.* (From *Description de l'Egypte*, courtesy of the Getty Research Institute)

own time. This was before the deciphering of the hieroglyphs by Jean-Françis Champollion, and spirited debate set the ceiling at a distance of several thousand years. As the debate took hold in feverish French salons over what the zodiac precisely depicted, and what it meant, it quickly became a known entity, a possession worth having.

Almost twenty years later, when the massive folio *Description de l'Egypte* was finally published, Egyptomania was in full swing in Europe, and private adventurers were busy denuding Egypt of its treasures, mainly on behalf of their national governments, or whichever

national government would be the highest bidder. As recounted earlier, Sebastien Saulnier and his agent, Jean Baptiste Lelorrain, hacked the ceiling out of the temple over twenty-two days, dragged it on rollers to the Nile, and sent it on to France, where it arrived in Paris in 1822 and went on display temporarily at the Louvre before heading to the Bibliothèque Nationale.

Champollion's decoding of the hieroglyphs only added to the excitement over the zodiac ceiling, and this fueled still more debate over its age and its significance. It even inspired a line in a comedy in a Parisian theater: "Paris has a zodiac from Denderah," it went, "so Denderah should have a zodiac from Paris." Soon enough Denderah did, but it was one made in black, the soot-colored version before cleaning, and a poor copy at that.

On visiting the temple today and seeing the black mass where the ceiling once was, one cannot but reflect on such a naked act of archaeological vandalism, of personal greed and nationalistic pride. There is no question here of having taken the ceiling in order to save it. By any measure, the ceiling should never have been ripped from the place where it was built and meant to be.

But ought it to be returned, where almost no one would see it?

When Rabia Hamdan, the Egyptian government's chief archaeological authority in the region, walked me up to the roof and showed me the cast, he had little to say. The black replacement spoke for itself. After pacing around the small space, finally, the mild-mannered Hamdan blurted out: "It's part of the temple. What if I went to your flat and took a small piece out of the ceiling. Would it bother you?" I suggested that the Temple of Denderah didn't "belong" to Egypt, but rather to world culture, in which we all share. "There is the sense that something belongs to you," he agreed. "But it belongs to me first. As a cultural heritage, it belongs to the world. But first it belongs to us." Round and round such arguments spin.

I was reminded of the very reasonable words expressed to me repeatedly, by various people, during my journey across the ancient world: an apology goes a long way. It would be an excellent start for France to apologize for having sponsored the mutilation of this temple. And right on the heels of that comes the imperative that the Louvre offer a clear

explanation to visitors of how the ceiling arrived there, in all its unpleasant truth: the covetousness of Saulnier, the mutilations of Lelorrain, the complicity of Mehmet Ali, and the purchase by Louis XVIII.

That would be a good place to start.

MUSTAFA WAZERY PICKED me up from Luxor International Airport and set off in a pickup truck toward the Valley of the Kings. A tough-talking, aviator-glasses-wearing, mountain-boot-stomping Egyptologist, he had been personally recruited by Hawass to join the Supreme Council of Antiquities.

It was Hawass who had taught Wazery, as a young university graduate excavating ancient boats near the Giza plateau, how to wield a brush, how to remove an object from the ground—and how to divine the meaning of those objects. "I saw he did it because he loved it," Wazery recalled. "I watched his every step, his every move, his way of walking, explaining. And I started to love antiquities. When I talk about antiquities now, it comes not from my tongue but from my heart."

Wazery didn't last long as an archaeologist. Instead, he became a tour guide in the private sector, because the government salary was so low. He went from making five hundred Egyptian pounds—about one hundred dollars—per month as an SCA archaeologist to, after ten years, earning about fifteen to twenty thousand Egyptian pounds per month as a tour guide. This allowed him to get married and buy an apartment. He became one of the best-known guides in the Luxor region, sought after for his fluent English, detailed knowledge, and animated delivery. Hawass recruited him to return in 2003 as the public relations director for the SCA in Luxor and had just promoted him to be director of the Valley of the Kings. Hawass, he said, "is my spiritual father."

Wazery jumped into this new role with enthusiasm, demanding that the wooden shelters for tourists be immediately painted off-white to match the sandstone hills, ordering the installation of pavement stones for disabled visitors who make their way up into the central area of the tombs, moving some portable toilets out of the main sight line. His temper flares every time he sees a tourist reach up and touch the painting on the wall of a tomb to check if the color comes off, and he

gives them a piece of his mind. (The tombs all need Plexiglas protective panels put up at hand height.) On the day I arrived, he had just hauled an errant tourist into his office to demand why the visitor had dared to take photographs inside a tomb, when there were signs everywhere indicating that this was absolutely forbidden. The tourist was a Russian (apparently these transgressors often are) and pleaded an inability to read the English and Arabic signs. Wazery let him go, with a stern warning.

Driving over a recently constructed bridge connecting the east and west banks of Luxor, Wazery acknowledged that changes here in recent decades have not all been good. Take the bridge, for example. "It used to take two hours to cross over to the Valley of the Kings," he said. "Now it takes twenty-five minutes." Because of that, traffic to the Valley of the Kings is way up, and locals and foreigners have begun building villas along the Nile, barely a mile from where the tombs sit. "Before, you'd stand on the east bank and look across the Nile, and you'd see miles of green and then the mountain," said Wazery. "Now you see concrete and all these half-finished houses."

We drive along a road that passes the Colossi of Memnon, toward Qurna, an ancient village up on a hill above the road, where the houses are embedded into the hillside, among the tombs of the ancient nobles. These are the same villages that Giovanni Belzoni encountered in the 1820s, where he lived for a time. Originally, villagers built up here because the Nile flood inundated the plain below, though flooding has not reached this area for years. In more modern times, the government had been trying to move the villagers, who live in primitive conditions atop the tombs without running water or electricity, but many villagers resisted. This particular village persisted until 2007, when the government came in and bulldozed the houses, moving most of the residents to new apartments a few miles away. Western archaeologists said that the bulldozers and backhoes that demolished the Qurna shacks did not take care to protect the tombs beneath the houses. "The hillside looks like Beirut after the war," one angry archaeologist told me. "They've done serious damage to the tombs below." Wazery, who was not responsible for the Qurna demolition, disputed this and said the backhoes did not go more than a few inches deep into the earth.

Either way, it doesn't matter much. The Qurna villagers long ago destroyed what was worth saving in the tombs. They stole anything that could be stolen, and the unpleasant by-product of their lack of running water has meant sewage runoff into the tombs themselves. I am not in favor of looting tombs, but it is true that the artifacts Belzoni took, and those the villagers sold to collectors, have at least a chance of survival. What is in the tombs today has little similar chance.

Big changes were afoot in Luxor. The governor, Samir Farag, had taken the increase in tourism to heart and announced an ambitious plan to upgrade the sites and create a more tourist-friendly, if also a more controlled, environment. On the whole, Egypt is banking on an aggressive tourist policy to help its ever-ailing economy, and it is on a campaign to raise its annual tourism numbers from 9 million per year to 12 million per year by 2012. How Egypt's already fragile monuments will handle this increased flow of humanity remains to be seen. It is certainly something of which Zahi Hawass is aware, and which causes great concern in the archaeological community. What is good for the tourist trade is generally dangerous for the monuments, and the question of security has complicated this picture. Because the government wants to move people en masse, large groups of tourists tend to arrive simultaneously at the Valley of the Kings to visit the heat-sensitive tombs of the pharaohs there. So rather than being able to spread visitors throughout the day, tour directors in the Valley of the Kings must deal with large-scale arrivals and departures. Even a few people entering a tomb can quickly raise the level of humidity in the air and the temperature, which has a direct and corrosive effect on the salinity in the walls, causing the artworks to fade or, worse, to flake off. Thus, a further complication of the debate between museums and source countries: seeing antiquities *in situ,* as some of the more militant archaeologists insist is absolutely necessary, can be murder on the *situ.*

Zahi Hawass instituted a few simple measures, which have had an enormous impact on reducing human damage to the tombs. Some already-corroded tombs have been closed permanently, and today there are severe penalties for taking photographs inside the tombs. Tour guides now give their lectures outside the tombs; only afterward do their

groups walk through the dark crypts. This has greatly reduced the amount of time spent by each tourist inside the tombs, which means less damage. And there is also a new rotating system of tomb visits, which means that tourists no longer choose any open tomb but must pick from the ensemble of the tombs spread throughout the valley. This is because the tombs closer to the entrance, along with the most famous tombs, were the ones most avidly visited, while many others had virtually no visitors.

In the summer of 2007 Governor Farag bulldozed long-standing structures used by the French for their archaeological projects, part of an ambitious plan to create a new and grander entrance to the nearby monuments. Most significantly, Farag is preparing to dismantle some thirty structures—houses, hotels, and a mosque—that stand between the temples of Luxor and Karnak. The idea is to restore a mile-long pedestrian avenue along the Nile that in ancient times was lined with carved stone sphinxes. Only a few of the originals remain today. If restored, it will create a recreation-style park. It's hard to know now if that will ultimately feel authentic, aesthetically or archaeologically, or more like, say, Las Vegas.

Either way, Luxor has increasingly become a tightly controlled environment, economically speaking, geared toward mass tourism. The cruise ships are careful to schedule the tourist day to include preselected alabaster, carpet, and other souvenir "factories." (What is left unsaid is that the vast majority of these items are made in China, and the local "workers" erupt into a hive of activity at the sight of the headlights of the tour buses.) There are stern warnings not to go wandering into Luxor, because of the security dangers, which amounts to fearmongering that serves to keep the tourists spending at preselected shops and shrink the slim commerce of small Luxor merchants even more. These practices have alienated the locals from the big industry and from the tourists themselves.

Some observers warn that Farag's plan is taking the opposite approach of most conservation projects, by isolating the locals and pushing them out of the cycle of prosperity created by the monuments among which they live. "Everyone else is going the other way," said Nigel Hetherington, a young British conservationist. "Everyone else

is getting the local people involved. In Luxor, they're trying to exclude the local community. That's a good way of breeding terrorists." Hetherington has looked closely at Farag's plan. Ultimately, the aim is to move twenty-five thousand residents out of Luxor to make way for a grander tourist experience. As for when the city demolishes the mosque to make way for the avenue of the sphinxes—"there will be hell to pay," Hetherington predicted.

STEPPING FROM THE blinding heat of the Valley of the Kings into the cool darkness of the tomb of Seti I, Mustafa Wazery and I walk gingerly down the long, sloping corridor that leads to the most spectacular of all the tombs in this place.

Seti I, the father of Ramses II, was one of the greatest pharaohs in Egypt, traditionally known as the pharaoh who reigned before Ramses, that hard-hearted figure played by Yul Brynner in the movie *The Ten Commandments*. That may be unproven to a certainty, but Seti certainly reigned in the nineteenth dynasty of the New Kingdom and was credited with restoring the kingdom's power abroad after its decline during attacks by the Hittites, who came from the Anatolian northeast. He undertook military campaigns in Canaan and farther north, in Phoenicia, winning Egyptian control there and in Syria. He also struck a historic nonaggression pact with the Hittites to end the armed conflict with that rival power. At home, he created the awe-inspiring hypostyle hall at the Temple of Karnak and built the Temple of Abydos, one of Egypt's most magnificent monuments (which stopped Napoleon's savants in their tracks), witnesses to Egypt's power and accomplishment. His tomb reflects the glory of the period. Carved three hundred feet deep into the dry bedrock, it was the handiwork of artists who created room after room of magnificent scenes of the gods with the pharaoh. Seti's mummy is one of the most famed in modern Egyptology for its preservation of his noble profile: the sloped forehead, the aquiline nose, the small but haughty head. And his place of rest is equally remarkable. Discovered by Belzoni in 1817, Seti's tomb leads the visitor down a colored, decorated tunnel, down past one room, then another, then another, into the central burial hall. There once sat the famed alabaster sarcophagus, taken by Belzoni, at great trouble and cost, who desperately tried to

sell it to the British Museum. The burial hall itself is a breathtaking spectacle, with a soaring, twenty-foot ceiling (highly unusual in the usually cramped tombs), painted midnight blue and decorated with images of the astrological sky, arranged in straight lines. The dry, hot climate of the Valley of the Kings and the sandy stone in which the tombs are carved have been ideal environments for the survival of the artworks. The colors are vibrant, the carvings look fresh, unmuddied by dust, undimmed by time.

But again, relatively recent visitors have done discernible damage. The handiwork of nineteenth-century visitors is evident, and appalling. In the darkness Wazery points his flashlight at the ceiling of an anteroom to the main burial chamber, where the wall contains beautiful, life-size images of Seti holding the hand of Horus, and then the hand of another god, Anubis. Above, in big black, block letters, reads: "Deloc, 1822." And then, circled in black: "Costei, 1837," and askew at an angle: "Meade, 1860." Seti's tomb is rare and inspiring. It takes great effort to get there. To those who take the trouble to visit, it is certainly one of life's memorable visions, a step into a vivid, unfamiliar ancient past. It is thus astonishing that not one group, but many, over successive decades of visits to this monumental masterpiece, would leave their signatures scrawled here in massive letters. It says much about the arrogance of Europeans who visited at the time and their own sense of entitlement.

That was, of course, not the beginning or the end of the indignities inflicted on Seti's tomb. Ancient tomb robbers had stolen most of the treasures inside the tomb in previous millennia. But the nineteenth century was when collectors began to dismantle the tomb itself, hacking artwork from the walls, stealing entire panels. On several pillars in the main burial chamber, the decoration from ceiling to floor is gone, most probably the panels taken by Champollion. "This whole side is in the Louvre," said Wazery, pointing to one empty panel. How did it feel to the people at that time—hacking and peeling in this chamber of exquisite artistry, grabbing and gouging? Excited, perhaps. Ashamed, perhaps not.

Theft from Seti's tomb is still not a thing of the past. In an offering room just off the main burial chamber, three pieces of sculpture,

including a striped and painted stone lip along the edge of a carved offering ledge, showed up at auction in the United States in 2003.

Today, the tomb of Seti is closed because of the risks posed by human traffic to the artworks. No one can see it or photograph it, except by special permission. But that does not justify keeping stolen pieces of the tomb, nor excuse the Louvre from telling its visitors about the provenance of the Seti artwork on its walls. There is a principle here too. In some ways, Belzoni had the right idea. He hired an Italian artist to make wax models of Seti's tomb and reconstructed full-scale models of two rooms, including the main, pillared burial chamber, in London. He opened it as a tourist attraction and business endeavor in 1821 at the Egyptian Hall in Piccadilly and charged an entrance fee. The exhibit was such a hit that it lasted a full year. It is worth considering in our age of modern technology. Can't we build a replica and invite everyone in? Constructing the same sort of model today would be easier and more faithful to the original. It would open up access to the wonders of ancient Egypt and could travel the world or sit permanently near the Valley of the Kings. In short, perhaps Seti could be brought to the people if the people cannot be brought to Seti.

THAT IS NOT the end of the tour of nineteenth-century European outrages in the Valley of the Kings, when it comes to desecration of the art. We head to the tomb of Amenophis III, which is not open to the public, and never has been. The tomb is reached along a dirt-and-stone road that circles around the hills to the western side of the valley. Tucked away in a crevice at the top of one rise, the tomb is hard to find, but nineteenth-century explorers found it. As Wazery walks me into the tomb, the space is pitch-black, since electricity has never been installed here. Instead, Wazery switches on his high-powered flashlight. A wondrous tableau unfolds on the walls of the room: Amenophis in life-size glory, naked to the waist, his skin a reddish brown, his gold-and-black-striped headdress on his head, holding the ankh, the symbol of life. He stands in a series of poses with one god, then another, Horus on one side, Anubis on the other. Above their heads, on the bright blue background, a series of pharaonic eagles fly, in between hieroglyphs and the cartouche, or signature, of the pharaoh's name.

It is all so beautiful, so pristine, that what is missing is all the more disturbing: in these floor-to-ceiling scenes, a looter cut out three of the heads of Amenophis from the series of figures. It is shocking. Imagine the Mona Lisa's face cut out of her canvas with a kitchen knife and the missing piece displayed in a museum in China or Russia. The world would be outraged, and rightly so. In this case, the missing heads are in the Louvre, on display under glass in the Sully wing, labeled simply: "From the tomb of Amenophis III."

Who would do such a thing? The sad answer is, all too many visitors to the Valley of the Kings. In 1849 the American consul in Egypt, George Gliddon, pleaded for the preservation of treasures such as this in a pamphlet he titled *An Appeal to the Antiquaries of Europe on the Destruction of the Monuments of Egypt*. In it, he referred to an "Anglo-Indian gentleman" who cut bas-reliefs off the walls of Amenophis III's tomb so he could draw them more effectively on board his Nile boat. When the artist had finished, according to Gliddon, the originals were thrown into the river. While this sounds like the same instance of vandalism, it does not seem to correspond to the known history of the pharaoh heads. They were cataloged at the Bibliothèque Nationale in the nineteenth century by Jean-Antoine Letronne, an archaeologist, and moved to the Louvre in 1992.

The tomb was discovered in 1799 by two of Napoleon's savants, and in 1829 Champollion was able to read the cartouches in the tomb and determine that it belonged to Amenophis III, one of the greatest of the eighteenth-dynasty pharaohs, who ruled from 1391 to 1353 BC. In 1845 Richard Lepsius, the German archaeologist, noted its unique beauty, along with the damage that had been done to it.

Amenophis, also known as Amenhotep III, was the father of the rebel-reformer pharaoh, Akhenaten. He was one of Egypt's greatest builders, and he left a legacy unique in the pharaonic world. Museums are filled with colossi and other statuary of him and his wife, Queen Tiyi. The two remaining colossi that guard the entrance to the Valley of the Kings, the Colossi of Memnon, are of Amenophis III and Tiyi, all that remains of his great mortuary temple. His reign was a period of unprecedented prosperity and influence of the Egyptian empire, as it reached the heights of its artistic and cultural power. (No wonder,

then, that Akhenaten reacted by overturning it all and creating his own capital at el Amarna.) Amenophis III built substantial parts of the temples of Luxor and Karnak, and tales of his projects and strategic marriages to foreign princesses have been found in excavations as far away as Syria and Somalia. Indeed, the pharaoh—with his almond eyes and broad lips—is the most easily recognized today by Egyptologists because he has more surviving statues than any other.

Little wonder, then, that his tomb would be spectacular, and it is, at least the part that I saw. The room is described thus in a 2005 UNESCO report: "These elaborate paintings, depicting kings and gods together with intricate hieroglyphic texts, are rated as the most exquisite works among the royal tombs of the Eighteenth Dynasty." Still, the report doesn't mention the missing heads. It is instead most concerned with cracks in the walls and paintings, and the fact that failure of the bedrock could lead to the tomb's collapse. The tomb has also been susceptible to flooding, and when a Japanese restoration team began work there in 2003, it found the magnificent wall painting dimmed and damaged by bat droppings and corrosive bacteria. As elsewhere, the looted images are only a small part of what must worry conservationists, and the archaeologists have restored the painting to a state of pristine magnificence. In 2005 Zahi Hawass formally asked the Louvre for the return of the heads, but the museum declined, offering instead to send copies. "We would still like the originals back," Hawass said.

As the afternoon sun headed on its downward descent, Wazery and I stopped at the Temple of Luxor, the beautiful complex built by Amenophis III and completed by Ramses II. The temple stretches along the Nile, its pylons stark and stately beside the massive double statues of Ramses. A pink granite obelisk stands sentry at the front of the temple, eighty-two feet tall, in good condition, and all alone. Egyptian temple entrances, when graced by obelisks, are usually flanked by a pair. But the other obelisk that once stood here is now thousands of miles away, in Paris. In 1835 the Albanian-born ruler of Egypt, Mehmet Ali, gave the obelisk to France as a gift at the request of Jean-François Champollion. It was installed with great fanfare in 1836 on the Place de la Concorde,

its triangular tip gilded in gold (an echo of the original, which was covered in a silver-and-gold mix called electrum) and the base beautifully inscribed with diagrams of the careful engineering required to remove the object from its home in Luxor and transport it to that spot. King Louis Philippe and two hundred thousand French attended the inauguration of the obelisk, where it stands to this day, at the center of a huge roundabout at the entrance to the Tuileries gardens, across the Seine from the French parliament.

Elegant, powerful, masculine, obelisks have been prizes of war, souvenirs of emperors, and curios of rich collectors going back to the fourth century AD, when Constantine the Great carted off an Egyptian obelisk to his new capital, Constantinople. That obelisk was erected on the hippodrome, near the Hagia Sophia, and after 1,700 years seems a permanent part of that landscape. Another Egyptian obelisk was erected in Rome, in the Circus Maximus, by the emperor Domitian. But that one broke into pieces. Later it was moved to the Piazza Navona, soldered back together, and in the seventeenth century it was incorporated into one of Gian Lorenzo Bernini's most famous fountains, "The Four Rivers," for the glory of Pope Innocent X. So it is now an integral part of another historic monument.

The ancient Romans were fascinated by obelisks and stole as many as they could. Today, Rome is filled with the obelisks of Egypt. The city has no fewer than thirteen, more than remain in all of Egypt today, which has a total of only seven. The tallest is on St. Peter's Square outside the Vatican basilica, seventy-five feet high, and is magnificent in that setting; it has been in Rome for almost two thousand years, since AD 37, when it was hauled to the imperial capital by the emperor Caligula, according to an account by Pliny the Elder.

The obelisks that remained in Egypt succumbed to the nineteenth-century frenzy to plunder the riches of Egypt's past. The Earl of Cavan pressed Mehmet Ali for permission to take an obelisk for England, and in 1819 the pasha agreed. He granted the British a massive obelisk that had been fashioned under the reign of Thutmosis III for his temple in Heliopolis around 1450 BC. The occasion of the gift

*The remaining obelisk at the Temple of Luxor at left (the other is on the Place de la Concorde in Paris) and an obelisk taken by the Roman emperor Domitian, now on the Piazza Navona in Rome, part of "The Four Rivers," the glorious work by Bernini.* (Photos © Sharon Waxman)

was to commemorate the victory of Admiral Nelson over the French at the Battle of the Nile. The British, however, were less than enthusiastic about their prize, which was known as "Cleopatra's Needle" because it had been moved by the Romans in 12 BC from its original home near Cairo to a temple in Alexandria built by Cleopatra. The obelisk languished in Alexandria until 1877, when a British private citizen sponsored its transportation to London. The boat on which the sixty-eight-foot obelisk was sent, the *Cleopatra*, capsized in a storm in the Bay of Biscay. The ship did not sink, but it drifted until

it was rescued by a British naval vessel. The obelisk survived this journey to be erected in 1878 on the Victoria Embankment, where it stands today.

Around the same time, the United States received its own "Cleopatra's Needle," the only such monument to come to American shores. In 1869 Ismail Pasha, the khedive of Egypt, sought to entice Americans into trading via the newly opened Suez Canal and thought an obelisk might be a friendly gesture. But it was his son Tewfik Pasha who finally got around to offering up the other obelisk at Cleopatra's temple. When it came time to send the obelisk to America, the locals had had enough of their rulers' generosity. Lieutenant Commander Henry Honeychurch Gorringe, an American naval officer, took charge of the moving of the obelisk in 1879 but learned that Alexandria residents had already planned to build a new apartment house around it, with the obelisk as the decorative centerpiece. These residents had enough local support to keep Gorringe from executing his original plan to move the obelisk a mile across land to his waiting ship, so he had to move it ten miles by water, costing him an additional $21,000. Once he had the obelisk on board, he discovered that no Egyptian crew would sign on to sail it to America. In desperation, the commander brought a Serbian crew to Alexandria from Trieste "only to learn that no member had ever been to sea and that not a single one spoke any language but Serbo-Croatian," went one account.

After great travails, the obelisk eventually made it to New York, docked in Staten Island, was transferred to a slip at West Ninety-sixth Street, and then was moved two miles to Central Park by block and tackle. This operation took 112 days and was completed on January 22, 1881. The whole enterprise was financed by Gorringe's friend the railroad tycoon William H. Vanderbilt, costing a relative fortune: $102,567. To Gorringe, it was a great prize. To New Yorkers, apparently, it was a foreign object with little meaning. Today, the obelisk sits without fanfare on a windswept rise in the park, just behind the Metropolitan Museum of Art. Storms and pollution have erased most of the hieroglyphics on a monument that had survived for some 3,500 years in Egypt without substantial damage. In March 2007 a writer for the *New York Sun* lamented the neglect of a once-proud

landmark: "An obelisk is a magnificent place-making form, yet ours makes no place, defines no space, but stands, rather forlornly, in an amorphous part of the park." When Zahi Hawass visited the city and saw the condition of the obelisk, he wrote a letter to Mayor Michael Bloomberg to complain. He received no reply.

# A TALE OF TWO CITIES

My FINAL HOURS IN LUXOR WERE SPENT IN A PLACE that offered a glimpse of what Egypt, with all its treasures, can be at its best. The Luxor Museum, built in 1975, is a small, low-lying building along the Nile, just a stone's throw from the Temple of Luxor. With smooth stone floors, air-conditioning, and low lighting, it was a gem to visit.

It was also completely empty of visitors.

The museum is small but carefully curated, every display well lit and well explained. The mummies of two pharaohs lie in separate rooms, each in temperature-controlled glass cases: Ahmose and a pharaoh now believed to be Ramses I. The latter languished in a Niagara Falls tourist attraction from the late 1800s—where it ended up after being stolen by grave robbers and sold to Western collectors—until 1999, when he came back to Luxor. The mummies, in a quiet, dark place that encourages reflection and calm, are accompanied by two or three choice items—including a beautiful gold-sheathed dagger—that speak eloquently about the nature of the lives that these pharaohs enjoyed. The same is true for a glass display case of King Tutankhamun's bows and arrows, smooth, painstaking woodwork, carefully inlaid with precious

stones and hieroglyphs. Or his astonishing chariot, found intact in his tomb. Or the linen shroud that was found covering his sarcophagus, hung with 637 gold rosette decorations.

The museum is a reminder of how the treasures inside Egypt dwarf the most spectacular collections in the West. A small room in the front of the museum contains a series of statues in pristine condition, lit beautifully and set on simple pedestals. The statues here are of the rarest sort, since they were discovered accidentally in 1989 during renovation work at the Luxor temple. Two dozen statues were carefully hidden below ground thousands of years earlier, probably in anticipation of an outside threat. They too were found in near-perfect condition. Among those on display in the museum's front hall is a particularly exquisite Egyptian statue, a near life-size sculpture of Thutmosis III, the great warrior pharaoh, as a young man: strong and mostly naked, arms loose at his sides, with his hands curled powerfully around batons, his leg muscles rippling tautly in the grain of green-black basalt. (His mummy suggests that Thutmosis III actually looked nothing like this, but he was paying the sculptor.)

This small, selective museum, with its clear explanations and decent lighting, should be the model of what Egypt seeks to achieve with its masses of treasure piled haphazardly in back rooms and storage spots around the country. It would certainly strengthen Egypt's arguments to regain items now held by Western institutions. But, visibly, the country is decades away from achieving this reality.

EARLY ON A hot summer morning in Cairo, a teeming throng of Japanese, Swiss, German, American, but mostly Egyptian tourists is pushing toward the entrance of a stately building painted salmon pink along Tahrir Square, the central, life-affirming (or, alternately, life-ending) roundabout in the capital.

This is the Egyptian Museum in Cairo, a neoclassical structure dating from 1900, founded by French archaeologists working with the Egyptian government to house the treasures being rapidly unearthed in the late nineteenth and early twentieth centuries. No country on earth has more pharaonic treasures in its museums than Egypt, and no museum in Egypt has more than the Egyptian Museum. Indeed, no one

knows precisely how many pieces are here, but a rough guess puts the number at 120,000, with thousands of others stashed away in various corners of the building, including beneath the glassed vitrines that hold rare pieces.

The history of the collection goes back farther than 1900, to the age of pillaging colonials. The Service des Antiquités de l'Egypte was established in 1835, first in the Azbakian garden in Cairo, and designed to slow the early frenzy of looting. Organized under French principles by the French, the collection then moved to a building in the citadel of Saladin until 1858, when a temporary museum was set up by the French archaeologist Auguste Mariette. The collection was transferred again to part of the Giza palace of Ismail Pasha, the ruler of Egypt, in 1880. Finally, this museum was built in 1900 by the French architect Marcel Dourgnon.

And there the collection has stayed, untouched in many cases, since that time. The museum is swelteringly hot and dingy, the air thick with dust. The central hall, a large, soaring space, is packed with statues, sarcophagi, stone pyramids, and coffins. Some of them have labels, but those are yellowed and cracked, written in the dense typeface and syntax of one hundred years ago. Many have no labels at all. In any event, it's hard to read them since almost no natural light comes through the grime-covered windows high above in the twenty-foot ceiling. What little filters through the dirt is an ugly gray, casting a dull film over the treasures. The walls, once painted pinky beige, are now an industrial putty color. A few desultory, fluorescent fixtures hung here and there don't help matters. And much of the collection is cached in a legendarily chaotic and largely unexplored basement of the building, jealously guarded by its own separate curator, with no proper inventory or conservation. In 2005, after the theft of three statues from the basement storage, Zahi Hawass promised to inventory and categorize this chaotic mess, too. A *New York Times* reporter who visited found the space covered in cobwebs and packed with floor-to-ceiling crates, along with human remains on shelves, human skulls sitting in crates, tablets and amulets and bowls and jars scattered here and there. Two years later, the inventory still was not done. Upstairs, the guards are few and far between, and they do not protest when visitors walk up to

pieces and touch them. On the lawn in front of the museum, a tourist sits on one of the sphinxes for a picture, unbothered by guards who stand nearby.

Even a cursory glance at the Cairo Museum makes it hard to imagine what makes Hawass think that Egypt is prepared to bring the standards of this museum up to contemporary ones, much less build twenty new museums around the country and take stewardship of the Rosetta Stone and the Nefertiti bust. A new state-of-the-art museum is planned for completion in 2012 beside the great pyramids at Giza. That, certainly, will be Hawass's great test. But still—there is the rhetoric, and there is the reality. There is Hawass and his ideas, his energy, and passion, and will—and then there is the actual status quo, an Egypt held back by decades of inaction, underfunding, and, one imagines, disinterest. The stultifying weight of colonial-era bureaucracy and modern-era stasis greets any visitor to this institution. There is the dream, and then there is Egypt.

Even so, the treasures here are awe-inspiring. The most famous items here include the treasures of the sole intact tomb of a pharaoh ever found, the tomb of Tutankhamun, in an air-conditioned space on the second floor. The vitrines are filled with dazzling things—elaborate jewels, scepters, headdresses, and the famed golden mask, to name a small sampling—far more than those that caused a sensation overseas in the 1970s. The museum is also famed for its collection of royal mummies—Ramses II, Seti I, Thutmosis I, II, and III—but this barely scratches the surface. Other priceless items include an unlabeled masterpiece of Khafra, an Old Kingdom pharaoh sculpted in black basalt in near-perfect condition. In the hallway just nearby is an oversized head of Queen Hatshepsut painted in bright colors, depicted here and elsewhere as a man, whose architecturally imposing mortuary temple at Deir el-Bahri is one of the most famous sites in the Luxor region. The room next door houses pristine, life-size statues of a seated high priest and his wife, Rahotep and Nofret, though no description explains their importance. He is red-skinned, with the pencil mustache apparently popular among men of the fourth dynasty (other finds from that period nearby also have mustachioed men), and his wife is draped dramatically in white, with colored edges, her face calm and expressive.

They are from the Memphis cemetery in Cairo and were sculpted 4,500 years ago. They appear as if they were painted last week.

But none of those last items have any labels. The Egyptian Museum has countless wonders, though the average visitor would be hard-pressed to find or identify many of them.

Besides Tut, the only space that reflects signs of modern-era curating is the Amarna room. In a red-painted niche off the main hallway are treasures from the reign of Akhenaten, the sun worshipper, including four ten-foot stone colossi, nearly intact, lit with floodlights, stunning examples of the artistic style of this period: Akhenaten with elongated nose, almond eyes, sunken cheeks, and articulated lips. The statues, from Karnak in Luxor, have a pulled-taffy look at the top, but the bottom is the opposite: hips are wide, the belly spilling over the waist. There is also a magnificent mummy-coffin of a still-unidentified pharaoh made of gold in the center of the room and a carved quartzite head of Nefertiti, with a long, graceful neck and elegant, even features. She is identical in shape and style to the famed bust housed in Berlin, which archaeologists now believe was most likely a study for this unfinished version. The beauty in this room, I confess, made me weak in the knees.

The Cairo Museum, however, is less than the sum of its parts. Walking through this space with Janice Kamrin, Zahi Hawass's chief assistant, we happened across the Amarna curator, Ibrahim Abdel Gawad. Why, I asked him, was this particular room redone in this way, painted and lit and carefully arranged, so unlike the rest of the museum? "Because Akhenaten worshiped the sun," he said, cryptically, and sped away. "He's an idiot; he has no idea," muttered Kamrin under her breath, heading back to the main esplanade.

At the entrance to the museum there was a reminder of Hawass's discontent: a copy of the Rosetta Stone, framed under glass, beside a bronze bust of Jean-François Champollion. A group of young Egyptians stopped in front of the stone to hear a guide explain its significance. "Does it matter to you if the true Rosetta Stone comes back to Egypt?" I asked them. They nodded, more or less enthusiastically. "It's Egyptian history," said the guide. "World civilization started with Egypt. And before this stone, no one understood Egyptian civilization. It should be in Egypt."

*Janice Kamrin (center, pointing) explains to volunteers how to register and inventory objects at the Cairo Museum.* (Photo © Sharon Waxman)

But the larger task facing Hawass is evident in a corner off to the right of the central hall, behind a few dividers. Here in the stale humidity, Janice Kamrin is working with about a dozen people to inventory the holdings of the museum for the first time. There is no complete listing of what the museum owns. This makes it impossible to verify when things go missing. The same is the case for most other Egyptian museums.

It was Kamrin's idea and her initiative to establish a computerized database of the collection, to go through the patchwork of catalogs documenting the pieces, log in the information, verify and cross-reference it. This seems like a basic component for running any modern-day museum, but such a reference simply did not exist. The task is huge, and Kamrin began in 2006 with a handful of foreign volunteers and Egyptian registrars. They sit in a corner of a museum working on a dozen laptops and a few precious desktop computers, logging information on a jury-rigged system devised by Kamrin that will eventually be transferred

to a proper mainframe system. The volunteers must go through no fewer than four different sets of mostly handwritten catalogs that detail the holdings of the museum. Some of the information is incorrect, and much of it is contradictory from one log to the next.

The oldest is the original *Journal d'Entrée*—known as the JE—handwritten logs of the pieces as they were brought to the museum over one hundred years ago and entered into its collection. Kamrin photographed and digitized the pages of this log, the painstakingly written entries in curled, turn-of-the-century French script on tightly ruled lines that assign a number to each item. Next comes the *Catalogue Generale*, the general catalog of the museum, which may or may not have assigned the item a different number.

A volunteer, Maggie Bryson, a graduate student in anthropology at Georgia State University, is cataloging mummies, hunched over the image of the *Journal d'Entrée* on her laptop. Number 26199 tells her that the mummy of Nesi-Khonsou joined the museum shortly after the turn of the twentieth century. She cross-references the number with the general catalog and finds that in that log the number corresponds only to the mummy itself. There is another number for the coffin that held the mummy, and that is not in the JE; indeed, the general catalog entry has three numbers: for the outer coffin, the inner coffin, and the mummy. Three numbers for what the JE logged in as one number. And that is better than some entries, in which the JE number corresponds to a different item entirely from what is in the general catalog. At this point Bryson is trying simply to reconcile information, but at some point someone will have to go look at the mummy itself and make sure that it is in fact properly labeled, once the new system assigns it a final identification number. This goes on all day for the volunteers.

Making sense of things here is hard, harder than it need be. A third set of logs, the most recent and apparently the most important set, is called the Special Register, which assigns items an SR number. Many items have SR numbers written on them, which can easily be confused with the JE numbers. In the case of the Nesi-Khonsou mummy, Bryson cannot consult and cross-reference this log because the museum curators have locked the copies in their offices. Asked about this, Kamrin sighed

and explained that there are very few SR registers, and as a result, the curators don't want to let them out of their sight. "In the 1950s they divided the museum into seven sections," she said. "They made new books and gave everything new numbers. But they're hard to get access to." The curators guard these books jealously, and some regard Kamrin's project with suspicion, rather than as an attempt to help them. "This is their power, and they are afraid of losing it," she said. "Some section heads comply; we are getting some collaboration, but this is new for the curators. They don't get the concept of having unique ID numbers. It is like telling them that 'we're playing baseball, and you've been playing football.'"

As I observed the volunteers logging information, a new arrival, a young Frenchwoman named Virginie Cerdeira, asked Kamrin if she could explain the difference between this inventory project and another one being conducted by an Egyptian curator, Mohamed Sami, in preparation for the transfer of certain objects from this museum to the new Grand Museum out at the pyramids. Sami was giving these same objects—about half of those being examined by Kamrin's group—yet another identification number to be used in the new museum. His inventory used a different software system, one that was not compatible with Kamrin's system. I was flummoxed by this news. Were there really two competing inventory projects, duplicating each other's work, on different software systems in the same building? And wasn't that an insane waste of resources? "Yes," Kamrin said, "but I'm not going to trust their data." Her project came first, and she didn't intend to give it up, she said. She particularly did not like the fact that in Sami's database there was no section that cited all the sources of information. Sami's project, meanwhile, was secret. Cerdeira conspiratorially showed me a page from his group that she had copied by hand. "It took me four weeks to get to see this," she said.

Egypt's attempts to catalog and standardize its vast collections for the twenty-first century seemed mired in the same inefficiency that resulted in the twentieth-century mess at the Egyptian Museum. Even having seen the gem that is the Luxor Museum, it was hard for me to imagine the emergence of a rationalized system from this bureaucratic labyrinth. But Kamrin just shrugged. She was used to the contradic-

tions of Egypt. "This is normal here," she said and turned back to her work. When she was done with the database, she intended to press ahead with a labeling project.

In two sharp right turns and a couple of hundred yards, I found my way to Mohamed Sami's modern, air-conditioned workspace in the basement of the museum. His team of fifteen young Egyptologists—all of them Egyptian—worked at new desktop computers, paid for by a Japanese grant, which was underwriting the work of his group. Sami, a twenty-eight-year-old archaeologist educated at the University of Cairo, was friendly and spoke fluent English, and I asked him about what appeared to be two rival projects with similar aims. "This is not double work," he said. "What I'm doing is a museological design for my museum. Janice is inventorying old objects of the Cairo Museum."

But it was true, he acknowledged, that both groups of registrars were inventorying many of the same items. And it was also true that there would be two new sets of identifying numbers for the objects, and that the software systems were so far not compatible. "Unfortunately we started before Janice, four years ago," he said, contradicting Kamrin. "So, yes, it's confusing—I mean, the project concerning Janice, not me." Wouldn't he want a single system to unify the work? Of course. "We're trying to unify the system," he said. "We have a committee to do that, and hopefully we will do that with other museums too."

Actually, Sami was more confused by another piece of news that had come his way. He had read in the paper that Zahi Hawass signed an accord with the Italians a month earlier, for them to create a database for the Egyptian Museum in Cairo. "It was in *al-Ahram*," he said. "Until now I don't know what they're doing, but they have a 1.2-million-euro budget."

He sighed. "For me, it's very confusing to have different databases for different museums. I am dreaming of having one database. Hopefully that will happen."

The state of Egypt's central museum does not negate Hawass's arguments for the return of ancient treasures that were removed from the country during the colonial era. But it strongly suggests that Egypt has plenty of other work to do. The new museum near the pyramids

in Giza is meant to be a model of state-of-the-art museology, gathering one hundred thousand objects for display in the shadow of the Sphinx. But will it represent a clean break with the past, the chaotic culture on display in Tahrir Square? The confusion over such basic measures as the inventory process, the lack of training of security guards, the poor communication among curators and administrators who are nominally working toward the same goals may legitimately give pause to Western museum directors who are under pressure to repair the wounds of colonial history.

PAINSTAKINGLY RENOVATED, ASSIDUOUSLY maintained, Paris is like a beautiful woman who wears her gifts with abandon: The crisp glory of the Arc de Triomphe. The golden statues along the Alexander III bridge, just between the Grand Palais and the Invalides. The Tuileries gardens, Notre Dame—all scraped of a century of grime and, at night, lit to maximum effect. To the visitor who hasn't been in a while, it's like being a man starved of female company, suddenly thrust in close proximity to a naturally stunning woman. Paris has thrown on a frock and some heels, a spot of lipstick, and stops the traffic when she walks past. But she pretends not to know the effect she has on people.

The city is a reminder of just how deeply the French state is willing to invest in the public good. There is widespread public support for government funding not just of parks and decorative lighting but of culture and the spaces where culture can be experienced—especially museums. In the week before the Pentecost holiday in late May 2007 (another Monday off for the ever-vacationing French), the air in Paris had a sweetness to it that made it one of the most glorious places to be on earth. Car windows came down, bicycles careered around the Concorde roundabout, dodging tourists and minimotorcycles. The city's limestone monuments glowed golden in the gentle sunlight of late spring. At the triangular pools outside the Louvre's pyramid, schoolgirls on class trips loitered, rolling down their socks and dipping their feet into the clear water.

Not far from there, Henri Loyrette, the lanky, fifty-four-year-old director of the Louvre, bounded out into the hallway outside his office to greet a visitor. The Mollien wing, with its mustard-toned chintz

*Henri Loyrette, the director of the Louvre.* (Photo © Sharon Waxman)

wallpaper, was lined with marble busts, lending a formal air. But inside the director's office, as such hideaways go, the space was more academic clutter than administrative heft. Piles of books and catalogs teetered everywhere, including all but one of the chairs in the room. The walls were lacquered black, a vestige of the nineteenth-century design of the office, which was announced by a painted *1886* on an elaborate molding across from his desk. Behind the desk, a soaring painting of Greek vases set off the black walls, lit by sunlight streaming in from the windows along the Seine.

Loyrette was a curator of nineteenth-century paintings by training, the son of a lawyer (his father) and an Egypt specialist (his mother). From 1994 to 2001, he was the director of the Musée d'Orsay, on the other side of the Seine, before being tapped to run the largest museum in the world, where he is now in his second three-year posting. But while he has spent a career in art history, Loyrette's style is more CEO than academic. He is a new breed of director, a contrast to the insular

attitude once so common to career curators at the Louvre, who tended to be bookish, cranky, underpaid, and unaccustomed to speaking to outsiders. The curators who joined the Louvre under the former policy of lifetime tenure were defined, in some measure, by their penchant for spending time with inanimate objects, thinking hard about past centuries and civilizations long gone; Loyrette, by contrast, has an engaging, open manner and an insistently optimistic tone. He was even, one might say, to the Louvre born, having grown up in an apartment just across from the great museum, with its aura casting a spell over his already intellectual childhood. In addition to his devotion to impressionist paintings, Loyrette is a member of a half dozen sociocultural societies—like the Franco-Italian Forum for Dialogue in Civil Society and the board of the Institute of the Arab World—and he dabbles in classical music. Friends dropping in on his apartment, where he lives with his wife and three children, might find him quietly studying the libretto to an opera, as the music plays on in his head.

But in the new age of acquisition and restitution challenges, Loyrette's job had become ever more sensitive. Matters of international diplomacy now took up a large chunk of his time. On this particular day, he was about to jet off to Iran for some intensive negotiations, over what he would not say. In the past year, Loyrette had been obliged to publicly defend a decision that was not his choice and with which he disagreed, the licensing of the Louvre's expertise and the loan of items from its collection to Abu Dhabi. This was a decision made above his head by the culture minister, Renaud Donnedieu de Vabres. In May 2007 that minister was replaced by Christine Albanel, following the election of France's new president, Nicolas Sarkozy, but the Louvre's Abu Dhabi project moved forward, demanding a huge amount of Loyrette's attention, as well as remaining a public-relations nightmare.

Then there were the pressures of the restitution issue. Two weeks earlier, Zahi Hawass had sent a letter requesting the loan of the zodiac ceiling for three months, for the opening of a new Cairo museum. "I know Zahi Hawass," said Loyrette. "I like him." Hawass's request was for a loan, but elsewhere he had made clear that he believes the zodiac should be permanently in Egypt. Still, Hawass knows what everyone knows: that items belonging to the Louvre are part of the French pat-

rimony. By law, they are French and cannot permanently leave the country.

In general, Loyrette explained, any claims against the Louvre regarding objects acquired long ago are "not legitimate." "I contest this idea very strongly," he said. "You need to distinguish between claims of things that have been taken illegally in recent years, and things that have been legally in a collection for a century or more. In a legal sense, you cannot judge the practices of the nineteenth century by the lights of today. You have to see things in their historic context."

But times have changed. Archaeologists argue that removing artifacts from their country of origin robs them of their context and strips the viewer's ability to understand the objects in the way they were meant to be seen. And perhaps there are ancient wrongs to be righted in such a situation. But Loyrette said that this argument was not new. He cited those who opposed, even as long ago as the 1790s, the notion of taking artworks from their original context. A hue and cry was raised after Napoleon carted off spoils of war from across Europe for the greater glory of his empire. That is in the very nature of museums, he said. "Ninety percent of our objects were created for other reasons, to be worshipped, or used in another context. They come from churches or mausoleums. How do you take a painting that was meant to be in a church, and prayed over, and have it now be in a museum?" he said. "It is displaced from its meaning. The idea of a museum was new. It overturned the weight of the artifact itself. It is no longer a religious artifact. The museum changes its context. And that's a good thing."

Developing countries are not the only ones affected by objects being taken from one place to another, he added. "These were practices that touch not just Egypt or Greece or Syria; it is true for most other countries too. French patrimony is in the United States. Italy and Germany have both suffered. But I'd never ask for things back. I find it absurd." Loyrette gave as an example the Cloisters, the medieval branch of the Metropolitan Museum of Art, whose building is made up of five French medieval cloisters that were disassembled in France and reassembled in Fort Tryon Park in upper Manhattan in the 1930s.

"The idea of the museum is evolving," he said. "The Louvre was

conceived as a universal museum. And here is a major difference, between a universal museum and a national museum. We are interested in all domains, in all civilizations. But this debate over 'civilization' is *tarte à la crème*"—by which he meant something like "dust in our eyes," a distraction. "The Louvre is a universal museum not only because of the objects but because everyone from around the world comes. Sixty-five percent of our visitors are from outside of France. One of the great fortunes of humanity is to have the Louvre," he continued. "The works here are seen by eight million people a year."

Loyrette makes a good point, and a fair argument for the relevance of the Louvre in the twenty-first century. In some sense its relevance is self-evident, proved by the crowds of people from all over the world who continue to flock there every day. The same cannot be said for museums across the ancient world, which do not have the same investment in their museums, nor do they have the public to support them. The Louvre, too, has reached for a more multicultural tone with measures such as inviting the poet Maya Angelou to write poems that are listed alongside objects from classical Greece or the Renaissance.

To Loyrette, the notion of restitution fights against the purpose of a universal museum and stems from a reflex to turn inward. "It is this idea of turning in on oneself, rather than openness," he says. "It is a conservative impulse, against the universalist one." The problem with this argument, of course, is that France has chosen itself as the locus for a universalist message to the world. Why does Paris get to be the center of that universe, rather than Cairo or Athens? And to any student of history, it is obvious the Louvre might have professed a universalist ideal at its inception, but it was nationalism that fueled the growth of its collections.

And what about Hawass's request for a loan of the zodiac ceiling? "We will consider this normally, like any loan," said Loyrette. "It's a question of fragility, of its ability to travel, in what condition it is, of the guarantees we will get of its return," he said. Asked about the legal status of the ceiling, he consulted a paper on his desk. "It was ceded to France in 1822 by Mehmet Ali, and in 1919 it came to the Louvre."

But that didn't answer the question, of course. What was Loyrette's view of restitution in general? Was he skeptical of a loan request, know-

ing that Hawass wanted the object returned permanently? Was there a moral case to be made that the zodiac ceiling should never have left the country and that it is an integral part of the Egyptian cultural identity?

"What does this mean, that an object is tied to the national identity?" Loyrette retorted, now a bit peeved. "I don't understand this idea. Egypt's patrimony is in Egypt. Greece's patrimony is in Greece. Zahi Hawass is not the Egyptian state. This needs to be a matter from one president to another, or perhaps the minister. It's a state matter, not a matter for the Louvre to decide."

A few blocks away, Anne Distel, the French official responsible for restitution claims and acquisitions for all thirty-three of France's national museums, had a more nuanced view of the issue. A graying woman in her fifties with heavy-framed glasses, Distel works for the Reunion of National Museums, a branch of the Culture Ministry, on the rue des Pyramides, a stone's throw from a famous statue of Joan of Arc near the Tuileries. More than almost any other French bureaucrat, she understands how radically, and how quickly, things are changing in the world of cultural patrimony. The restitution issue has made her life exponentially more difficult. Nowadays acquiring any artifact has become much more complicated than it was just a few years ago. Distel first engaged this issue in dealing with restitution claims related to World War II, and she has seen the shift toward the interest being shown by source countries.

Acquisition, one of her main responsibilities, is changing, too. In previous decades, a curator went to a reputable merchant and looked at an object. "The worry was if it was real and how to find the money to pay for it," she said. Now it's practically a police matter. The dealer is asked to provide a copy of his identity card. "I'm embarrassed, but I do it," said Distel. The dealer must answer detailed questions: Are you the owner? Where did you buy it? When? The museum curators also resent having to assemble all the information that is now required. After all, they want the object to complete their collections. Sometimes the object is rejected, for lack of information. And the curators complain that it will disappear into some private person's cache. But the state doesn't have much choice. "It's become terrible," she said. "Suspicion is the norm. Now, when you see something, the first thing you

ask is: 'Does it have a real provenance?' Rather than: 'Is it of a quality to join this great museum?' It's unpleasant. But it will pass." Antiquities have become especially difficult to buy. "We have a terrible time finding documentation," she said. "What's clear is, we will never acquire again in the way we used to. Museums are very circumspect."

As she parries demands for restitution while pushing back against curators who press for her agreement in a sale, Distel thinks a lot about whether museums remain relevant in the twenty-first century. For her, it is complicated: she feels the weight of European misdeeds of the past, and she sees the modern benefit that museums bring. "It's a question we ask today that we wouldn't have asked ten years ago or even five years ago. It isn't shocking. But it isn't easy to respond, either," she said. "Certain abuses have led to this question, like in Peru, with pillage of ceramic and silver masterpieces. We start there, and we end up with the Elgin Marbles." She continued: "When I go to the Louvre, I'm struck by the number of people who have come. They see things they wouldn't see in their own museums or their own countries. These great institititions are irreplaceable. They have history, the weight of their curators, archaeologists, and academics, people who wanted to show these unparalleled treasures to the world. We will think of how to proceed over the next five hundred years."

But Distel is open to change, and she envisions a different system, where museums would no longer buy works but would exchange them with source countries, under agreements worked out in advance. "It's a very personal, utopian vision," she admitted. "And it would be very difficult to put into practice."

DOWN THE STREET from Anne Distel's office there is a graceful palace with a public square and garden just beside the Louvre. The Palais Royal holds old and new France in the crease of its palm. Once the home of Cardinal Richelieu, the power behind King Louis XIII in the seventeenth century, the palace now displays black-and-white-striped concrete stumps of varying heights across its stone esplanade, the 1986 contribution of the French artist Daniel Buren. In this same place two hundred years before that, a political firebrand jumped on a

café table and shouted, "Aux armes!" setting off street demonstrations that ended with the fall of the Bastille prison. Around this square in 1848, a French mob burned and looted the reconstituted royals during a new round of revolution. Today, the Culture Ministry, one of the great sources of French global influence, is based here. And the Constitutional Council, one of the state's most untouchable powers, rather like the U.S. Supreme Court, is next door. Completing the square along the walkways between the palaces at either end of the park are historic cafés and trendy clothing stores. The arched galleries of the promenade shelter the ladies of the night who once loitered here—and sometimes still do.

The Palais Royal is also home to R. Khawam & Co., the shop of the Khawam family, four generations of antiquities merchants, plying a trade that has become increasingly difficult with each passing year. The store window has lit vitrines, with a small, sculpted bronze Greek head on one pedestal and glass jewelry from the classical period draped in another display. Through the glass window a jagged chunk of mosaic flooring can be seen along the carpeted floor, while a glass case on the interior has a spotlight on a delicate Egyptian bronze sculpture of Isis, holding an infant Horus at her breast. They are all the kinds of things one might find at the Louvre.

The Khawam name in the antiquities trade dates back to 1860 in Cairo, when Selim Khawam, a jeweler of Syrian-Catholic origin, realized that there was more money to be made in selling ancient artifacts than in peddling jewels. It was then that the family began collecting and trading, buying from Egyptian peasants and fortune seekers, selling to European collectors and museums. "We have always furnished museums with pieces," said Bertrand Khawam proudly, Selim's handsome, forty-seven-year-old descendant. He has close-clipped dark hair and on this day wore a black turtleneck sweater and white corduroys. Bertrand has taken over the business from his father, Roger, who retired in recent years but is still well known to major museum curators. The shop was empty of visitors, and Bertrand was happy to talk, producing crumbling copies of Egyptian newspapers from 1933 with articles about his family. When the family's shop was still in Cairo, he

recalled, Dietrich von Bothmer, the legendary curator at the Met, "used to come to my father's shop and say, 'I'll take this, and this, and this.' And the museum had to scramble to find the money."

But all that is about to end. Bertrand will be the last Khawam to sell antiquities. It has all become too complicated. Today, every item is scrutinized as if under a microscope for spotless provenance. Demand is a problem; supply is a problem. Museums are afraid to consider any piece that doesn't come from a known collection, preferably from an earlier century. As it is, Bertrand sells mainly pieces that have been in his family for decades, or that were sold to family friends and which he is now brokering for resale. He can no longer find new pieces to buy, as it is illegal to take anything out of Egypt or any country of antiquity, and even so, curators have become cagey about buying anything at all.

What was once a thriving business has become mired in national politics, ego, and greed. "The mentality of the people in the field has changed," he said. "My father always said, 'Don't look at the hand holding the object, look at the object.' But today we like to look at the hand." Khawam blames countries like Egypt for killing their own industry and sending it underground. "Up to the 1960s, Egypt used to give exit permits to antique dealers," he said. "It was supervised and policed. But then they went crying to the UN, and to UNESCO, saying, 'We're being looted. They're stealing our patrimony.'" As a result, only smugglers sell antiquities, and the objects disappear into private collections, never to be seen by the public.

Despite his Arab origins, Khawam is among those who find the Arab attitude toward European collectors self-defeating. He believes that Egypt owes a debt to the French. "Without Napoleon's scientific expedition, Egypt would have been destroyed," he said. "The Mamluks didn't care. It is thanks to the curators and the scientists that Egyptian civilization was saved." And he has nothing but scorn for Zahi Hawass. "With that hat, he thinks he's Indiana Jones. He's a blowhard of the first order," he said.

Objects of great beauty are for sale here. The bronze statue of Isis sells for 40,000 euros (about $60,000), and there is a small, sculpted Greek head for sale for 70,000 euros ($105,000). Khawam went into a

wall-sized iron safe, like a bank vault, and brought out a leather-bound box. When he opened it, my heart stopped. Inside was a heavy gold chain choker, with sculpted gold lion heads of intricate craftmanship on each end, known as a terminal. There was a matching bracelet in twisted gold, also with the lion heads as terminals. The set was 2,200 years old, from Thessaly, Greece, and was in perfect condition. "My grandfather bought it in 1902," he said. In another box was a heavy belt of solid gold with a flowered brooch and a molded face in the center, also Greek. It looked like some ancient Versace-style bauble. The price: 150,000 euros (about $225,000). Another masterpiece nestled in a velvet box below: a gold necklace, heavy with golden pomegranates hanging along the chain. It was even older, from 1525 BC, an Egyptian treasure from the New Kingdom. It too cost 150,000 euros.

Bertrand wants to sell them, close the shop, and move to New York to design and sell contemporary furniture. But even this is not as easy as might be thought, though the ownership of the jewelry is within his family. "Normally a museum should buy it right away," he said. "But they're afraid of being accused of buying a fake. And then they're afraid of the problem of dating, because the gold doesn't oxidize." As for himself, he said, "I never buy. Not at auction, nowhere. The pieces are not very interesting, and very expensive. It's all become impossible."

A few days later, his father, Roger Khawam, came to the shop for a rare visit. Now eighty-five, the elder Khawam carries the living memory of the remarkable changes in the antiquities trade that have occurred over his lifetime. Roger Khawam began selling antiquites at age fifteen in Cairo. His father ran Khawam Frères, a shop in the central bazaar of the city. The family had moved to Egypt from Syria in 1860, when Turkish and Druse massacres of Syrian-Lebanese Christians sent them fleeing the country. In 1912 the Khawams were certified as official antiquities merchants by the Antiquities Service, the predecessor of today's Supreme Council of Antiquities. From 1939 to 1945 Roger Khawam apprenticed under his father, and then he left in 1945 to study Egyptology at the Sorbonne. In 1952 he took over the shop from his father in Cairo.

Roger Khawam is known for his eye. Like most antiquities dealers,

he considers himself a lover of the objects he sells, someone who preserves history, not someone who loots the past. Khawam remembers fondly the days when the antiquities trade was a small circle of people who worked on a handshake and a reputation. He was frequently in the habit of handing over an object worth tens of thousands of dollars, trusting that the object would either be bought or come back to him. Now the entire trade is fraught with suspicion—of forgeries, of illegal provenance, of shady dealings. Roger Khawam is exceedingly proud of having united two pieces of a thirty-centimeter-high statue of Queen Tiyi, the wife of Amenophis III. In 1962 Khawam had the upper half of the statue for sale. The lower half of the statue had been in the Louvre since 1826, part of the Henry Salt cache that formed the heart of the museum's Egyptian collection. Khawam's father, Joseph, had bought the piece in Cairo, and Roger Khawam brought it to Paris with an export permit. The curator, Jacques Vandier, said it was too expensive, but Roger Khawam was undeterred. "I said, 'Take it, look at it, and send it back when you're done,'" he recalled. "The next day I got a card: 'I must see you. I must buy it; give me a good price.'" Today the statue is a treasured piece in the Louvre, seen in the Sully wing. How did such a piece get an export permit? "Often the commission didn't know what they were looking at," he said. "If the object had a high price attached to it, they'd just say no. So often we would show them the piece with a fake price."

More recently, in 2002, Roger Khawam placed the lower half of an ancient Egyptian statue in the window of his shop at the Palais Royal. It had been exported from Egypt in the 1950s, when it was still legal to do so, and came from a dig in Tell el-Dabaa in upper Egypt. The hieroglyphics on the statue indicated that it was a priest who had contributed to the building of a temple, a specialist in snake bites. Somewhere in his memory Khawam believed he had seen the upper half of the statue before. He began combing through catalogs and auction photographs. It took weeks, but he eventually found a photo in a tiny catalog published in the 1960s by the State Museum for Egyptian Art in Munich. He called the museum and declared triumphantly, "I think I have the bottom of your statue." He was right; the German museum did have it, in its storage reserves. It was one of Khawam's

proudest moments as an antiquities dealer. He sold the statue for forty thousand euros.

Khawam said that today's view—that dealers were pillaging Egypt and other ancient countries—is wrong. "We never pillaged," he protested. "We followed the law." He pulled out a tome of Egyptian laws regarding antiquities, covering the period from 1835 to 1960. "You cannot say it was clandestine or illegal. Today we want to insert morality where there was none. To the Egyptians, these were rocks. They used mummies to build fires. For us, today, in the twenty-first century, we find this immoral. But it's as true for the Venus de Milo as anything else. All of these objects left Egypt and are all over the world; we have to say that they were saved." He recalled an incident when one of his suppliers brought him the bust of a statue. "He bought it from a peasant who had been using it as a hammer," he said. "I have hundreds of stories like this. Farmers used to destroy pieces to keep the Supreme Council of Antiquities from confiscating their farms. Or instead they would sell them surreptitiously. And even if it was illegal, the SCA tolerated it because at least it meant the objects were saved. If they left to New York, they were better preserved."

Both Bertrand and Roger Khawam believe that the system was better when some exports were permitted. Banning them completely has merely sent the trade underground, they said. Between 1912 and 1978, an Egyptian commission would review objects submitted for export permits and decide if an object could leave the country. But the issue finally became too sensitive. For a while the commission did not convene at all. For the Khawams, it was the end of the road in Egypt. Their business had essentially been outlawed, so Roger Khawam moved to Paris in 1978, ahead of the Egyptian government's decision in 1983 to ban all exports. But the buying and selling of antiquities did not cease, Roger said; it merely was sent underground, creating the conditions for rampant abuse—including by antiquities officials.

"My colleagues in the business stayed, but they continued to work illegally," he said. "Actually, it became easier. It just became a matter of who would pay the most for an object. Before, you would submit objects to an SCA inspector. They would come by and see if the object was something the Egyptian museum should have. After 1979,

there was complete abuse. You bought what you wanted; you sold what you wanted." It is an accepted fact that corruption had been rampant in the antiquities service for years. Zahi Hawass has worked hard to crack down on corruption in his service and among dealers; nonetheless, even now the Egyptian press frequently runs stories of arrests and investigations into the theft of items missing from storage units or elsewhere within Egypt. Hawass has put Egyptian traffickers in prison and prosecuted officials from his own service when they were found to be on the take. Khawam said some of those put in jail had been his suppliers, though he declined to name them. "Some of them became jewelers, and in the back room they'd buy antiquities. They'd pay off customs officials to allow them to take it out of the country," he said. "If they brought it to me in Europe, I bought it. How it got there was not going to be my problem. I had guys who brought me fifty pieces in their suitcases. I'd meet them in a hotel room. Often I'd just go for curiosity's sake. Sometimes I would buy one or two pieces. But when there's no law [allowing export], all kinds of excesses are possible. You can buy anything and take it out illegally." Still, he admitted, Hawass has succeeded in quashing much of the black market. "It still exists, but it's much more difficult," he said.

Roger Khawam also scoffed at the notion of creating provenance for antiquities. "You can invent whatever documents you want," he said. "Just find an old typewriter." Bertrand, too, derided the efforts of the Art Loss Register, an international listing that records antiquities that are known to be lost or stolen. Dealers and buyers are meant to consult the list to avoid buying a looted piece. But this list only involves stolen pieces that have been reported, not those newly dug from the ground. And sometimes relationships still matter more than any formal listing. When Bertrand tried to send a bas-relief to a buyer in New York in 2006, U.S. customs blocked its entry. He called Interpol, which told him to have his father, well known in the business, write a letter stating that, on his honor, the piece had been in his possession for thirty years. This Roger Khawam did. It was better, he said, when a code of honor was in place, adding, "This profession of antique dealer can no longer be done normally." And that, he said, was a loss. "We have the experience, and the knowledge," he observed. "You can have

chemists and geologists, but to recognize an object is authentic, you need an Egyptologist."

BACK IN CAIRO, Zahi Hawass spends much of his time facing outward, toward the global audience that treasures Egyptian antiquities. It is where one can find dealers like the Khawams, their customers, the largest part of the academic community, and sources of generous funding. As a scholar-in-residence for National Geographic, Hawass taps into his most avid mass audience—Egyptophiles across the globe—through the magazine and its television channel. But he faces a harder time at home in Egypt, where he is regarded more as a quaint media presence rather than a reigning cultural powerhouse. There is no mistaking the fact that among young people in Egypt, the prevailing culture is that of Islam and its seductive political message rejecting the West and its values. Hawass's competing message—that pharaonic history is uniquely Egyptian and must be reclaimed from the West as part of the national patrimony—is harder to sell. The challenge that Hawass faces in connecting to young Egyptians is evident, and no more starkly so than in his own family.

On a Friday afternoon after prayers, I met Sherif Hawass, Zahi Hawass's eldest son, at the restaurant La Pietra, which is half owned by Sherif's younger brother Kareem. It is in the upscale Cairo neighborhood of Mohandeseen, where Mercedes cruise past stores like Bang & Olufson and Diesel Jeans, a Gianfranco Ferre boutique, and private schools.

La Pietra is a restaurant that would fit comfortably in West Hollywood. It was still early and thus deserted, which allowed plenty of time to admire the Asian decor, heavy wooden beams, and hip, low-voltage lighting. The bathroom had gleaming copper basins and offbeat, vintage American art. Sherif, a thirty-one-year-old doctor-turned-businessman, would fit equally well in West Hollywood, with his sculpted-at-the-gym physique, tousled black hair, day-after stubble, and ripped jeans. He speaks English better than Arabic, he said, having spent ages three to twelve in the United States while his father worked on his doctorate at the University of Pennsylvania.

The Hawass family, Sherif told me, comes from a village on the Nile called Abidiya, near the port of Damietta. It is the nexus where

the Nile flows into the Mediterranean Sea, where people earn their living farming and making wood furniture. Zahi's father, Abbas Hawass, was a farmer who died when Zahi was young, leaving him to be raised by his mother. The family was not well off, said Sherif, but neither was anyone else in the village; of Zahi's five siblings, two died. Zahi's wife, Fekria, was a cousin also from the Hawass family. (Marriage between cousins is a common practice in Egypt.) She and Zahi both attended the University of Alexandria, where he got a bachelor's degree in the faculty of Greco-Roman studies, while she studied premedicine and went on to became a gynecologist. They have been married for several decades.

Growing up, Sherif Hawass followed his mother's path into medicine and was not particularly drawn to archaeology, despite his father's success—or perhaps because of it. "If you look at my father, he's the one successful person in the whole country on the subject," he said. "What are the chances of my ending up like him? He has passion. It was something that I didn't have in medicine. I'm more interested in the history of wars and in religion." By religion, Sherif Hawass meant Islam, which in recent years he had begun to study on his own. All appearances to the contrary, he had become a devout Muslim, struggling to shed the trappings of his secular, Westernized upbringing. "I don't listen to music anymore," he said. "I only listen to the Koran. It's more beautiful than any music."

Sherif Hawass is like many young Egyptians—having searched for meaning and a sense of cultural identity, he found it in Islam, rather than in the country's ancient pharaonic roots. "I wasn't a Muslim before; I was different," he told me. "Now I'm convinced that this is the right thing to do. The times are confusing, but I have the exact answer in religion. The people I see in the mosque, you feel that you like them for no reason. They have light in their faces. They're not afraid. They have no stress."

His friends, he said, were constantly chasing a materialist ideal that brought him no fulfillment. "Faith is the biggest thing in Islam," he said. "It's hard to find a religion where people follow everything, no matter what. And it's really difficult to live this lifestyle." Sherif was struggling with the demands of his faith: giving up sex, alcohol, pork.

He was getting married to his girlfriend and wasn't sure she would agree to wear the veil. "It's giving me a lot of stress," he confessed.

But Sherif wanted to prepare because he believed a kind of Armageddon was around the corner. "The years that are coming will be very terrible. It's all written in the Koran. Natural disasters, a war against Islam, especially from the Jews, it's the sign of the last days. It's like a puzzle."

The Jews? This is a common refrain in the Arab world, but I was nonetheless surprised to hear it from the son of Zahi Hawass. The archaeologist's academic mentor was David Silverman, a Jewish professor at the University of Pennsylvania with whom he remains good friends. And in the worlds of academia and the media, Zahi Hawass encounters Jewish people regularly. And yet without prodding, Sherif Hawass held forth on Osama bin Laden, the Palestinians, the American-Israel connection, the bombings in London by radical Muslims claiming to be acting on behalf of innocent victims in Iraq. In his paradigm, the world is black and white, good and evil. The good guys and bad guys will never reconcile; Islam has predicted all of this. He could not be more certain of his views. "I know the truth," he said.

A few days later I asked Hawass about his son's religiosity. The archaeologist seemed only vaguely aware of the depth of Sherif's devotion to notions of radical Islam. (And it is probably more accurate to say that among young people in Egypt these notions are not radical at all; indeed, they are widely accepted.) But Hawass said that whatever his son's choices, his own quest to win over young people was nonetheless succeeding. He pointed to his popular youth programs at the Cairo Museum, and to the swelling ranks of young archaeologists in the SCA. Fundamentally, Hawass sees himself as a visionary. He believes his ideas will prevail, if not now then in ten or twenty years. Egyptian artifacts will return home, and he will have been the one to have launched this campaign. "Everything starts as a dream," he said. "If you think something is impossible—you are wrong. It is important to dream." He paused to reflect. "Maybe I will be the one to open people's eyes. Maybe it will never happen in my lifetime. But at least museums must understand that this will happen. It is fair. These monuments belong to everyone, I believe in that. But Egypt is the guardian of these monuments. We have the responsibility."

# TOMB
# ROBBERS
## *on*
# FIFTH
# AVENUE

# CHASING
# THE LYDIAN HOARD

H E CALLS IT "THE CASTLE," THOUGH NOT BECAUSE OF
its size. It's a tiny apartment tucked away in a residential neighborhood
of Ankara, the capital of Turkey, across from the Cuban embassy, sand-
wiched between a lonely playground and a corner market where if
you push a button a cab will appear out of nowhere in about five min-
utes. The castle is impossible to find; it's a castle, perhaps, because he
rarely leaves.

In forty years of investigative work on behalf of looted Turkish an-
tiquities, Özgen Acar has slowly seen his apartment disappear, sucked
into the vortex of his passion. His bedroom is big enough just for a
bed and a dresser. A second bedroom has no bed at all; it is filled en-
tirely with file cabinets, labeled carefully for each project he has pur-
sued. In the hallway, a poster with the phrase he coined—"History
is beautiful where it belongs," which was used in a regional campaign
to raise awareness about restitution—competes for attention with a
poster-size cover of *Connoisseur* magazine from 1990, highlighting his
cover story about art smugglers and stolen pieces. (Since then, one of
the two artifacts on the cover has been returned to Turkey; the other is
still at the Getty Museum in Los Angeles.) A third bedroom serves as

an office for his assistants, archaeology and art students who volunteer their time and who have neatly arranged photocopies of his major articles in wooden cubbies.

But it's the room that was once a living-dining space that has been truly submerged beneath the imperative of Acar's obsession. Much of the room is taken up by his desk, covered in papers and files, the computer dinging every few minutes as new e-mails arrive. From top to bottom, the walls are lined with bookshelves that hold the contents of a multilingual library about ancient civilizations, art, museums, looting, archaeology. The shelves have handwritten tabs sticking out. They are labeled: Mosaic, Cappadocia, Rome, Mesopotamia, Ceramics, Mythology, and on and on. For those who can find him, this collection has become a lending library. At the end of the bookcase, a typed list taped to the wood lets Acar know who borrowed what and when, with names and phone numbers. He crosses off the names as the books are returned.

Acar's work has won him many awards. Near the ceiling in his living room-cum-office is a shelf for his many trophies and accolades. A tabletop hosts a shrine to his fallen workhorses from across the decades, a typewriter graveyard: manuals lined up side by side—a Royal, a Consul, an Olympic. There's an early Apple computer and an old laptop, silent testimonials to the thousands of words that have passed through their circuits.

Acar's wife gave up on this place long ago. She now lives in Switzerland, as a Turkish diplomat working for the World Trade Organization in Geneva. She visits occasionally.

But mostly Acar lives the life of a bachelor with a day job. He is the foreign affairs columnist at *Cumhuriyet*, Turkey's oldest daily newspaper, which leans to the left politically. As Turkey has become a modern economic powerhouse, *Cumhuriyet* has faded. It is no longer among the most read papers in the country, but it retains a historic prestige. To pursue his passion and do his job, Acar has to be very organized. He produces a column twice a week and devotes most of the rest of his time to looted antiquities, fielding calls and chasing down tips. ("Did you hear," he asked me in an urgent cell-phone call, "that Turkey has suspended cultural exchange with Germany over the Boguzkoy sphinx?") But he's

done in time to turn on his beloved Beethoven on the stereo and pour himself a Johnnie Walker Red at 5:00 p.m. every evening.

Özgen Acar has been intimately involved with just about every important major revelation of stolen antiquities in Turkey in recent times. It was largely at his prodding that the Turkish government took up the cause of stolen cultural patrimony in the 1980s, one of the first source countries to do so. Quietly, patiently, with the persistence of a cub reporter, he helped uncover the theft of a massive collection of silver Greek coins, the Elmali Hoard, dug from the ground by local peasants in the town of Elmali, sold through international back channels and scattered throughout the auction world where they were bought by a dozen collectors. It was Acar who wrote in depth for *Connoisseur* magazine about the Telli family, a ring of smugglers through whom a billion dollars' worth of stolen antiquities flowed. They sued him; he was acquitted. He then got death threats. He ignored them. He later learned that the plan was to kidnap him, tie him up, and ship him, with an oxygen tank, to a Swiss museum.

It was Acar who first wrote about the striking similarity between a torso of Hercules on loan to the Metropolitan Museum from the Boston Museum of Fine Arts and the lower half of a statue in the Antalya archaeological museum in Turkey. At first, the Boston museum dismissed his observation in a statement to the *New York Times*, saying, "A statue cannot have two navels." Later, a cast of the lower half was brought to Boston and found to fit perfectly. He received an anonymous call that a garlanded sarcophagus in the Brooklyn Museum, marked as a private loan, had been stolen from Turkey. He investigated, went to see the piece, and wrote about it. The sarcophagus was ultimately returned. He wrote article after article, year after year, laying out facts, following the threads. He made diagrams. He traced bills. Along the way, he scolded governments, shamed great museums, punctured the sanctimony of posh auction houses, and lifted the veil on the lucrative and largely unrestrained trade of antiquities. "Like portly citizens who decry rich foods while gobbling them," he and Melik Kaylan, another crusading journalist, wrote for *Connoisseur* in 1988, "the wealthy nations do little to strengthen their nominal disapprobation with specific laws; their appetite for acquiring ancient artifacts is too great."

Among the more monumental pieces taken from Turkey that form central parts of Western museum collections is a Lycian mortuary temple that now stands in the British Museum. This beautiful building—the entire edifice, brought block by block, the marble statues with their sea-sprayed, windswept goddesses—came to London through the efforts of Charles Fellows, a nineteenth-century explorer. Another masterpiece is the Great Altar of Pergamon, also known as the Altar of Zeus, which forms the centerpiece of the Pergamon Museum in Berlin. It is an even larger structure that was dismantled piece by piece—with the government's permission—in 1879 and 1904, and brought in its entirety to Germany as that country was racing to catch up to the great collections in England and France. With its signature U-shape and friezes with reliefs of gods and giants, the altar and its colonnade is monumental and imposing. In modern-day Bergama (or Pergamon), an ancient town along Turkey's western coast, there is a flat foundation stone where the building used to stand, on the acropolis at the highest part of the city.

At one point local officials in Bergama mounted a campaign to win the return of the altar from Germany, but Acar—surprisingly—is against it, just as he opposes returning the Parthenon marbles from the British Museum to Greece. At least for now. "I'm very happy these were carried away in the nineteenth or eighteenth centuries, because they were protected," he says. "If not, piece by piece those marbles would have been used to build mosques or churches. Luckily they were taken away and protected on behalf of mankind. But today we live in the modern world. We have to educate the local people, poor people. The Elgin Marbles and the Altar of Zeus will return home. They must return and be displayed in their original places. But for today, let's keep them where they are." Acar's focus, instead, is on pieces that have been looted in recent decades. Indeed, modern-day looting in Turkey has inflicted great damage on archaeological sites and on the world's understanding of the context in which objects are found. And when world-class museums buy smuggled treasures, it feeds the market for still more looting.

His whiskey gone, Acar settles back into his worn, oxblood-colored easy chair and into his favorite topic. "Turkey is a crossroads," he begins,

*Özgen Acar, the Turkish journalist who has crusaded against smugglers, standing in front of a poster celebrating the return of the Lydian Hoard.* (Photo © Sharon Waxman)

launching into a lecture on his country's importance in the foundation of both Western and Islamic civilizations. Acar has short, nearly white hair, and on this night he wears a white T-shirt from the Metropolitan Museum of Art, printed with images of a column from the Temple of Artemis in Sardis, Turkey. A pair of reading glasses is slung around his neck. He speaks a clean, careful English in a manner that brooks no stupidity. Acar is accustomed to speaking in the manner of a university lecturer and to having people listen when he speaks. When I respond with a comment that is sufficiently sensible to Acar, he nods vigorously and bellows, "Corrrrrect."

Turkey is not a bridge between East and West, as so many have

claimed, he tells me. No, it's a crossroads, from east to west, and north to south. Most everyone and everything has passed through here: war, culture, philosophy, religion, food. From Asia on its way to the Levant, from Assyria on the road to Greece and beyond. It is home to dozens of indigenous cultures, many long dead, forty-two different civilizations from the Neolithic period and forward, long before the arrival of Islam. Anatolia, the heart of modern-day Turkey, has a history going as far back as 9000 BC, and the remains of some three thousand ancient cities lie beneath its topsoil. It has more Greek cities than Greece and more Roman cities than Italy. The remains of those civilizations exist in some twenty thousand mounds—including the city of Troy, the crucible of Homer's famed (and apparently true) story of love and war—and an additional twenty-five thousand tumuli, or burial mounds, across the nation.

The cultural heritage of Turkey, Acar says, is unparalleled anywhere in the world. Istanbul was the capital of no fewer than three separate empires: Roman, Byzantine, and Ottoman. That leaves aside the Lydians (King Croesus), Phrygians (King Midas), Trojans, Hittites, and Lycians. The remains of those empires are everywhere. "Wherever you dig in Turkey, you can find something, a coin, a marble statue, a jar," he says. Acar pulls off his shelf a thick coffee-table book, *The Treasures of Troy*, with heavy gold chains on its cover, believed to be a royal headdress from the famed cache of treasures found by the German archaeologist Heinrich Schliemann in the 1870s. The book has glossy images of the most breathtaking artifacts, 4,600 years old: elegant ceremonial hand axes, one made from jade, another made of lapis lazuli. Neither stone, Acar points out, is native to Turkey, his point being that Anatolia has drawn beauty from around the world for thousands of years. But the treasures of Troy are not in Turkey. Known as "Priam's treasure" after the fabled king from *The Iliad*, they were taken to Germany by Schliemann, smuggled out of the country through the use of a U.S. Navy boat. Schliemann had made a fortune in business and used the money to pursue his conviction that *The Iliad* and *The Odyssey* were based on real cities and people. (He even named his children Andromache and Agamemnon.) Indeed, the intrepid Schliemann found the remains of Troy near Turkey's Aegean coast.

When Turkey learned that the treasures had been smuggled out of the country, the government was furious and successfully sued Schliemann. Still, in a sign of the international complications of such cases, most of the artifacts remained at the Berlin Museum. Today, an exhibit at the Istanbul Archaeology Museum displays a handwritten letter from Schliemann to the Ottoman authorities, dated June 19, 1873, explaining that he had sunk too much of his own money into finding Troy to consider leaving the treasures behind. ("It is impossible," he wrote, "as I found it after three years and spending 200,000 francs.") During World War II, the treasures of Troy were hidden in a bunker beneath the Berlin Zoo but were stolen in the days after the war ended. The spectacular golden artifacts were thought lost to history until 1993, when they were unexpectedly rediscovered in the basement of the Pushkin Museum in Moscow. Now Germany wants the treasures back, but Russian museum directors are claiming them as repayment for the destruction of Russian cities during the war. Turkey, in the meantime, has a very nice coffee-table book, with pictures.

BUT WHAT IS Acar fighting for, exactly? For Turkey's culture or for the principle that those who take antiquities somehow diminish world culture? Did Schliemann impoverish world culture by taking Priam's treasure out of Turkey, or did he enrich it by making it available to thousands of people in Berlin (and now in Moscow)?

Turkey is complicated, culturally speaking. With so many different civilizations come and gone on this fertile soil and along its sparkling waterways, it is hard to know what it means to be a modern-day Turk. Who are the Turks' ancestors? To what and whom are they the heirs? Are they the descendants of the Lydians, Trojans, Hittites, and Mycenaeans? Or are they merely custodians of the remains of these ancient civilizations who happened to inhabit this piece of land before they did? There may be more Greek cities here than in Greece, but in no way are the Turks the descendants of Greek civilization, their bitter rivals of recent centuries. Indeed, many observers have remarked that Greek sites in Turkey suffer from neglect because of that animosity; the Turks, not surprisingly, deny this.

True or not, the Turks of today are a rich—or, put another way,

confusing—blend of the many cultures that have thrived here, including Kurdish, Greek, Armenian, Christian, Muslim, Jewish, Persian, and central Asian. In the main, modern Turks consider themselves to be descended from the Ottomans, the conquering horsemen who came thundering down into Anatolia in the late thirteenth century from across the plains of central Asia and established an empire that lasted until World War I. The citizens of Turkey are mainly Muslim, another cultural difference from the ancient, polytheistic civilizations that once thrived here. And while Christian Byzantium reigned for centuries, it is the Muslim Ottoman Empire that left the dominant cultural mark on contemporary Turkish society.

This creates a kind of conundrum when raising the question of cultural patrimony and the debate over who ought to own the symbols of the past. Repatriation is usually connected to the idea that a country's modern cultural identity is tied to the objects of its ancient history, that those objects are the tangible symbols of the link between a nation's past and its present. The debate is thick with the sense of stolen identity, of the theft of a nation's very soul, which is largely why this debate surpasses legal minutiae to take on moral overtones. But in Turkey, there is no direct link between the 73 million people who live here today and the hundreds of archaeological sites that dot the country. This is already the subject of intense scholarly debate and has a philosophical underpinning. "The Turkish case of repatriation depends on a melting pot argument," explained one scholar. "The thesis known in Turkish as '*topragin kulturu*,' literally, the 'culture of earth,' argues for the continuity of memory, not in the subjectivity of an ethnically and linguistically defined group, but in the 'genius of place.'" Still, however one intellectually slices this argument, in practical terms it is a confusing link in the chain of logic for restitution. Restitution for whom? Does it make sense to remove an item from a Western museum, where it is seen by hundreds of thousands of visitors from around the world, for the benefit of the Turkish population? The Turkish museums, filled with objects of astonishing beauty, are vast and in many cases well curated, well lit, and cogently explained. But they are nearly empty of visitors.

In the summer of 2007, I visited museums all over the country: in Istanbul, Ankara, Antalya, and beyond. Not one of them was full; most

had just a smattering of visitors. At the Antalya Museum in the south, which has a breathtaking collection of Roman statues and sarcophagi (including several repatriated looted pieces), I spent three hours and saw perhaps five other visitors. And that museum gets more traffic, surprisingly, than the stately, neoclassical Anatolia Archaeological Museum in Istanbul, with one of the most important antiquities collections in the world, including the celebrated Alexander sarcophagus from the Lebanese city of Sidon, with its thrilling sculptures of Alexander the Great in battle. (I would add that this sarcophagus was taken from Sidon by a Turkish archaeologist in 1887 and, according to Acar's phrase, probably ought to be returned to Lebanon. But I won't seek to complicate this discussion.)

On my visit to Turkey, I met Cemal Pulak, a Turkish-born archaeologist from Texas A&M University, who was excavating a half dozen boats from antiquity that were unearthed when the city of Istanbul began digging a new railroad terminal. In so doing, the diggers unearthed the largest cache of ancient ships ever found—twenty-four—and the excavation is the subject of a well-done exhibit at the Istanbul Archaeology Museum. But no one comes to see it. Which may not matter, since most of the museum is closed to visitors anyway. There is not enough money in the museum budget to maintain security and air-conditioning in the galleries that will stand empty, even as thousands flock to the nearby Topkapi Palace to see the home of the Ottoman sultans and their spectacular jewels. I also visited the much smaller, but arguably more important, Anatolian Civilizations Museum in Ankara, which was awarded the title of the best museum of the year from the European Union in 1997. A guide there told me that several years ago the museum used to get five thousand visitors per month, but now that number has shrunk to one thousand.

The decline in museum attendance is apparent across the country. It would be easy to conclude that there isn't much interest in antiquities in Turkey. A report funded by the European Commission listed the ten most visited museums in Turkey in 2003; the Istanbul Archaeology Museum was not among them. The top three sites—Topkapi, Mevlana, and the Hagia Sophia, each with about 1 million visitors per year or more—are all connected to Ottoman and Muslim history. (Mevlana is a Muslim

shrine.) The rest lagged far behind. The magnificent Antalya Museum had a grand total of 151,202 visitors in 2003. The rich, well-displayed Ankara museum had 308,451—fewer than 1,000 per day. This suggests that the average Turk doesn't feel connected to these ancient objects and this history.

Still, the most pressing question does not concern enthusiasm but rather practicality: can Turkey care for the treasures that it has so insistently demanded be returned? The story of Özgen Acar's first and greatest triumph, the return of the Lydian Hoard in 1993, suggests that the answer is open to debate.

ÖZGEN ACAR HAD been a reporter for *Cumhuriyet* for a decade when, in 1970, he received a visit from Peter Hopkirk, a British journalist from the *Sunday Times* of London.

"I'm chasing a treasure," Hopkirk told Acar, intriguingly. "It's been smuggled out of Turkey. A U.S. museum bought it, and it's a big secret."

Acar had grown up in Izmir, on the western coast of Turkey, and had an early taste of antiquities when his mother, an elementary school teacher, took him to museums and to the sites of the ancient Greek origins of his native city. In 1963 he traveled with his backpack along the Turkish coastline, discovering the cultural riches there. But his abiding interest was current affairs, and he had studied political science and economics before getting his first job as a journalist.

Nonetheless, he was intrigued by Hopkirk's call. Earlier that year, American journalists had gotten a whiff of a brewing scandal at the Metropolitan Museum of Art in New York. The *Boston Globe* had written about a set of golden treasures acquired controversially by the Boston Museum of Fine Arts, and in doing so mentioned a "Lydian hoard" taken from tombs near Sardis, in the Hermus river valley, that was being held in secret by the Met. In August 1970 the *New York Times* printed a dispatch from the *Times* of London in which Turkey officially asked for details about the alleged illegal export, warning that it would bar foreign archaeologists from any country that did not return smuggled treasures. Theodore Rousseau, the Met's chief curator, denied that the museum had exported anything illegally, but added mys-

teriously that there "seemed to be hearsay fabricated around something that might have a kernel of truth to it."

Hopkirk, the British journalist, was looking to break the story, but he needed a Turkish partner to help him chase the trail locally. He offered Acar the opportunity to team up and investigate and publish simultaneously in both papers. Acar grabbed what seemed like a good story.

They chased the clues that Hopkirk had from his sources: a group of hundreds of golden pieces, coins and jewelry and household goods, had been found near Usak, in southwestern Turkey. Usak was the closest population center to what had been the heart of the kingdom of Lydia in the sixth century BC. The trove had been bought by the Met, which knew that the pieces had no known origin, or provenance, and was keeping the pieces in its storerooms. Acar traveled to Usak, a small town where the residents said no one had heard of a recently discovered golden hoard. He also went to New York and visited the Met. He called the Ancient Near East department and spoke to the curator, Oscar White Muscarella. Muscarella told him there was nothing like what he described in the department. (The treasure turned out to be with the Greek and Roman department, but Muscarella didn't know that.) In the end, the journalists couldn't produce anything definitive. Hopkirk was frustrated, but Acar was intrigued; why, he wondered, did a British journalist care so much about ancient pieces from Turkey anyway? He began to consider the issue from a different perspective, as a problem that affected world culture and human history, not just Turkish history. No one, he decided, has the right to smuggle antiquities. As he continued his research, he became more convinced of this, and angrier at those who had irretrievably damaged a tangible link to the past.

For sixteen years, Acar didn't publish a thing about the Lydian treasures. But he continued to work on the story in his spare time. As 1970 gave way to 1971 and 1972, he traveled to Usak once every five or six months, making the six-hour journey to the small town by bus. He asked if anyone had heard about digs in the tumuli outside of town, but no one said they had, at least initially. But as two years became three, and three years became five, six, and eight, Acar became a familiar face in the village. Sources began to crack. He would hear the grumbling, here

and there, from people who had missed out on the windfall, about others who had been paid for digging in the tumuli. He conducted research about the Lydian kingdom, whose capital was in Sardis and whose borders stretched from the Aegean Sea to the Persian frontier. The greatest of the Lydian kings, Croesus, was renowned for his vast treasures of gold and silver. His name became synonymous in the West with the measure of extreme wealth—"as rich as Croesus." By some accounts Croesus was the first ruler to mint coins, and he filled the Lydian treasury with his wealth. He ordered the construction of the Temple of Artemis at Ephesus, one of the Seven Wonders of the Ancient World. But he was also the last king of Lydia. In 547 BC, Croesus was toppled by King Cyrus of Persia, who reduced the Lydian kingdom to a distant outpost of his empire.

Convinced that the Met possessed the Lydian Hoard but was refusing to acknowledge it, Acar continued his investigation, year after year, visiting Usak and, when he could, questioning the Met. (In Turkey, the hoard became known as "the Karun treasures," as *Karun* is the Arabic and Persian rendition of *Croesus*. Karun is also a biblical-era figure in the Koran known for his great wealth.) Acar became known in Usak for opposing the looting of Turkey's cultural patrimony, and on one visit he was talking to some villagers in a café when one called him into the street to speak privately. "There are six or seven of us going to rob one of the tumuli," the villager told him. "But my heart isn't in it." He gave him the name of the place and asked him to inform the local officials. Acar did. One of those officials was Kazim Akbiyikoglu, a local archaeologist and the curator of the Usak museum. The police assigned Akbiyikoglu to excavate there instead. He discovered a cache of treasures from the Phrygian kingdom, a civilization that followed the Lydians.

IN NEW YORK, where the Met had muffled rumors of a spectacular, possibly illegal, purchase, more rumors emerged in 1973. This time, the museum quietly leaked a story to the *New York Times* about the acquisition of 219 Greek gold and silver pieces, still being held in storage. The *Times*'s art critic John Canaday noted that the treasures dated to the sixth century BC and had reportedly been bought for about

$500,000 by the Madison Avenue dealer John J. Klejman and sold to the museum in 1966, 1967, and 1968. The *New York Post* weighed in at this time, too, and asked the curator of the Greek and Roman department, Dietrich von Bothmer, where the treasures came from. "You should ask Mr. J. J. Klejman that," retorted von Bothmer. A few pieces from the collection had been shown in the previous year in a survey exhibit, but the objects were not published in the catalog and remained in the museum's storerooms. The director of the Met, Thomas Hoving, and von Bothmer believed that the museum had no obligation to determine whether the objects had been looted. The acquisition predated the UNESCO agreement of 1970, which banned the illegal export and transfer of cultural property, and both Klejman and the museum justified the purchase under the rules of the old code, whereby works whose provenance could not be specifically demonstrated as illegal could be legitimately purchased and sold.

Turkey, they would soon learn, felt differently.

Özgen Acar did not see the *New York Times* article, and anyway, he was looking for treasures from Lydian civilization, not Greek. The years passed and the issue faded, though it remained in the back of his mind.

In 1981 Acar visited New York again, this time with photographs of pieces from the hoard, obtained from the Turkish police. Still there was no hard evidence or any word of any Lydian treasure from the Met, where officials did not return his calls. Acar moved to New York soon thereafter to work for a different Turkish newspaper, *Milliyet*, and subsequently struck out on his own as a freelancer. One day in 1984 he was visiting the Met and was surprised to see on display fifty pieces that closely matched the description he had of the Lydian Hoard. They were labeled simply "East Greek treasure." This was no chance sighting. Acar had been watching the Met's public exhibitions and scouring its catalogs all along, looking for some sign that the museum indeed had the pieces. "I was shocked," he recalled. "The villagers who had taken them knew what the items were. By this time, I knew them like the lines of my own palm." Until now, he had found no concrete sign of an acquisition. The objects were published in the museum's summer bulletin that same year.

This was the proof Acar had been waiting for. He flew back to Turkey and got an interview with the minister of education, showing him what he'd managed to gather over the years. That local villagers had secretly excavated tumuli outside of town and sold the contents to smugglers, who had sold a hoard of golden Lydian treasures to no less an institution than the Metropolitan Museum of Art in New York. And photographs comparing the pieces seized from looters in the 1960s to the pieces at the Met all but proved that the Met's pieces were Lydian and came from the same area as the others. "If that all turns out to be true," the minister responded, "then we will sue the Met." Acar broke the story in a series of seven articles in *Milliyet* in 1986, the first of which carried the eight-column headline "Turks Want the Lydian, Croesus Treasures Back."

In Acar's investigation the path of the theft became clear. In 1965 four farmers from the towns of Gure and Usak dug into a tumulus called Ikiztepe and struck it big—these were tombs of the Lydian nobility and upper class and were laid out traditionally with a body on a bed, surrounded by precious objects. Police learned of the theft and were able to recover some of the objects in 1966, and these were handed over to Turkish museums. But most of the artifacts had already left the country. The looters sold their find to Ali Bayirlar, a Turkish antiquities smuggler, who sold the hoard to J. J. Klejman, the owner of a Madison Avenue art gallery, and George Zacos, a Swiss dealer. The Met bought successive groups of the Lydian treasures from 1966 to 1970. As often happened in such cases, when word spread in Usak that several local farmers had successfully sold their loot, others went frantically burrowing in other nearby tumuli, Aktepe and Toptepe, where they found still more Lydian pieces: gold, silver, pieces of exquisite artistry, and wall paintings from the tombs themselves. In a statement to the police, one looter described the efforts expended to burrow into the tombs.

> We dug in turns for nine or 10 days. . . . On the 10th day we
> reached the stones, each of which was almost 1.5 meters in
> height and 80 cms wide. . . . It would be hard for five or six

> persons to lift one of them. . . . We had tried to break the
> stones with sledgehammers and pokers, but were not success-
> ful. I exploded [the main entrance] using black powder.

The looters found a corpse that was, in the main, a pile of dust and
a hunk of hair. But the gold and silver objects were undamaged. That
one tomb held 125 pieces.

Meanwhile, the treasures were presented to the Met's acquisitions
committee by Dietrich von Bothmer. It was the time of "don't ask, don't
tell" when it came to buying unprovenanced treasures. The pieces were
unique, and they were exquisite: acorn-shaped pendants along one
heavy golden necklace; bracelets with intricately carved lion heads at
each end; carefully ribbed and sculpted silver bowls; a silver ewer
with the handle in the form of a graceful human figure arching
backward. And of course the masterpiece, a tiny golden brooch in the
shape of a hippocampus—a horse with wings and a fish's tail, repre-
senting land, water, and air. The horse, barely an inch and a half in
height, had three sets of tassels of three hanging, golden braids, each
braid ending in an intricate golden ball in the shape of a pomegranate.
There was not another like it in the world. The Met paid $1.5 million
for the treasures over several years.

Under increasing pressure from the Turks, the Met dragged its feet,
trying to head off a legal battle. The museum lobbied for state legisla-
tion in New York to change the start date for the three-year statute of
limitations on stolen antiquities, to reduce its vulnerability to lawsuits.
The bill was vetoed twice by Governor Mario Cuomo, who argued
that it denied the rightful owners a "reasonable opportunity" to be
notified of a possible theft. The Turks tried asking politely, formally
requesting the return of the Lydian Hoard in July 1986 and sending
their consul general to meet with museum officials. Meanwhile, in-
side the museum, documents later emerged that showed the Met
knew full well that the "East Greek" pieces were what von Bothmer
described as "the Lydian hoard," the pieces Turkey had inquired about
from the early 1970s forward. Hoving states bluntly in his memoir that
everyone knew the stuff was contraband.

Dietrich von Bothmer asked what we should do if any dam-
aging evidence were found that our East Greek treasure had
been excavated illegally and smuggled out of Turkey. . . . I
was exasperated. "We all believe the stuff was illegally dug
up," I told him. . . . "For Christ's sake, if the Turks come up
with the proof from their side, we'll give the East Greek trea-
sure back. And that's policy. We took our chances when we
bought the material."

On May 29, 1987, the Republic of Turkey filed a lawsuit in Man-
hattan federal court against the Metropolitan Museum of Art, con-
tending that several hundred artifacts had been illegally excavated and
illegally exported from the country in the 1960s. This was a spectacu-
larly bold move by a country with no track record in suing major in-
stitutions in foreign countries. Would it work? Turkey, represented by
the American lawyers Harry Rand and Lawrence Kaye, was betting
that the American justice system would judge the evidence fairly and
be willing to embarrass a respected U.S. institution in favor of a coun-
try with a history of military coups and an overabundance of ancient
civilizations. Predictably, the Met filed a motion for dismissal, claiming
it was far too late to sue for artifacts it had bought in good faith. But
in 1990 Judge Vincent L. Broderick accepted the Turkish position. In
pretrial discovery, the Met allowed a team of outside scholars to inspect
the treasures for the first time. Among those who came was Kazim Ak-
biyikoglu of the Usak museum, who gave an affidavit providing the ev-
idence that he had of the treasures' origin. The Met's defenses crumbled
fairly quickly. Wall paintings were measured and found to fit the gaps in
the walls of one tomb. Looters cooperating with the investigation de-
scribed pieces they had stolen that matched the cache at the Met. The
case was covered prominently in the press, and it was beginning to look
like a black eye for the museum.

Seeking to salvage things, museum officials tried to negotiate a set-
tlement. Under one plan, the Met would admit that the treasures were
Turkish and would propose a kind of joint custody, in which the
hoard—now known to be 363 pieces—would spend five years in New
York and five years in Turkey. The Turks dispute this version, saying that

the offer was to return merely a small portion of the hoard. Around Christmas 1992, the Met's president, William Luers, and its director, Philippe de Montebello, traveled to Turkey to work out this deal with the minister of culture, Fikri Sağlar. But the minister refused to meet with them.

It was game over. Facing an imminent trial, the Met agreed in September 1993 to return the Lydian Hoard, explaining in a press release: "Turkish authorities did provide evidence that most of the material in question may indeed have been removed clandestinely from the tombs in the Usak region, much of it only months before the museum acquired it. And second, we learned through the legal process of discovery that our own records suggested that some museum staff during the 1960s were likely aware, even as they acquired these objects, that their provenance was controversial."

This was an astonishing admission by a major American museum. The Met bought the pieces that within a matter of weeks had gone directly from a group of looters, through middlemen, to the storerooms of the museum. Documents proved that the museum officials knew that these pieces were likely looted and essentially hid them for some twenty years. Nonetheless, the museum resisted Turkey's demands for more than a decade and fought the lawsuit for six years, until finally acknowledging its actions.

Back in Turkey, the triumph was complete. Acar's campaign had been taken up by the local Usak region, and the curator Kazim Akbiyikoglu—now his dear friend and ally—adopted the cause of stopping looting in his region. Acar's slogan, "History is beautiful where it belongs," became a poster that was found in libraries, classrooms, city buildings, and shops. The local Usak newspaper beat the drum for the return of the Lydian Hoard. In October 1993, just a month after the Met's concession, the artifacts arrived amid great celebration. At the arrival in Ankara, President Suleiman Demirel made a speech: when he was originally told that the bill for the American attorneys would be $200,000, he said, he never believed the jewels would come back. Culture officials opened the boxes themselves to admire the golden and silver treasures. And the success of the lawsuit put the issue on the map.

The lawsuit emboldened Turkey to chase other objects that had been taken improperly. The government pursued the auction house Sotheby's for trafficking in looted artifacts and sued for objects being held in Germany and London. It also went after the Telli family and the high-profile defendants who had taken the Elmali Hoard. The Brooklyn Museum had exhibited a garlanded sarcophagus, owned by a private collector, Damon Mezzacappa; Turkey threatened to sue, and the sarcophagus came back. The Getty Museum relinquished a sculpture from a Perge sarcophagus that had been sliced up and sold by looters. A German foundation gave up other portions of the same sculpture. A large bronze Dionysus, in excellent condition, came under scrutiny. The Tellis were involved in this purchase, too; Turkey had it confiscated in Switzerland in 1998 and sued for its return. A British court awarded the statue to Turkey, and it is now on the ground floor of the Ankara museum. Turkey became known as a leader in the battle against looting. By the latter half of the 1990s, the looters were on the defensive. Smugglers looked to work elsewhere. Turkey's lawsuits made a clear statement of its intention to assert the country's cultural rights.

For two years the treasures of the Lydian Hoard were displayed in the Anatolian Civilizations Museum in Ankara, before being transferred in 1995 to Usak, to an aging one-room museum in the town, whose population had grown to one hundred thousand. Not only was the return of the Lydian Hoard a source of undeniable pride in Usak but it also made restitution a popular cause in neighboring communities that once were centers of the ancient world. The mayor of Bergama wrote a book, calling for the return of the Altar of Zeus, and in Antalya, where the lower half of the weary Heracles was displayed, the museum held a cartoon contest for kids about protecting Turkish patrimony. Even the looters came to regret their actions. On a visit to Usak in the late 1990s, Acar took three of the confessed grave robbers to the museum. "They were crying and said, 'How stupid were we. We were idiots,'" he recalled with pride. "We created a consciousness."

But that consciousness didn't translate into broad viewership of the

hoard. In 2006 the top culture official in Usak reported that in the previous five years, only 769 people had visited the museum. That may not be so terribly surprising, since only about seventeen thousand tourists had visited the region in that time, he said. Back in New York, the Met was unimpressed. "Those who've visited those treasures in Turkey is roughly equal to one hour's worth of visitors at the Met," Harold Holzer, the museum's spokesman, remarked dryly.

That was bad enough, but the news soon turned dire. In April 2006 the newspaper *Milliyet* published another scoop on its front page: the masterpiece of the Lydian Hoard, the golden hippocampus, the artifact that now stood as the symbol of Usak, its image published every day on the front page of the local newspaper—was a fake. The real hippocampus had been stolen from the Usak museum and replaced with a counterfeit.

How could such a thing happen? The police examined the hippocampus on display; it was indeed a fake. The original weighed 14.3 grams of gold. The one in the museum was 23.5 grams.

But the bigger bombshell did not drop for several more weeks of investigation, when the Culture Ministry announced that the director of the museum, Kazim Akbiyikoglu—the man who had worked diligently for the return of the hoard to Usak, who had gathered evidence and gone to the United States and examined the hoard on behalf of their return—was suspected in the theft.

Acar's life work had been betrayed. And by a friend. "Of course I was disappointed," said Acar. "I was shocked."

It was not possible, he thought. Kazim Akbiyikoglu was one of the most honest people he knew. Akbiyikoglu's father was a member of parliament, and he himself was one of the most respected archaeologists in Turkey. He had worked tirelessly to accomplish the return of the Lydian Hoard. He believed, like Acar, that history was beautiful where it belonged, near its find site. He was held in the highest regard in Usak. If he knew three honest men in the world, Acar thought, Kazim Akbiyikoglu was one of them.

Acar spoke to Orhan Düzgün, the government representative for monuments and museums. "You can't be right," he told him. "Kazim is an honest man." Düzgün demurred. The evidence pointed to

Akbiyikoglu, he said. Acar refused to accept it. He went on television to defend his friend against the accusations.

For two weeks, Acar couldn't sleep. It was embarrassing enough to Turkey that any of these treasures so hard won, so publicly demanded, would be lost through clumsiness or corruption. Indeed, when the hoard moved to Usak, Acar had begged the ministry to install a proper security system. There was none, or none that worked. But the news about Akbiyikoglu—this was beyond mortification. For twenty years, the curator had fought with local smugglers, trying to expose them, get the police to take notice. The local mafia had been trying to get rid of him. He had devoted night and day to archaeology and the museum. But over time, these efforts had taken a toll on his personal life. Akbiyikoglu was gone a lot from home; his wife, with whom he had two children, had an affair with the mayor of Usak and divorced him, marrying her lover. Akbiyikoglu found himself on his own, at loose ends. His ex-wife and her new husband were involved in a freak traffic accident in 2005, with Akbiyikoglu's two children in the back-seat. The wife and her new husband were killed. After that, Acar lost touch with his old friend until he read the news in the paper. And eventually, the curator's lawyer called to ask: would Acar give a character reference at the trial?

Today, the file of the Lydian treasures takes up four boxes in Acar's office. His friend sits in jail while the trial over the theft stretches on, with no end in sight. The masterpiece of the Lydian Hoard is gone. Acar thinks that perhaps the thieves have melted it down, to destroy the evidence.

History has disappeared, from where it once belonged.

# LOSING LYDIA

KAZIM AKBIYIKOGLU IS A GOOD MAN. ASK ANYONE IN Usak.

Nonetheless, for a year and a half he has sat in jail, a new prison built about five miles outside of town, the town that was his home for more than fifty years, and where he was a celebrated local figure. The white cellblocks are new, and the prisoners can wear their own clothes as they stroll around the exercise yard. But there is nothing save dry scrub and rocks beyond the double barbed-wire fence. The property sits beside an open cesspool whose stench is enough to buckle the knees, though it doesn't seem to deter the roving packs of famished, growling dogs.

This is a state of desolation difficult to fathom for one of Usak's leading lights, a lover of history and of knowledge. The locals who championed Kazim Akbiyikoglu, who followed his career and celebrated his triumphs and accomplishments, are dismayed. Their Kazim must be innocent, they say, citing his Rotary Club award for winning the return of the Karun treasures. He is the only man in Turkey who could read the ancient Lydian alphabet, they boast. "I think he was framed," said Taskin Ozler, one of two brothers who run the local newspaper. "I know him

*Kazim Akbiyikoglu, the director of the Usak Archaeological Museum,
standing in front of the display case with the Lydian treasures, before his
arrest in 2006 for their theft. Two years later, his trial was still under way.*
(Photo by Yavuz Kuşdemir)

since childhood. We saw him every day." Why has all this happened? It's
a curse, they say, the curse of the Lydian Hoard, the same curse that
caused one tomb robber to go blind, another to be paralyzed, and a third
to die in a tractor accident.

"It's not a curse," countered Omer Erbil, the Istanbul-based jour-
nalist who investigated the curator's life and exposed a very human
tale of depradation. "It's just greed."

ON A BLAZING summer day, pedestrians stroll ever so slowly down
the main street of Usak, lined with clothing stores, kabob stands, and

Internet cafés. The cars move slowly, too, slow enough to read the signs placed prominently along the second-story windows for accountants, lawyers, dentists, and doctors.

"Usak, the golden city," says the cover of a promotional leaflet for the town, which features a photograph, on black background, of the contested gold hippocampus. The town has relentlessly tied its name to that of the Lydian Hoard. "Usak is a mysterious place which has witnessed the rise and fall of several civilizations since 6000 years," the leaflet reads. "Throughout the centuries, it has been the crosspoint of roads, climates and lands; and the Silk Road has been the bridge between East and West. The unique, peerless and invaluable treasures of gold art have adorned the necks of its women. . . . Maybe this is why it is a preferred place. Maybe it is the wealth, the Treasure of Croesus." The back flap of the leaflet shows still more pictures of the masterpieces of the collection. "This treasure with its peerless beauty is waiting to be discovered by the visitors," it says.

The main street leads to the town's central plaza, with a massive abstract steel sculpture that sits in front of a simple, three-story courthouse where on the top floor Mehmet Aybek has been prosecuting Kazim Akbiyikoglu for about eight months, a case that began under another prosecutor in July 2006. Aybek has little to say about the proceedings, claiming that the law prohibits him from revealing anything about it, and he says he has no idea when it might end. The trial convenes just one day a month at most, a maddening hallmark of the court systems not just in Turkey but in Greece and Italy, too. In the meantime, the nine other defendants have been released, if not acquitted. Only Akbiyikoglu remains in jail, apparently because of the strength of the evidence against him.

Down a single flight of stairs, Omer Erdogmus, who heads the three-judge panel in the trial, is more open about the case. A pleasant, articulate man in his thirties, he had hoped to have finished by April 2007, "but we don't have the proper documents yet," he said. Apparently the trial has still not established the fact that is the heart of the crime, and which has long been reported by the police and in the media: that the authentic hippocampus was exchanged for a counterfeit. There is no agreement between the prosecution and defense on what

constitutes an authentic photo dated from before the reported swap, and the trial is at a standstill over these attempts to establish an image of the original, versus what is currently displayed at the museum. There was a photo in *Focus* magazine, a defunct Turkish publication, and another in the magazine for Turkish Airlines. Apparently no one can find a copy of *Focus*, and Turkish Airlines has not responded to requests for photos. "We've been trying to reach them, but they haven't answered," said the judge with a sigh. "We lost five or six months over this."

He seems aware, at least vaguely, of how absurd this sounds. A catalog published by the Turkish Ministry of Culture shortly after the return of the Lydian Hoard, titled *Heritage Recovered: The Lydian Treasure*, had the hippocampus splashed on the cover, enlarged several times its actual size, on a black background. He doesn't have an answer as to why that picture is not an acceptable control for establishing theft.

Erdogmus thinks that this case is an international embarrassment for Turkey, but he is determined to see it through. "This is a very important case," he said. "We are talking about a unique piece here. The eyes of the world are on us. Mr. Kazim told me the big challenges he faced while trying to get these treasures back, and the tug-of-war over them. The Americans may be angry at us, because at the end of all this, the treasures were brought back, and Turkey could not protect them." He paused, as if he had thought about these things a great deal but wasn't sure if he should share his conclusions. "We Turks didn't make these treasures," he finally said. "They were made by other civilizations and found in Turkey. It's the heritage of all humanity, the heritage of the whole world. This land belongs to us, but what we find under the soil, if we can't look after it, maybe other people should."

But more people in Usak seem prepared to believe the version put forth by Akbiyikoglu's lawyer, Coskun Mavioglu, a tall, lumbering character with an air-conditioning unit in his office that makes conversation almost inaudible, if comfortable. His client is accused of stealing state property and of committing that crime as a state official; the penalty could be up to seven years in prison. Mavioglu puts forth a novel argument for Akbiyikoglu's innocence: he says that the piece that came back to Turkey from the Met in 1993 may not have been the

*Coskun Mavioglu, the lawyer for Kazim Akbiyikoglu, with the case file.* (Photo ©
Sharon Waxman)

original. When the Met prepared to send back the 363 pieces of the
Lydian Hoard, he explains, "Kazim went there. The pieces were all put
in boxes with the official record and a signature that they'd been re-
ceived. But the pieces weren't weighed or measured. They were just
all put in boxes and handed to Kazim." He reads from Akbiyikoglu's
court testimony: "I wasn't allowed to examine the pieces; I could only
see photocopies of them. I didn't understand this logic at the time, but
the documents showed more pieces than they gave me." Akbiyikoglu
said in his testimony that one piece of the 363 items was missing at the
moment of the handover and "we don't know what happened to that
counterfeit piece. We aren't accusing the Met. But what was delivered
from the United States is now on display in the museum. If I was
given a fake, that's what I'm displaying."

I asked Mavioglu about the reports of Akbiyikoglu's gambling and
womanizing. "I don't want to comment on his private life," said the
lawyer. "I'm only interested in the case file. His statement doesn't reflect

this." He acknowledged that there had been a case against Akbiyikoglu over stolen carpets, but said that all other charges against him had been proven false. "My personal belief is that he's not guilty," said Mavioglu. "I believe he'll be acquitted. But his emotional state is bad. He's very upset. He's not afraid of being judged. But what upsets him most is that he's worked most of his life on this issue, and now he's being charged with a crime."

OMER ERBIL, A thirty-six-year-old investigative journalist at the newspaper *Milliyet* in Istanbul, broke the Usak story. Blond, buff, and with no particular background in art history or archaeology, Erbil—much like Özgen Acar thirty years before him—took an abiding interest in the cultural plunder going on around him because it was a good story. He'd written about smuggling and looters many times before, so he wasn't particularly surprised when a source called him in April 2006 with a tip that something was up at the Usak museum. This time the news was juicy: the seahorse brooch, the hippocampus, the most famous piece among the Karun treasures, had been stolen. Two fakes of the original had been made. One was in the museum, and the second's whereabouts were unknown.

"I didn't go to sleep that night; I went straight to Usak to talk to the museum director," Erbil recalled. The next day he found Kazim Akbiyikoglu excavating at a tumulus outside of town. He asked the museum director: was it true that the golden hippocampus on display at the museum was a fake? The director denied any knowledge.

Four months earlier, the governor of Usak, Kayhan Kavas, had also gotten an anonymous tip, in the form of a letter, with the same information: the brooch at the museum was a fake. The letter demanded an investigation. It so happened that Erbil arrived in Usak at the same time as two inspectors from the Ministry of Culture, who had come to inspect the hippocampus. Akbiyikoglu had told the inspectors that the hippocampus was the authentic original. "I talked to the inspector at the museum, and he said the piece was real," Erbil recalled. "But even I could tell it was a fake. I looked at the original in the picture. I could tell this was cast from a mold, and the braids [of gold] did not look handmade."

At the museum, Erbil noticed other disturbing things. There was a single security guard, who also sold the tickets. There was no alarm system. A camera system had been set up but wasn't working. The case that held the golden brooch, along with two heavy lion-headed arm-bands and golden coins, was a single-pane glass window with a pale blue wooden frame, protected by a simple lock such as one might use on a school locker. It would take no effort at all to jimmy the lock or break the glass. Erbil was amazed at the lax security and told Ak-biyikoglu so.

"In the end, I promised him I wouldn't write about it in the news-paper, because it would be embarrassing to Turkey in the outside world. He was reassured, and so he started talking," Erbil recalled. In bits and pieces, in half-truths and half-lies, the story began to emerge. Akbiyikoglu told Erbil that he had made enemies among antiquities smugglers because of his efforts to end the looting of antiquities sites. It was they who had replaced the original with a fake, he said, work-ing with people inside the museum and then trying to sell the piece in a nearby town using his name.

Erbil asked: did Akbiyikoglu have debts? In response the curator spun a complicated story about a neighbor whose child had cancer, who persuaded him to borrow money from the mafia to pay for an operation. "That's still his story," said Erbil. "It's all made up."

Erbil may not have noticed, but the Croesus treasures had not been well treated by Akbiyikoglu even before the theft. A year earlier, Usak's culture and tourism officials had acknowledged that the treasures had corroded since being at the museum because of a lack of sufficient funds to care for them. The *Zaman* newspaper wrote about the issue in May 2005, accompanied by a picture of a damaged pitcher in a dis-play case. "Many of the pieces have been corroded because they have been stacked one on top of the other in the museum, where no camera has been provided," the article stated, also noting the lack of security.

Was the theft of the hippocampus just one more step in a pattern of neglect and disregard? Akbiyikoglu's personal odyssey seemed somehow to be related to all of this.

Erbil spent ten days digging for facts in Usak, and evidence began to emerge that blew holes in the stories put forth by the curator. The police

investigation turned up similar evidence. The life of the curator—previously respected and admired—had begun to spiral downward after the breakup of his marriage in 1995. He had begun going out at night and gambling heavily. He began dating various women, and both activities led to his running up debts. There were accounts of Akbiyikoglu holding parties at the museum after hours. Erbil learned that Akbiyikoglu had been reprimanded previously by the Culture Ministry for stealing things. A ministry inspector's report revealed that by 2000, Akbiyikoglu had begun selling antique rugs of historic importance—270 of them—from the storehouse of a museum foundation. Then the curator moved on to a handwritten Koran, also sold from the storage rooms, and an ancient electrum coin. Akbiyikoglu had also been accused by the ministry of abetting a theft from the Atatürk Museum and of the partying at the Usak museum.

Meanwhile, the police investigation was under way. The police tapped the curator's phone and recorded 259 telephone conversations between him and local smugglers. In the phone conversations, Akbiyikoglu referred to the original brooch as an "organic tomato" and the fake one as an "inorganic tomato." Two local suspects were recorded talking to buyers in Istanbul, their identities still unknown. They were also heard talking about taking the brooch to Japan and storing it in Bulgaria. Within a month, Akbiyikoglu was arrested, along with nine other people who'd been implicated.

Erbil was not afraid, it turns out, to embarrass Turkey with this story. On the contrary, he thought that the country's museums were neglected and ignored, and the truth needed to emerge. He wrote a series of five articles about the scandal, each revealing a bit more corruption, a bit more disarray. "If I hadn't written this, the Culture Ministry would have covered it up," Erbil said. "My starting point was, if I wrote it, the government would have to do something about the museums."

THE MINISTRY OF Culture in Ankara is an intoxicating blend of East and West, set against the ever-present image of Mustafa Kemal Atatürk, the crusading leader-cum-dictator of the 1920s who aggressively westernized Turkish society after the collapse of the Ottoman

Empire. His image is sculpted, painted, photographed, carved in stone, and otherwise rendered everywhere in the country. A central plaza just a few yards from the ministry building features a towering, Stalin-inspired Atatürk, twenty feet tall, in uniform, astride a horse. Beneath him, bronze soldiers trudge back from battle, and women refugees cower for protection. Ankara itself is a big surprise. It feels a bit like northern Europe, with its neatly paved sidewalks and sophisticated residents who stroll along in jeans and T-shirts. The office buildings, in cubic modernist styles, and the pastel-colored apartment complexes tucked into the cliffsides also lend an unexpectedly European air.

The Culture Ministry is a throwback to Turkey's era of change from Eastern empire to Western-looking republic. Set back from the street, it was the parliament building from the 1920s until the 1960s and is part of a complex of stone buildings in a park. Made of rough-hewn gray stone on the outside, the building is richly appointed in heavy Turkish carpets and dark wood paneling inside. Along the stairway up to the floor of offices (the parliamentary chamber is now a public exhibit) are early-twentieth-century black-and-white photos of women in a harem and men in Western suits and the Turkish fez.

I came here to meet Orhan Düzgün, a Turkish bureaucrat in his early forties with a thick mustache and a tendency to giggle inexplicably. He is the director general of monuments and museums, in charge of all restitution requests and looting investigations. These days his brief is as full as ever. That morning Düzgün had arrived from China, where he was seeking to sign a bilateral agreement over the repatriation of stolen artifacts and cultural heritage. And despite Turkey's twenty-year campaign of lawsuits and successes in repatriation, the undeniable reality is that illegal excavation, looting, and smuggling continue at an alarming rate. Many in Turkey believe that the deterrent effect of the lawsuits from the 1990s has worn off. "We have twenty-three objects from Dubai that arrived last week," Düzgün said, ordering a sheaf of photographs from a secretary.

Düzgün's office is a large, gracefully furnished affair with parquet floors, tall windows that look out onto the park, and no fewer than ten fin-de-siècle crystal chandeliers dotting the ceiling. In the background there is music, a melodious Turkish crooner like one might hear in a

1920s nightclub. Atatürk looms, in a black-and-white photograph, over Düzgün's shoulder. Düzgün explained that seizures like the one in Dubai are a regular occurrence. Customs officials found three tons of antiquities wrapped in carpets and stored in wooden crates, all manner of Roman and Byzantine artifacts. There were several headless statues, including a female nude and a man draped partly in a cloak, a Byzantine bas-relief, and a graceful sculpted female head. None was particularly unique, but they were large and worthy of exhibit. A group of Turkish and Arab smugglers were arrested. Düzgün said he did not know where the antiquities had come from or why they might have ended up in Dubai. But that seems obvious. Few Western museums will now consider acquiring an antiquity without crystal-clear provenance, but looters can still sell to private collectors who don't care about the origin of objects, marking them as having come from a "private collection, Switzerland." In today's world of nouveau riche billionaires, that often means collectors in unregulated countries like China, Russia, or the oil-rich, status-hungry Arab states of the Persian Gulf.

Asked about how well Turkey is able to control the looting and smuggling, Düzgün said that the situation is "getting better." But as he rattled off a series of recent arrests and restitutions—316 pieces from Austria in April, a ring of smugglers in England two weeks earlier, a classical frieze from Idan Province near Izmir—what became clear was not so much how well Turkey has suppressed antiquity smuggling but how smuggling continues virtually unabated.

The continued problem of smuggling has not dampened Düzgün's attempts to secure restitution of some key objects. On the same day as my visit, the German ambassador swept into Düzgün's office with an entourage of four officials to talk about an issue of longtime contention, the Boguzkoy sphinx. The sphinx is in the Berlin Museum and is one of those historic oddities of restitution. Turkey sent the stone sphinxes, along with 10,400 other objects from the Hittite kingdom, to be restored in Germany in 1912. Over the course of the twentieth century, everything was sent back except the lone sphinx.

What is Germany's justification? "I don't know," Düzgün said with his trademark giggle. "We'll ask him now."

But Turkey has given up its campaign of filing lawsuits, after the

heady successes of the 1990s. That isn't all that suprising, given its lack of resources earmarked for museums and the preservation of ancient culture. Under the conservative government of the Islamic Justice and Development Party, the culture budgets have been diminishing or stagnating. The government runs ninety-three museums and more than 140 archaeological sites, all managed by the central government. But in 2007 only $66 million (two-tenths of 1 percent) was allotted from the national budget for museum costs, archaeological excavations, and salaries of those who maintain the collections and safeguard the buildings and sites—a pittance when one considers how thin it has to be spread. The *New York Times* reported that while seventy-eight of Turkey's ninety-three museums have electronic security systems, many of these do not work. Accurate museum inventories are virtually nonexistent, making it close to impossible to track objects individually. Pieces go missing from museums and storerooms—just as in Egypt— more frequently than might be supposed. In 2006 forty-three objects from the Topkapi Palace Museum went missing. "Thieves have already made it into most of the museums in Turkey and stolen numerous invaluable pieces, which did not receive as much media attention as the objects from the Lydian Hoard collection did—because they were not returned from the U.S.," said Ahmed Tirpan, the chairman of the country's archaeology association. The minister of culture, Atilla Koç, confirmed this view, telling the *Turkish Daily News* in 2006 that he had ordered an investigation into thirty-two public museums and "would not be surprised if every one of them reported missing pieces." And like Egypt, Turkey is overwhelmed by the amount of cultural patrimony in its borders. This results in a serious disconnect between the demand for the return of objects from overseas and the realities of conservation and security for the antiquities already in the country.

But it is no stretch to understand why Turkey has tapered off its aggressive campaign for the return of ancient artifacts. The country's interest has wandered elsewhere. The focus of the current government, led by Recep Tayyip Erdogan, a politician who comes from the Islamic Justice and Development Party, is hell-bent on the economic development of the country. But this has also meant a palpable neglect felt throughout the museum system, including the partial closure

of the Istanbul museum. Though ticket revenues at museums go directly to the central government, the individual museum budgets are not affected by the number of tickets sold. And there are, so far, no initiatives, as in Egypt, to raise money by loaning masterpieces for exhibit abroad and negotiating for a portion of the ticket revenues. Still, it is not hard to imagine that the embarrassing theft of the masterpiece of the Lydian Hoard has also sapped the ministry's enthusiasm to pursue looted cultural objects abroad. The journalist Özgen Acar is certain that this is true. "The Western countries started with their sneaky smiles—'You see what happens?'" he lamented. "So aggressive moves have been suspended."

If it is true that Turkey does not take adequate care of its treasures, does not allocate critical funding, does not promote its museums to the public and make its ancient history a living part of the national story—what Zahi Hawass has been trying so hard to do in Egypt—then it is legitimate to question whether antiquities plundered many years ago from his country ought to be returned at all. Perhaps they should be returned. But perhaps they should not be returned just yet.

I asked Düzgün about the theft of the Lydian treasure from the Usak museum. "This is a terrible story," he acknowledged. "But it is not common." The theft occurred in May or June 2005, a few months before Düzgün was appointed to his position. Since the theft, he said, electronic security has been added to forty-six museums, and nine hundred new museum guards have been hired, figures that seemed to contradict what Atilla Koç had said on the record.

But mainly, Düzgün was struck by the human drama of the Usak affair. It was an inside job, he said, by the museum director and various cohorts. "It's a tragedy," he said. "It's human weakness." There were accounts of the museum director becoming involved with women, whispers of his having gambling debts. "But this is not just a story in a museum," said Düzgün. "This could happen to a bank director, to anyone, in any country."

THE OZLER BROTHERS, Taskin and Coskun, aged sixty-five and sixty-nine, have known Kazim Akbiyikoglu since he was a child. They knew his father, a member of parliament. They have been journalists

for forty years and were around when the tumuli were first excavated in 1966. They were there when the Lydian Hoard came back to Usak in 1995. And they covered it all for the *Usak Haber* (the Usak News). The brothers work out of a small shopfront at the intersection of two pedestrian streets in central Usak, a few steps from the lawyer Mavioglu's office and a few more steps away from the Usak museum. They have little doubt that Akbiyikoglu is innocent. "Interesting, isn't it, that a year after the opening of the trial, they still can't distinguish the original from the fake," Coskun mused, as his brother picked up a squawk box dangling from a wire to order tea, pronto, presumably from the head office. "I think this is all being done to take revenge" for Akbiyikoglu's efforts against local smugglers, he added, citing a case where Akbiyikoglu found out that a mosaic floor near Usak had been stolen and exposed the theft just before the piece was about to be exported.

But the Ozlers, too, are wary of the curse of the Karun treasures. They know of seventeen or eighteen people who have suffered ill fates in the wake of their contact with it. One person who opened a tumulus had his throat cut in an argument with his son over the treasures. The son was later shot. Then three others died: one in a tractor accident, one went blind and died paralyzed, the third was a blacksmith who removed a metal seal on the tomb and died soon after. Akbiyikoglu's troubles began once he came into contact with the Lydian Hoard, said Coskun. Not only did he lose his wife, who then died in an accident, but one of his brothers committed suicide.

"We don't accept" that Kazim was depressed in his personal life, said Coskun, adding, "He may have been drinking alcohol, but he wasn't gambling." The brothers believe that Akbiyikoglu was framed by a powerful real estate group that had wanted to open a gold mine near Usak but was blocked by the curator, who was trying to protect the antiquities in the area.

"I used to go to the museum every week before this news happened," said Coskun. "I don't go anymore. Kazim knew everything about it. Now everything's changed. There's no one there to tell me about the museum now." And the Ozlers say the theft has halted plans to build a new museum in Usak. The museum has about forty

thousand pieces, the vast majority in its storerooms. But since the scandal, the Ministry of Culture reallocated the money that was supposed to go to build a new museum in Usak. "The city needs a museum as big as Antalya," said Coskun, referring to the archaeologically rich museum in the coastal city to the south. "We want this case finished so we can rescue our reputation."

In February 2009, the case was finally finished. Kazim Akbiyikoglu was sentenced to twelve years and eleven months in prison "for dereliction of duty and misappropriation of an antique brooch that went missing in 2006," according to the local newspaper report of the sentencing. One accomplice received a similar sentence, while eight others were sentenced to jail terms from six years to ten months. The brooch has never been recovered.

THE USAK ARCHAEOLOGICAL Museum is a single-story concrete block structure faded to a dull blue, situated on a three-sided corner just behind city hall. From its hand-lettered sign above the door to the clutter of antiquities lying about the garden, the museum is simple as can be, yet still utterly disorganized. On the lawn, which surrounds the building on three sides, bas-reliefs lean up against the building, three and four deep. Statuary and pieces of pillars are stacked in a corner and piled against one another in the back of the building. Inside the entrance to the left of the door, there are more ancient stone pieces, fragments of buildings and statues and monuments piled in a corner, including an Islamic carving, a bit of Greek column, a Hittite head, and assorted pediments. The building is exposed on all sides, encircled by a fence and a gate, though the gate isn't locked and the fence isn't high. Anyone could easily hop over and, with a bit of effort, walk off with the antiquities piled outside. And the vast majority of the collection is in storage. "The museum is still easy to break into, even now," said Coskun Ozler as he walked into the building. The acting director declined to be interviewed but walked through the galleries nervously, sighing deeply at the sight of a journalist.

The galleries themselves are unadorned, with fluorescent lighting, perhaps one thousand square feet of space divided up into a few interconnected chambers. Signs in English and Turkish explain the history

of Lydian art, which flourished under King Croesus. The Lydians had their own language, art, and culture, and after the kingdom was conquered by the Persians in the fifth century BC, it was Lydian craftsmen who built the palace at Suse for the Persian king Darius. And the presence of the Karun treasures is a source of evident pride. "The safe return of the Lydian treasures on exhibit now is a sign of modern international conscience and justice in preserving ancient art in its original context and homeland," reads one plaque.

Behind wall-length windows, the artifacts reflect the mystical beauty of Lydian handiwork, with the tiniest attention to detail and the most skillful ability to work in gold and silver. A series of silver bowls are worked in gold on the underside, ribbed like the ridges of a pumpkin. There are golden perfume holders and incense burners, delicate earrings and necklaces any woman would wear today, in addition to the massive gold necklace heavy with golden acorns and inlaid with precious stones. Beside the hippocampus, the other most famous piece is presented here, the silver wine pitcher, with a boy arching backward as the handle.

A security camera—apparently functional—is trained on the vitrine holding the golden seahorse, which is unimaginably tiny in real life. But as Erbil noted, nothing more than a simple lock protects the case. The security system is about as Bronze Age as the artifacts. To the upper-left-hand corner of the display a police seal is plastered over the seam where the glass frame opens, to indicate tampering, with a hook on each side and a wire twisting them closed. But the purpose of this is unclear, since the hippocampus is displayed as if it is the original. I am astonished to note no sign of the scandal that has the museum in upheaval. "Brooch with pendants," says a small sign beside the seahorse, on an azure fabric background. There is no explanation to suggest that the one hanging here is a fake or contested in any way. And I am mystified by a noticeable difference between the one here and the original. No one can seem to explain why the hippocampus in the museum has a smooth spike of gold emerging from the end of one of the hanging braids, with a red ornament in it. There is no such detail on previously published images of the artifact, which instead have a blue or greenish ornament at the bottom of two of the hanging braids. This is true for the image on the cover of the promotional brochure, on the cover of the Ministry of

*The display case at the Usak museum from where the hippocampus was taken. The case is secured by a simple lock (see close-up at right), and although there is a police seal directly below the lock, no signage indicates that the original was stolen or that the object displayed is a counterfeit.* (Photos © Sharon Waxman)

Culture catalog, and in a museum gift shop. It is equally true for a large poster of the hippocampus that hangs just a few feet away, on the wall of the gallery, in a frame with cracked glass. "Karun Hazinesi, 19-11-93," reads the poster, in commemoration of the treasure's return to Turkey.

Omer Erbil does not believe that the golden brooch was melted down to eliminate the evidence. He is writing a book and a screenplay about the theft, and he has continued to chase the piece. Erbil cites anonymous sources among the police and smugglers who tell him that a sale is still in the works. In the fall of 2005 there was an initial meeting at an Istanbul hotel to try to arrange a sale of the hippocampus. At this first meeting, the offer was $300,000. But the sellers wanted $1.5 million. (The hotel's owner testified at trial that the demand was $3 million, but Erbil's sources say otherwise.) The smugglers from Usak, members of the local gambling mafia to whom Akbiyikoglu owed money, were relative amateurs; the sellers were not. Erbil's sources tell him that in October 2005 there was a second meeting, this time at the Majestic Hotel in Istanbul. The hippocampus—the authentic one—was produced at the meeting for verification. Guns were drawn, and the piece was stolen by the erstwhile buyers. Police raided the hotel

within minutes of the meeting and arrested some of the criminals but did not nab the hippocampus. Erbil believes the piece is still in Istanbul. "I believe it will come back to Usak someday," he says. "I am as sure that it still exists as I am of my own name."

In the wake of the scandal, Turkey has taken measures to improve security in all its museums. There are plans to conduct inventories, which until now have been conspicuously lacking in a country with such vast cultural wealth. But it cannot be said that the Usak museum is secure; even a cursory look makes this fact evident. Still, Usak's governor, Kayhan Kavas, stated that he will not consider the transfer of the Lydian Hoard to any other museum. "Our museum possesses comprehensive security measures and has never experienced such a thing before," he said in 2006. And there is no denying that even if the Usak museum had a better security system in place, that would not have prevented what appears to have been an inside job.

Still, on one thing both Omer Erbil and Özgen Acar, investigating journalists in different decades with different perspectives, agree. Neither regrets that the Met was forced to return the Lydian Hoard. Even with the theft, for both of them, it was important to establish the principle that buying looted art cannot be tolerated. "Usak does not reflect the general situation in Turkey," said Erbil. "Just because a very bad thing happened, this doesn't mean that the general principle is wrong. No one can guarantee anything. You can't protect things 100 percent. Yes, Turkey did not give enough importance to its museum. But now the government is improving the museums and raising salaries. All of those Western countries that see themselves as developed should stop buying antiquities."

Acar is even more convinced of his cause. "All our operations to retrieve objects started with this one. Many other items have come back because of it," he said. To him, the principle is more important than any one piece. The rich Western countries must help the poorer developing nations. It is the only way, he believes, to protect what is the cultural patrimony of the world. The money that the Met spent to buy the Lydian Hoard would be better used as a gift to Turkey to protect its treasures. "Isn't it better to make better museums in Turkey with $1.7 million, the same amount of money?" he asked. "The museums

here are not good. With $4 per capita income, you cannot do it. Better support the poor counties, so that Turkey can loan it to you."

The hippocampus lost, the embarrassment to the country, the tragedy for his friend Kazim—"I don't regret it," said Acar. "I'd do it again."

STRIDING INTO THE sultan's living quarters at the Topkapi Palace, Ilber Ortayli, the director of the palace museum and one of Turkey's most recognizable cultural figures, feels right at home. This is his office, in the heart of the sultan's lair, set high on a ridge overlooking the Bosphorus, with history staring out from every vitrine, every molding, every window clasp. Topkapi, the magnificent complex of buildings that hosted one Ottoman dynasty after another, adorned with opulent furniture, luxurious fabrics, and legendary jewels, vividly evokes the past. Out in the courtyard, hundreds of camera-toting tourists wander about, awestruck, slack-jawed. They are from every country, every ethnicity: Gulf Arab families, the husband in madras shorts and the wives cloaked in black from head to toe, two eyes peeking through their niqab; curious Chinese, following a flag-bearing leader; an African family in brightly colored fabric; Italians and French and Germans and Swedes.

Ortayli, a big bear of a man in a checked shirt and trousers, with a portly midsection and an imperious tone, ignores them all as he barrels through the sculpted doorway and across the mosaic tile floor. He is immediately surrounded by assistants, who lead in two security guards about to take retirement. They have come for a handshake and a fancy chocolate, which he duly provides. They do not, however, interrupt the curator's focus on the subject at hand: looted antiquities. He has a clear view on all this: What was found in Turkey belongs in Turkey. The West has no business meddling in ancient affairs, unless it is here to make amends or lend a hand. In this paradigm, there are good guys and bad guys, and Ortayli has no doubt at all which is which.

"Don't they have any honest exhibition places in the U.S.? I'd say the Smithsonian," he says. They are the good guys. The Metropolitan Museum of Art? Bad guys. "The Met is an awful place," he says, pronouncing the word *owe-ful*. "They buy everything possible." As far as he is

concerned, the Met is unrepentant and unchanged in its attitude from the 1960s, when the museum surreptitiously purchased the Lydian Hoard. Turkey had a chance to bring the Met to heel, in his view, but it blinked. "The greatest mistake Turkey made was twenty years ago they settled over the Croesus treasure," he pronounces. "I don't know why they came to a compromise. If they would have lost it legally, I trust the U.S. courts. And probably smuggling would have been stopped."

He sits down to his cup of tea and cookie, as his reading glasses slide down his nose and dangle on the tip. "The Louvre is not a good one," he continues. "They have pieces, stolen ones." He is referring to the dispute over mosaic tiles from the tomb of Selim II, at the Hagia Sophia mausoleum, now at the Louvre. The French museum says they were bought legally from a restorer, who was given the tiles as a gift for restoring the other pieces of the mosaic. This is preposterous, Ortayli snorts. Who on earth would believe that Turkey would allow the tiles of the mausoleum of a hallowed leader, in a mosque, to be defaced in this way? Absurd. "The Turkish government paid a man to restore it, the sultan's dentist. He stole the pieces," he says and screws his face up as if he were sucking on a lemon. "Can you imagine?" he charges. "Can you believe such a childish, stupid story? A liar should be fantastic. This is childish." And Henri Loyrette, the director of the Louvre? "He's a French intellectual," he says with derision. "He has been once to Istanbul. Once to Topkapi. Stupid man. This is an intellectual? So. Write: 'the distinguished intellectual of our era.'" And he bursts out laughing, a guttural, coughing sound like the starting of a rusty engine.

What about the Germans? The sphinx of Boguzkoy must come back to Turkey, he says. This is not like the Altar of Zeus from Bergama, which is also in Berlin, taken wholesale but with Turkey's permission. The sphinx is not up for discussion. "It's a clearly signed contract. So give it back. They won't," he says, sitting back in his chair. The glasses, having slipped from his upper lip, to his lower lip, to his chin, have finally succumbed to gravity and now hang from a lanyard on his chest. "Interesting: 'You hold my emerald until after the wedding; then, can I have it back?' They say, 'We keep it better.'" A pause. "Such shameless people. Germans."

Back to the Met. "Ooooh. The Met, they are wonderful smugglers.

It's a national shame." I point out that the matter of the Lydian Hoard was settled long ago and that the Met may have improved its practices since then. After all, the museum did finally give the hoard back. Ortayli rejects this possibility out of hand. "Now they went into the monastery?" he retorts. "No, no, no. They should be pioneers. They should change their ways. They have enough shame. No one asks how many black excavations they make."

Ortayli is full of accusations. Some are valid and well known; others seem utterly fantastic. He says he feels "owe-ful" about the theft of the gold hippocampus in the Usak museum. "Write it," he says. The theft has led him to wonder if the objects in provincial museums ought to be brought under central control. That would not necessarily help, however, since the Culture Ministry has acknowledged that forty-three pieces have gone missing from Topkapi in recent years. Then Ortayli suggests that the Met might have been involved in the theft of the hippocampus from Usak. "It was probably stolen by them, during the transfer" back to Turkey, he says. "There are a lot of rumors. Put a question mark."

But even if it was stolen in Turkey, "do not use this as an excuse: 'those primitive bastard animals,'" he warns. "We can take care of our things, to some extent. We are trying to clean up. But this is like the Hitlerians accusing the French and the English and the Jews."

I confess that I don't follow that logic. The Turks were victimized because the Lydian treasure was stolen from the Usak museum? "It's a scandal," he says, calming. "We couldn't keep it well. But that is not a reason. That's very, very arrogant ideology of the nineteenth century, especially the Germans. But now people have changed. Everyone has wonderful archaeologists, art historians. Why still keep these ideas?"

To Ortayli, it is a minor point whether Turkey can properly care for its treasures. The sins of the past must be expiated, and the West has done little to lose its air of superiority. He flips his hands toward his visitor with a whimsical air: dismissed. "Try not to be arrogant," he says, grasping my shoulders as he guides me toward the door. "Everyone has a country. But the world is ours." He turns on his heel. "Oh, I'm so tired now." And he kicks me out.

# THE MET

O<small>N A BRISK</small> D<small>ECEMBER NIGHT IN</small> 2006, <small>THE CAREFULLY</small> groomed and heavily jeweled cultural patrons of Manhattan gathered at the Grace Rainey Rogers Auditorium, deep within the Metropolitan Museum of Art along Fifth Avenue. They had come to hear a lecture by the museum's formidable director, Philippe de Montebello, a Frenchman turned American with an ancestry that dated back to Napoleon and the longest-serving leader of the Met since its creation.

As they gathered, it was a sea of white hair and fur coats, men with walking canes, rouged women in high heels and elegant hats, air kisses and familiar faces, the upper crust of the city who numbered among the museum's most important donors. In this city of stunning diversity, few if any nonwhite faces could be seen in the audience of several hundred. And among them were museum trustees, including Shelby White, the widow of the Oppenheimer Fund magnate Leon Levy and now one of the country's leading antiquities collectors. A recent article in the *New York Times* had reported an accusation against White by the government of Italy, contending that she owned many antiquities that had been looted from the country. Italy, it was clear, was feeling

powerful, having just weeks earlier concluded an agreement with the Met for return of the museum's most valuable ancient Greek vase, the Euphronios krater, which had been taken improperly from the country more than thirty years before. Now it wanted White to relinquish her allegedly tainted works.

On this evening, the tangled loyalties and shifting norms in this world of collecting and exhibiting and owning were not far away. Just a few hundred yards from the lecture hall, in the very same building, workmen had finished their labors for the day on the new Leon Levy and Shelby White Greek and Roman Hall, a soaring new space built to house many of the museum's antiquities and to honor two of its greatest patrons. The hall would open in April 2007.

Mounting the podium, de Montebello didn't waste a minute. "A flurry of newspaper articles of late have been suggesting not if but when will museums be returning antiquities from their collections," he began in a decisive tone, dispensing with small talk, warm-up humor, or even just "Good evening."

"It is as if antiquities are no longer the patrimony of all mankind, but of someone else's particular heritage," he stated. "Those same people might rue the outcome of pushing this argument ad absurdum—if museums were emptied of their artifacts."

For an hour, he lamented the fact that museums had been far too slow to react to the rising tide of "politically correct" "nationalist ideology" that had been taking hold when it came to the question of cultural property. People should not so "blithely" accept the idea that cultural objects belong in the countries where they happen to have been dug up, he said.

As a slide projector showed images of schoolchildren gathered around exhibits at the Met, he reminded the crowd that museums were born of the Enlightenment, of humanist principles that exalted human understanding and knowledge, the notion that museums should house the essence of all human civilization and achievement for the purpose of study and greater human progress. He used noble words— and angry ones. "The new chauvinism does a great disservice to mankind," he observed. Should that approach have been taken two hundred years ago, "our knowledge of the ancient past would still be

Dr. Zahi Hawass, the chairman of Egypt's Supreme Council of Antiquities. His high-profile campaign to force the world's great museums to return their pharaonic treasures to Egypt has won him as many enemies as admirers. (Photograph by Sandro Vannini)

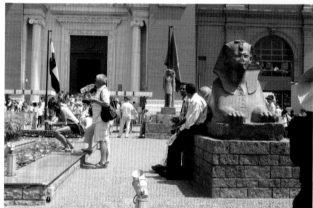

The Egyptian Museum in Cairo. Tourists and locals climb on the antiquities in the garden, undisturbed. (Photograph © Sharon Waxman)

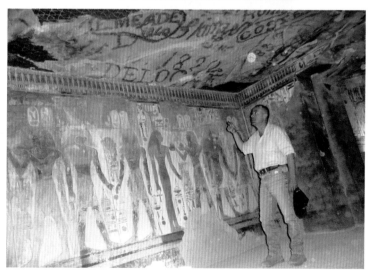

The archaeologist Mustafa Wazery points to graffiti left by nineteenth-century European visitors to the tomb of the pharaoh Seti I in the Valley of the Kings. (Photograph © Sharon Waxman)

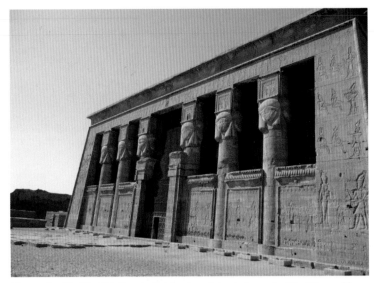

*The soaring Temple of Hathor, in Denderah, a shrine to the ancient Egyptian goddess of music and dance.* (PHOTOGRAPH © SHARON WAXMAN)

*A blackened plaster replica of the zodiac ceiling in the Temple of Hathor. The original was removed with explosives in 1821 by agents for the collector Sebastien Louis Saulnier, who sold it to King Louis XVIII. Today it is in the Louvre.* (PHOTOGRAPH © SHARON WAXMAN)

A rare photo of the interior of the tomb of Amenophis III, which is not open to the public. Looters in the nineteenth century cut out the head of the pharaoh in three of the murals; here the pharaoh is flanked by gods. (PHOTOGRAPH © SHARON WAXMAN)

The missing head of Amenophis III, which now resides in the Louvre. (PHOTOGRAPH COURTESY OF ZAHI HAWASS)

The hippocampus, the masterpiece of the Lydian Hoard from the time of King Croesus, pictured on the cover of a promotional brochure for the city of Usak. (COLLECTION OF THE AUTHOR)

In 2006, it was discovered that the hippocampus had been stolen from its case and replaced with a fake. This counterfeit is now on display at the Usak museum. (PHOTOGRAPH © SHARON WAXMAN)

The column from the Temple of Artemis at Sardis, at the Metropolitan Museum of Art in New York. Taken by American archaeologists in 1922 during a Greek-Turkish war, it was allowed to remain at the Met in a negotiated settlement with Turkey. (THE METROPOLITAN MUSEUM OF ART, GIFT OF THE AMERICAN SOCIETY FOR THE EXCAVATION OF SARDIS, 1926 [26.59.1], IMAGE © THE METROPOLITAN MUSEUM OF ART)

The Euphronios krater, depicting the dying Sarpedon. Acquired by the Metropolitan Museum of Art in 1972, it was later revealed as having been excavated illegally from the Etruscan necropolis at Cerveteri, north of Rome. After years of negotiations, it was returned to Italy in 2008.
(IMAGE © THE METROPOLITAN MUSEUM OF ART, COURTESY OF THE MINISTRY OF CULTURE OF THE REPUBLIC OF ITALY)

The Leon Levy and Shelby White Court is the centerpiece of the new Greek and Roman galleries at the Metropolitan Museum of Art, which opened in April 2007.
(PHOTOGRAPH © SHARON WAXMAN)

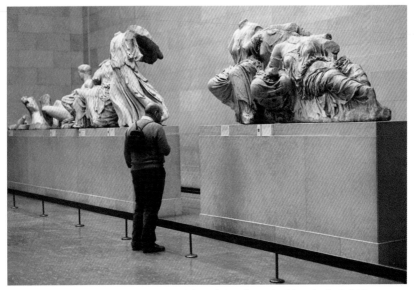

The Elgin Marbles, sculptures removed from the Parthenon in Athens by the British nobleman and diplomat Lord Elgin in the early nineteenth century, on display at the British Museum in London. (PHOTOGRAPH BY GRAHAM BARCLAY/GETTY IMAGES)

The archaeologist Dimitrios Pandermalis (in a hard hat), on the top floor of the New Acropolis Museum, which will house about half of the sculptures from the Parthenon, visible atop the Acropolis in the background. (PHOTOGRAPH © SHARON WAXMAN)

The cover of an outdated catalog of the antiquities collection at the J. Paul Getty Museum in Los Angeles. It shows detail of an exquisite Macedonian gold wreath, which was said to have belonged to Philip II, the father of Alexander the Great.
(COLLECTION OF THE AUTHOR)

The Getty wreath was returned to Greece in March 2007. It is here shown on display at the National Archaeological Museum in Athens. (PHOTOGRAPH © SHARON WAXMAN)

Ephebe of Marathon, or Marathon Boy, a celebrated bronze at the Praxiteles exhibit at the National Archaeological Museum in Athens. In 2007 Greece rejected the Louvre's request for a loan of the sculpture, deciding that it "cannot leave the territory." (PHOTOGRAPH © SHARON WAXMAN)

*The antiquities dealer Roger Khawam (left) and his son, Bertrand, at their shop at the Palais Royal in Paris.* (PHOTOGRAPH COURTESY OF ROGER AND BERTRAND KHAWAM)

*The Getty villa in Malibu, north of Los Angeles. It was here that so many spectacular works of ancient art were displayed, only to be repatriated to Greece and Italy when their dubious provenance was discovered.* (PHOTOGRAPH © 2006 J. PAUL GETTY TRUST)

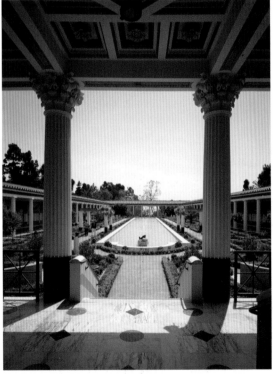

in its infancy," he said. "And the notion of the encyclopaedic museum would be nonexistent.

"The whole debate saddens me," he said. "We believed that others agreed that museums with encyclopaedic collections are a way to understand the whole of human history in a cross-cultural environment. We remain puzzled that what's being assailed, that what has nourished the curiosity and soul of art lovers, could be given up so easily. Where are the letters to the editor? Where are the op-eds?"

And he saved his harshest words for archaeologists, who are now demanding clear provenance before publishing work about a new object. The Met remains one of the few major museums that continues to collect antiquities that lack a clear provenance; both the Getty Museum and the British Museum have adopted policies restricting their acquisitions to objects with clear lines of ownership. The museum also attracts criticism for authenticating, and displaying, privately owned works by donors whose objects do not have provenance, such as those belonging to White or to another board member, the hedge fund manager Michael Steinhardt.

But works without provenance are not without merit, he argued, chastising archaeologists for showing "a shocking level of antagonism" to the artifacts themselves, as well as little concern for the public's desire to see them, in supporting the efforts of Italy to force the return of artifacts.

Philippe de Montebello was preaching to the choir, to be sure. The crowd gasped audibly when he mentioned that only 769 people had visited the Lydian Hoard in the first five years after the Met returned the objects to Turkey. And, as if in church and listening to a sermon, they murmured their assent when he invoked the idea of the "universal museum" and how it reminds us to have humility. Because to consider Western culture to be primary, he cautioned, is to be "inexcusably arrogant."

The next day, a freezing wind blew into the city, whipping mercilessly at early morning visitors to the Met, as they fought their way across the esplanade to the steps. Outside de Montebello's office, three assistants answered phones ("Nan Kempner's sister-in-law? You got

it?" one chattered), and a Claude Monet landscape—a minor one, apparently—hung, barely noticed, in the waiting area.

Inside, before a sweeping view of Central Park, de Montebello sat at his conference table beneath a dark landscape painting by Claude Lorrain and barely paused to pick up where he left off the night before. "What makes me angry is that people don't think," he said. His dark hair was slicked tight against his head, and he wore a blue blazer over a V-neck sweater against the cold. Tall and distinguished, in his early seventies, with wire-rimmed glasses and a Continental accent, de Montebello has a gentle, avuncular manner. He also exudes an authoritative air, which comes in part from his aristocratic background and which some would certainly mistake for arrogance. The de Montebello family received its title for the valiant military service of an ancestor in Napoleon's victorious battle in the Italian town of the same name; Jean Lannes, the general, was made a duke and a marshal of France. Count Roger Lannes de Montebello, Philippe's father, was a portrait painter, an art critic, and a member of the French Resistance during World War II. His mother, Germaine Wiener de Croisset, was a descendant of the Marquis de Sade. Philippe grew up in a large villa in Grasse, a perfume-making town in southern France. The family also owned beautiful art in Paris, and one relative had a stunning private collection—works by Rubens, Delacroix, Goya, along with Picasso and Ernst. The young Philippe met Picasso at age thirteen or fourteen at a bullfight in Nîmes. But soon the family's fortunes turned. The de Montebellos were financially devastated in the war, and to make a living they turned to a newfangled business—developing a form of three-dimensional photography—a project that brought Roger de Montebello to New York. The rest of the family moved to Canada to await visas, which finally came through in 1951.

From that time, Philippe de Montebello stayed in America. The title was not to be his; the Duke de Montebello was his older brother. He needed his own path and found a calling in the study of fine arts. He attended Harvard to study art history and went on to seek a higher degree at New York University, when in 1963 he was offered a spot as an assistant in the Met's Department of European Paintings. Except

for four years at the Houston Museum of Fine Arts, de Montebello has spent his entire career at the Met, rising to the director's post in 1977, at the age of forty-one.

By most measures, de Montebello's tenure at the Met has been a resounding success. He nearly doubled the size of the museum and throughout has remained its chief curator. As a credo, he has said: "I don't like controversy. I like conciliation. I like people working together." In many ways, he *is* the museum, the voice that visitors hear over the headphones for the recorded audioguides—in English, French, Italian, Spanish, and German. He told one interviewer that this was exactly true: "The institution and I have totally merged. I am the Met. The Met is me." But now, after thirty years of distinguished service, after three decades of holding the line of academic seriousness in the age of goofy and sensationalist rivals, de Montebello found himself having to defend his very purpose and the mission of the institution he led for so long. Suddenly he had to explain to people why the Met was the hero, not the villain, in the narrative of the preservation of world history, art, and culture. The restitution debate "is pure politics," he said in 2003. "But we've lost, they've won, and the public has lost as a consequence." Five years later, he would announce his retirement, knowing that the battle over restitution will be not only part of his swan song but also a central preoccupation for his successor.

In his office, de Montebello plumbed the depths of his frustration. "They just have knee-jerk reactions," he said. "They don't say, 'What's the context?' Israel jailed an archaeologist for publishing the Judas scroll. What about the Dead Sea scrolls? Today no archaeologist would dare study them. They were found by Bedouins and passed around until they reached a dealer. They technically are without provenance."

The stricter policies are a blow to scholarship, and to art, he said. People who find artifacts will be afraid to bring them forward. And they'll never admit where something came from, whether looted or not, for fear of getting into trouble with the police. He gave an example. Two identical lions, exquisite examples of ancient Assyrian art, were bought in 1948, one by the Met, the other by the Louvre. The lions were bought from a dealer who said they were excavated at Tell

*Philippe de Montebello, the director of the Metropolitan Museum of Art.* (Photo by Fred R. Conrad/The New York Times)

Mozan, a village in Syria. Working backward, archaeologists sought out the village and were able to locate the ancient city of Urkesh. Nowadays, this wouldn't happen, he said. "The paradox of this strictness is that the information vital to archaeology is going to be lost. Now no dealer will admit that something was dug up in Tell Mozan," he said, quickly adding, "Not that that's a good excuse to go loot."

Italy and Greece impose absurd double standards in their quest to reclaim treasures, he pointed out. "They use antiquities as a political pawn. The United States supports Italy, because what they want is permission to fly over Italy en route to the Middle East." In the 1950s, 1960s, and 1970s, he said, everyone was buying from crooked dealers: "The British Museum, the Louvre, Munich—they bought as much as we did. There's clearly an anti-Americanism at work, along with the friendliness of American law. It's outrageous." He mentioned one

dealer, Robert Hecht, who had been tried by Italy on looting charges. "Hecht sold to the Ashmolean in Oxford, to Basel, Copenhagen, Berlin," he said. "And, I suspect, to Italian museums.

"The whole thing is nonsense," he went on. "And it's not as if these countries are bereft. Do you have some sense that the Egyptians cannot appreciate their pharaonic past? They cannot claim they have been denuded of their past." And as for the Rosetta Stone, the British Museum should not give it back. "Hawass should be reminded that the people who decoded this object are French, so he owes them a debt of gratitude," he said. "Repatriation would be a purely political and ideological act." And anyway, he added, "it wouldn't go back to Rosetta." As for the new museum being built at the pyramids, de Montebello rolled his eyes. "No comment," he said. "Will the pyramids look good surrounded by sand? Or by buildings?"

To de Montebello, the problem over unprovenanced antiquities has been addressed by Western museums. The chance of a museum acquiring a looted object today, he said, is "practically zero." Thus Western museums can no longer be considered a factor in the looting of sites. Still, the looting goes on.

PHILIPPE DE MONTEBELLO's confidence and sense of accomplishment contrasts sharply with the view held in countries that were once the great powers of the ancient world. There, the Met has a surprisingly poor reputation, and its collecting policies and resistance to challenges to provenance have left a bitter taste in the mouths of scholars and curators with whom the museum ought to be on good terms.

The view from Greece and Turkey is particularly derisive. Alexander Mantis, the director of the Acropolis and the man in charge of archaeology in the entire Athens region, was low-key when asked about the Elgin Marbles, the sculptures held at the British Museum for the past two centuries. But he did not compliment the Met. When asked what Greece's relationship is with this great museum, he laughed and treated it as if it were some back-alley dealer. "They have many good things," he said. "Some it's obvious were stolen. You can recognize the origin in many pieces—the style, the Parian marble. You can smell that it's from Greece. The difference with them and us is that they have

stolen or bought their things, where we have excavated them." When Mantis said "stolen," he meant acquired. "Stolen or bought—it's the same thing," he said. Similar sentiments were offered by Ilber Ortayli, the curator of Turkey's majestic Topkapi Museum, who huffed and puffed when asked about the Met, calling the curators "wonderful smugglers." Colin Renfrew, a British restitution activist, derided de Montebello as "a hypocrite" and worse. And finally there is Oscar White Muscarella, a dissident curator within the Met, who refers to the Greek and Roman galleries as "the Temple of Plunder," so filled with stolen artworks does he consider them to be.

But the Met still wins the admiration of many archaeologists for its excavations, scholarship, and conservation support, despite the acquisitions policy. "It is absolutely true" that the Met has continued its dubious policies, said Betsy Bryan, the Egyptologist from Johns Hopkins, over her dinner with Zahi Hawass. "But what Philippe de Montebello represents is way more than that. He's someone who continues to ask the question: what do you do with what you have?" To her, the question over what future there will be for museums is just as important as the question of restitution and proper acquisition. American museums are in crisis, in her view, and the Met is one of the few institutions that has a serious mission and pursues it vigorously. "U.S. museums have lost their way. Philippe de Montebello cares about learning," she went on. "Most museums in the U.S. are just entertainment centers— Brooklyn is a sad but obvious choice. The shows are not even geared to research into its own collection, but what will get people through the door. . . . So they bring in outside exhibits on *Star Wars* and robots. When you do an exhibit, the test is whether it will challenge a twelve-year-old. You can't write a label anywhere that's harder than that. The limit is eighty-eight words. Museums are in a horrible identity crisis, and if they don't get over it soon, I don't think we'll have museums as places of education." Bryan was referring most pointedly to the director of the Brooklyn Museum, Arnold L. Lehman, who cut many of the curatorial jobs and mounted exhibits based on the *Star Wars* movies and Ralph Lauren's car collection. The Met, she believes, is an exception to this trend. "There are not many directors left who will fight" for scholarship, she said. "Every Egyptian archaeologist I

know thinks Philippe de Montebello walks on water. He expends resources for research that have dried up elsewhere."

"FIVE THOUSAND YEARS of Art," proudly states the Web site for the Metropolitan Museum of Art. Two million works of art, nineteen curatorial departments, one hundred curators, and a total staff of two thousand—the Met is a staggering cultural institution by any measure. It spans the range of human artistry, from classical and Egyptian antiquities, to European masters, to its holdings of African, Asian, Oceanic, Byzantine, and Islamic art. It has costume collections, an impressive grouping of armor and weapons, musical instruments, and an extensive store of American art, including contemporary and modern pieces.

Founded on April 13, 1870, the Met was created with the aim of "encouraging and developing the study of the fine arts, and the application of arts to manufacture and practical life, of advancing the general knowledge of kindred subjects, and, to that end, of furnishing popular instruction." The educational mission of the Met was built into its foundation, as was a hope of fostering a climate that would bring the arts into the daily lives of New Yorkers. The mission statement was revised in 2000, and it focused even more single-mindedly on education, while also reflecting the weight of cultural diversification. The Met's purpose is to "preserve, study, exhibit and stimulate appreciation for and advance knowledge of works of art that collectively represent the broadest spectrum of human achievement at the highest level of quality, all in the service of the public and in accordance with the highest professional standards." Hewing to the "highest professional standards" must be more than lip service for an institution that has tax-exempt status and which receives generous funding from New York City and a rent-free lease for its two-million-square-foot Beaux Arts building in Central Park.

From the start, antiquities were a central part of the museum's mission. Indeed, the Met's first accessioned piece was a Roman sarcophagus, still part of the permanent collection. The origins of the museum's collections are inexorably tied to Louis Palma di Cesnola, an Italian-born military commander who had fought in the Civil War— and whose ancestor, like de Montebello's, had fought for Napoleon.

Cesnola's excavating history cannot be divorced from the notion of plunder. He was named U.S. consul to Cyprus in 1865, and like so many of his diplomatic counterparts at the time, Cesnola caught the archaeology bug. He began excavating in the tombs of Larnaca, gathering sculptures and small objects in what quickly became a large-scale operation. Working with *firmans* when he could get them and without *firmans* when he couldn't, Cesnola kept one hundred diggers busy on the site, turning his house on Cyprus into a kind of museum, visited by the rich and curious. And while there were no export bans at the time, when the Ottoman authorities in Constantinople got wind of Cesnola's hoard, they sent orders to prevent its export, along with a Turkish naval corvette that dropped anchor in front of his house.

What to do? Cesnola recounted that it was his dragoman, Besbes, who came up with an ingenious, Ottoman-style solution. At the time, Cesnola was also the representative of Russia in Cyprus, and the export ban issued from Constantinople barred only "the U.S. consul" from sending the antiquities abroad. Besbes pointed out that there was no such ban that applied to the Russian consul. "My Western civilization would never have arrived at this truly oriental solution of the difficulty," recalled Cesnola, and his 360 packing cases promptly sailed off as the property of the Russian consul.

Half of his cache ended up at the bottom of the Mediterranean, when one boat sank in a storm, but Cesnola sold the rest of the collection for sixty thousand dollars to John Taylor Johnston, the railroad executive who was the first president of the Met. (Johnston paid with his own money.) Cesnola insisted that the collection remain together and bear his name. "I have the pride of my race," he wrote, "and that of a discoverer who wants his name perpetuated with his work if possible."

There was much more to come. In eleven years on Cyprus, Cesnola explored sixteen ancient cities, excavated fifteen temples, sixty-five necropoli, and 60,932 tombs. He collected no fewer than 35,573 objects, including 2,000 statues, 2,000 busts, 14,000 vases, and nearly 4,000 glass objects. He claimed to have found the "treasure of Curium," a rich hoard of gold, silver, and bronze objects from the sixth century

*Louis Palma di Cesnola, the first director of the Met and a plunderer in his own right.* (The Metropolitan Museum of Art, Image © The Metropolitan Museum of Art)

BC, on the western coast of Cyprus, for which the Met—lacking funds at the time—nonetheless scraped together the purchase price of sixty thousand dollars, to be paid in installments. The ten thousand objects—one-third of which had been shared with the Turkish authorities in a partage arrangement—arrived in 1877. But the hoard, like many of Cesnola's finds, raised objections. Later archaeologists could find no trace of the funerary chamber that Cesnola described in his book as having been beneath a temple, containing many of the objects he found. Max Ohnefalsch-Richter, a German archaeologist who checked out Cesnola's claims, said in 1893, "We found by our excavations that the temple existed only in the imaginative mind of Gen. Cesnola." He concluded that "it appears that the General, by error or want of memory, or by lack of archeological qualifications, has created the so-called temple of Curium and its wonderful vaults." Today, the Metropolitan Museum of Art considers this episode simply "a mystery which cannot be cleared up." Cesnola subsequently joined the board

of trustees and in 1879 became the museum's first professional director. Later, he weathered still more storms of controversy over the authenticity of the works he had found, which today are considered authentic, but which have no provenance.

Over the decades, the museum grew through bequest, gift, purchase, and excavation to become one of the largest and richest art museums in the world. Except for the Louvre, no museum can match the Met's encyclopedic survey of the history of art, and few museums can match the huge, avid public that surges through its halls. The Met benefited early on from the collections of artifacts bequeathed by wealthy donors, a practice that fed the museum from its early days until current times. Forty percent of the industrialist J. P. Morgan's collection ended up at the Met, much of it on permanent display. (Its provenance is anyone's guess.) It included a broad range of objects, from sixteenth-century sculpture groups to Egyptian material; alabaster reliefs from King Ashurnasirpal at Nimrud; silver plates from Cyprus; Byzantine ivories; Gothic carvings; and numerous Renaissance works of all kinds. Benjamin Altman, the department store magnate, left a rich collection of paintings and other works, as did George Blumenthal, a prominent art collector. The Cloisters collection of medieval art, in a separate building entirely, came to the Met through the philanthropy of John D. Rockefeller Jr. in the 1920s and 1930s. Robert Lehman, a prominent banker, left the museum some three thousand works of art on his death in 1969.

And unlike the Louvre and the British Museum, the Met's collection of Egyptian antiquities comes not primarily from plunder but from expeditions led by the museum's own archaeologists, who shared their findings with antiquities authorities under the partage system in force until the 1920s. Gaston Maspero, the Frenchman who served as director general of antiquities in Egypt, had cozy relations with the museum, and the partage policy was liberal, yielding pieces from the royal cemetery fifty miles south of Cairo, in the Kharga Oasis, and in the palace of Amenophis III in Luxor. In 1924, in the wake of Howard Carter's discovery of the tomb of Tutankhamun, the partage policy ended, and acquisitions were no longer so quickly forthcoming. The Met bought the antiquities collection of the Earl of Carnarvon, who

had financed Carter, yielding 1,400 objects. The Near Eastern collection grew through excavations in the 1930s, under the partage policy, in Iraq and Iran. The Met has continued to fund excavations and archaeological research to the present day, although it no longer may claim any of the finds for its collection.

UNTIL JANUARY 2008, an unobtrusive pot stood alone in a glass vitrine in the Bothmer Gallery on the first floor of the Met. Eighteen inches tall and twenty-one inches in diameter, it was identified as "Terra cotta calyx-krater (bowl for mixing wine and water). Greek, Attic, 315 B.C." At the bottom of the tag, in small letters, a seemingly innocuous phrase had been added: "Lent by the Republic of Italy."

One would never know by the label that this was the Euphronios krater, one of the finest Greek vases known to exist, the Met's greatest loss in the tug-of-war over looted antiquities. The vase is a rarity, one of only a couple dozen existing known to be painted by the famed artist Euphronios. Along one side of the pot, a naked Sarpedon, the son of Zeus and an ally of the ancient Trojans, lies prostrate, mortally wounded, in a mythic battle immortalized by Homer in *The Iliad*. His hair is long and wavy, his muscles ripple as blood streams from his death wounds. Two winged and helmeted gods, Death and Sleep, bear him away. Hermes, another son of Zeus, carries a scepter and observes from the midst of a tableau of figures, with the name of each written in Greek, along with the signature of the artist, Euphronios, and the potter, Euxitheos. The reverse of the vase shows a group of warriors, preparing for battle.

The Euphronios krater first came to the attention of the Met in September 1971, when Thomas Hoving, the museum's director, received a phone call from Elizabeth Hecht, the wife of Robert Hecht, an American antiquities dealer based in Europe. "She told me that Bob had just been consigned a 'startling piece,'" Hoving recalled, "and he might offer it in a few months."

Hecht was a very successful dealer who bought and sold antiquities on behalf of the great Western museums, but he had a bit of an outlaw reputation. "Bob is the kind of guy who seems always stooped over slightly and is never capable or willing to look you in the eye," Hoving

recalled. "He has a stuttering laugh and often seems to converse in code. Whatever role he's playing at the moment—scholar, 'amateur dealer,' finagler—he is sharp, witty, always on the cutting edge of art information worldwide. And he always has great, great stuff." Hecht had been declared persona non grata by Turkey on suspicion that he sold smuggled antiquities, and he had already fought similar charges in Italy. But he was connected, and he had an unerring eye.

A few months after Elizabeth Hecht's phone call, the museum's Greek and Roman curator, Dietrich von Bothmer, was contacted directly by Robert Hecht, who indeed claimed to have gotten his hands on a wondrous object: a vase by Euphronios in near-perfect condition. As if this were some kind of spy drama, Hecht's letter was in code.

> Regarding p. 14 of Jackie Dear's red I made a hint asking you and your trusted associates would make a super gigantic effort. Now please imagine this broken, but COMPLETE and in PERFECT STATE—by complete I mean 99 44/100 % and by "perfect state" I mean brilliant, not weathered. It would hardly be incorrect to say that such a thing could be considered the best of its kind—I don't say that necessarily it is, but . . . it's hard to find competitors.

Von Bothmer was ready to bite. The curator was part of a wave of German intellectuals who had fled before World War II to make a career in America. He had fought in the Pacific, was decorated with a Bronze Star for bravery, and joined the Met in 1946, becoming a pillar of the museum's classical department. For most of that time he was a respected scholar known for his great passion for antiquities and for his unique expertise in Greek vases, developed over decades. And he was a collector himself, gathering potsherds for his own private use. But the curator was of another time, another era in standards of collecting and acquisition. "If the Italians don't look after their own things, I'd rather have it in New York than kept somewhere where it's not appreciated," he would later state. "I bought fragments for so long because dealers didn't pay attention to them, and I didn't find enormous prices, and it

was a way of making sure they didn't throw them out." In later years, he often donated vases and shards to museums across the country. Indeed, von Bothmer himself has been responsible for upwards of $5 million of donations to the Met, and two galleries now bear his name.

Seeing photos of the krater, von Bothmer was immediately won over. The vase was in pristine condition, the only such Euphronios to come to light. (Hecht at first claimed it was in perfect condition, but in fact the vase had been broken and glued back together.) Provenance was not high on his or anyone's list of concerns; authenticity came first. It would have been reasonable to presume that no one knew about the vase previously because it had been recently dug up, but the "don't ask, don't tell" culture held sway.

Hoving and von Bothmer flew immediately to Zurich, where Hecht was keeping the vase, meeting the dealer at the home of his restorer, Fritz Bürki. Hoving was aware of the 1970 UNESCO agreement and demanded to know the provenance. Hecht reassured him, saying that the krater belonged to Dikran Sarrafian, a Lebanese dealer, whose family had long been in possession of the piece. Hoving claims in his memoir that he did not believe Hecht at the time but was determined to have this piece in his museum. "I wanted the vase; I would have it," he states, with something close to lasciviousness. Everyone involved in the transaction understood that the Met needed a paper trail to provide plausible documentation, and Hoving got it—a letter from Sarrafian, claiming that the krater had been in his family since 1920. The date got around both the UNESCO restriction and Italian law, which prohibited the export of unauthorized antiquities excavated after 1939. Hoving sent the requisite letters to other foreign countries asking if there was any problem, to their knowledge, with this particular vase. There was none. But of course no country could claim the vase as stolen if it had been illegally excavated and smuggled out, which Hoving well knew.

After gaining approval from his board, Hoving paid a stunning $1 million for the krater, doing so by selling off a valuable coin collection. It was the most money the museum had ever paid for a single artifact. Hoving was ecstatic. "We had landed a work that I guessed would be the last monumental piece to come out of Italy," he wrote, "slipping in

just underneath the crack in the door of the imminent Unesco treaty, which would drastically limit future trade in antiquities."

Arthur "Punch" Sulzberger, the publisher of the *New York Times*, was a trustee of the Met, and he ordered up a glossy magazine piece about the Euphronios krater. But almost immediately, suspicions about the krater's origins began to circulate. The *Times*'s art critic John Canaday had heard rumblings and told the metropolitan editor Arthur Gelb, who assigned an investigative reporter named Nicholas Gage to check them out. Though Gage knew nothing about art, he proceeded to crack the Met's story wide open. In a series of front-page articles that began about a month after the acquisition announcement in November 1972, Gage tracked down Hecht in Rome, exposing him as a dealer who had been in legal jeopardy before, and found sources who said that the piece had been dug up near Rome in December 1971. The crushing blow came when Gage flew to Beirut to interview the supposed seller, Dikran Sarrafian. In a rambling interview, Sarrafian said that he'd kept the pieces of the pot in a hatbox and that he had never seen the vase assembled until he saw the picture in the paper. This squarely contradicted Hecht's official story, which was that Sarrafian had had the krater restored three years previously. In addition, Sarrafian told Gage that Hecht pocketed most of the money, contradicting what the dealer had told the Met. "I had all the facts," Gage later recalled. "But Hoving refused to admit it."

Within the Met, a dissident voice protested the purchase of the Euphronios. Oscar White Muscarella, an associate curator in the Near East department, committed the museological crime of heresy, by speaking against the krater not only within the museum but also publicly. As the *New York Times* wrote story after story about the controversy, Muscarella gave an interview to the *Times* reporter David Shirey, saying of his superiors, "They have abdicated responsibility. They should have checked out every possible origin before it was purchased." And he excoriated the Met for its "exorbitant" payment, which he said would encourage looters to continue looting tombs: "Can we blame them any more than the people who pay them or who buy their finds?" Muscarella was fired in the wake of this article, but he sued for wrongful

termination, won, and was restored at a lower position. An understandably embittered man, Muscarella has lived out his career at the museum, a thorn in its side; his presence is especially aggravating, one suspects, for his having been right.

Embarrassed by all of these articles in the *Times*, Hoving pressed Hecht for more detailed answers, and he was surprised by the dealer's nonchalance. Then the Italian government pursued a criminal case against Hecht, unsuccessfully. A grand jury was subsequently convened in New York to investigate Hecht, Hoving, and von Bothmer, but it found insufficient evidence for an indictment. The Met conducted its own internal investigation and found—not surprisingly—that the vase had not been smuggled.

There was, in fact, a true mystery in the conflicting versions of the Euphronios krater's origin. Dikran Sarrafian did indeed have shards of a Euphronios vase that had been stored in a hatbox and handed down in his family earlier in the century. And quite evidently, there were several valuable pieces that had been illegally dug up in 1971 in a tomb at Cerveteri, a famed Etruscan necropolis north of Rome, including several works by Euphronios. But Hecht, it seems, already had the Sarrafian shards when a strange coincidence occurred: his sources among the *tombaroli* (grave robbers) dug up another krater, the exquisite Euphronios that he offered to the Met. So there were *two* kraters by Euphronios, both consigned to Robert Hecht, emerging at about the same time. Hecht thus managed an ingenious switcheroo. Hecht used the paperwork from Sarrafian to create a provenance that did not exist for the more expensive, complete krater going to the Met, which came from Cerveteri. Meanwhile the other krater—a smaller one, which was incomplete and whose shards could fit in a hatbox—was sold much later, in June 1990. The buyers were Leon Levy and Shelby White, the pillars of Manhattan society and the Met's most dedicated classical donors, who paid $1.65 million. But in the 1970s the mystery could not be resolved.

So lay the Euphronios matter for about twenty years, until Swiss police raided the Geneva warehouse of Giacomo Medici in 1995. Medici was an antiquities dealer who worked frequently with Robert

Hecht. The police hit the jackpot; Medici's depot was filled with un-provenanced antiquities and hundreds of photographs, evidence that kicked off years of investigation. That investigation eventually led to a raid on Hecht's apartment in Paris in 2001, where police found an unpublished memoir of Hecht's life sitting right on his desk. The memoir gave away the game of the Euphronios krater.

Instead of having bought the krater from Sarrafian, Hecht's memoir said it was bought in 1971 from Medici, the Italian dealer. "He appeared at our apartment with a Polaroid of a krater signed by Euphronios," Hecht wrote in the memoir. "I could not believe my eyes. I took the train to Lugano, where Medici had the krater in a safe-deposit box. The negotiations did not take long." Hecht wrote that he made an offer on the spot of 1.5 million Swiss francs (about $380,000 at the time), and provided a down payment of about $40,000. He took the vase straight to Zurich, where he left it with a restorer before heading back to Rome for a family ski trip. Queried by reporters when the memoir was leaked, Hecht said it was fiction and produced another memoir with a different, more conventional backstory. When reached at his New York apartment by reporters from the *Los Angeles Times* in 2005, Hecht continued to prop up the story that by then no one believed. Of the two accounts, he said, "One is the fact and the other is a fancy invention." Medici also denied the account. But no one believed him either.

Fueled by the trove of Medici evidence, Italy now said that the Euphronios vase had been taken from a tomb north of Rome and announced that it was prepared to go back to the Met to claim the krater, along with a number of other pieces that it believed were looted. The central evidence was Hecht's memoir—though by the time it was made public, the statute of limitations had long since run out. Other evidence included a deposition by Marion True, a curator at the Getty Museum, who was now under indictment for trafficking in looted antiquities. True said that von Bothmer had shown her an aerial photograph of a tomb in a heavily looted necropolis where the krater came from. Von Bothmer denied ever having done this.

Now started the backstabbing, as the curators found themselves in the legal crosshairs. True's testimony was stunning, given the small world in which curators operate; von Bothmer had been her mentor

and had recruited her to the Met decades earlier. And in perfidy, von Bothmer was equally generous. "Marion True had her own way of interpreting the law, and that was her downfall," he said of his former protégée. "I avoided her like the plague." The Italians also found two men from the necropolis site, who said they helped remove the krater from a tomb in 1971. And they had photos of Medici and Hecht each posing next to the vase at the Met, which they interpreted as evidence of proprietary pride. For his part, Medici denied having sold the Euphronios krater. He said he often posed in front of beautiful objects, not just those he sold, and produced many photographs of him standing in front of items acquired in the early twentieth century.

But as in the case of the Lydian Hoard, the Met stalled, stonewalled, and would not be swayed—until it was forced to do so. The culture of the institution did not seem to have changed much since the museum's experience with Turkey. The Met proved unwilling to open its records or propose a compromise, until it had to. The Italians wanted not only the Euphronios krater but also twenty other items, along with a fifteen-piece set of Hellenistic silver. The art and Italian press were being leaked a steady stream of stories about the Medici trove. The Met was under intense pressure. Finally, the museum agreed to open discussions about the krater's provenance.

"I BOUGHT A lot of smuggled stuff," Thomas Hoving said in a telephone interview in late 2006. The Euphronios krater was "one of dozens. I had a rolodex of the best smugglers to get stuff into Switzerland. I knew their names. I talked to them. I had dinner with them. I met them in London. They routinely sent me communications: 'There's so and so, do you want it?' My favorite story to get something out of Italy was to bring the children in a station wagon, put mattresses in the back on the hottest day in August and leave with this stuff under the mattress. Just before going to customs, you'd give the kids ice cream cones. And the customs officials in their dress whites, you can't imagine how fast they put you through. A friend of mine did that routinely with small Italian pieces."

Hoving was dismissed by the board of the Met in 1977. And in the wake of that rejection, the former museum director—who had a

brilliant but turbulent stint as the head of the institution—had a change of heart. He decided that the museum was dirty and that its acquisitions policies harmed archaeological knowledge and encouraged looting. Hoving became the editor of *Connoisseur* magazine, where he published the muckraking scoops of Özgen Acar and Melik Kaylan about looted art and dirty dealers in American museums, and exposed the curator of the Getty Museum, Jiri Frel, for unscrupulous acquisition practices. He became a correspondent for the television newsmagazine *20/20*. And he cooperated with the Italians as they launched an aggressive restitution campaign. With the fervor of a convert and with the savvy of a man who can't resist a sound bite, Hoving denounced his own former conduct and, by extension, the attitudes of those who have tried to defend the pieces that he himself acquired.

Hoving started dealing in smuggled pieces when he was still a curator, having joined the Met in 1959. "Within two years I was collecting $850,000 [worth] a year. I organized stuff to be smuggled out of every country, mostly medieval stuff, mostly into Switzerland." He recalled a favorite piece: a twelfth-century Romanesque doorway carved in stone that had been found outside the former villa of a Russian aristocratic family in France. The villa was being torn down. "How do you smuggle a two-ton doorway out of France?" he asked. He used Byzantine logic; he argued to the French authorities that the doorway technically came from Italy, from the time when Nice was known as Nicaea and was part of the Kingdom of Sardinia. The border had changed in 1860, but technically the doorway had never left its country of origin. "I applied to the institute of Beaux Arts on that basis, and they said, 'Granted.' " If not, he said, he'd have found someone to smuggle it.

Why was the practice so accepted at the time? Greed, he essentially answered. "You did it because you wanted to boost your collection with beautiful things—and screw it," he said. "If you were a collecting curator back in the sixties, of course you knew where it came from. This stuff is not found in Malibu." In the world of American museums, he said, there was a strong sense that the source countries did not deserve consideration. "If you'd go to European museums in the fifties and sixties, it was clear they didn't much care about what they

*Thomas Hoving, the former director of the Met turned muckraker and restitutionist.* (Photo by Fred R. Conrad/The New York Times)

had," he continued. "There was the pride of getting it away from these jerks. They had no organized museological structures. It was haphazard. Half the stuff was in storage; if you tried to see something on a scholarly basis, it took seven weeks. Plus, we were saving something and putting it on view for an enormously wider audience. And we'd publish it. We thought we were adding to our collection, increasing our ego, getting promoted, and saving the world."

At a certain point things began to shift. By the time Hoving became the director of the Met in 1967, the signs of change were in the air. At his first director's meeting he learned of the purchase of the Lydian Hoard from Turkey, and he was nervous. "I thought, 'Boy, this is going to cause us a lot of trouble,'" he recalled. "And it did."

Fast-forward to today's climate, when restitution has become Topic A at museums all over the world. Hoving does not buy the argument that more people can see things at the Met than in Turkey or elsewhere,

even if it's true. "Don't be taken in by the dulcet tones of Philippe de Montebello," he warned. "I've heard the lecture; it's mostly specious."

Hoving is swift to dismiss what was once the very mission of his career. "It's the old nineteenth-century 'encyclopedic museum' specious argumentation," he said. "It's generally hogwash. I used to talk about it all the time when I was trying to finish a wing. But I didn't really believe it. It has nothing to do with reality; it's just a phase of westernization." To him, the rhetoric merely serves the purpose of the museum. "I gave eighteen speeches a month when I was director. I always spoke of 'completion of the encyclopedia.' It was a political gig to get people not to move the Temple of Dendur to the Bronx." Or to justify major acquisitions. In Hoving's opinion, museums should collect but should not attempt to get the major pieces of any civilization. "To get the best stuff is way beyond the bounds of moral museological behavior," he said. "To get stuff from another country that never had anything to do with yours is way over the line. You can get representative things, but you can't get the top things."

He also rejects the argument that museums give broad access to the public to see these great works of antiquity. The number of people who see something has nothing to do with the significance of art, he said. "All the paintings in the Met, up to the seventeenth century, are utterly irrelevant in their current circumstances. They're all religious art." Few others who have visited the great museums would agree, in all likelihood, but he insists on the point: art is no more worthy for being shared. "In the entire history of mankind, art was seen by specialists," he said. "The great masses seeing it doesn't make them or it any better. So what? It's a specious argument."

Hoving has concluded that "the whole world has changed. There'll be no more collecting of archaeological materials. It's come to a complete halt. It's good. It's fabulous. It stops this flood."

IN NOVEMBER 2005 Philippe de Montebello broke out in a case of shingles; he was a man under severe stress. The conflict with Italy was threatening the Met's biggest construction project, the new Greek and Roman galleries. But if he gave in on the pieces that Italy sought,

would it open up his star donors—who had bought from the very same sources—to unwanted scrutiny? Would it set a dangerous precedent? Seeking to put an end to the affair, he flew to Rome and headed to the headquarters of the Italian Ministry of Culture. He presumed it had documents that would cast serious doubt on pieces in his collection, and he hoped to get away with some kind of compromise—long-term loans, perhaps, and a change in official ownership. In the course of a tense, six-hour meeting, curators, police, and the minister of culture himself showed de Montebello their accumulated evidence of looted antiquities, some in the Met's permanent collection, some loaned by wealthy donors on the museum's board of trustees. The archaeologist Malcolm Bell III produced evidence proving that the fifteen-piece Hellenistic silver set was from Morgantina in Sicily, where he excavates for the University of Virginia. But for most of the face-off, de Montebello was not convinced. To him, the evidence the Italians were showing him was inconclusive and did not incontrovertibly prove that the items had been smuggled out of the country. No one had a photograph of the Euphronios krater freshly dug up, with dirt, in a warehouse. The negotiations ground to a standstill.

But the Italians were not going to back down, and finally they put their cards on the table. If the Met did not move to give up these pieces, the museum should prepare for criminal prosecution, starting with the aged Dietrich von Bothmer. There was every reason to believe that Italy was not bluffing. The government had been in similar, bare-knuckle negotiations with the J. Paul Getty Musem of Los Angeles, and the Getty had been similarly unconvinced. In response, Italy had started criminal proceedings against its curator, Marion True. The Italians told de Montebello that they had the evidence and would win in court. And even if they didn't, the implication was clear: the respected von Bothmer would be dragged through the mud. Faced with that prospect, de Montebello relented. A preliminary agreement was struck, and in February 2006 the Italian government announced an agreement with the Met under which the museum would return twenty-one treasures, including the Euphronios krater and the silver hoard, in exchange for loans of significant pieces from Italy. The krater would remain on loan in New York for two years and would return to Italy

in January 2008. From his previous skepticism, de Montebello found the words to justify the decision. "If you pile up enough circumstantial evidence, you've got something that's beyond a reasonable doubt," he told the press.

But in truth, the director didn't seem convinced, and from that point on he began to take up the mantle of defending the Met's acquisition policies, arguing that it was necessary to buy up important pieces even if they may have been looted. Not long after the agreement, he began giving speeches not only defending the mission of the museum but taking direct aim at the Italians. "The whole process of how Italy prosecuted its case in the United States was shabby," he told a packed auditorium at New York City's New School, at a forum on the antiquities scandal. The Italians made their initial claims "entirely through the press," he complained and said that only after repeated requests by the Met did cultural officials even agree to meet with the museum. Carlos Picón, the Greek and Roman curator, was similarly disenchanted. "Even the Italians admit there was no hard evidence to say it came from Morgantina, only southern Italy," he protested, referring to the silver. Malcolm Bell III "says that he saw bulldozers digging at his site when he was driving by. Why didn't he protect his site?"

Defenses and explanations aside, the question remains: what is the museum's true culpability in the ongoing looting of archaeological sites? Philippe de Montebello says there is no connection between the purchase of looted art and continued looting; that plunder has gone on since art began (which is true) and that it continues now, even when museums have largely stopped acquiring unprovenanced pieces (also true). But the purchase of the Euphronios krater in 1972 had a direct impact on the looting that occurred in Italy. Peter Watson and Cecilia Todeschini, the authors of the book *The Medici Conspiracy*, note that after the Met paid such a huge sum for the Euphronios krater, a more aggressive and sophisticated system of illegal excavations arose: "We are told that the tombaroli of Italy 'went crazy' when they heard the price that had been paid for the Euphronios krater and redoubled their efforts to search out whatever loot they could find—just in case." They also observe that several other Euphronios vases surfaced in the years immediately following the Met's purchase. The market responded as markets usually do.

Queried about the Euphronios krater in 2005, Oscar White Muscarella had no doubt that the museums, their donors, their collectors, the art critics, and this country's wealthiest individuals were collectively at fault for the destruction of the world's history. "I see it as a sick collaboration," he said in a jeremiad that sounds—as he often does—unhinged, but which at its heart contains the truth. "If you look at the language: 'I had to have it. A lust for antiquities.' Collecting antiquities is rape. . . . All these people are justifying their destruction, their power to have these objects in their apartment. Bring their guests in and say, 'Golly gee, look what I have!' Power and perversion of the wealthy. These are the people who are encouraging it. Who are authorizing it. Who are the recipients of it. Plunder does not exist without the existence of these people."

MANHATTAN WAS A mess on April 16, 2007, when a sudden nor'easter blew in, sending a freezing chill through the metropolis and flooding basements, swamping subways, and causing hundreds of flights to be canceled. New Yorkers bent sideways into the blowing rain and kept going, as usual.

Inside the Met, it was calm. Waiters in black vests and crisp white shirts served chilled grapefruit juice and croissants for the grand opening of the new Greek and Roman galleries, named for the late Leon Levy and his widow, Shelby White, who was present for a ribbon-cutting ceremony. Their names appeared everywhere, etched in stone.

The galleries were spectacular indeed, having taken fifteen years to plan, five years and $220 million to build, and allowing for nearly half of the museum's Greek, Roman, Etruscan, and South Italian art to be hauled out of storage, where much of it had been sitting since the early twentieth century, and placed on display. Some 5,300 pieces that had been in storage (some covered in dust since 1870) were installed for public view.

The most exciting space was a two-story central courtyard, a square, classical space recalling the atrium of a Roman villa, rimmed with pillars and anchored by a black, circular fountain beneath a soaring glass roof. The room had until recently been the Met's restaurant and cafeteria and in the renovation was completely transformed.

Colored marble was imported to echo the floor of the Pantheon in the inner square of the atrium, while a decision was made to leave in place the mosaic of black and white marble chips that created a Greco-Roman design around the outer edge of the space.

The gallery had become a statue garden, filled with the marvels of the Met, like a life-size Roman bronze of an aristocratic boy, from 27 BC, and a marble statue of Dionysus, god of wine, from the same period. There were two oversized statues of Hercules, facing each other, one with a lion skin draped over the left arm, the other an older, bearded warrior, with a lion skin over his shoulders. And many sarcophagi—such as a marble garland sarcophagus, found in Tarsus in southern Turkey in 1863. To bear the weight of these pieces and the pediments on which some of them stand, engineers had to install a steel skeleton beneath the floor. The statues and fragments had been cleaned of debris, varnish, and grime. The effect was both graceful and uplifting, a room strategically filled with muscular, heroic nudes and imposing busts, with space for each sculpture to breathe, and flooded with natural light—even on a rainy day like this one.

The rooms coming off the gallery displayed one wondrous object after another, but the question of plunder, provenance, and restitution hovered around many of the most beautiful pieces. One was an enormous Ionic pillar from the Temple of Artemis at Sardis, in Turkey. The original was fifty-eight feet high, and this is about half that size and still seems like a colossus. The pillar was originally plundered by Americans in an incident dating back to 1922 as the Greeks and Turks warred over the port of Izmir. (Of course, there is no mention of this provenance in any of the explanations attached to the piece, nor in the catalog, nor on the museum's Web site.) The column, along with hundreds of other pieces, was spirited away during the conflict by the American Society for the Excavation of Sardis and was sent to the Met. When the hostilities ended, the Turks protested and it became an international diplomatic incident, recorded in State Department archives. After much negotiation, the Turks ceded ownership of the column in exchange for the return of fifty-three cases of antiquities also stolen from Sardis.

The Greek and Roman galleries also boasted beautiful, delicate glasswork, bronze helmets, and tools of war. There were small, delicate

objects—gold earrings and a pair of heavy gold armbands, with tritons on the head, from 200 BC. Vibrantly painted murals from a villa near Vesuvius, preserved in volcano ash and newly cleaned of dust and varnish for the unveiling of the galleries—how did they get here? No word. Also mosaic floors and an actual divan, with carvings of delicate bone and glass inlays, with blue cushions—the kind of thing that instantly conjures up a caesar lounging on a balcony.

The beauty was astounding, but it wasn't just that. Wandering through the new galleries, one continually saw a variety of objects. A single room had a statue, a piece of furniture, mosaic, jewelry, and several red-black vases, a welcome change from the numbing encyclopedic approach of earlier decades visible in the Louvre's nine rooms of vases. Many of these pieces were discoveries to the museum officials themselves. "There was a bronze room under the stairs of the Great Hall, where there were boxes and boxes of brass inside," said Jeffrey Daly, the senior design adviser of the museum, who oversaw the redesign of the space. "It was packed away in these old boxes; it had not been looked at in generations."

Upstairs, beside smaller rooms filled with glass display cases for jewelry and artifacts from daily life—space that once held the executive offices of the museum director—the museum installed computer monitors where visitors can easily look up the name of the item, the year it was found, the purpose it served.

Carlos Picón, the curator in charge of the department of Greek and Roman art, was wandering through the galleries, greeting members of the press and several early guests. He said that in the current climate, he took care to include as much information as possible about the provenance of the pieces on view. "We are being more transparent, even with the people who normally would like to remain anonymous," he said. A dapper, dark-haired man who was born in San Juan, Puerto Rico, and educated at Oxford, he has a warm manner and was visibly delighted at the opening festivities. Even the questions over provenance did not seem to annoy him on this day. "We've encouraged the donors to be more open. I don't have anything to hide. On the whole, we tend to give out more information than we did before, even five years ago, including the dealer's names." He added, "Every

piece on loan here from a private collection has been checked by me, very carefully."

In the press kit handed out for the opening, there was visibly more of an effort to account for provenance than in other Met exhibits or catalogs, though nowhere was a dealer's name in evidence. The press kit mentioned, for example, that the two larger-than-life Hercules came from the Guistiniani Collection in Rome, "first published in 1631." The garland sarcophagus was "the first object offered to and accepted by the museum" in 1870. Another sarcophagus came from the collection of the dukes of Beaufort. But many other pieces had no stated provenance—notably the stunning wall paintings from the imperial villas near Mount Vesuvius, which were "partially excavated between 1903 and 1905 after its accidental discovery during work on a railway." And there was mysteriously no information at all for recent acquisitions, including a Roman sarcophagus and a funerary urn.

The new catalog accompanying the opening of the galleries reflected this awareness of provenance in a strikingly different manner. Almost every piece shown in a photograph—a fraction of what was on view and a smaller fraction of what the museum possesses—was an acquisition from before 1970, the UNESCO cut-off date for pieces without provenance. The back of the catalog provided the information accompanying the photographs, divided into sections of classical Greece, Etrurian, Hellenistic, and Roman art. Piece after piece said the same: "Rogers Fund, 1916." "Fletcher Fund, 1927." "Cesnola Collection, 1874." I could find few if any pictured pieces from the Levy-White donations and only a couple from the fund provided by the retired curator Dietrich von Bothmer in the 1990s. The more recent pieces were, of course, in the galleries but appear to have been carefully omitted from the reference guide.

This is in notable contrast to the 1991 catalog that accompanied a 1990 Met exhibit of treasures belonging to the Levy-Whites. "Glories of the Past, the Art from the Shelby White and Leon Levy Collection," edited by von Bothmer, shows artifact after artifact with no provenance at all. In a typical entry, the catalog's author says he tried in vain to plumb the origin of a painted vase, a rhyton: "In the absence of known provenance, it is difficult to identify with certainty the local

style employed here. It may be Crete, or Keos, or Nexos." And the weary Hercules bust, sought by Turkey to reunite with its lower half in Antalya, is in this catalog, too, without notation of its missing half or the request to unite the two pieces. The archaeologists David Gill and Christopher Chippindale examined this catalog and concluded that of the works shown at the Met in the 1990 exhibit, 84 percent first surfaced after 1973, the year the Archaeological Institute of America adopted the UNESCO convention, and thus with no known provenance must be considered to have been looted.

The dispute over the Euphronios krater has been resolved, and the Met has no pending demands for restitution. But the museum did have at least two pieces on display under dispute. Italy had challenged Shelby White over twenty pieces from her collection, two of which had been at the Met since 1999, one a krater believed to be by Euphronios depicting Hercules slaying Cycnos, and the other a krater attributed to the Eucharides painter, depicting Zeus and his cupbearer Ganymede. "She can't speak about it," Picón said. "And I don't want to know." (Through a spokesman, White declined numerous requests for interviews.) According to the sentencing document in the conviction of Giacomo Medici, the Italian dealer-smuggler, White owned eight items that he sold, including a bronze statuette of a nude youth, purchased for $1.2 million in 1990, and seven vases bought for at least $5 million. Italy wants them back, although the laws governing a good-faith sale would make legal recourse difficult. In the end, here, too, Italy prevailed. In January 2008 Italian cultural officials announced that after eighteen months of talks, White ceded ten antiquities from her collection—including the two on display at the Met. She did so in return for Italy's agreement not to pursue any other pieces published in the "Glories of the Past" catalog. Thus, with no more than public pressure and the shadowy prospect of prosecution overseas, White gave up ownership of millions of dollars of her legally purchased antiquities. She promptly had the pieces boxed and delivered to the Italian consulate on Park Avenue. (Six months later, White reached a separate agreement with the Greek Ministry of Culture to relinquish two additional pieces—a marble sculpture that originally decorated an ancient grave and a bronze vase, both dating from the fourth century BC.)

The negotiations with White suggest strongly that she will not be the last private collector to be targeted by a source country. But there is a more complicated aspect to this dispute. When donors loan their unprovenanced artifacts to museums, they are creating a provenance—and museums are being complicit in doing so. The next time the object appears, the venue will report that it was exhibited at the Met, offering the appearance of legitimacy; many believe this is unethical behavior. And other trustees of the Met own objects that were smuggled, according to rulings in three Italian and U.S. cases since 1999. In addition to White, there is Michael Steinhardt, the hedge fund manager whose name adorns one of the Met galleries for Greek art. He has donated upwards of $1 million to the museum.

On the day of the opening of the Greek and Roman galleries, Carlos Picón was eager to defend the museum's policies of displaying works from such donors, arguing that the campaign to remove important pieces from major museums would result in the emptying of the galleries and the impoverishment of culture. "I don't respect this extremism," he said. "It's not a humanist point of view. We are as educational as any university. Our historical faculty is better than any university in the world. This condescension is very boring. It dismisses us. You cannot rewrite the past. The Mona Lisa cannot go back to Italy. The Louvre cannot be closed and emptied for the sake of a few politicians."

The next night, the Met held the second of three days of celebration of its new galleries. The strains of string music wafted through the lobby, where the circular information booth had been turned into a bar, filled with a mass of apple blossoms. Waiters walked around with trays of Bellinis, champagne with peach juice, and buffet tables were piled high with the choicest salmon, asparagus, smoked meats, and artfully stacked chunks of aged Parmesan cheese.

On this night, Shelby White stayed away, and Philippe de Montebello—still recovering from double-knee-replacement surgery in January—chose not to circulate in a wheelchair or on a cane. This evening was for press and dignitaries from other museums. Peace and cooperation were in the air; the Italian ambassador to the United Nations attended, and the culture minister, Francesco Rutelli, had sent a letter of congratulations.

Harold Holzer, the affable spokesman of the museum, was in a buoyant mood. In addition to all the festivities, the new gallery and Carlos Picón had been featured the previous week in a glowing piece in the *New Yorker*. He was not about to be disturbed by the latest report of a restitution demand—an Italian village that wanted the return of an Etruscan chariot, one of the most spectacular pieces in the Met's Greek collection. Holzer dismissed the claim, observing, "They're a village. And we acquired it in 1903." Earlier in the day, a report had surfaced that Neil MacGregor, the director of the British Museum, had given an interview in which he suggested he might loan the Elgin Marbles to Greece for three months. It later turned out not to be more than a hypothetical, much-conditional offer, which MacGregor had floated before, but it did make a few headlines.

Holzer was dubious about this idea. If the British should loan the marbles to Greece, he said, the Greeks "will never give it back."

# LORD
# ELGIN'S
# LEGACY

# THE BRITISH MUSEUM

He's slight and spry and Scottish, with a right eye that wanders a bit to one side. Neil MacGregor, the superstar director of the British Museum, folds himself nimbly into a wing chair and pours a cup of tea.

At sixty-one, MacGregor has presided over a remarkable revival of the British Museum, the imposing cultural temple in the Bloomsbury section of London that dates back to 1753. At its founding, the British Museum was the first of a new kind of museum, created to serve the nation. To collect everything under the sun. To belong not to the government but to the public. To be run by trustees and not the state. To cost visitors nothing. A universal museum, open to the open mind.

But by the time MacGregor was prevailed upon to take over the museum in 2002, what was once among the greatest museums in the world was in complete disarray. The museum had a £5 million debt. Curators had been laid off, and many of the galleries were closed for lack of funding. The staff was in revolt, picketing the building and at one point forcing the museum to close its doors. The trustees were at loggerheads, and the government was uninterested in giving this chaotic institution any more money. They offered the job to MacGregor with

more hope than expectation. In the words of one former trustee, "It was a job no one wanted."

MacGregor took it anyway. Many doubted he could succeed. The British Museum was too entrenched in its bad habits, too riven by in-fighting. It was a failing institution. His first week a marble head was stolen from one of the closed galleries.

But MacGregor had a track record of reviving lost causes. His main claim to fame was the resuscitation of the National Gallery, which had been in decrepit condition when he took over in 1987. After decades of neglect, the country's premier art museum was a shabby gallery with nineteenth-century rooms overlaid with ugly 1970s design concepts: plenty of concrete, fabric wall coverings, low ceilings, poor lighting. MacGregor slowly transformed the galleries into elegant spaces, restoring the high Victorian ceilings that dated to the 1830s. He persuaded the British government to donate more money and drew in prominent members of the British establishment. Many have pointed out that British culture, unlike French or Italian, is not particularly visually oriented; it is far more rooted in the literary tradition, steeped in drama, the novel, and poetry. MacGregor strived to overcome that bias, bringing in donors to expand the collection and making it fashionable to spend money on the National Gallery.

At the British Museum, MacGregor was similarly ambitious. He took stock of the museum's reputation as a fusty, colonial relic, an anachronism of the imperial age, and quickly decided that the new age of cultural diversity had to be woven into the museum's mission if it was going to survive. He diversified the board of trustees to include representatives from Nigeria, Cyprus, and the West Indies. He raised money to restore the galleries and the magnificent eighteenth-century King's Library. He established links with faraway cultures by arranging loans and touring exhibits in Tehran and Beijing. He reorganized the collections on the main floor to put the emphasis on universalism. His new credo was the interconnectedness of diverse, ancient civilizations, all of which contributed to the artistry and progress of humankind. It was an argument that reached back to the Enlightenment and the ideals on which the museum was founded. The Rosetta Stone, for ex-

ample, was moved in 2004 from a dark corner against a wall in the main gallery to a central intersection between the Egyptian, Greek, and Mesopotamian spaces. The idea was to use one of the museum's most famous icons—with its Greek and hieroglyphic inscriptions—to highlight how one civilization flowed into another.

But MacGregor was doing this just as Western museums were coming under pressure as never before to justify their mandates and to explain their often cloudy collecting practices. He took up the mantle of explaining the reason for the British Museum's preeminence and cast it as being uniquely placed to preserve and compare the diverse cultures from around the world. A new philosophy for a multicultural age. And it was a kind of genius: the British Museum, he posited, was an argument for Western *humility*. Here was the place where any fourteen-year-old British lad could visit China or Tahiti while never leaving London. Here that young person could understand that Western civilization was not the only culture in the world, or the best culture, and that it owed a debt to those that came before. The British Museum, in short, was a place to open a narrow mind to human accomplishments from around the world.

Having found a new mission for the British Museum and having restored a sense of leadership to the institution, MacGregor became the rock star of British arts. In 2008 the British government created a new diplomatic post and named MacGregor to it: chairman of world collections, with the mandate of being Britain's cultural ambassador around the world. His name was often heard dangled as a possible successor to Philippe de Montebello at the Met. The normally sober *Sunday Times* of London gushed, "He is the most flawlessly fragrant [*sic*] arts boss we have, the most politically adept and, giggles notwithstanding, the most serious." MacGregor allowed a BBC camera crew to follow him around for a ten-part television series about the British Museum, which the *Times* described as "an extended hymn of praise to MacGregor's mighty Bloomsbury mansion." Reviewing the same series, the *Guardian* swooned as well, calling MacGregor "high-minded to a fault, passionate about cultural history—and the most politically savvy museum director in the game." And he was apparently modest too. David Landau, a former trustee at the National Gallery, observed,

"This is a man who has achieved the most in art in this country in his lifetime than anyone, and his entry in *Who's Who* is [only] two inches. Great people like Neil have small entries."

In his spacious office in a wing that snakes behind the Egyptian galleries, MacGregor greeted me at the end of the day with a smile. Behind him hung a large, undulating work by a contemporary Ghanaian artist, which wove metal foil and liquor bottle tops into a clothlike mural, an unusual choice for the office of the director of the British Museum and one that consciously evoked his new, multicultural esprit. "It's a document of a particular contact between two cultures, which is why we were so keen to acquire it for the museum. And why we came to hang it," he explained.

Apart from MacGregor's sophisticated global approach, he is a natural politician. His understated charm and soft Scottish brogue cleverly play against the archetype of the stiff British academic. His geniality is a welcome antidote to a centuries-bred tone of superiority so often doled out in institutions like this one. MacGregor is an art historian by training, rather than an anthropologist or archaeologist, having studied at Oxford and Edinburgh universities. He's the kinder, gentler face of the British Empire.

Still, charm and a willingness to listen may go a long way, but they do not dispel the fundamental problems attached to holding on to objects taken from their place of origin without permission. Especially if those places of origin want, indeed feel they need, those objects returned. The Elgin Marbles, taken from Greece two centuries ago, are a problem that refuses to go away. Add to that the Egyptians, who are agitating for the loan (but eventually the return) of the Rosetta Stone. These two cases just happen to be the most famous of all the millions of pieces housed in the British Museum. If they were to be returned, how would that affect the museum's prestige? Might it affect the numbers of tourists who flock to its halls?

WITH ITS FORTY-FOUR Ionic pillars soaring forty-five feet high, the British Museum is a monument to the Greek ideal. Indeed, the architect Sir Robert Smirke based the 1823 design on a temple of Athena at Priene, an ancient Ionian city. The sculptures of the trian-

gular pediment, installed in 1852, are as familiar as they are emblematic of a certain time and a certain notion of architecture: Britain's nineteenth-century image of ancient Greece. The sculptures depict "The Progress of Civilization," fifteen allegorical figures that preside over the history and culture within the building's walls. The square, massive structure—ninety-four galleries of artwork on thirteen and a half acres of land—sits in the midst of a quiet stone esplanade, surrounded by a spiked iron gate, a few steps from bustling Oxford Street. Founded by an act of Parliament in 1753, the museum was conceived as an expression of the ideals of the Enlightenment—"promoting discovery and understanding of the whole of human knowledge, to advance the condition of the human species," the legislation declared. Despite the progressive philosophy, early visitors to the museum had to apply in writing to see if they were "proper to be admitted." If so, tickets were delivered by the porter, and only then might they attend, though no more than ten people per hour nor more than five in one party.

Sir Hans Sloane, a physician and collector of species, bequeathed to the state his collection of books, manuscripts, natural specimens, prints, drawings, and a smattering of antiquities, and these became an early cornerstone of the museum's holdings. Since then, more than two and a half centuries of collecting have made the museum into a thrilling survey of objects from around the world and through time. It holds untold treasures from the ancient world—here a pristine wig from ancient Egypt, and there a gracefully carved lyre from the site of a mass grave in Ur, the birthplace of Abraham. An entire building was transported here from Turkey: the Nereid Monument, a temple-tomb from the Lycian culture that was situated between Greece and Persia in the fourth century BC. The tomb, lit theatrically from within, is a graceful, imposing version of a Greek temple, adorned by windswept, water-sprayed sculptures of gods and goddesses that lend the structure a feeling of movement and emotion. A sign beside the tomb, whose sculptures take up an entire room the size of a soccer pitch, explains that the civilization was discovered in 1838 by a British explorer, Charles Fellows, who the following year received a permit from the Turkish authorities to excavate. But Fellows did far more than that. "The resulting finds were packed

and transported down the river and to the sea," the sign explains, adding that they "caused a sensation" when put on display in the museum. The sign does not elaborate. How was the Nereid Monument brought here? By what right did Fellows pick up an entire building and send it out of the region, rather than merely excavate and make drawings? The sign does say that Fellows made plaster casts of the sculptures, though that does not explain why the building was removed from its place of residence. One can only imagine.

In this new age of contested antiquities, more information seems to be demanded. In 2006 the British Museum appointed Jonathan Williams to be its full-time specialist in international relations. "I work across the different collections to strengthen our message about our international strategy work," he explained, as we strolled past the Nereid Monument. He confessed to knowing no more than was posted about Charles Fellows and how and why he took this building. Williams is actually a Roman historian by training, but the museum has been in need of someone to publicly articulate its mission and the necessity of keeping its collection intact.

What the British Museum does, Williams explained, "is to bring together representative pieces from three different great world civilizations, that are usually considered in isolation." He wandered up to the Rosetta Stone, in its glass vitrine, lit from below. The Greek script is absolutely tiny, and the stone is broken in a jagged edge across the top. I'd never noticed that the Rosetta Stone changes color dramatically to a lighter color near the top portion. "It is a closely interconnected story," Williams went on, "the ancient eastern Mediterranean and the Middle East. It is important to correct the traditional story about Greece. We cannot understand ancient Greece without understanding Mesopotamia and Egypt." The Rosetta Stone bears the traces of those who took it as the spoils of war. Along the side of the rectangular block is the painted inscription "Captured in Egypt by the British Army in 1801." And the other side reads, "Presented by King George III."

Williams's reference to the traditional story of Greece referred to notions that arose in the age of empire that served to feed the mythology of Western powers. Museums were built and assembled to burnish those legends. Now, Williams suggested, the British Musem was trying

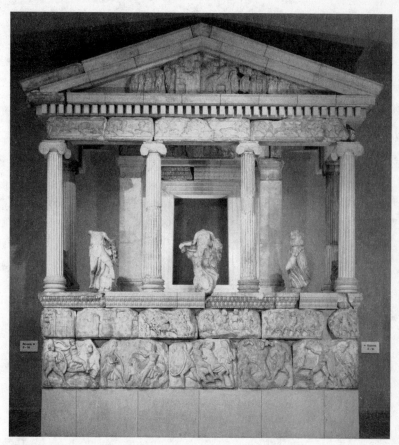

*The Nereid Monument at the British Museum.* (Photo by The Bridgeman Art Library/ Getty Images)

to get the story right. "The way Greece was imagined in European classicism, it was a place just like us—white, civilized," he said. "We used to think that the Greeks were just like us, while the Egyptians were entirely different. But the rise of civilization is all about the connections with Egypt and the Middle East." Take the Nereid Monument, he said. "No Greek would have buried himself in something like that," said Williams. "The average Greek would have thought that was a temple."

That is certainly relevant. It is interesting. But it is also interesting

to learn how Charles Fellows brought the Nereid Monument—then known as the Xanthian Monument—to this place during that age of empire. In fact Fellows was a sketch artist and archaeologist who in 1838 made a daring voyage to Asia Minor, where, by following the Xanthus River, he discovered the remains of Lycia, a kingdom referred to in the writings of Herodotus and Pliny the Elder. On returning home, Fellows published a journal of his discoveries and drawings of the items he'd found, sparking wonder at yet another new source of ancient art. The authorities at the British Museum decided they wanted to have some of these beautiful things in their collection and planned an expedition to get them. Through the British consul in Constantinople, the museum prevailed on the Ottoman government to allow the removal. Fellows volunteered his expertise, but in the end he had to organize and even finance the undertaking himself. In 1839 he went back to Asia Minor, and according to newspaper accounts at the time, he loaded up seventy-eight "large and heavy packages" on a British ship after "the greatest enterprise and self-denial on the part of the gentleman by whom they were discovered." Fellows received a knighthood for his work.

FILLING THE HALLS of the British Museum are many objects that were plundered in the most basic sense: taken without permission of the local populace, appropriated in the nineteenth century under the norms of the time, which is to say, without any consideration for the residents in the places of origin and often enough without even the accord of the governing authority. The Egyptian collection began with the Rosetta Stone and other antiquities confiscated from the French army in Egypt. Thereafter much of the massive collection— only an estimated 4 percent of the holdings are on display—came via commerce-minded collectors under *firmans* bribed from the Ottoman ruler at the time or without *firmans* at all.

The finds of Henry Salt, the British consul general in Egypt, with the help of the former strongman Giovanni Belzoni, are emblematic. Salt took the massive bust of Ramses II from the Ramasseum in the Valley of the Kings in a famous incident that involved weeks of work, bribes, and the hacking of monuments that were in the way. Howard

Carter, who later discovered the tomb of King Tut, wrote of that period, "Those were the great days of excavating. Anything to which a fancy was taken, from a scarab to an obelisk, was just appropriated, and if there was a difference with a brother excavator, one laid for him with a gun." But the museum's Web site makes it sound as if the Ottomans practically begged Salt to despoil the country. "Egypt then came under the control of Mohammed Ali, who was determined to welcome foreigners into the country. As a result foreign consuls began to form collections of antiquities," the site reads, with highly selective emphasis. "Henry Salt, Britain's consul, created a large collection with his agent Belzoni, who was responsible for the removal of the colossal bust of Ramses II, known as the 'Younger Memnon', presented to the British Museum in 1817." Salt was a diplomat, but his antiquities dealing was a thriving business, the start of decades in which Europeans grabbed for themselves the beauty and glory of ancient Egypt. He sold his work to the British Museum for a paltry two thousand pounds, rather than the eight thousand pounds he wanted, and the rest was auctioned for far more money after he died of an intestinal infection—still not rich—in 1827. The museum owes the public a more candid account.

E. A. Wallis Budge, the museum's keeper of Egyptian and Assyrian antiquities in this era, is hailed in Britain for his role in enriching the collection of the British Museum. But he too was a plunderer extraordinaire, bribing customs officials, smuggling in diplomatic pouches, and buying antiquity cases wholesale from pliable members of the antiquities service. Budge bought from the Rasuls, the famed Egyptian tomb-robbing family. He covertly exported twenty-four cases of antiquities, despite the furious objections of the Egyptian antiquities service—who were themselves French. Budge also stole a famous papyrus, the seventy-eight-foot-long "Book of the Dead," a rare, complete document painted for a royal scribe, secreting it out of the country in official military baggage. Budge insisted that he saved the papyrus from the grip of corrupt antiquities officials. Critical historians today beg to differ. "Budge's expeditions were models of illegal purchase, excavation and what can only be described as dubious archeological tactics," wrote Brian Fagan in his 1975 book *The Rape of the*

*Nile*. But this reevaluation is not reflected on the British Museum's Web site, which notes: "He was a man of great energy and very considerable intellectual abilities, a devoted servant of the Trustees of the Museum, who in his time both tripled the size of the Egyptian collections, and, by his numerous publications, greatly advanced popular enthusiasm for ancient Egypt." It goes on to observe with choice understatement, "The dealers' shops in Egypt were overflowing with objects from chance discoveries and illicit excavations. It was possible to purchase material freely, and in whatever area lay the interests of the purchaser. Budge exploited his opportunities with enthusiasm." That is as far as the museum goes to acknowledge the unsavory side of Budge's acquisitions. The museum passed a special minute in April 1887 commending Budge for his "energy," and he later received a knighthood.

The British Museum's spectacular acquisitions from Mesopotamia were made with the benefit of *firmans* from the Ottoman government, which ruled what is modern-day Iraq. A. H. Layard excavated at Nimrud and Nineveh, working first on behalf of a British viscount and then on behalf of the museum. He found the awesome, winged, human-headed bulls from the palace of Ashurnasirpal II and the black obelisk of Shalmaneser III, both from ninth-century BC Assyrian kings, even as the French consul at Mosul, M. Botta, was taking similar artifacts for the Louvre. The question whether the finds ought to have been sent to Europe did not arise. "Agents of the museum . . . plunged into the great mounds of the land of the Tigris and Euphrates and emerged rapturously and triumphantly with Assyria—sending another great tonnage of recovered history home to London" went one wince-inducing history of the collection from 1957. Budge, who followed Layard, was in the habit of buying vast numbers of cuneiform tablets from local residents and bringing them back to the museum in his suitcases. He thus managed to acquire some twenty thousand tablets and fragments.

Appropriation went hand in hand with discovery for other parts of the museum's holdings, such as the Aurel Stein Collection, Asian paintings and prints from the seventh to tenth centuries. Marc Aurel Stein, a British civil servant of Hungarian origin, traveled extensively

through central Asia in the early twentieth century, making archaeological finds along the Silk Road. His greatest discovery was made at the Mogao Caves, also known as the Caves of the Thousand Buddhas, near Dunhuang in Gansu Province, China. It was there that he discovered the Diamond Sutra, the world's oldest dated printed text, along with forty thousand other scrolls, all of which he removed by gradually winning the confidence of the caves' Buddhist caretaker. Some of the manuscripts are at the British Library.

Most problematic of all is the museum's collection of Benin bronzes. The British army invaded Benin in 1897, conquering the tiny West African kingdom, which is in present-day Nigeria. In a bloody campaign of retribution for the killing of eight British representatives, the British troops deposed the king and looted the territory, stealing a hoard of three thousand ancient works from the palace before burning it down. The artworks, in brass, bronze, and ivory, were sold in London and elsewhere, and many came to be in the British Museum through the curator Charles Read. As a result, very few of the relics remain in Africa; the majority are in Europe. Here is how the collection is described on the museum Web site: "During the last third of the nineteenth century, following imperial expeditions in what are now Ethiopia, Ghana and Nigeria, significant African collections were brought to the Museum. Most notably after the Benin expedition of 1897, 1000 brass plaques were placed in the British Museum for dispersal, 200 of which remain in the collection today." The euphemistic phrase "imperial expeditions" does a grave disservice to history. The artifacts, some over one thousand years old, tell much about the sophistication of Beninese art and cultural life. But they are also spiritual objects, used in ancient rituals that cannot be performed in their absence. Nigeria has repeatedly asked for their return, only to be turned down thus far on various grounds, including Nigeria's inability to protect the artifacts. That is certainly a legitimate concern. But I could find no mention of Nigeria's demand for restitution on the museum's Web site, hardly a sign of honesty in advertising. The British Museum sold off some of the bronzes to private collectors in 1950, and, shockingly, Nigeria was forced to buy back five stolen bronzes from Britain, at a cost of £800,000. In 2002 the museum sold another thirty bronzes to private collectors to raise cash. The museum's

failure to candidly acknowledge the violent history of that collection is ahistorical and undermines its self-appointed position as a custodian of the past.

In that sense, the British Museum is hardly unlike its peers. Ethiopia has for years been demanding the return of imperial and religious treasures stolen by British troops in 1868. The circumstances sound familiar; England sent troops to release two envoys held by the Ethiopian emperor Tewedros in Magdala, the capital; the emperor committed suicide, the city was destroyed, and the treasures looted. Today the spoils—including a golden crown, bibles, and illuminated manuscripts—are divided among the Victoria and Albert Museum, the British Library, and various British universities. The cobwebs need to be swept away and the daylight of truthful history acknowledged at all these institutions.

As concerns modern acquisitions of antiquities, the jury is still out, but the record is clearer. In 1998 the British Museum adopted a policy that it would no longer buy antiquities without clear provenance. This meant that the museum essentially opted out of participating in the marketplace of antiquities, which is rife with looted artifacts vaguely labeled as having come from a "private collection" or "Swiss collector" or "family heirloom" to mask their illicit origin. But before that time the museum had continued to enlarge its antiquities collections through purchases even as other museums, notably the Getty, were doing the same thing with far more excoriation. There is no simple way to track the source of these acquisitions or tally their provenances, no database for the public to consult. In the age of computers, this seems a strange lapse of information and one that denies the public the benefit of transparency. When asked, a museum official said that the British Museum acquired an estimated eleven thousand objects from 1980 through 2007, none of which had come through the controversial dealers Giacomo Medici and Robin Symes. She added that most of those artifacts were acquired from previously known collections in Europe. With its new policy in 1998, the museum adopted a code of ethics that follows the UNESCO guidelines, banning the possession of artifacts with no clear provenance that emerged from 1970 onward. Since most of the collection predates that code, it means that most of

the objects in the museum are officially exempt from scrutiny, no matter how dubious or reprehensible the path of their arrival.

HE WAS AN accomplished man, Thomas Bruce, the seventh Earl of Elgin. Handsome, educated, and with an unvarnished sense of duty to his class (upper), his king (George III), his party (Tory), and his nation, he was voted into the upper house of Parliament as a Scottish peer after a series of promotions in the army, having inherited his title at the tender age of five. By twenty-four, he had a seat in the House of Lords. The king sent the promising young Elgin off on sensitive diplomatic missions to Vienna and Berlin in the 1790s, as Europe presided over tumultuous political change. Elgin was then offered the chance to go to Constantinople as the ambassador to the Ottoman Empire. His life lay before him, a glittering path of acclaim and adventure.

But by the age of thirty-two, his fortunes began on a downward slide. In 1798 Lord Elgin was still unmarried, in declining health from asthma and, it seems, syphilis, which over time would progressively eat his nose off his face. And he was broke, a situation that would only worsen. His role in Constantinople was to represent the British Empire at a fateful moment. His mission was to secure Britain's access to the Black Sea and to confound any overtures between the Ottoman Empire and the dreaded French, who required constant vigilance, having just invaded Egypt under the command of their brilliant, upstart general Napoleon Bonaparte. Britain's Admiral Nelson was soon to sail to the rescue, but it was clear that the French were on the march in the Orient.

Of course, Elgin accepted the role. It was a prestigious position but it paid poorly, and his first move after the assignment was to marry Mary Nisbet, a twenty-one-year-old heiress and, it is said, a beauty. He badly needed an heiress; Elgin had borrowed a large sum to build himself a sprawling country estate, Broomhall, where his father's modest home had once stood. And while finishing Broomhall, Lord Elgin's architect, Thomas Harrison, made a fateful suggestion. Elgin's new position as ambassador, Harrison observed, offered a unique opportunity to educate the British people about Greek architecture and Greece itself, which was under the control of the Ottoman Empire. Elgin could

make a great contribution to British society, the architect suggested, by bringing back life-size plaster casts of Greek sculpture, which had been adopted among the cultural upper crust as the highest standard of civilized artistry.

Elgin was inspired by this mission. He saw that he could single-handedly raise the level of artistic appreciation in Great Britain and bestow "some benefit on the progress of taste" while aiding in the "advancement of literature and the arts" by bringing back copies of Greek artwork. He petitioned the British government for money to hire professional artists for this noble project. Unswayed by Elgin's

vision and lacking a slush fund for art appreciation, the government turned him down.

He was not deterred. Stopping in Italy on his way to his new assignment in Constantinople, Elgin hired the Italian painter Giovanni Battista Lusieri, who had been commissioned by the king of Naples to sketch the antiquities of Sicily, for his project. Lusieri could not complete such an assignment without help, and he went to Rome to recruit other artists. There were none to be had. Napoleon had recently conquered Italy, too, and had stripped the peninsula's museums of their finest works, sending them on to the Louvre in the time-honored tradition of the victor claiming the spoils of war. Italian artists were in great demand to help with the removals. Eventually Elgin prevailed: a Russian artist was hired along with architects who would do drawings of Greek buildings. The artists went directly to Athens to begin their work, while Lord and Lady Elgin arrived in Constantinople in May 1800.

Lord Elgin's project must be seen in the context of eighteenth- and nineteenth-century European plunder of ancient sites. It was a different time, with attitudes that are shocking to today's sensibilities. At that time, what antiquities you saw and you liked, you took. Perhaps you took it for the glory of your country or for the glory of your country estate. What you left untouched was either out of a vague sense of propriety or for lack of logistical support or for fear of running afoul of an unpredictable, often-distant authority (in most cases, Ottoman). It was rarely because of local sensitivities. For centuries, plunder had been the rule rather than the exception, and the privileges of colonial tribute and empire seemed to bestow similar entitlements. The nineteenth century inaugurated a whole new era of plunder, on a whole new scale of audacity. With the arrival of Napoleon in Egypt, wide-scale grabbing was about to begin in that unimaginably rich land. With the nascent science of archaeology came the parallel impulse to possess, and suddenly entire buildings from sun-drenched Mesopotamia and Asia Minor would end up reconstituted in cloud-covered capitals half a world away. With the rise of philhellenism in England and Germany in particular, the land that was ancient Greece was about to experience similar greed. Even France, fixated on Rome

more than ancient Greece, kept its hand in the game. Just before El-
gin's arrival, the French ambassador to Constantinople, the Comte de
Choiseul-Gouffier, sent his agent to Athens to make casts and draw-
ings at the Parthenon. His instructions left no room for uncertainty:
"Take everything you can," he wrote his agent, Fauvel. "Do not ne-
glect any opportunity to pillage anything that is pillageable in Athens
and its territory. Spare neither the dead nor the living." But even the
Turks drew the line at the Parthenon. Despite numerous requests, they
refused the count permission to remove any sculpture from the build-
ing. Nonetheless, Fauvel obtained a frieze and two metopes, individual
scenes of the battles of the gods, that had been dug up or were other-
wise found on the Acropolis. The first metope was captured during a
seizure of the French boat at sea by the British. It was sold to Lord
Elgin at auction in 1806. After a complicated journey, the frieze and a
single metope ended up at the Louvre, where they are displayed today
in the Hall of Diana.

Thus it began. But Lord Elgin's plan to make plaster casts and draw-
ings of the magnificent sculptures of the Acropolis became far more
complex and controversial. How it evolved into a project to remove the
sculptures themselves off the building is the story of an architectural
tragedy. It came about as the result of diplomatic feint, a response to
evolving relations between Britain and the Ottoman Empire and that
overambitious Corsican, Napoleon.

At first, Elgin's artists had no more luck than their French counter-
parts in working on the Acropolis. Back in Constantinople, Elgin en-
deavored, with scant success, to obtain a *firman* to make drawings of
the Acropolis and other ancient sites. What made all the difference,
unexpectedly, was Napoleon Bonaparte, who in 1798 had stormed
into Egypt, but the British were quick on his heels. In 1799 Admiral
Nelson's expeditionary force landed at Aboukir Bay in Egypt and, in a
brilliant move, cut the French off from their supplies. From there, it
was a continuing rout, with the British decimating the French fleet in
the Battle of the Nile, the French retreating farther inland, and the
British taking each successive city by siege. Soon Egypt was in the
hands of the British, who gave control back to the Ottoman Empire.
The news was received with great celebration in Constantinople, with

fireworks and music and gun salutes by warships in the harbor. Lord Elgin, whose country was responsible for this restoration of Ottoman power, became the celebrity of the moment, showered with exotic gifts of the court, including a jewel from the sultan's turban, a diamond-encrusted decoration, and a visit for Lady Elgin to the sultan's mother, escorted by a retinue of black eunuchs.

Also: the much-desired *firman* to work at the top of the Acropolis.

On June 17, 1801, the British received the French surrender of Cairo. On July 6, Lord Elgin obtained his cherished permit. It stipulated permission to:

1. enter freely within the walls of the Citadel, and to draw and model with plaster the ancient temples there.
2. to erect scaffolding and to dig where they may wish to discover the ancient foundations.
3. liberty to take away any sculptures or inscriptions which do not interfere with the works or walls of the Citadel.

As William St. Clair points out in his definitive account, *Lord Elgin and the Marbles*, "The firman confers no authority to remove sculptures from the building or to damage them in any way." So what happened? A rescue operation? Greed, fueled by the initial success with the Turks? Entitlement? A human need to possess the beauty it admires? Any and all of the above. The urge to possess dated from the very start of the project.

Elgin's chaplain, Reverend Philip Hunt, brought the *firman* to the voivode of Athens, the Ottoman authority in the city, and immediately pressed its limits, as he recounted in a letter at the time. He asked for permission to take down a metope from the Parthenon—the seventh one, one of the best surviving, situated at a corner of the south colonnade—and convinced the voivode that the *firman* granted permission to do so, even though it was not stated explicitly. It certainly helped that Hunt represented a foreign ambassador who basked in the sultan's favor. The disdar, the authority responsible for the Acropolis, protested, but he was ignored. As Hunt wrote rather cynically, "I did not even mention my having presents for him till the Metopes were in

motion." And so began the operation that eventually removed more than half of the remaining sculptures off what many consider to be the greatest single artistic achievement in Western history, in the service of giving British citizenry real-life models from which to craft better china, vases, and knickknacks. As he sent off the first two metopes, Hunt wrote, "I trust they will reach England in safety where they must prove of inestimable service in improving the National Taste." Elgin heartily agreed. "The very great variety in our manufactures, in objects either of elegance or luxury, offers a thousand applications for such details," he replied to Hunt. "A chair, a footstool, designs or shapes for porcelain, ornaments for cornices, nothing is indifferent."

At the time, it should be noted, the Acropolis was no tourist site with pristine monuments. For centuries, the Acropolis had been used as a military garrison, with direct responsibility held by local Turkish officers. Turks living at the top of the rock built houses and fortifications around the ruins, using ancient fragments in the walls of their homes or outer gates and using sculpture for fortification. Turkish soldiers dismantled reliefs lying about to remove the lead inside (which held the sculptures together) for their bullets. The interior of the Parthenon was now a mosque, while the pillars of the grand gate, the propylaea, were bricked halfway up to protect Turkish guns. The Parthenon was already partly destroyed. The propylaea had been used to store gunpowder and was exploded in 1645 during a lightning storm. And in 1687 the Venetians lay siege to the Acropolis. Their general Morosini set off a cannon blast that was a direct hit to the Parthenon, where the gunpowder was stored by the Turks. The roof was demolished, and one entire length of the Parthenon's colonnades was decimated. Morosini did still more damage when he tried to take home some sculptures. It was the worst moment in the Parthenon's history—until the arrival of Lord Elgin.

Even with the neglect of the Turkish soldiers and those living on the Acropolis in 1801, not everyone was indifferent to the startling sight of the dismantling of the Parthenon. Not everyone regarded this as a rescue operation, as many in Britain would have us believe today. Removing the sculptures meant removing integral parts of the building itself, not mere decorations. Taking the metopes block by block

left the Parthenon looking like a gap-toothed hag. Many were struck by this mutilation, even by the norms of the time. "I had the inexpressible mortification of being present when the Parthenon was despoiled of its finest sculpture," wrote the British traveler Edward Dodwell, in a book he published in 1819. "Instead of the picturesque beauty and high preservation in which I first saw it, it is now comparatively reduced to a state of shattered desolation." The disdar himself seemed progressively more distraught as operations proceeded, though he was unwilling to counter the agents of a powerful European ambassador. Another British traveler, Edward Daniel Clarke, wrote a sad account of watching the removal of a metope in 1801. "We saw this fine piece of sculpture raised from its station between the triglyphs," he wrote. "But the workmen endeavoring to give it a position adapted to the projected line of descent, a part of the adjoining masonry was loosened by the machinery, and down came the fine masses of Pentelican marble, scattering their white fragments with thundering noise among the ruins. The Disdar, seeing this, could no longer restrain his emotions. But actually took the pipe from his mouth, and letting fall a tear, said in a most emphatic tone of voice, 'Telos!' "—"The end!" or "Never again!"

But it was to happen again and again, until the Parthenon was denuded of its best sculpture. In ten months Elgin's people took more than half the sculpture they would eventually gather, including seven metopes and twenty slabs of frieze and whatever surviving figures of the pediments they could find. Elgin's agents also gathered antiquities in other parts of Greece and sent them on to London. A second set of dismantling took place from 1803. The destruction to the building that was integral to taking the sculptures seemed to weigh not just on the poor disdar but on Elgin's chief overseer Lusieri, who was, after all, a painter and not a contractor. He wrote to Elgin that he wanted to continue drawing: "I must do more still and I must want to try it, so that some barbarisms I have been obliged to commit in your service may be forgotten. . . . When the work of collecting is going on so furiously, how can I find the time to draw, or have the head for it?" The British architect Robert Smirke—who later designed the British Museum—came to Athens and witnessed Lusieri working on the Parthenon. "It particularly affected me when I saw the destruction

made to get down the basso-relievos on the walls of the cell [frieze]," he wrote, describing the iron crowbars used to lever the stones off the building. "Each stone as it fell shook the ground with its ponderous weight with a deep hollow noise; it seemed like a convulsive groan of the injured spirit of the Temple." The question whether Elgin was rescuing the Parthenon marbles or destroying them endures to this day. It's as if observers cannot decide how to qualify what happened. They give Elgin credit for preserving the sculpture, even while noting the objective destruction of the building that occurred as a result of his efforts. Even William St. Clair conflates these ideas. In one sentence he writes about a nineteenth-century observer, "He, too, was distressed at the *destruction* to the Parthenon which the *rescue* operation involved" (my emphasis). That is a sentence at war with itself.

The story of Lord Elgin's quest did not end with the *firman*. Nor did the adventures of Lord Elgin himself. It would be easy to interpret his life as having been cursed for stealing the sculptures, though the rational observer would more likely call it the natural consequence of his single-minded obsession. Having dismantled the Parthenon, Elgin needed to send the sculptures home. But the first shipment of marbles, seventeen cases' worth, ended up at the bottom of the Mediterranean in a storm-tossed shipwreck off the island of Cythera. It sat there for more than a year, awaiting retrieval. Meanwhile, Elgin managed to make an enemy of Napoleon, who had him arrested during a visit to France in 1805 and threw him in prison. Then Elgin lost his wife, the flamboyantly charming Lady Elgin, mother to his three children. He divorced her after she had an affair with his best friend, Robert Ferguson. That affair was trotted out in humiliating detail in court and, for good measure, in an act of Parliament. Napoleon finally released him, but at the price of Elgin's public career. The release was extracted on guarantee of parole, a promise that he would return to France when France so demanded. The British government could not risk employing him under such a constraint, and he lost his seat in the House of Lords. As if to mirror his fall from fortune, his appearance was in a state of constant deterioration because of his eroded nose.

Elgin's nearly ten-year obsession with the Parthenon marbles had

also ruined him financially. Taking the marbles had cost him more than sixty thousand pounds, most of it borrowed, and he had no means to return the loans. He was reduced to living quietly in a corner of Broomhall, his estate, having let go most of his servants. More sculptures remained to be brought to Britain, and a second set was marooned first near Athens, then in Malta, where Lusieri had managed to ship them. Once in London, the sculptures lacked storage options. Elgin had to move the marbles from one borrowed place to another; he scrambled for cash by selling his own property. Finally, in the wake of his entreaties, Parliament took up the matter of buying the sculptures from him. It offered thirty thousand pounds, half of what it had cost to gather them. Elgin refused. While negotiations foundered and months passed, Elgin's bills rose still higher.

> Noseless himself he brings here noseless blocks
> To show what time has done and what the pox.
>
> —*ditty about Elgin, popular in London around 1810*

In London, the first shipment of sculptures went on display in 1807, in a shed behind Piccadilly Circus. Artists and connoisseurs came to visit Elgin's marbles, for most people their first glimpse of original Greek art. This went some distance to restore Elgin's reputation. One visitor, a prominent painter, wrote to thank Elgin for this "rescue from barbarism." And while many artists were immediately influenced by the ancient Greeks' craft and their depth of understanding of the human form, others seemed intent on diminishing the sculptures' importance, notably the influential critic Richard Payne Knight, who called the marbles overrated and at first declared them Roman rather than Greek.

But from a moral perspective it was Lord Byron, the romantic poet, who turned the tide of public opinion against Elgin. Byron was a dashing figure who had traveled to the ancient world himself to see the sights and had been struck by the beauty of the ruins and their contrast to the impoverished Greeks who lived among them. His poetry vividly transmitted those feelings to the British public. Byron became a prime

mover in the nascent movement to awaken the Greeks to a nationalist agenda, and the Parthenon, as a symbol, was from the start a part of that sensibility. In his view, Lord Elgin was among those who had degraded and further abused the Greeks. He wrote his scorn in a lengthy poem called "Childe Harold's Pilgrimage," which attacked Elgin personally.

> But who, of all the plunderers of yon fane
> On high—where Pallas linger'd loth to flee
> The latest relic of her ancient reign;
> The last, the worst, dull spoiler, who was he?
> Blush, Caledonia! Such thy son could be!
> England! I joy no child he was of thine;
> Thy free-born men should spare what once
>     was free;
> Yet they could violate each saddening shrine;
> And bear these altars o'er the long-reluctant brine.

And later in "Curse of Minerva," he was even more explicit.

> What more I owe let gratitude attest—
> Know, Alaric and Elgin did the rest.
> That all may learn from whence the plunderer came,
> The insulted wall sustains his hated name.

In case verse was too obscure, Byron explained himself in prose, published along with the first poem. The poet, visibly, was furious: "Never did the littleness of man, and the vanity of his very best virtues, of patriotism to exalt, and of valour to defend his country, appear more conspicuous than in the record of what Athens was, and the certainty of what she now is. . . . How are the mighty fallen, when two painters [Lusieri and Fauvel] contest the privilege of plundering the Parthenon, and triumph in turn, according to the tenor of each succeeding firman! Sylla could but punish, Philip subdue, and Xerxes burn Athens; but it remained for the paltry Antiquarian, and his despicable agents, to render her contemptible as himself and his pursuits." "Childe Harold's Pilgrimage" sold out within days of its publication in 1812 and was circu-

lated everywhere in Britain, becoming one of the best-known poems of the century. Byron became and remains a national hero to the Greeks.

By the time Greek nationalists set to arms to overthrow the Turkish occupation in 1821, wholesale plunder was widespread in and around Athens. Soldiers, travelers, antiquarians were all led to pluck, or sometimes hack, bits off of great Greek monuments. Some (including Byron) left their names inscribed on them. There was little evidence that the Greeks themselves were moved to protest.

Lord Elgin never truly recovered from the multiple blows to his finances, his reputation, and his health that followed his pursuit of the Parthenon marbles. He did remarry and have more children, and he eventually reacquired his seat in the House of Lords. In 1816 the British Parliament voted to buy the sculptures from the beleaguered Elgin, for the sum of £35,000, just £5,000 more than had been offered a decade earlier.

But over time there was a certain vindication of Elgin's actions within Britain and elsewhere in the West. For one thing, those who had denigrated the beauty and importance of the Parthenon sculptures were proved definitively wrong. Once the sculptures were fully displayed in 1817, they were visited by artists, aficionados, and the general public and confirmed as landmarks of artistic grace. The sculptures proved to be highly influential as part of the neoclassical movement in Western architecture and the arts in general. The poet John Keats was so inspired by them that he would sit and stare for hours. His "Ode on a Grecian Urn" draws directly on imagery from the Parthenon friezes, and his contemplation of this and other Greek masterpieces in London led to the inspired words that ring down through the centuries: "Beauty is truth, truth beauty," he wrote, "that is all / Ye know on earth, and all ye need to know."

Yet there was one who never budged from his stance that Elgin was a criminal: Lord Byron, who went on to fight, and die, in the Greek war for independence from the Turks. "I opposed—and ever will oppose—the robbery of ruins from Athens to instruct the English in Sculpture—(who are capable of Sculpture as the Egyptians of skating)," he wrote, after public opinion had begun to swing in Elgin's direction. "Why did I do so?—the ruins are as poetical in Piccadilly as

they were in the Parthenon—but the Parthenon and its rock are less so without them."

From Greece's standpoint, the removal of the Parthenon sculptures was a constant, abiding humiliation. The independent Greek government, newly formed in 1833, immediately began repair work on the Acropolis, filled with the detritus of war and military occupation. The government made haste to officially request the return of the sculptures in 1835 after the British Museum offered plaster casts. But there was no agreement nor has there been in spite of the successive requests over more than 170 years for the marbles' return.

# A GREEK TRAGEDY

*You must understand what the Parthenon Marbles mean
to us. They are our pride. They are our sacrifices. They
are our noblest symbol of excellence. They are a tribute to
the democratic philosophy.*

—MELINA MERCOURI, GREEK MINISTER OF CULTURE, 1986

MORNING, 45 DEGREES CELSIUS, OVER 110 DEGREES
Fahrenheit. The cicadas protest violently. Their screeching tears
through the silence among the dry, scrubby pines that cling to the base
of the Acropolis, the sacred rock, the center of Athens. As an icon of
antiquity and a symbol of democracy, the Acropolis is unique in the
world. Visible from every side, it rises five hundred feet into the air, cul-
minating in a flattened ledge that provides a view, 360 degrees around, of
the world below, and a perch for one of the great artistic achievements in
human history, the Parthenon. It is the embodiment of drama, carved by
nature and enhanced by human hand. Nature and man have made the
glory of the Acropolis, and nature and man have destroyed the Acropo-
lis, too. The remains are ever remarkable. Here ancient Greece reached
its pinnacle, artistically and politically. Here modern Greece has turned
for its rebirth, reaching back through time—past foreign occupation, Ot-
toman dominance, ethnic dislocation, military dictatorships, and war—to
grasp the thread of past greatness.

I mount from the southeast side, where the goddess Athena's great
temple, imperious and in pieces, stares down from above. To reach

the Parthenon, one must tread a dirt path followed by millions—
worshippers, pilgrims, soldiers, explorers, vandals, tourists, thieves. To
the right of the base of the hill are the remains of a Byzantine chapel.
I continue past the Temple of Dionysus, of which today just a few
blocks of limestone remain. It is hot, too hot. Sweat trickles down my
back. I dream of silencing the cicadas' roar and suck on my plastic wa-
ter bottle gone warm. Hewn into the hillside is an ancient open-air
theater, one of the oldest known to humanity. It is lovely and open
and close to intact. The theater has a staircase carved deep into the
stone in twelve sections, radiating outward from the stage. A sign indi-
cates that this is the spot where Aeschylus's plays were first performed,
and those of Euripides, too. I spare a thought for the first Greek thes-
pians and continue upward, past a colonnaded promenade, sixty-four
Doric columns, a gift donated in the early second century BC by
Eumenes II, the king of Pergamon in Anatolia. Ten more minutes up is
the Sanctuary of Asclepios and his daughter Hygieia, the goddess of
health, built in 420 BC. Three white marble columns stand here anew,
the result of a restoration project. As the incline steepens, the city of
Athens unfolds below. I think of the pilgrims filing on this path for the
festival of Athena, the virgins and the young men leading garlanded cat-
tle, and I remember the sculptures of the Parthenon that depict the
pageantry of the ancient festival, occurring once every four years and
culminating in a ceremony to place a new woolen robe, a peplos, on the
gold and ivory statue of Athena in her temple. I pass another theater,
larger this time, from AD 161, one that seats six thousand spectators, do-
nated by Herodus Atticus. This theater is in Roman style, embellished
behind the stage with a towering backdrop of arched niches, each niche
occupied by a marble statue. The roof was made of Lebanese cedar, now
gone. Up I continue, sweating, heaving the thinning air, finally reaching
the entrance, the propylaea, the pillared gateway. A set of broad mar-
ble stairs (Roman) and a ramp (Greek) rise up toward majestic white
columns that line a simple pathway toward the Parthenon. The ceiling
of the propylaea was once painted blue with golden stars and had tower-
ing wooden doors. This is the doorway into the glories of the past at the
top of this hill, the heart of modern Greece's spiritual renaissance and its
embrace of democracy in the last century.

So much symbolism is bound up in the buildings on the top of this hill that it is easy to expect to be underwhelmed. But, like the great pyramids of Egypt, the Parthenon does not disappoint. Once, and for one thousand years, this temple stood as a pinnacle of the artistic and cultural achievement of the golden age of Athens. Pericles, the charismatic Athenian military leader, the populist, gifted orator, and democrat whose reign lasted from 461 to 429 BC, undertook this ambitious project. He entrusted the building of the Parthenon to his close friend the sculptor Phidias, who oversaw the design and execution. It would cost a fortune but take a relatively brief fifteen years. The famous frieze sculpted on the site under the supervision of Phidias followed the line of the roof along the inner structure for 480 feet all the way around. Ninety-two metopes adorned the space above the forty-six outer pillars. The pediments, the sculpted tableaux in the triangular spaces at the front and back entrances of the building, told on the east side the story of the birth of Athena as she sprang from the head of her father, Zeus, and on the west side the story of the contest between Athena and Poseidon to become the city's true patron. Practically none of this is on the Parthenon today. A couple of plaster metopes and frieze sculptures remain to give a whiff of the original glory, and one or two lonely original sculptures are on a corner. Compared to the original building, with its pristine columns topped by sculptures painted in a ribbon of vibrant gold and red and blue, the statue of Athena in ivory and gold in the middle of the temple, today the Parthenon is a bleached skeleton on a towering rock.

Still, in all its broken beauty, the crumbling rectangular ruin that stands today possesses an almost spiritual simplicity. Shorn of all remaining color, with a gaping hole along one side from a seventeenth-century explosion, stripped of its sculptures in the nineteenth century, its gargantuan statue of Athena stolen one thousand years before, surrounded by a web of scaffolding—it matters little. No one enters the Parthenon, with its base of twelve steep steps, three marble slabs, and then the building, through eight majestic columns. No, visitors walk around it and admire the view from every aspect, and then turn their backs and view Athens from every perspective as the backdrop. The building, so denuded and diminished, retains all of its dignity. Perhaps

*The Parthenon.* (Photo by Popperfoto/Getty Images)

it is all that still, empty air around the monument. I stare up at where the triangular pediment once held sculptures in high relief and see its stark, clean angles against the sky. Perhaps it is the contrast between the temple, looming large over the flat, rocky expanse at the top of the hill, and the urban clutter of Athens far in the background. The perfect symmetry of the building is such that it is not hard to imagine it complete. For all its reduced state, the Parthenon touches the soul.

Modern Greeks can claim a direct connection to the ancient Greek civilization, and do, but it is not a given that the average citizen pays much attention to the restitution debate or demands by the government for the return of stolen artifacts. Indeed, when the Getty museum agreed in July 2006 to return two of four objects that the Greek government had been demanding for many years—one a grave marker, the other a small marble relief—there was little public interest. "I was expecting it to be major news, but it barely made the prime-time newscast," said Anthee Carassava, the *New York Times*'s stringer in

Greece. "I was dumbfounded. Here was the moment Greece had been waiting for, and you'd think they'd make a big deal of it. It was nothing. I remember zapping through channels on the TV and looking on the front page. It wasn't there."

But it's not quite the same for the Parthenon, which the European Union officially designated its most important cultural heritage monument in March 2007. Like few other antiquities in Greece or anywhere else, this monument is so visible and so long-standing, so much a part of the physical landscape of Athens, and so woven into the mythology of modern-day Greece, that the reuniting of its marble sculptures from around the world is a subject that animates the average citizen in this small country of 11 million. Any taxi driver and barkeep will have a strong opinion about it, much less the director of the new museum that will house the Parthenon marbles. It is worth pointing out, however—as the Greek writer Nikos Dimou does—that apparently fully half of the residents of Athens have never visited the Acropolis. "I'm not so sure that Greeks are very proud of their antiquities," he said. Still, it is painful to imagine what it felt like to be an Athenian in the early nineteenth century, watching Lord Elgin's laborers stripping and hacking at the marbles over the better part of a decade to ship them to Britain. The Greek Ministry of Culture reminds the world of this in its official statements, in no uncertain terms: "Over a period of 10 years his men dismembered the Parthenon and removed sections of the buildings on the Acropolis. For 10 years the enslaved Greeks watched this great crime against their cultural heritage being perpetrated before their eyes." To leaven this remark with a bit of reality: Athens's population was ten thousand at that time, and the Turks had a military garrison on the Acropolis, where they dismantled marble columns to remove the lead for their bullets.

Today signs on the Acropolis everywhere say, "Do not touch the marble," and the slightest approach gets a shrill whistle from a guard. The sculptures taken by Lord Elgin have been reproduced in plaster and adorn the subway station of the Acropolis, with an accompanying admonition that the visitor will not be seeing those works when they emerge above. The Greek Ministry of Culture has any number of educational books and pamphlets designed to sting the conscience and sway the average foreign visitor about the justice of its quest to have

the marbles returned. One such booklet presents the sculptures at the British Museum with a vellum overlay showing other remnants possessed by Greece and then a third page uniting the two "after they are reunified in the New Acropolis Museum," the booklet states confidently. "Seeing these examples, the reader can appreciate the necessity of the reunification of all these sculptures," it reads, "the head misses its body, the horse's flanks need their legs and hooves, Goddess Athena's head calls for its torso, dismembered riders, sacrificed animals, votive bearers and Olympian Gods break the flow of the Panathenaic Procession." And indeed, the visual impact of the booklet feeds an undeniable logic. When seen in this way, all the strenuous arguments melt away, and it is hard to conclude anything other than that the sculptures belong together. And who, upon visiting the Parthenon, seeing the building where the frieze once hung high along the inner colonnade, the scenes of battle on the metopes above the outer colonnade, does not want to explore the sculptures in person? When visiting the Parthenon, it seems only logical, natural, *reasonable* that the sculptures that were once on the building should be viewable together, nearby.

It is this goal that Greece has assiduously pursued for decades, with a plan to build a state-of-the art museum at the base of the Acropolis that would eliminate any last argument over where the Parthenon marbles now housed in London belong.

ACCORDING TO GREECE, 56 of the 97 surviving sculptured blocks of the Parthenon frieze are in London, and 40 in Athens. Of the 64 metopes that survive, 48 are in Athens and 15 are in London. Of the 28 sculptures from the two pediments, 19 are in London and just 9 are in Athens. That makes 90 out of 189 sculptures, or about half, in London. Greece, calculating differently, counts this as about 60 percent of the sculptures, perhaps because the pediment sculptures are larger than the metopes.

Ever since the fall of the military junta that ruled Greece in from 1967 to 1974, the so-called Regime of the Colonels, and the reestablishment of democracy in modern-day Greece, the restoration of the Parthenon has been a national focus as a symbol of the country's embrace of democracy. Part of that project was a renewed impulse to

bring the Parthenon marbles back from London. But it wasn't until the early 1980s that the issue was elevated to a national cultural priority, as the Greek culture minister, Melina Mercouri, mounted an emotional campaign to rally fellow Greeks and average British citizens to the cause of repatriation. She argued the case on television, in the halls of the British Museum, and ringingly in a famous speech at the Oxford Union. An actress turned political activist who had been exiled by the junta for her antiregime positions, Mercouri emoted her pain over the missing marbles everywhere she could, including, at one point, tearily wailing her inner "ache" over the missing sculptures in front of British cameras. As Mercouri turned up the emotional pressure, Greece moved to respond to every argument that the British Museum had offered in favor of keeping the marbles, with successive steps designed to remove each justification.

Britain said, for example, that Lord Elgin did the world a great favor by removing the marbles because pollution and grime in Athens had caused the deterioration of the marbles that remained. Despite the fact that Lord Elgin could not have known about future pollution when he took the marbles, in practical terms this was true. Marble is a highly susceptible stone, and the sculptures left on the temple were eroded badly in the pollution of industrialized, twentieth-century Athens, the chief culprits being car exhaust and acid rain. In 1975 Greece removed many of the remaining sculptures from the Parthenon and in 1979 took down the remaining, stunning caryatids—graceful female figures who serve as pillars on the nearby Erechtheion temple— and placed them in a museum on the Acropolis. "I came back from studying in Germany in the 1970s," recalled Alexander Mantis, the director of the Acropolis and the chief archaeologist for the Athens region. "You could not breathe in Athens. You could not see in front of you when you drove." The rest of the sculptures were removed from the west frieze in 1993, after weather damage. Greek authorities moved to slow the rate of pollution damage, blocking traffic beneath the Acropolis and closing the road around the hill. In the 1970s the area around the Acropolis was a red-light district, famous for its brothels. Those were closed as well, and the neighborhood began to improve. Greece also took drastic measures to reduce pollution, offering trade-ins

of old polluting cars and introducing an odd/even license plate system for driving privileges in the capital.

The Greeks simultaneously began an ambitious renovation project to restore the Parthenon and reverse the poorly done restoration of the nineteenth and early twentieth centuries, such as the use of metal pins, susceptible to rust, in the marble columns. Greek archaeologists fully documented the site. New marble was brought in from the original quarry on Mount Pentelicus outside of Athens to fill in chipped areas of the column drums and lintels. The monument was restabilized to guard against earthquakes. Today the reconstruction continues, and the south side of the monument is a mostly restored row of pristine white columns. The other side, where a hole was blown in the colonnade during the standoff between Venetian and Turkish forces in 1687, will not be fully restored, but the damage will be mitigated. Ultimately, almost all the major pieces of marble will be placed in the structure where they originally would have been, supported as needed by modern materials.

The most powerful argument the British had was that the Parthenon marbles taken by Lord Elgin were safer in London, better cared for, and better displayed. The galleries built to house the marbles—a long, narrow space with beige walls and a high, curved ceiling, with the sculptures hung low enough for a close viewing—were better than the cramped, uneven spaces in the 4,500-square-foot museum on the top of the Acropolis. It was glaringly obvious that the Greek museum did not have space for the Elgin Marbles even if England would have sent them.

In answer to this argument, Greece announced plans to build a grand new museum that would be able to house all the Parthenon sculptures. A competition was held among Greek architects in 1977, but neither that call for entries nor another in 1979 yielded a winning design, and the momentum and funding for the project withered. "Nothing was exceptional, and we lost time," said Mantis. In the 1980s, as excavation and restoration continued on the Acropolis, more space was created in the area by removing a subway station. In 1989 and 1990 a new competition for design entries was held, this time with international entries, and five hundred designs flooded in. The winners were a pair of young Italian architects, Manfredi Nicoletti and Lucio Passarelli, who conceived of a sprawling, 350,000-square-foot, $100

million museum with the entrance and part of the structure below ground, "so as to convey the idea of a descent into history," Nicoletti said in 1990, on winning the commission.

Sitting in his office at the base of the Acropolis, Mantis, a lanky man in his fifties with tousled gray hair and pale green eyes, sighed as he recounted this history. Excavation had begun on the site for the museum at the base of the Acropolis, and an extensive late Roman and Byzantine settlement was found, with houses, streets, shops, and baths. Debate began over whether it was proper to build a new museum on top of the remains of an important Roman-era site. It could not be built, not with this design, and in the end the project had to be abandoned. Another decade passed. It was not until 2000 that a new competition was held for architectural proposals, and this time a design from the Swiss-born, New York–based architect Bernard Tschumi was chosen. His three-story design allowed for a glass floor built on stilts at ground level that would exhibit a portion of the excavations recently uncovered and, most spectacularly, a top-floor gallery made of specially designed glass, where the Parthenon sculptures would be arranged in a shape echoing that of the actual building, within view of the monument, some three hundred yards away. Construction was to begin in 2002 and be completed in time for the Athens Olympics in 2004.

But could Greece be organized enough to bring this project to fruition? For a long time the answer seemed in doubt. Indeed, this was far from the end of the controversy over the new museum. The engineer and the architect clashed over the design, and the former—who wanted a building that echoed the symmetry of the Parthenon—was fired. Critics complained that the heavy, angular, and dark contemporary building was too monolithic and stylistically out of step with the surrounding residential neighborhood, made up mostly of tourist shops and unremarkable apartment buildings from the 1970s along with some beautiful art deco buildings from the 1920s. Lawsuits began raining down on the municipality from angry residents and shop owners who had to be moved out of the area to make way for the new building, and others who didn't like the idea of this heavy new structure—200,000 square feet—looming over their daily lives and into their bedroom windows. Months, then years, passed with

construction bogged down by lawsuits. At one point a group of Greek scholars persuaded the country's top administrative court to stop work on part of the archaeological site below. The government then stepped in to move things along more aggressively, with the police forcibly emptying apartments in 2003 that had been condemned. News reports said that residents barely had time to collect their things, while the protest leader was reportedly carried off in a headlock. The Olympics came and went, and the project was not anywhere close to completion. Instead there was a flurry of embarrassing news stories around the world about how the Greeks could not finish their famed national project in time. The lawsuits and protests continued, as construction inched along for another four years. But finally the building rose, despite lingering local resentment. In late 2007 Greek officials were projecting an opening date of mid-2008, while Mantis said even that was too optimistic.

When the *New York Times* asked Bernard Tschumi in 2004 about the Elgin Marbles and the new museum, he waxed optimistic. "I truly believe that the day the museum is finished, the marbles will return," he said.

DIMITRIOS PANDERMALIS IS a reserved man. Sixty-seven years old, he is compact of frame, with a graying head of hair and sympathetic eyes under bushy brows. He smiles easily and keeps a disco ringtone on his cell phone. He is not given to great displays of emotion, and he does not get exercised over the Elgin Marbles. The impassioned antics of Melina Mercouri are not for a reasoned academic like him. As a young graduate student, Pandermalis studied philosophy and enjoyed languages, literature, and history. "And I was really fascinated by ancient material culture," he explains to me. "You can deal better with ideas if you have the material thing." He does not talk about "pillaging" by the British or the evil ways of the "Asiatic barbarian" (that would be the Turks), as his colleague Alexander Mantis has been known to do. "It's the pride of the nation," Pandermalis says calmly of the Parthenon sculptures. "But I don't like to express it. I prefer to be silent on the issue."

As the president of the New Acropolis Museum, Pandermalis is entrusted with the momentous task of overseeing the construction of the $195 million new building and ensuring that its message is accu-

rately transmitted to the world. For seven years, his life has been dedi-
cated to the completion of this national project, a fact that he believes
should speak loudly enough as to how he feels about the reunion of its
sculptures. "For me—you think a little, you know a little history," he
says with a gentle smile, in his office beside the construction site,
where he is surrounded by piles of paper, architectural plans, photos,
books, and several pairs of eyeglasses. "They say it's nationalism. It has
nothing to do with that. For me, it's—a part of my life." His fingertips
are stained with ink. His cell phone, the one with the disco ringtone,
keeps going off. The contractor wants to check the dimensions of the
scaffolding. The workers want a break; it's too hot. A few minutes
later, the workers want to leave; it's too hot. "The idea of return is not
merely 'give the treasures back,' " he says. "It's part of an extended
program to reunify the architectural pieces, to put together what was
broken. From the viewpoint of an archaeologist, this is the only cor-
rect thing: if something is broken, you put it together."

Across from his office in the functional brick building that houses
the headquarters for the archaeological service at the Acropolis, the
new glass and concrete building is rising in a steady whine of metal
saws and the loud warning bells of incoming freight. Donning a hard
hat, Pandermalis, in gray pin-striped trousers and a white Oxford-cloth
shirt, can scarcely conceal his excitement as he leads me through the
entrance of the building as it takes its final shape. After years of com-
mon struggle, Pandermalis has bonded with the workers, who take
evident pride in their pounding and sawing. He walks toward the en-
trance, where the glass floor beneath our feet reveals a sixth-century AD
tower unearthed during excavations. Also visible are public baths and
private houses from the late Roman through the early Byzantine pe-
riods. The contemporary building looks forbidding from the outside,
but on the inside it is spacious and airy, with a broad, dramatic ramp
leading up to the second floor, eventually to be lined with sculptures
from the Acropolis and mimicking the entrance up toward the propy-
laea. The gallery on the second floor, the Archaic Gallery, has a soaring
ceiling thirty feet high that will hold the sculptures found buried at the
top of the Acropolis that date from before the Parthenon was built. In
this space, a monumental plaster Athena is wearing a hard hat.

The museum was only partially the response to the British contention that Greece had nowhere to house the Elgin Marbles, Pandermalis says. "It's from a real need," he explains, pointing out that one-third of Greece's Parthenon sculptures are in storage, and other bits are in different museums. "We need it."

Walking up a still-inanimate escalator, we arrive at the third floor and the centerpiece of the museum, the Parthenon Galleries. It is a vast, rectangular glass hall, the contemporary-style space laid out to match the size and the shape of the Parthenon itself, which is visible perched up on its cliff. Extending a hand, Pandermalis feels the glass— it is well over a hundred degrees outside—and nods approvingly. This particular low-iron glass was designed by an engineer who promised it would absorb 80 percent of the searing heat in Athens. So far, it does. Around the windows, a marble ledge will allow visitors to sit and feel pockets of cold air along the glass, a kind of cold "skin" around the room. But the entire gallery is pivoted toward the orientation of the Parthenon, making the experience of mentally placing the marbles on their original home an automatic step. The space overall is contemporary, with the columns—the same number as on the Parthenon—not Doric in style, but smooth, stainless steel supports for the structure. The metopes will be placed at eye level, between the columns, while the frieze will be placed a few feet above eye level, far lower than it was on the actual Parthenon. Arranged in an outward-facing rectangle, 69.3 by 191.4 feet (21 by 58 meters), the sculptures will otherwise be presented as they were 2,500 years ago. The entire frieze, all 480 feet of it, will be arrayed here, but substituting for the sculptures in England there will be plaster reproductions, displayed under a gray scrim, a kind of shroud. (Apparently Greece moved away from the defiant position it held a few years earlier, when the culture minister, Evangelos Venizelos, swore that if the marbles were not returned, the gallery would sit empty, "as a constant reminder of this unfulfilled debt to world heritage.")

"We want to give the visitor the feeling not just of the sculptures but of the whole building," said Alexander Mantis, in an earlier conversation. "We have to construct a structure resembling the Parthenon itself so we can present the sculptures in the same way as they were

*The New Acropolis Museum in Athens.* (Photo © Sharon Waxman)

then." This approach, both Mantis and Pandermalis were swift to point out, is the reverse of how the sculptures are presented in London. At the British Museum, "you see the sculptures facing inside, not facing outside. We want to show the relationship of the sculpture to the building," said Mantis. Pandermalis agrees. "One display is presenting the fragments in portions, like paintings, hanging in a big hall," he observes of the British Museum. "We say, 'These are architectural sculptures that are derived from a building and need to be seen that way.'"

To Pandermalis and most Greeks, it seems self-evident that once the new museum is completed, the logic of this space will demand the

return of the Elgin Marbles. There is no small truth to this statement. Standing near the marble windowseat, a few yards from where plaster models of the frieze sculptures stand in for the real ones, a few hundred yards from the edge of the Parthenon, I had what might be called a "blink" moment, in the parlance of the cultural observer Malcolm Gladwell. Without quite knowing why, and in the space of an instant, I understood and agreed that the authentic Parthenon sculptures belonged in this space. The average person would, I think, blink, too.

People other than those who run the British Museum have already signed on to this logic. Pieces of the Parthenon are all over the world, and bit by bit they keep coming back. There are fragments of the Parthenon sculptures in the Louvre, the Vatican, the Glyptothek in Munich—in a total of nine museums outside of Greece. There are other pieces scattered in the homes of individuals whose ancestors were among the Victorian souvenir seekers, and many other pieces are undoubtedly lost forever. "People feel the necessity to give back a single fragment," said Mantis. "They come here to give it back; it has meaning." In January 2006 the University of Heidelberg returned a fragment of a relief from the Parthenon's north frieze. In November a retired Swedish gym teacher returned a piece of sculpted marble taken from the Erechtheion temple beside the Parthenon, a piece that had been in her family for 110 years. In April 2007 the son of an eminent British scholar, following his father's will, returned six ancient ceramic artifacts to "his beloved Greece." In June a fragment of an ancient marble relief was returned by a Danish family that had owned it for over a century. And in September an ancient stone coffin and a sculpture of a lion's head were returned by private owners in the United States.

And yet the negotiations with London over the Elgin Marbles proceeded with little change. Meetings happened, but they served little purpose beyond pleasantries. In April 2007 Pandermalis and the minister of culture met with British officials at the British Museum in London. The museum moved a half-inch forward, according to Pandermalis, saying that it might be possible to send the sculptures to Greece for a limited time. But no further news followed.

Pandermalis is tired of the various accusations. He doesn't accept that the friezes are better cared for in London. "It's ridiculous to argue

this," he says, pointing out that neither side is perfect. "It's not the bad British and the good Greeks, or the bad Greeks and the good British. For me, to realize this symbol you have to see it in its entirety. I can't deal with feelings. I'm here to make the best environment possible for classical sculpture. And I'm open to any collaboration. We have to change ourselves. To share. To receive. To exchange pieces. We have to develop this attitude. I have the feeling, it's my personal impression, that with discussions and negotiations, we can find a solution. I have followed this issue for the last fifteen years. It started as a very hot polemic. Now both sides speak about mutual exchange. I see it from a distance."

How far should Greece push? "I don't know," he says. "For many years the British refused on the ground that we didn't have an appropriate place to put the marbles. Now we have it, and we are proud. This was my duty."

THE BRITISH ARGUMENT for keeping the Elgin Marbles has evolved over the years, but it progresses more or less like this: Lord Elgin rescued the sculptures, which were being destroyed by the Turks and neglected by the Greeks. France would have taken them had Elgin not done so first. The Greeks did not preserve the remaining sculptures and allowed them to be further eroded by industrial pollution. The Greeks do not have a proper place to display the sculptures. The British Museum has done a superior job preserving and displaying the sculptures.

The preservation argument had been a strong one. But in 1998 a new edition of *Lord Elgin and the Marbles* by William St. Clair revealed a little-known episode that essentially pulverized that logic. It turned out that the British Museum had overseen a radical "cleaning" of the marbles in the late 1930s, using metal tools and harsh chemicals. The cleaning removed traces of color that had been on the sculptures, along with their millennia-old patina. Worse, the British Museum decided to cover up its mistake. In this case, the superior knowledge and scientific acumen of the West were defeated by its own arrogance.

Most visitors to the Acropolis in the late eighteenth and early nineteenth centuries noted that the Parthenon was a rust-colored brown, reflected in many of the sketches and watercolors made by travelers.

James Stuart and Nicholas Revett, chroniclers of the Parthenon in the 1750s, took note of traces of paint on the sculptures, which had originally been coated in bright, rich colors and hung with gold ornaments. When the Elgin Marbles arrived at the British Museum in 1816, they were the color that the marble had aged over thousands of years, a honey-brown. The natural exposure of the marble to the elements had created a protective patina over the original surface. But Europeans influenced by Johann Winckelmann, the eighteenth-century German taste maker and a founding force in art history, believed that Greek sculptures ought to be white, which was indeed the color of the marble when quarried. Copies of Roman and Greek sculptures scattered throughout the estates and castles of Europe were white. According to the revivified Greek aesthetic—reflected in buildings springing up across England and Germany—Greek art was meant to be white, despite evidence that in ancient Greece most monuments were brightly colored. And in the 1930s, as notions of racial superiority took hold, the northern European ethos was that of purity and cleanliness, just the opposite of the raucous culture associated with vibrant color and the culture of the Mediterranean. Thus, while the archaeological evidence showed that Greek architecture and sculpture were highly colored, such a view ran counter to political ideas at the time, and it was rejected.

The Parthenon marbles in dingy London were not white, nor close to it. When Sir Joseph Duveen, a millionaire art dealer, offered to donate money for a new gallery to properly house and display the Parthenon sculptures, the British Museum gratefully accepted. But Lord Duveen had his own ideas about how the marbles should look. In step with contemporary standards of beauty, he wanted them whiter. Disregarding accepted preservation policies, the British Museum simply allowed the donor to undertake various schemes to improve the look of the marbles. Work began in 1936 on the new galleries and proceeded from mid-1937 on the sculptures themselves. Incredibly, Duveen's workers were given free access to the marbles. It was not until September 1938 that the director of the museum, John Forsdyke, passed through the sculpture department and noticed a group of sculptures being cleaned with a number of copper tools and a piece of coarse Carborundum, a hard

substance usually used for grinding steel or polishing granite. "From the appearance of the sculptures he at once saw that the tools had been used on the sculptures," read the official report by the museum's trustees. The report went on: "Some important pieces had been greatly damaged. . . . The effect of the method employed in cleaning the sculptures has been to remove the surface of the marble and to impart to it a smooth and white appearance. Mr. Pryce [the assistant keeper of the marbles] described the Selene's horse's head as having been 'skinned.' "

That was bad enough, but more outrages were to follow. Rather than face the humiliation of admitting such a fundamental lapse of stewardship over the sculptures so long demanded by Greece, the museum authorities decided to cover it up. A second report in December 1938 concluded disingenuously that "a public statement need not be made." The Duveen Gallery was meant to open in the spring of 1939; but the damage was visible and likely to raise questions. So the museum tried to cover its tracks. The report noted that "remedial measures" had been taken by the director and a scientific expert that "mitigated to a considerable extent the evidence of the treatment." St. Clair interprets this to mean that the museum *recolored* the marbles brown. The museum has not denied doing so. In addition, the museum staff most directly involved with the cleaning episode were not disciplined but were pressed to resign, quietly. So the episode might have passed unnoticed. But in 1939 rumors in the art world about damage to the sculptures began to leak to the press. The museum was forced to respond and, in doing so, lied by half-truth: "Unauthorized methods were being introduced in some instances" and "The effects of the methods used were imperceptible to anyone but an expert" were the responses given. There were questions in Parliament about the matter. More half-truths: "If any damage has been done, it is completely imperceptible to ordinary people like ourselves," said the financial secretary to the treasury, Harry Crookshank. According to St. Clair, a Foreign Office file about the copper tools damaging the sculptures was destroyed. The relevant documents were suppressed. Europe was about to go to war, and when it did the Parthenon sculptures remained out of sight until after the end of World War II. By the time they reappeared in 1949, few remembered

exactly what the sculptures had looked like before being taken from view. Officially, it was as if the cleaning had never happened.

For decades after, the museum ignored the episode of damage done to the Elgin Marbles or treated it as a triviality. The museum continued to trumpet the argument that it was an outstanding custodian of these masterpieces, preserving them for the public and for scholars on behalf of the entire world. Meanwhile, St. Clair estimates that 80 to 90 percent of the frieze, all the metopes, and half the pedimental sculptures were damaged by the cleaning. Only a minority were not damaged. He concludes with devastating directness: "Now that the British Museum's stewardship of the Elgin Marbles turns out to have been a cynical sham for more than half a century, the British claim to a trusteeship has been forfeited."

The revelation of the cleaning episode led to an uproar and created a fair amount of tension between Greek scholars and the British Museum. The episode was of course known within the museum before 1999, but it was not widely disseminated. Alexander Mantis excoriates himself for not having noticed the damage to the sculptures during his previous research trips to London. "After you read the information and the sources and you look at the sculptures again, you see it," he said. "This is a degree of damage that's been done, and it is quite visible. You can see where the metal tools scraped the marble." As a young scholar, Mantis once had a three-month scholarship from the British School in Athens to work in London. He poked around in the storerooms of the British Museum for hours, alone, held fragments of the Parthenon in his hand. "I've seen it from many points of view," he said. "We still discuss it. We don't think morning, noon, and night about the Elgin Marbles. But Greece and Britain used to have good relations." In the wake of the news, the British Museum convened an international seminar on the damage, and Alexander Mantis and Dimitrios Pandermalis were included in the Greek delegation. The conference further inflamed tensions between British and Greek scholars. After tense days of discussion, the closing reception was held in the Duveen Gallery, where wine and sandwiches were served. A museum official invited the scholars—who had been handling greasy sandwiches—to touch the sculptures for themselves, a gesture intended to demonstrate

that the patina of the sculptures had not been harmed by the cleaning. But the gesture had the opposite effect. The Greek delegation was incensed and stormed out. The incident became known as "the food fight" at the British Museum.

Ian Jenkins, the British Museum's curator for the Greek and Roman collection, disputed some of St. Clair's conclusions. In an e-mail, he argued that there were numerous errors of fact in St. Clair's account. He estimated that only about 40 percent of the west frieze was damaged by the cleaning, about 60 percent of the backgrounds rather than the figures of the metopes, and only 10 percent of the east pediment. He pointed out that the Greeks had also "skinned" one of the friezes in their possession in 1953 "but no one complained." Mainly, though, he defended the museum for having made a mistake in the distant past, while the Greeks allowed damage to continue to the remaining sculptures in this generation. "The scandal of the British Museum's cleaning of the Elgin Marbles 60 years ago is not what they did, but the way they did it," he wrote. "The fact that the cleaning was unauthorized was a scandal; the way the Museum tried and failed to cover it up, was a scandal." He concluded that the 1930s cleaning was "an unfortunate incident of another generation and another age," but it did not change the museum's commitment to safeguarding the sculptures.

One doubts that anyone in Greece is swayed by these counterarguments. It is notable that the British Museum still does not mention the cleaning episode in the public galleries, where pamphlets are stacked about the Elgin controversy for the perusal of visitors. History, we are reminded yet again, is a selective affair. In a lengthy article published in September 2007, the BBC reporter Trevor Timpson described a new film at the British Museum that showed the Parthenon sculptures re-created digitally with full color. He never mentioned that the museum had itself removed remaining color from the marbles and in a stunning bit of unintentional irony wrote in his lead sentence: "The Elgin Marbles in the British Museum are marvelous—but they're a bit, well, *colourless*, aren't they?"

# HARD-LINERS

THE DAY WAS GRAY AND MILD, AND THE MASSIVE, NEO-Gothic spires of the House of Parliament loomed with intimidating force.

Great Britain's power lies here. A visitor is meant to feel its weight and its history. The sheer size of the Parliament, which takes up two full city blocks along the Thames, is enough to make any pedestrian feel insignificant. I passed the statue of Oliver Cromwell, the purifying tyrant, and a bronze, rearing horse bearing Richard the Lion-Hearted, the unlucky crusader king.

But on approach, the realities of the postmodern world, with its incertitudes and fears, undermined the impression of an unshakable institution. A fifteen-foot-high iron protective screen kept passersby from approaching, and ubiquitous security cameras were trained on the groups of schoolchildren and foreign tourists who came to visit.

This parliamentary building dates to the mid-nineteenth century, when it was rebuilt in high neo-Gothic style after a fire in 1834 gutted the original structure, once home to medieval monarchs as the palace of Westminster. It is one of the largest parliaments in the world—some 1,200 rooms and two miles of corridors—erected at the dawn of the

Victorian era, when the sun never set on the British Empire, when the glories of the naval fleet were freshly told, and when the ancient Mediterranean past was being found by explorers and adventurers and its myths adopted and adapted to fit the prevailing tale of national greatness.

In the House of Lords, where I was headed, no possible opulence was spared for the peers of the realm. The vestibule outside the parliamentary chamber features a life-size marble statue of a youthful Queen Victoria—back ramrod straight, one arm crooked upward with monarchical certitude—flanked by two marble sentries. Around her, filling the niches on the soaring, wainscoted walls and ceilings, are oil paintings of her predecessors and relations: Henry VIII, with his succession of wives, including Anne Boleyn, Jane Seymour, Anne of Cleves. Below the paintings, sculpted friezes in black stone portray various scenes of conquest and governance.

Still, the vestibule is a trifle compared to the cavernous Royal Gallery next door, through which Queen Elizabeth II "processes" on the annual day that she opens Parliament with a speech and a wave and the blaring of trumpets. The room is immense, half the size of a football field. And empty, save for the elaborate decor. Here the paintings are larger than life-size and hover near the intricate wooden carved ceilings, painted gold and burgundy red: King George I, with a flowing white wig, King George III (the last monarch to rule America), King Edward VII, and at the far end of the hall, the reigning Queen Elizabeth II, Prince Philip, and the recently deceased Queen Mother. In the center of the hall, a twenty-foot-long mural depicts the glorious death of Lord Nelson in the heat of battle at Trafalgar. The facing wall portrays the defeat of the French at Waterloo. At the state opening of Parliament, the queen makes her appearance here, parading in full formal dress through these halls to an elaborate throne within the House of Lords chamber where she presides, wearing the Imperial State Crown with its Black Prince ruby in the center. The members of the House of Commons gather at the opposite entrance to the chamber, forbidden to enter but bidden to stand and listen to the monarch's address.

In the midst of all this glory, it was a little surprising to meet Colin Renfrew—Lord Renfrew of Kaimsthorn—a rather sweet-looking man nearly seventy years old, with a white pudding complexion and stooped

shoulders, who came to fetch his visitor at the entrance to the House of Lords old-school style, summoned by a porter in full formal dress, complete with tails.

Dressed in a loose jacket and sensible shoes, Lord Renfrew earned his title in an era when most members of the House of Lords were conferred by the queen for merit or leadership, rather than inherited by blood. Lord Renfrew has been a member of the House of Lords since 1991, and until his retirement in 2007 he was the head of Cambridge University's archaeology department. He was also the founder of the Illicit Antiquities Research Centre in Cambridge, which tracked looting at archaeological sites. Renfrew more or less single-handedly put the issue of looted antiquities on the public agenda. He has spoken out tirelessly and vociferously on the subject of museums and looted objects and enthusiastically advocated their return. Still, I could not help feeling a sense of irony in meeting him here, in the Parliament, where numerous debates have rejected calls to return the Elgin Marbles and where Elgin himself won his seat in the Lords, then lost it. And there's this: so many precious antiquities were taken on behalf of the British Empire, by men who were rewarded for having done so by Renfrew's predecessors.

Nonetheless, it's a new era, and Lord Renfrew represented its vanguard as far as antiquities were concerned. Seated in a hallway (the only quiet place we could find to chat), he explained how he came to dedicate himself to the subject. It was an outgrowth of his work as an archaeologist. After studying natural sciences and archaeology at Cambridge, he became the head of the archaeology department at the University of Sheffield. He returned to Cambridge in the 1990s to become the master of Jesus College and, in time, to lead the archaeology department. While digging for antiquities on the island of Keros, in the Cyclades islands of Greece, Renfrew became increasingly cognizant of illegal traffic in Cycladic sculptures, abstract figures whose simple curves and geometric elegance delighted collectors and inspired modernist sculptors such as Giacometti. The figures began turning up for sale in art auctions and elsewhere, with no record of where they came from or how they were found. Renfrew realized that the dealers were robbing history of the understanding of how the sculptures came to be and what

purpose they served in ancient society. "I became increasingly angered by the damage being done to our heritage, by this very selfish looting for personal gain, with ill-advised museums betraying their trust," he said. He gave an example: a five-foot Cycladic figure in the British Museum that dates back to 2500 BC but has no known provenance. "So it is not known how it was used, if it was in a shrine, a sanctuary," he said. "We're deprived of our heritage by the looting process."

Renfrew blames American museums for being the worst offenders in encouraging the continued looting. "I get very angry with the hypocrisy of the Philippe de Montebellos," he said, as the former prime minister Margaret Thatcher, now a baroness, dressed in a tan coat with fur collar, tottered by on the arm of a supporter. On the wall behind us in the hallway was a massive painting of the sitting members on the benches of the House of Lords. Lord Renfrew, a Conservative, was recognizable in the painting, seated just behind Thatcher. His round face turned red during much of our interview as he skewered the practices of many American museums, the Met chief among them. "The most scandalous thing about the Met is the way they lead collectors like Shelby White, encouraging them to buy all these looted pieces and then exhibiting them," he said. In some cases the museums help hide the artifacts' lack of provenance by authenticating them. "This is the great tragedy of modern archaeology," he observed. "The sites are being destroyed looking for things to sell on the illicit market."

Renfrew accused museums of doing little to discourage the looting of archaeological sites and using self-serving arguments to justify holding on to pieces they should never have bought in the first place. "If you buy looted antiquities, you are funding the looting process," he said. "You cannot possibly justify buying looted stuff and essentially conspiring to break the laws of the countries in question." The arguments in favor of a "universal museum," the humanist mission of the Enlightenment, do not convince him. "The only place I hear that argument, in those words, are from people who are trying to justify their crimes," he said. "I only hear that from Philippe de Montebello, or apologists, often quite well-paid apologists." He singled out John Henry Merryman, a consultant to the Met who has staked out positions defending the mission of museums, for what he calls "the

*Colin Renfrew, Lord Renfrew of Kaimsthorn, the restitution activist.* (Photo © Colin Renfrew)

pernicious Merryman argument," which he characterized as follows: "They say, 'Our duty is to present things to the world. So basically we can do anything. And countries that oppose that are retentionist.'"

But while Renfrew is widely admired for putting the issue of illegal looting on the map, he has rubbed many the wrong way, even would-be allies, with his uncompromising stance. In my travels I often heard quiet criticism of Renfrew, and sometimes not so quiet. "The problem with Colin Renfrew is he thinks museums have no place," said Betsy Bryan, the American Egyptologist from Johns Hopkins. "He has this severe attitude toward museums generally, and toward the acquisition of objects. The problem with him is that there's no conversation to be had." Jerome Eisenberg, a longtime American dealer in antiquities with a shop on East Fifty-seventh Street in Manhattan, said that Renfrew refused to talk to him. "To Lord Renfrew, every dealer is an anathema," Eisenberg said. "I tried speaking to Lord Renfrew in 1992 and '93, when I gave a paper on the trade. He looked up his nose and walked away; he wouldn't talk to me."

Renfrew disputed that he is antimuseum, stating that there is an argument for the existence of museums, as a venue to juxtapose differ-

ent civilizations and human accomplishments. "There is a value in that, absolutely," he said. "But some antiquities are so connected to their place of origin that this is ultimately where they belong. How you define that is not easy, particularly if you believe in the universal museum." The best solution, in his opinion, would be a reinstitution of partage, the dividing of found artifacts, or else some system of enlightened exchange. "It's a shame the partage system has gone into decline," he said, "because I think it was a very good system whereby people put in resources, and then the state in question had ultimate jurisdiction and probably was able to take some really unique pieces, and then there was a division beyond that."

Still, if Renfrew has a damning attitude toward American museums and dealers, he excuses the British Museum—where he was once a trustee—when it comes to similar matters. That is because the museum adopted a policy in 1998 to bar the purchase of antiquities that have been on the market after 1970, adhering to the UNESCO cutoff date. "That, for me, is the acid test," said Renfrew. "At that point, the British Museum got it right." Fair enough. But of course the core of the British Museum's collection was assembled well over a century ago, and the circumstances of many pieces are dubious by today's standards. What's more, the British Museum has not been forthcoming in describing how it acquired its antiquities, like the Benin bronzes, and has actively hidden its own misdeeds when it came to damaging the Elgin Marbles in the 1930s.

Most surprising, Renfrew does not support the return of the Elgin Marbles to Greece, though he acknowledged that there is a strong case for doing so. "The argument that they could be well curated in Athens is strong indeed," he said. "But we shouldn't get swept away in a tide of restitutionalism." I pointed out that Greece has been trying to get the marbles back for more than 150 years. He shrugged. "Up to now the trustees have been clear: there has never been a faction among the trustees for their return," he said, adding, "It's my view that if you think about the rights and wrongs of it all, that some national things are so important, that there is a case for the return of the Parthenon marbles. But if I were the director of the British Museum, I'd say I'm not going to argue it."

Betsy Bryan insists that Renfrew has been inconsistent on the El-gin Marbles. She recalled a vociferous debate at a conference in 2005 where he argued for their return to Greece, while she took the other side. As for the Rosetta Stone, Hawass's quest for its return, Renfrew said, is "a very appropriate way for a nation like Egypt to operate. But I could only imagine it working if principles were developed to limit the matter, so those are the only pieces and stay the only pieces." He added, "the case for the Parthenon marbles is much stronger."

Renfrew's tortured stance—excusing the British Museum while being so openly critical of American institutions—is emblematic of the strained politics in the world of museology and archaeology. So is the fate of his organization, the Illicit Antiquities Research Centre. In a strange turn of events in September 2007, Cambridge University pre-cipitously closed the IARC after ten successful years, just as the restitu-tion debate had come to dominate art headlines around the world. Renfrew retired and in an e-mail gave no indication as to why the IARC had closed, except to refer to the "logic of having shifting, medium-term projects" that suggested the center may have run its course. "Meanwhile," he wrote, "I shall be slogging on with the cam-paign against the illicit traffic in antiquities."

In fact, a new director of the McDonald Institute for Archaeologi-cal Research, Graeme Barker, had been appointed, who disagreed with the focus on the issue of looted antiquities. As Renfrew took manda-tory retirement, Barker closed the IARC and replaced the academics who worked there with others. One scholar, Jenny Doole, changed ca-reers, while another, Neil Brodie, moved to Stanford University, where he began setting up a "Cultural Heritage Resource" center. Brodie said the closure of the Cambridge center had been at a "high cost" to the issue of stolen antiquities; an archive assembled by the IARC over a decade was dismantled, and the network of contacts built up over time had been lost. "I think it's crazy, really," he said. "It sends quite a poor message; it sends out the message that academic archaeology doesn't care about the looting of archaeological sites."

IT'S A COMPLICATED game, this business of repatriation. It allows fingers to be pointed in so many directions, and in many cases the fingers

end up pointed at oneself. It is an endless tangle, with one injustice piled on another and one agenda merely masking another. "Art is, was, and will always be a status symbol," said Smaro Toloupa, a tour guide in Athens with excellent English and very well-developed ideas about the problem of repatriation. Toloupa, an elegant brunette, met me at a café in the pavement-melting heat of Athens across from the New Acropolis Museum. She was carrying a backpack prepared for a dash to the Greek islands after our chat. Toloupa grew up in Athens and has a degree in cultural heritage from a British university, and she knows the arguments for and against the Elgin Marbles. Elgin, a saint? Or Elgin, a villain? "It isn't either-or," she said. "He couldn't foresee what would happen. . . . All our judgments now are made in hindsight. That's the wrong way to go. We can't know his intentions. He probably believed he was saving art for the good of the world. But it was a status symbol. All the upper class needed that status. So it was a mixture of intentions, mixed in with this feeling that 'these people are barbarians.' "

If Toloupa bears a healthy resentment toward the British, neither is she blind to the self-serving nature of the Greek arguments. Like so many of her countrymen, she expresses more resentment toward the Turks, whom she considers responsible for Greece's arrested development. She wishes the Parthenon sculptures were in Greece, though she is willing to consider the value of keeping the Elgin Marbles where they are. What disturbs her most of all is what she sees as the superior attitude on the part of the British. She remembered picking up the pamphlet at the British Museum about the marbles and bristling at the argument that the sculptures ought to be in a "world museum," as she recalled it. "When I hear that, I feel they are still living in the colonial world that disappeared years ago," she said. "Why should England, or New York, or Berlin, be the center of the world? Why? And who makes it that? It's not an argument about the marbles. It's an argument about the colonial attitude. To me that's what it's all about. I don't mind them keeping the marbles, but honestly, that is so annoying."

In response to the charge of cultural nationalism, Toloupa pleads guilty. Cultural nationalism is a fine argument for the British when it serves their purpose, she said. When it doesn't—"they claim humanism, concerning what? Concerning their museum, and their art dealers and

their small circle of supporters. Cultural nationalism is a Western invention. Why should we renounce it?" Then she said what I have come to suspect is really true: "Many, many countries would stop screaming and shouting if the Western powers would just acknowledge that they did it because they could do it. Because they had power, the upper hand."

Toloupa is no more forgiving of the outrages among her people, the Greeks, pointing out that the biggest buyers of looted antiquities are Greek. The wealthiest among them donate their illegal collections to foundations open to the public, and it all suddenly becomes acceptable. The Goulandris family, rich shipowners, opened the Museum of Cycladic Art in Athens to showcase their collection. But Cycladic art is notoriously hard to find and cannot be bought or sold privately at all, by Greek law. The former prime minister Konstantinos Mitsotakis had a huge, private collection of ancient Greek and Minoan antiquities, bought from locals, with unclear provenance. Questions were raised. Eventually he donated the entire thing to the Greek state to avoid uncomfortable conversations. The same can be said for the Benaki Museum, which houses a collection of classical objects assembled by a wealthy Greek family and has been further enriched by the collections of a long list of other wealthy Greeks. The museum's Web site tells you nothing about how the founder, Antonis Benakis, constituted his collection and is typically cryptic about specific provenance: "The collection of Prehistoric, Ancient Greek and Roman antiquities, formed through the contributions of several Greek and foreign donors, as well as from the reserves of other museums, covers a vast chronological period stretching from the dawn of prehistory to the end of the Roman era."

"It's 'don't ask, don't tell,'" said Toloupa. "This is the establishment of Greece. You can't touch them. It has to do with the elite, which needs art to reconfirm its elitism." I asked several Greek officials about this. They said the Goulandris and Benakis families were given special permission by the government to collect otherwise-illegal antiquities in order to keep the artifacts from leaving the country. But these same officials grudgingly admitted that doing so undermines the principle behind the pursuit of Western museums and collectors, which is that their demand feeds the illicit market. Buying looted art encourages looters to continue their destruction of archaeological sites, goes this

argument, and it ought to apply to any collector, foreign or Greek. Clearly it is politically acceptable in Greece to target some individuals and institutions but not others.

That is not the only hypocrisy involved in Greece's demands for its patrimony. When the shoe is on the other foot, empathy is not forthcoming. In 2007 Bulgaria protested that a cache of silver plates from the Byzantine era had been illegally excavated and smuggled into Greece. Far from investigating Bulgaria's claim, the museum of Byzantine art in Thessalonika displayed the plates, accompanied by a sign in front of a coin box, asking for contributions from patrons to help pay for their acquisition. (The plates had been on loan with an option to purchase, presumably from the looter.) Then there was the embarrassing political scandal that rocked Greece in early 2008, after the government's top archaeologist, Christos Zachopoulos, threw himself from the fourth-floor balcony of his home. (He survived.) The suicide attempt was related to sexual blackmail by Zachopoulos's secretary, but as the story unfolded it became clear that he had also removed some two hundred archaeological sites from the nation's list of protected patrimony. A prosecutor is currently investigating at least ten of those instances. To any critical observer, the scandal must raise questions about Greek stewardship and its demand to return objects now held abroad.

Toloupa, for one, also sees politics as the central motivation behind the New Acropolis Museum. She finds it intrusive at the least and at worst a sign of Greece's need to overcompensate, to act in response to more powerful countries rather than initiate for its own reasons. "All these fights have led us to that thing over there"—she pointed at the hulking structure across the street—"and honestly I'm not sure how much good this will do for the Greek people. It cost a lot of money. The building is out of context. Nobody likes it. Pandermalis says they 'cleared' the area—this means they demolished thirty-five buildings. But why build the goddamn thing here in the first place? The whole neighborhood wants to set it on fire. This is a disaster. Such a loud thing. Such a loud statement about antiquity, in search of an identity we haven't yet found. In Greece there are hidden issues. The classicism, the *Greekness*. We need to prove that we're the direct descendants of Pericles. That's what this is about. And that bothers me."

This led me to wonder what it is to be Greek. And why the Greeks, who are part of the European Union after all, feel such a burning need to proclaim their link to the ancient past. I asked Toloupa, who had made several offhand references to "the West," as if it were somewhere else. "Sometimes we're Europe; sometimes we're not," she said with a sigh. Greece, despite a growing economy and relatively high per capita income ($27,000 per year, at the high end of the EU average), has a palpable inferiority complex compared to the rest of the West: nursing its anger at the Turks, who occupied the country for hundreds of years; skeptical of the Americans, whose hegemonic power makes them the modern-day equivalent of what ancient Greece once was; resentful of the British, who stole the Parthenon marbles and act as if Greece should thank them for doing so.

"Greece remains the most anti-Western country in the world, with the possible exceptions of Pakistan and Iran," said Nikos Dimou, the iconoclastic writer of a landmark book on the subject of Greekness. Though Greece is known as the cradle of democracy, he said, its history is in fact one of empire, occupation, civil war, and dictatorship—with a couple of brief interludes for democracy. Under the rule of Pericles in the fifth century BC, the city-state of Athens was the center of a radical new experiment in government: democracy, rule by the people, led by the notions of law, freedom, and equality. But ever fractious, democratic Athens could not sustain its primacy at the head of the other Greek city-states. The collapse of the system in 405 BC paved the way for the rise of a charismatic conqueror, Alexander the Great. Between the death of Alexander in the fourth century BC and Greek independence in the early nineteenth century, the Greeks were for the most part the residents of someone else's empire.

Indeed, Greece in many ways owes its existence as a nation-state to the support of the West. This fact somehow upsets the balance of power in the discussion over art; the British feel they are owed a debt, and the Greeks feel they are not treated as equals because of Britain's historic role. The philosophers whose revolutionary ideas swept Europe at the end of the eighteenth century found their intellectual roots in ancient Greek philosophy and credited Greece as their intellectual

ancestor. This fueled a great philhellene resurgence, not just in thought but in architecture and sculpture. Much in the way that the drawings and discoveries of Napoleon's savants would fuel a rage for pharaonic art and civilization, the inquiries of a few daring Europeans fed a Greek revival. As Western political thinkers reached back thousands of years to draw on early Greek philosophy, James Stuart and Nicholas Revett, two British adventurers, traveled to Athens in 1751, then a dark outpost of the Ottoman Empire, and came back with sketchbooks filled with drawings and measurements of the ancient buildings. Their book *The Antiquities of Athens* was a sensation, and Stuart began building Greek reproductions as private houses and decorative temples. More important, his images fired the imaginations of politicians and architects. It is due to his influence that so many great monuments and institutions in the West—the U.S. Supreme Court, the Lincoln Memorial, the British Museum, the Brandenburg Gate in Berlin—mimic Greek architecture. Public taste was also widely influenced by the 1763 tome *History of Ancient Art* by Johann Winckelmann, who was Europe's great authority on classical sculpture. Greek sculpture was declared to be superior and to have been created under political and religious circumstances that were unique. And it comes full circle: this was the impetus for Lord Elgin to be taken with the Parthenon, and his motivation to bring back its sculptures as a trophy for the British Museum.

But just as Greece inspired western Europe, so western Europe inspired the modern-day Greeks. By the nineteenth century, Greece relied on its neighbors to the west for intellectual inspiration and its radical philosophies of liberation and self-determination. In 1821 the Greeks rebelled against the Ottoman Empire, a conflict that continued through six years of atrocities and political strife. In the end, it was the Great Powers—Britain, France, and Russia—who came to save the Greek cause and who, at the decisive Battle of Navarino in 1827, gave the new Greek state the territory to establish itself.

Democracy was still far off. It took another 150 years of monarchy, in-fighting, war with the Turks, military dictatorship, Nazi occupation, a civil war, and military juntas to arrive, finally, at democracy once again in 1974. Because Greece's modern democracy is so recent,

it is relatively fragile and in need of reaffirmation by the tie to its ancient roots.

Inferiority—for the average Greek, this topic comes up round about the third glass of ouzo. But it takes no alcoholic enhancement at all if you're Nikos Dimou. His best seller, *The Misfortune of Being Greek*, takes on the syndrome. He has persisted in peeling open the national psyche despite being labeled a self-hating Greek and other names, much worse, over a career in which he has written more than sixty books. "I don't believe in the continuity of thousands of years," he said. "I don't want the Elgin Marbles because they are Greek. I don't know if they are Greek in the sense that I'm Greek. The people that made them lived here 2,500 years ago. They didn't call themselves Greek. They didn't call themselves Hellenes. They called themselves Athenians. This idea of continuity of nations is for me another fiction. I don't claim the marbles are important because they're Greek. But from an aesthetic point of view, they belong to the building. It's wrong to see them separated like that. But I wouldn't extend this to every kind of art. And I'd say that if I was Turk, or whatever."

Dimou did not laugh when I asked whether Greeks consider themselves part of the West. They do, and they do not, he said. In everyday speech, the average Greek refers to the West as elsewhere, as Smaro Toloupa does. Someone in Greece will say, "I have studied in Europe," when they mean that they have studied in Germany. Or a person will say, "I'm traveling to Europe," when they are going to Paris. "A Frenchman traveling to Germany would not say, 'I traveled to Europe,'" observed Dimou. "But should you tell a Greek that they're not part of Europe, they'll get mad at you: 'What do you mean? Europe began here!'" For Dimou, the crucible events that created modern Europe passed Greece by, and this fundamental hole in the history of the country cannot be filled in by catchphrases or even a strong national economy. It is partly why symbols are so important. What led to modern Europe "was a succession of events which never took place in Greece," he said. "There was the scholastic philosophy of the Middle Ages, the Latin language of the Middle Ages, then came the Renaissance, then came the bourgeois class, and city-states in Europe with self-government. Then came the religious wars and the Reformation.

The French Revolution and the eighteenth-century philosophers: Locke and Hobbes and Voltaire. Then the American Revolution and the industrial revolution.

"None of these things happened in Greece," he continued. "Greece was a feudal society under the Byzantine empire. It remained feudal under Turkish occupation. Suddenly it was resurrected in the nineteenth century, and these Balkan peasants were suddenly told by admirers of the ancient Greeks—who were Westerners—'You are Greeks, Hellenes. Sons of Pericles and Plato.' They created for us such an ego for our small country."

It is a legacy that is hard to live up to, for any nation.

BACK AT THE British Museum, Neil MacGregor focuses on the legacy of the Enlightenment, rather than restitution. The museum was never more clear about its mission and its policies, he said. What is the raison d'être of the British Museum? To gather the world under one roof. "One of the starting points is, is it a useful function to try to have places where you can think about the whole world as the whole world, whether you are talking about natural history or plants or the written word, or indeed the material culture, which is what the British Museum is trying to do?" he asked rhetorically. "To think about the whole world as one. I think this was the great dream of the eighteenth century. Because for the first time in the eighteenth century it was physically possible to put the material culture of the world together, because it was the first time you had shipping connections with the whole world. This was an idea that couldn't be realized at any previous point in world history."

The debate over where artifacts belong is really about two conflicting notions of culture, he went on. It's essentially eighteenth-century universal humanism versus nineteenth-century nationalism. "The Enlightenment eighteenth-century notion is very much that if you look around the world you will see that lots and lots of things are the same," MacGregor noted. "It's what Swift is about, it's what *Gulliver's Travels* is about, it's what Voltaire is about, it's what the *Encyclopédie* is about, and obviously it lies behind all the assumptions of the United States. That essentially people have the same predicaments. . . . That's one way of thinking about culture. Either it's something that is a

shared inheritance of everyone, which was certainly the way the eighteenth-century Enlightenment thought, or you can see it as something that is the particular possession of one group. And that really is what the debate is. I mean, is culture . . . the shared inheritance of everybody? We would all regard Mozart or Shakespeare as everybody's; nobody would think for a second you could claim that the English had any particular right to determine what happened to Shakespeare now. He, his works, are the possession of the world. Or do you see it as something that actually is so particularly yours that you alone should be the guardian of it?"

MacGregor's point is valid and important. Culture belongs to the world, and museums open up the world to the viewer. They build vital bridges between cultures, creating avenues for mutual exchange and understanding. "Do you *want* to be able to look at Nefertiti in the context of images of rulers around the world, notions of beauty from different cultures in different periods?" MacGregor asked. "Do you want to be able to think of Nefertiti as one moment of supreme achievement among many others across the whole world, or do you want to see Nefertiti only in the context of other Egyptian sculptures? Now, obviously different people have different answers. But I think that's the question."

But what about the Rosetta Stone? It was found by a French soldier and handed over as the spoils of war to the British when they took control of Egypt from Napoleon's defeated forces. The piece has been in London for two hundred years. Zahi Hawass wants it back. I decided to repeat to MacGregor the typically undiplomatic comment about the British that Hawass made to me in Cairo: "I thought I should dance with them first, before I kiss them. Before I fuck them."

The smooth MacGregor was temporarily thrown. "We dance quite a lot with Zahi," he finally said and moved on. The reason the hieroglyphs were translated, he argued, was because the Rosetta Stone was in Britain. "A whole team of international scholars worked on that object in a way that couldn't have happened had it not been physically in Europe to be examined, and they couldn't have got to Egypt," he said. I pointed out that Jean-François Champollion actually worked from drawings of the Rosetta Stone in France (made by Napoleon's savants on discovery of the stone in 1799) and was sent to Turin, not

*Neil MacGregor, the director of the British Museum.* (Photo © The Trustees of the British Museum)

London, to study hieroglyphics. Champollion's great insight into decoding the hieroglyphics in 1822 thus did not depend on the Rosetta Stone being *physically* in Britain. It did depend on the fact that Napoleon (not Britain) invaded Egypt and, with his savants, rediscovered its ancient past, made drawings and casts, and created a new area of scientific inquiry: Egyptology.

Some might argue that MacGregor's argument is narrowly drawn, even self-serving. His notion of the founding principles of the British Museum are belied by many things, including the history of the Elgin Marbles. The sculptures were taken for the benefit of Britain, not for the benefit of the world. Elgin was a member of the British government, and he argued with his superiors for their support because his endeavor was on behalf of the betterment of the nation. And indeed, Elgin used his official clout to get his *firman* and used naval ships to

transport the sculptures, while constantly worrying that Napoleon might get there first. Elgin was not the only one who viewed the sculptures not only as a boon to the nation but as properly belonging to the civilized West. One early reviewer of the marbles' display approved heartily of Elgin's "rescue" for that reason, noting, "We should hold the revival of Grecian sculpture in the west a satisfactory reason for having deprived the east of treasures which it no longer understood, or any otherwise appreciated than as children value baubles." If the stones were to perish eventually, the writer went on, better they should perish in the service of inspiring European culture.

So while humanism may indeed have motivated the founding notion of the museum, there were other forces at play in the eighteenth century, namely a notion of culture that was not so much universalist as imperialist. In this view, the creation of Western museums like the British Museum—whatever the official philosophy—was actually informed by power, by empires that felt entitled to occupy distant lands and claim their cultural patrimony along with their natural resources, to take the symbols of ancient civilizations from elsewhere and fill their own museums with trophies that confirmed their power in the world. The scourge of nationalism followed in the nineteenth century, continuing ferociously into the twentieth century. Without doubt, the momentum of that force propelled countries like Greece and Egypt to preserve the past for their own purposes. But there is no small irony in this, for nationalism is a wholly European invention.

MacGregor made an additional argument for the British Museum's past practices: the acquisitions were legal. "The question is whether these collections should continue," he said. "Whether we're talking about the Rosetta Stone or the Elgin Marbles or the Hamilton vases, those were legally acquired by the laws and customs of the time. And they are part of institutions which are available for anyone to come and study. I see no reason why they *shouldn't* be where they are, available for everyone to study, available for everyone to see, and direct contact with the original is extremely important."

He also raised the question of why national identity should hinge on any single object, observing that the source countries have lots of antiquities without taking these back. "I'm puzzled by the notion that for

major countries, national identity can really hinge on *things*," he said. And after all, he added, it was thanks to Germany, France, and Britain that modern Greece was able to come into being. The antiquities fed western European interest in Greece and rallied public opinion to intervene on the side of Greek independence. And having the Parthenon sculptures in England allowed visitors to compare them with other civilizations. "You can't understand how you *get* to the Parthenon sculptures nearly as fully without looking in the context of Egypt, or Persia, and Assyria," he said.

Yet if the Parthenon hadn't been dismantled, I suggested, one wouldn't do so today for the benefit of a compare-and-contrast exercise in the museum. And whatever happened in the past, the Greeks today have demonstrated that they are capable of caring for the Parthenon sculptures and have built a state-of-the-art museum to house them. And they argue, quite convincingly (as do many others), that it seems absurd to have the sculptures separated. They were created as a single work of art, integral to the building on which they were presented. Wouldn't both history and artistic integrity suggest they should be made whole?

No, said MacGregor, without saying so exactly. The sculptures cannot be put back on the Parthenon. History is unpredictable, and there's an element of safety in dividing the sculptures should something catastrophic happen in one place or the other. He concluded that the best possible situation is the status quo—half of the sculptures in Athens and half in London. "It seems to me that at the moment with the Parthenon sculptures, you've the perfect, the absolutely best possible solution, given where history has left us," he said. "You can't make the Parthenon whole again; you can't recover the sculptures that have been lost and destroyed. About half the sculptural decoration is in Athens, where it can be seen in the context of the national tradition. About half of what remains is what is in London, where it can be seen in the context of the world. Some other bits are in the Louvre, as you know, in the Vatican, and so on. . . . Now that seems to me, given where we are with history, pretty well the ideal arrangement. That you can see the two narratives are both, I think, important for the world."

Beneath these high-minded arguments lies a palpable fear, articulated on the museum's Web sites and in various publications, op-ed

pieces, and letters: to give back the Elgin Marbles or any other major piece would open the door to the emptying not only of the British Museum but of all the great museums of the world. There is a sense that no matter how strong the arguments for the return of the Parthenon marbles, the trustees of the British Museum cannot allow this to happen for fear of bringing on the deluge. In April 2007 MacGregor seemed to suggest (in an interview with Bloomberg News Service) that a temporary loan of the Elgin Marbles—say, three to six months—might be possible. But the museum trustees' official position is to consider "any request for any part of the collection to be borrowed and then returned. The simple precondition is that the borrowing institution acknowledges the British Museum's ownership of the object. . . . Successive Greek governments have refused to recognize the Trustees' unquestionable legal ownership of the Parthenon Sculptures. This has made any meaningful discussion on the issue virtually impossible." Museum officials remain nervous at the idea of any loan, and given popular sentiment in Greece, it is easy to imagine that the sculptures would not be allowed to leave once they were in Athens.

The museum's arguments do not seem to convince either the Greeks or many others who look at the issue, including the British public. In 1998 a poll carried out in Britain by the well-regarded MORI organization found that a plurality of those asked would choose to return the marbles to Greece. Asked how they would vote if there was a referendum on the question, 39 percent of those polled said they would vote to return them to Greece. The next largest group, 28 percent, had no opinion, and only 15 percent said they would vote to keep them at the British Museum. A more recent poll in 2002 offered similar results. The museum archives have dozens of letters from schoolchildren, mostly weighing in on the side of return. In 1995 a young girl named Alice Vivian wrote in charming childish lettering: "Dear Sir/Madam, I believe that you should have all the pots back because the pots belong to you. . . . I wish it was up to me because I would give the pots to you but I can't."

What would Lord Elgin make of all this? It's hard to know for certain, and the closest you can get to his perspective is to ask his descendent, the current Earl of Elgin. Eighty-three years old, today's Lord

Elgin lives in Broomhall, the estate his ancestor built in Dunfermline, Scotland, a sprawling neoclassical spread where many sculptures taken from Greece now hang proudly in the vestibule. There are statues and bas-reliefs and funerary steles among them, both Roman and Greek. Elgin sold three sculptures to the Getty Museum in past decades, to raise some cash.

The current Lord Elgin's history is bound up with Greece on both sides of the family. On his mother's side he descends from a great British admiral, Thomas Alexander Cochrane, later the tenth Earl of Dundonald. Cochrane was a swashbuckling naval officer and politician who had a career filled with daring exploits but was dismissed from the Royal Navy after being convicted in a stock exchange fraud. (He received a royal pardon in 1832.) He then served in the rebel navies of Chile, Brazil, and Greece during their wars of independence. Cochrane took the command of the fledgling Greek navy at the request of the Greek revolutionary forces, backed by weapons and funds from the British. At the time, the Acropolis was still a Turkish garrison, but happily he chose not to order its bombardment. Cochrane's life, by the way, was said to be the inspiration for the daring fictional exploits of Horatio Hornblower and Jack Aubrey.

Elgin cheerily came to the telephone when I called. He has a most stolid antirestitution point of view, which carries no official weight, as it would take an act of Parliament to return the marbles that bear his family's name. Nonetheless, it is a view to which many pay attention. "I don't think things have changed very much since my great-great-grandfather had this decision to make: would it be something for civilization if he made this tremendous effort?" he asked. "There are times when the whole of civilization has to come together to make a concerted effort to help safeguard beautiful, historic things. It's not just entirely a nation's, but it is the responsibility of the whole of the thoughtful world."

It seemed as if Lord Elgin had been reading Neil MacGregor's brief. The sculptures, by this revisionist view, were taken to safeguard beautiful things on behalf of the world. That is not what the documentary evidence left behind by Elgin and others shows, but it does fit the politically acceptable narrative of the day. "I have a lot of people

who come here—Greek people and Greek friends—and they say, 'Thank you very much for doing this,'" said Elgin. "There are Greeks both ways."

He recalled hearing about the marble-cleaning episode at the British Museum as a young man and said that his father, who was then on the board of trustees, was dismayed. But compared to the deterioration of the sculptures left on the Parthenon, Elgin considered the damage unimportant. "I prefer a more sensible outlook," he said. "Things happen in history. But if you do not have the spirit of doing something for civilization as a whole, the world is a poorer place." And after all, he concluded, "to have made an achievement of this kind was extraordinarily difficult. To have brought the sculptures away, to a place of safety—that is a superb achievement."

Lord Elgin did not always hold these views. In 1983, at the height of Melina Mercouri's campaign, he told the British newspaper the *Observer* something quite different: If Greece built a museum that was suitable to hold the Parthenon sculptures, "I think that all the marbles would have to come together. It's not just a question of what's in Britain. But if that's the sort of thing the world could do with some of the great works of art, then—taking all the political heat out of it—it could be seen having been made possible by actions such as taken by my ancestor." In other words, if Britain gave the sculptures back, the historic Lord Elgin would be lauded for having saved them in the interim, arguably a constructive way of looking at the matter. But in the intervening decades, as Greece finally prepared to open the doors of the museum that could house all the sculptures, Lord Elgin apparently changed his view.

THE AMERICAN SCHOOL of Classical Studies in Athens is the oldest and largest American overseas research institute. Founded in 1881, the school is a consortium of 156 American universities that conduct research and other scholarly work among the ruins and in cooperation with the Greek government. The school has two excavations under its aegis: a site on Corinth, which has been under its control since the 1880s, and a more recent site, the Agora of Athens, the ancient marketplace and communal heart of the city, excavated since the 1930s.

Jack Davis is the lively, fire-breathing archaeologist who runs the

place, on leave from the University of Cincinnati. He has a long, angular face and a head of sandy hair. I met him in the bar of the Hotel Grande Bretagne, a magnificently refurbished Victorian relic that was built to accommodate the well-heeled European travelers who flocked to Athens as the Hellenic revival took hold. The hotel was bought in recent years by a wealthy Greek family, which gutted and redid the place to the most luxurious standards, at a cost of $150 million. As well-suited waiters glided past the Greek columns and silk drapes to the accompaniment of tinkling piano music, Davis expressed little sympathy for museums and museumgoers. "Why does the continued acquisition of objects from archaeological sites need to exist?" he asked. "I'm a historian. I can only learn from objects in context. This process of retrieving destroys history." He paused to let me absorb this. A world without the Met? Without the Louvre? Museums, in his view, are overrated. "I'm not sure in this day and age why museums feel the need to have ancient art departments," he continued. "What's the point? If I wanted to run a responsible museum, I'd approach a government and have frank discussions about how to do that. And we could drop this charade that antiquities just magically appear in museums, and educate people about the objects in context." Museums, he said, are very far from doing that. He visited the new Greek and Roman galleries at the Met and was disappointed: "Same old same old. Lots of pretty stuff. I was shocked by the acquisition dates of 2005 in that gallery. It suggests that they are still aggressively acquiring."

Davis is from the maximalist school of preventing looting and illegal digs. To him, artifacts are not art but history. They are art only because modern-day curators say they are, not because the ancients considered them art. "We impose our aesthetic," he said. "The Egyptians and the Greeks didn't define this stuff as art." Davis has no patience for museums that permit the acquisition of artifacts that do not meet the standard for provenance and careful acquisition policy, under the guise of serving the public. Indeed, he believes that collecting antiquities should more or less cease: "I think museums need to consider the ethical consequences of their collecting. By continuing to buy antiquities and encouraging collectors to do so, . . . they're destroying the heritage of the world in every country. And I'm sorry if that means they

need to shift the focus of their collection and be more inventive and disappoint some patrons."

Davis has been an advocate for universities to adopt ethical guidelines for their collections. The University of Cincinnati's Department of Classics was one of the first to do so, halting the practice of wealthy donors giving their antiquity collections to the university as a tax write-off. "We didn't want to take money from collectors who buy looted art," he said. As a result, his department passed a resolution to not accept financial support from Leon Levy and Shelby White, and his counterparts at Bryn Mawr College followed suit.

Davis is working on a book concerned with a little-known episode of plunder by Americans in 1922. As Turkey and Greece battled for control of the port of Izmir, eighty crates of antiquities were removed from Turkey and sent to the Met, including the massive column from Sardis that adorns the new Greek and Roman galleries. (It also happened to be the column emblazoned on Özgen Acar's T-shirt on the first night I met him and is an image used on mugs, bookmarks, and lots of other knickknacks.) Between 1920 and 1935 Turkey repeatedly asked the State Department for assistance in recovering these antiquities. In the end, the State Department pressed the Met to return most of the pieces to Izmir. The Sardis column, however, remains, a proudly prominent piece of the museum's Greek and Roman collection. The Met's catalog lists the column simply as "Gift of The American Society for the Excavation of Sardis, 1926." Davis wants to know how an American association could give a "gift" to a nonprofit institution like the Met that was a piece of property that belonged to a sovereign country? Don't ask. Don't tell.

Davis and his wife, Shari Stocker, also an archaeologist, have witnessed enough pillaging of ancient sites to turn them into radicals on the subject of restitution and punitive action. They were in Albania in 1997 and 1998 during the height of an ethnic war between Serbs and ethnic Albanians in Kosovo, which threatened the region's rich archaeological heritage. "We saw the Swiss and German dealers begin to arrive," recalled Davis. "We saw bulldozers brought over the border from Greece into southern Albania; we saw museums being looted in Albania. And we saw antiquities on sale at Sotheby's and at galleries in

New York from Albanian museums. It is within the capability of governments like Greece to lodge a protest. But Albania can't even do that." They watched in anger as Sotheby's proceeded with the sale of a Roman bust from a major Albanian museum, sold to an Italian collector. The story didn't end there. The Italian carabinieri seized the piece, but because the collector had bought it in good faith at Sotheby's, Albania had to buy it back if it wanted the piece returned. For an impoverished country like Albania, the price, 150,000 euros, was impossibly high.

Davis contends that the key to stopping looting is ending demand. "We stopped littering. We stopped smoking," he said, making the point that social pressure and changes in social mores can create change. This is a widely held view in his community, and it is true as far as it goes. But some people will continue to smoke because they enjoy it. And we will never snuff out demand for beautiful artifacts from ancient civilizations. As long as people admire beauty, as long as they prize symbols of prestige and power, there will be demand for artifacts from antiquity. And as smuggling and looting continues at an alarming rate in countries like Albania, Bulgaria, Iraq, and Turkey, the constraints on demand by Western museums do not seem to be dampening the enthusiasm for illegal digging. In its way, this problem poses itself similarly to the problem of illicit trade in drugs: Hit supply, or choke demand? Clamp down on demand by throwing addicts in jail? Or cut off supply by bombing poppy fields in developing countries with impoverished populations and limited resources for interdiction? As with drugs, the victim is society overall. And as with drugs, the precise damage is hard to depict objectively. But we are all the poorer for the loss to knowledge and to art. And in this case, the loss is irretrievable.

After drinks at the Hotel Grande Bretagne, Jack Davis and I hopped on a streetcar and headed to the National Archaeological Museum for the opening of a new exhibit on Praxiteles, the fourth-century BC sculptor who was the subject of a similar major exhibit at the Louvre a few months earlier, the project that had raised tensions between Paris and Athens over loans and restitution and a disputed marble at the Cleveland Museum of Art. Here in Greece, this was a national cultural event. In addition to the museum curator and culture minister, who

spoke at the opening ceremony, Prime Minister Kostas Karamanlis showed up to make the point that the talent of this ancient artist was a touchstone for modern Greece. "Praxiteles expresses the humanity and other characteristics of Greece," he said to a packed hall of upper-class patrons in the central gallery of the museum. "This is why we link the present and the past," he said. "We owe a debt to the past."

At the cocktail party afterward, Olga Palagia, a professor in classical archaeology at the University of Athens and a specialist in Greek sculpture, walked through the exhibit with a discerning eye. In addition to knowing everything about Praxiteles, she knew all about the politics of the exhibit. The show featured no actual sculptures by Praxiteles, the first artist to sculpt the nude figure. All that remains of his work are copies made by later Greek and Roman imitators. But the exhibit held a recent discovery that had Palagia walking excitedly through the galleries: a marble base on which the name Praxiteles was inscribed, just found during digging for a new Athens subway. Hopes had risen that an original might be found after all.

At the centerpiece of the show was a magnificent bronze of a young nude, called Marathon Boy, lit under a floodlight to highlight the elegant fluidity of the form and its beautiful proportion. It was one of the few complete bronzes in the show, and it was meant to be a centerpiece for the Louvre. It was this sculpture that Greece, at the last moment, declined to send to Paris, saying that its cultural significance made it unable to leave the territory, which infuriated the Louvre. "The Greeks say they never promised to send it," said Palagia with a shrug. "I don't know the truth." As it turned out, many pieces that Italy had sent to the Louvre for its Praxiteles show were not shared with Athens, for reasons that were unclear, though perhaps only because the Athens show was put together in a hurry.

But the politics of the world of museums and archaeology, of cultural identity and personality conflict, was never far away, even on such a celebratory occasion. On learning that I had come from California, Palagia wasted no time in going for the jugular of the J. Paul Getty Museum and its once-respected curator, Marion True.

"She's a crook," said Palagia. "She's a monster. I hope she goes to jail."

# ROUGH JUSTICE

# REVENGE IN ROME

THE OFFICE OF ITALY'S STATE ATTORNEY IS HIDDEN FROM
the street behind a churchlike facade on the Via dei Portoghesi in
Rome. Past the curled stone edges of the roof and a pair of towering
doors is a building that still feels very much like the monastery it once
was, with broad hallways, vaulted white ceilings, and echoing stone
floors.

On the second floor, Maurizio Fiorilli settled into his dark leather
wing chair. Dressed in a well-cut blue suit with an open-necked white
shirt and leather loafers, Fiorilli was feeling powerful, and it showed.
In addition to being a state prosecutor, he was president of a state
commission negotiating restitution agreements with American muse-
ums. Fiorilli played a central role in deciding whether prosecution was
warranted with the world's leading museums, or whether a more
friendly approach was called for. He and his colleagues were at the heart
of Italy's success in securing the return of looted art, having won the
return of the Euphronios krater and twenty other pieces from the Met-
ropolitan Museum of Art, along with thirteen pieces from Boston's
Museum of Fine Arts. And now Fiorilli was on the verge of sealing a

deal with the J. Paul Getty Museum, the most recalcitrant of the museums in Italy's sights.

It was July 30, 2007, the day before a deadline set by Italy for the return of one of the Getty's most beautiful and rare masterpieces, a bronze Greek sculpture of a boy called Victorious Youth. The Getty had long claimed that there was no legal basis to return the statue, but Italy said that if the museum did not hand it over, it would suspend cultural relations. As if to emphasize his connection to the missing object, Fiorilli had a small replica of the bronze sculpture on his desk.

These hard-nosed tactics had been going on for some time. The ultimatum, which had been issued by Culture Minister Francesco Rutelli, was just the latest thing. Fiorilli's trial of Marion True, a former Getty curator, had been dragging on for more than two years, with no end in sight. And while the Getty, under its new director, Michael Brand, had offered to return twenty-six disputed works, Italy had not responded. Brand wondered aloud in the press why Italy had not taken up his offer to continue negotiations.

All this placed Italy in the catbird seat. After feeling snubbed by the Getty for years, cultural officials had finally found the way to accomplish their goals. Fiorilli was a major element in that strategy. Together with another state prosecutor, Paolo Giorgio Ferri, he had been pursuing charges against True and others for illegal trafficking in antiquities. The public nature of the trial, the slow drip-drip of documents leaked to the media, had worked their effect, while also destroying True's career and reputation.

The Italian attitude seemed to be: a necessary step. It was the only way to accomplish the return of looted artifacts. "It is not true that Italy has been interested in restitution for just the past two years," said Fiorilli, with a golden summer tan and a calm expression. "Italy had initially asked for the bronze piece in a friendly way, as soon as we knew it had been removed illegally from the country. We asked for restitution on the basis of cultural evidence, and on the basis of scientific evidence."

Neither convinced the Getty, he said. "This is my experience. Until today, no American museum has accepted to return an artifact based on scientific evidence."

The Getty bronze seemed to obsess the Italians for reasons that

were hard to fathom. The legal case seemed extremely weak. Fiorilli pulled out his file. The statue had been recovered in international waters in 1964 by Italian fishermen near the town of Fano. Italy claimed that it had been exported illegally from the country, but the Getty said there was no proof of this. Conceding the point, Minister Rutelli called for the object's return as a "question of ethics." (A few months later, a court in Fano ruled against the Italian claim by rejecting a petition to confiscate the statue, further weakening the minister's argument.) Indeed, the ultimatum—issued by Rutelli during a visit to a Fano church—seemed to be based less on the law than on domestic politics; the center-left government of Prime Minister Romano Prodi had been under fire for supporting the expansion of a U.S. army base in Vicenza. With the war in Iraq making the United States extremely unpopular, protesters took to the streets, and the government had been teetering. Rutelli's posturing against the Getty was an effective anti-American counterbalance. Fiorilli acknowledged that Rutelli was a savvy political player. "He's put himself in the middle," he said with a sigh. "It went from being a legal question to a political one."

The bronze had little to do with Marion True, having been acquired before her arrival at the Getty. Nonetheless, Fiorilli was deep in the details of the piece. "When someone excavates clandestinely, we don't know about it," he said. "I don't know when something was found. When I see an object in a museum, I can only say, 'It belonged to a certain culture.' I don't know when it was excavated, who excavated it, or where it was acquired."

He launched into a summary of the question-and-answer process with the Getty. "Our request was based on certain facts: It is an Etruscan object. It was never published. It was scientifically of the type that is always found in a certain place. The museum's response is: The object is Greek. Italy's response: There was no distinction between states during the Greek civilization. The museum's response: The cultural space of Greece is all of the Mediterranean. Italy's response: Where did you get it? The museum: Under American law, the acquisition is covered by a confidentiality agreement. Italy: Since the origin is unknown, and you've acquired it, and your response on the provenance is uncertain, you owe me a response."

*Maurizio Fiorilli, the Italian state prosecutor who led the trial of the Getty Museum curator Marion True and was the president of a state commission negotiating restitution agreements.* (Photo © Sharon Waxman)

Fiorilli added, "One piece is not important. It's what it represents. The Italian request is not founded on money. We are working for culture." Italy's prosecution of art world insiders abroad has been paired with efforts to interdict illegal excavation at home, and it has had an impact, officials say. The centuries-old profession of *tombaroli* (grave robbers) has been severely scaled back.

Fiorilli leaned forward and poked a finger in my direction. "*You* observe a 'soft law,' with soft criteria for acquisition: you have to try to know the provenance of all cultural objects," he said. "So this is the question I put to American museums: why don't you give me the provenance, if the soft law obliges you to know it?"

I asked Fiorilli if he had threatened the Met with the prosecution of Dietrich von Bothmer, its retired curator for Greek and Roman antiquities, if the museum did not give up the Euphronios krater. Fiorilli

said yes. "They only react; they only return things when you threaten them with criminal proceedings," he said. And in the case of the Getty, did he threaten to prosecute the board of trustees or other officials besides Marion True? "That is a delicate question," he said. "For procedural reasons, the state prosecutor did not accept the extending of responsibility to the Trust." He declined to explain further.

But the bottom line was clear: harsh tactics were required to wrest looted items from these institutions; this was the point of prosecution, not the specific guilt of the individual on trial. "Museums started worrying about restitution when Italian judges began criminal investigations of dealers that had a monopoly on the American and worldwide market for illegally excavated archaeological objects in Italy," he said.

Was that justice? By this logic, Marion True had been ruined because the Getty did not agree to return the list of disputed items, but von Bothmer was spared because Philippe de Montebello gave up the Euphronios krater.

Fiorilli responded without emotion. He said he had no sympathy for von Bothmer and had been perfectly prepared to prosecute him. Von Bothmer had eagerly pursued the purchase of the Euphronios krater, he added, and "is the person who distributed fragments of pieces from illegal excavations to all the American museums." Fiorilli cited a letter that von Bothmer wrote to the Villa Giulia Museum in Rome a week after the Met bought the krater, asking about fragments from the base of the Euphronios that had been handed to Italian police, anonymously, the previous week. "No one knew that the carabinieri had these fragments, but von Bothmer knew about them," said Fiorilli with scorn; clearly this meant that the curator knew that the krater was looted in Italy and did not come intact from Lebanon, as had been claimed by the dealer Robert Hecht. "Ask him about it," he demanded. As for True, he noted that she had been the curator for the acquisition of forty-six of the fifty-two pieces that Italy had requested from the Getty. "We don't have a problem with the responsibility of Mrs. True or of the Trust. We want to know the mechanisms of clandestine traffic."

Fiorilli was critical of several aspects of American museum culture. For one thing, he disdained the habit among American museums of courting wealthy donors. The practice, he said, only encouraged looting.

"I am not a rich man. I am a poor man. I have given ten dollars to your museum. I have not given ten dollars for you to come to my country and steal my heritage. And to the American tax authorities I put another question: when Mr. Smith donates $1 million to the Met and gets a tax deduction, does that make it legitimate for the museum to acquire an object illegitimately?"

Fiorilli also found negotiations with American lawyers frustrating. "I'm particularly disgusted by the Getty for how they have treated this issue," he said. "We have all the elements, and we never get a precise response. We are always talking about numbers of objects. Never the reason that we're asking for them. I explain that the reason the Italian government makes these cultural agreements is that they presuppose a reciprocal faith. Reciprocal faith is based on concrete facts. When I give you a fact, you respond with words, with a statement to the newspaper. I always use facts, not words. American lawyers act as if they're rug salesmen. I'm not a rug salesman." The Getty's lawyers, Ron Olson and Luis Li, were most guilty of this, in his judgment. "Mr. Olson and Mr. Li are people who can deal with oil or peanuts, but they cannot deal with cultural goods," he said. (Li responded later: "We have the greatest respect for the Italian cultural officials and are pleased that this matter has been resolved in a spirit of cooperation and collaboration.")

For indeed, an end to the Getty situation was at hand. When I questioned why Italy had not responded to the Getty's requests to continue negotiations, Fiorilli laughed and stood up, walking over to his desk. He grasped a sheaf of papers in his hand. Across the top were the words *Draft Agreement,* with a note from the Getty's new director, Michael Brand. It was a final copy of the agreement that would be announced within three days: the Getty had agreed to return forty of the fifty-two objects demanded by Italy, including a statue of Aphrodite that the museum had bought for $18 million twenty years earlier. As for the bronze Victorious Youth, which had Fiorilli so exercised earlier in the conversation, the two parties had agreed to leave that contentious issue aside for another time, pending further investigation.

Game over for the museum. The Getty had surrendered unconditionally, and in return it was granted "long-term loans" of Italian objects.

Would this be the end of True's public miseries? As it turned out, her fate hung on this agreement, not on her ultimate innocence or guilt. "If the Getty reaches agreement, I will tell the constitutional court" to drop the civil charges against her, said Fiorilli. And yet despite the pending agreement, Fiorilli's attitude was not conciliatory. He said that many more looted pieces were in the museum. "We have asked for fifty-two pieces, but we have the evidence for three hundred," he said. If he wanted to, I asked, could he empty the Getty? "That is clear," he replied.

IN THE CONTEXT of nations seeking restitution of disputed art-works, Italy does not fit the postcolonial paradigm of Egypt and Greece. Italy was itself a colonizer, not a country that was colonized. And in the context of the ongoing tension between East and West, as developing nations assert their cultural identity by reclaiming plundered history, Italy does not exactly fit the mold. It is firmly in the West, an industrialized nation in the heart of Europe facing challenges of its own with a growing immigrant (mostly Muslim) population. But that doesn't mean that Italy doesn't suffer from an identity crisis. As a nation, it struggles to reconcile its glorious imperial past with its current, second-tier status within the European power structure, behind Britain, France, and Germany, and its diminished power on the global playing field.

Though these matters are hard to quantify, they exist nonetheless. This condition was described in a lengthy piece by Ian Fisher of the *New York Times* in December 2007. "The word here is '*malessere*,' or 'malaise,'" Fisher wrote. "It implies a collective funk—economic, political and social—summed up in a recent poll: Italians, despite their claim to have mastered the art of living, say they are the least happy people in Western Europe." He added, "Italy has charted its own way of belonging to Europe, struggling as few other countries do with fractured politics, uneven growth, organized crime and a tenuous sense of nationhood. But frustration is rising that these old weaknesses are still no better, and in some cases they are worse, as the world outside outpaces the country. In 1987, Italy celebrated its economic parity with Britain. Now Spain, which joined the European Union only a year

earlier, may soon overtake it, and Italy has fallen behind Britain." Fisher's story became front-page news and made television broadcasts all over Italy, eliciting more response than anything he had ever written about the country, he later said. It struck a nerve.

So it is not that surprising that many of the inconsistencies that I found in my inquiries around the Mediterranean found echoes in Italy, suggesting that here, too, issues of power and self-definition lie at the heart of this cultural struggle, rather than strict ethics or preservation. In demanding the return of artifacts it claims were stolen, Italy has been more aggressive than any other country in recent years. And yet, when plundered countries have asked Italy for objects to be returned to them, Italian officials have been slow to respond, much in the manner of other Western institutions. Since 1989, Libya has been asking for the return of a marble statue of Venus taken by Italian troops in 1912, a year after Italy officially made the North African nation a colony. The headless marble sculpture, a second-century AD Roman copy of a Greek original, was taken from the ancient Greek settlement of Cyrene on the Libyan coast by Italian troops. Though an Italian court had ruled in Libya's favor in April 2007 (and that is slow justice), a year later Italy still had not returned the statue. What could possibly justify keeping this statue, plundered in the twentieth century, in a country that had made a mission of demanding the return of stolen pieces from elsewhere? It's not as though Italy is in short supply of marble Venuses.

While the reason for the delay was unclear, a conservative group, Italia Nostra (Our Italy), filed an appeal of the court's ruling. A spokeswoman for the group explained, "The statue of Venus was not stolen by the Italians but discovered by chance in Cyrene which was then under Italian rule." She contrasted this with the demands of American museums. "The works Italy wants returned from the Getty Museum were illegally excavated, exported in violation of the 1939 law, and acquired in an illegal way," she said. "The Venus is not comparable. It's like asking for the restitution of works from the Louvre taken from Italy by Napoleon." By this logic, Italy should support Britain in its retention of the Elgin Marbles and encourage the Louvre to keep the zodiac ceiling, both of which had Ottoman *firmans* at the time of their appro-

priation. And one more thing: Italy did demand, and receive back, most of the works taken by Napoleon.

Even more perplexing was Italy's unwillingness for sixty years to return an obelisk looted from Ethiopa. The obelisk, seventy-eight feet tall and inscribed with intricate carvings, was made in the fourth century AD by artists in the Kingdom of Axum, an ancient Ethiopian civilization. The monument was taken by Mussolini's troops when they invaded Ethiopia in 1937. In time-honored fashion, they sent it back to Italy, where it was erected in front of the Ministry for Italian Africa. Ethiopia asked for it back almost immediately, and Italy agreed to return the obelisk in 1947. But decade after decade passed, and no action was taken. Elias Wondimu, an Ethiopian expatriate, told the *Los Angeles Times*, "It is quite ironic for me to see them try to reclaim what they've lost, while they are keeping others from reclaiming stolen property." The obelisk was finally returned in 2005. It remained in storage for three years, until its re-erection in Axum in the summer of 2008.

Then there is the question of how well Italy preserves the artifacts already in its care. The country is burdened and blessed with a staggering quantity of archaeological and artistic monuments and treasures. A stroll down any street in Rome may take the visitor through Roman, medieval, Renaissance, and pontifical epochs. The remnants of Greek and Etruscan civilization are in the fabric of the country, sometimes knitted into the monuments of civilizations that followed. The antiquities museums, little visited compared to places like the Louvre (excepting the Vatican), are chockablock with marble statuary, with entire walls lined with busts of Roman emperors. Even for an industrialized nation, it is a heavy responsibility to preserve, and Italy cannot always keep up. Many pieces in museum storehouses remain unstudied and unrestored, for lack of funds.

Italy recognizes that many of its ancient sites are crumbling from a lack of attention. In a television fund-raiser in October 2007, Italian artists and celebrities gathered to raise money for restoration, warning that such prominent buildings as the home of Emperor Augustus on Rome's Palatine Hill, where the frescoes and stone floors were under

threat, would be lost without a major restoration effort. Italy has forty-one sites designated by UNESCO as cultural monuments, and only so many resources to protect them. Culture officials say that Italy can afford less than half of the required annual budget of 700 million euros (more than $1 billion) to protect its sites. The telethon was an effort to raise private funds to supplement the government budget. But it's not clear that Italians are interested in paying for preservation from their own pockets; during the previous year's telethon, Italians donated only about 42 million euros ($60 million) to protect their monuments. One reason Italians may be less than enthusiastic about donating money to their government's cultural projects is that they have cause to be skeptical about where the money might go, as corruption is widespread in Italy. One recent scandal arose when it was revealed that the cost of maintaining the presidential palace, with its army of guards, servants, and maintenance workers, was higher than that of Buckingham Palace. It was no coincidence that Culture Minister Rutelli announced the exhibit of treasures being returned by the Getty and other museums the same week that criticism erupted over the presidential maintenance budget.

HE WAS LEANING in the doorway of the Cinema Adriano on the Piazza Cavour, a trim, balding man close to seventy years old. Giacomo Medici doesn't stand out in any way. Wearing a green polo shirt, with a gold chain nestled in his chest hair, he looked like an average Roman resident loitering on a summer afternoon; the ladies might easily have found him handsome. Over the phone, Medici had quickly agreed to a meeting and chose a central, inconspicuous place to meet. Though he refused a request to have his picture taken, Medici was surprisingly friendly and entirely willing to talk about his life as a convicted smuggler of antiquities.

Medici's conviction in 2004 is considered one of the triumphs of the art squad of the Italian carabinieri, the culmination of a vigorous effort to gather evidence and prosecute a man who was one of the central conduits for illegally excavated antiquities sold over the past thirty years. Medici is credited (or blamed) for the sale of hundreds, if not thousands, of looted artifacts to foreign museums and collectors. After a fast-tracked trial that led to a summary judgment, Medici was

convicted of dealing in stolen artifacts and sentenced to ten years in prison and a fine of 10 million euros. It was the largest penalty ever imposed by an Italian court in an antiquities case.

Yet in 2008 he was still a free man. The case was under appeal, and while Medici waited for another shot at a verdict, he held forth to those who would listen. It was an absurd conviction, he said, based on a flimsy case made by a politically motivated prosecutor who distorted the evidence found in Medici's warehouse. "Photographs! They convicted me based on nothing but photographs!" he exclaimed in the car on the way to his apartment, speaking in French. (Medici speaks no English, and I don't speak Italian.) "Who has ever heard of such a thing? Not one document! Show me one!" We were riding in a small Fiat sedan, heading toward the Tiber. The car was driven by his daughter Monica, an impossibly lovely young woman who has a doctorate in art history and who believes deeply in her father's innocence. "He has suffered so much," she said quietly in English, as we parked the car at their apartment building. Her father's marriage couldn't withstand the stress engendered by his arrest; since his divorce, he has been dealing with prostate cancer, his daughter said.

The nightmare began for Giacomo Medici when Swiss police raided his warehouse on September 13, 1995, at the Geneva Freeport. Medici had moved his Geneva gallery to this border zone south of the city that is exempt from taxes and customs documentation and is largely used for moving goods in and out of Switzerland. Many art dealers were based there, as were merchants in other big-ticket items like wine or jewelry or high-end cars. Medici had been there for several years, in a steel-gray warehouse known as Corridor 17. The raid, which had been authorized based on the seizure of other documents in a chance arrest of a *tombaroli*, came as a shock.

"For the Italian authorities, the fact that something is in the Freeport means it is illegal," said Medici. "The accusation says that the only reason I chose the Freeport is because my commerce is illegal. If you start from there, that's madness. Everyone uses the Freeport."

The raid on Medici's warehouse turned up far more than just photographs, and the photographs were not insignificant in themselves, as many artifacts in the photos turned out to be objects now owned by

museums. Acting on a request from the carabinieri, Swiss police searched Medici's company, Editions Service, and found cupboards packed with antiquities. As Peter Watson and Cecilia Todeschini describe in their 2006 book *The Medici Conspiracy*:

> Some were wrapped in newspapers; frescoes lay on the floor or leaning against walls; other vases were packed in fruit boxes, and many had dirt on them. Some had Sotheby's labels tied to them with white string. But that wasn't all. There was also a huge safe, five feet tall and three feet wide. Amazingly, it wasn't locked. If the contents of the cupboards had been astounding, the contents of the safe were truly astonishing. . . . Inside were 20 of the most exquisite classical Greek dinner plates that anyone there that day had ever seen, plus a number of red-figure vases by famous classical vase painters. The Carabinieri immediately recognized one as by none other than Euphronios. Together, the objects in the safe must have been worth millions of dollars.

(Watson actually testified at Medici's trial, and his testimony was used to convict the dealer. This fact—that a journalist had access to privileged information during an investigation—is one of the elements of the appeal.) Medici, who has never spoken to Watson, said the office of Editions Service held perhaps 150 artifacts of value and another 1,700 pieces that were small, of negligible worth. "They did an incredible thing," he said. "I could not be there. They didn't allow me to have a lawyer. The Swiss police locked the doors, and for five years, they made a harsh investigation. The Swiss said, 'If these pieces are stolen, from where do they come?' After five years they dropped the case because they had no proof that these were stolen."

In 2000 the Swiss handed over all of the seized evidence to the Italians, and the objects from Medici's warehouse remain in police custody. But the hundreds of Polaroids turned out to be among the most damaging items taken by police. Some of them depicted antiquities still encrusted with dirt; others showed Medici standing next to antiquities at the Met or the Getty, including a picture of him appearing to preen

before the Euphronios krater. Prosecutors said this was proof that he had sold the looted objects to U.S. museums and would then go visit those objects and proudly take his picture beside them. As for the objects with the Sotheby's tags, Italian police argued that Medici had bought his own objects at Sotheby's to give them the legitimacy of having come through the auction house. These arguments were used as the basis for the charges against him, and his conviction.

Medici said this was absurd. In four hours of intense conversation, he held forth in great detail on the injustice of the case presented against him, on the lack of evidence, and the political bent of the prosecutors. But he didn't quite claim to be free of culpability. His main assertion was that he was innocent of the charges of which he was accused and that the police never had solid proof of his dealing in stolen artifacts. "You can believe anything you want. But if you accuse someone, you have to have proof," he protested. To whom did he sell? "It's not important who I sold to. It's important that there is no proof for what I'm convicted of. All there are are photos. Can you convict someone on the basis of photos? This is absurd." Seated in the living room of his daughter's apartment (next door to his own), and as Monica placidly nodded her assent, Medici paced and pondered, he shouted, he laughed bitterly and finally worked himself up into a frenzy of rage over the injustice dealt him and the ruin of his career. By the end, he stood before me, his legs planted, his arms flailing, raging at the top of his lungs: "Medici, *diavolo*! Medici, *diavolo*! Medici, *diavolo*!" Medici, he called himself, the Devil.

"Did I do bad things? Maybe. Not maybe. Yes," he reasoned, with a logic honed by years in the public pillory. "But not what you accused me of. And that's hypocrisy. In the future they'll say, 'This poor man.' They'll study my case to see the violations of my rights. Now, they want to ride on their victory chariot. But it's hypocrisy."

Unfortunately for Medici, there is a wealth of evidence showing his deep involvement with looted art. Former collaborators such as Felicity Nicholson, the former head of Sotheby's antiquities division, have admitted in court that Medici was the person supplying unprovenanced antiquities for sale at the auction house. Similarly, self-identified tomb robbers have identified Medici as someone with whom they frequently did business. And the photos, while they don't come with accompanying

documentation, suggest damning ties between himself, the *tombaroli*, and collectors.

Giacomo Medici is caught in a contradiction of his own making; he believes that, whatever his strict innocence or guilt, he has been treated unfairly. He believes himself to be a lover of antiquities, some-one who cares for his nation's cultural past. He cannot square his offi-cial label of "convicted smuggler" with the life he has led for thirty-five years, doing business with powerful curators like Marion True, upscale dealers like Robin Symes, and auction houses like Sotheby's. And in truth, through the decades of a flourishing art mar-ket in the 1970s, 1980s, and into the 1990s, Italy did not seem terribly disturbed by the illegal trade in antiquities. (Prosecutors say they did not have enough evidence to crack down on the network of illegal excavators, smugglers, and dealers.) But it was the determination of General Roberto Conforti of the carabinieri, who took on the issue in the 1990s, that marked a change; Conforti made the exposing of ille-gal trafficking his personal quest. And politicians took up the banner for reasons of their own.

In his histrionics, Medici would contradict himself, condemning the plunder of his country's patrimony one moment—"I'm against illegal excavation," he said—while the next moment calling the *tombaroli* "sweet peasants" who loved the past. But in his hours of self-defense, he also raised some questions worth considering. Medici claimed never to have seen many of the photos of artifacts he is accused of selling. And he said the police took three years to do a proper inventory of what was found at the Freeport. He believes that photos from the in-vestigation of Pasquale Camera, another antiquities smuggler, were mixed in with his file. "With my heart, I tell you, I have so many pho-tos, and I've never seen these," he said, arguing that the prosecutor's art expert must have mixed them up. "These photos are not of my paint-ings," he claimed. "They belonged to Camera. They made a mine-strone of things." Of all the stolen pieces that the police attributed to Medici, "only one was mine," he admitted, a vase painted with a figure of Hercules.

Medici was convicted of having sold an illegally excavated Greek

*Giacomo Medici, convicted looter, shown in two Polaroid photos that were used as evidence at his trial. At top he is standing in front of an Etruscan chariot and at bottom in front of the Euphronios krater, both at the Metropolitan Museum of Art in New York.*

kore, a statue, based on his having a photo of the kore in his gallery. Prosecutors said he sold the piece to Robin Symes, who sold it to the Getty. But the kore was found to have come from Greece, not Italy, and in the wake of an investigation, the Getty returned the piece to Greece in 2007. "I don't know who sold it to Symes, and I was convicted based on the photo. But it belonged to Greece," he said. Robert Hecht is accused of selling a Greek statue of Sabina to the Boston Museum of Fine Arts. "Boston returned it to Italy, but it came from

Turkey," he said. "This is absurd; the piece is not Italian. It's typically Turkish, of smooth marble. Now it's in the Villa Adriana."

Medici also insisted he had nothing to do with the Euphronios krater, though he was convicted of being the middleman in that deal, too, allegedly having sold it to Hecht, who fingered Medici in the first version of his memoir, which he has since repudiated. Except for Hecht's memoir, there is only the 1987 photo of him in front of the vase at the Met as proof. "This is not an argument that I sold it," he insisted, frustrated. "I was convicted for this, and I didn't make a penny from it." He pointed to a similar photo of himself in front of a famed Etruscan chariot, also at the Met; that piece was acquired in 1903. He simply liked to take photographs of himself with antiquities, he maintained.

Medici said he was not only a dealer in antiquities but also an expert who authenticated pieces belonging to other people. That was why he had so many photos, he said; curators and others in the art world would send him pictures of pieces and ask him to judge their authenticity and to speculate on their value. And he claimed that the police wrongly used Medici's photos of trucks moving dirt in Vulci, north of Rome, against him. The police claimed the photos were proof of Medici's involvement with looters; Medici said he took the photos to denounce looters to the local police for destroying an archaeological site. As for the photos of dirt-encrusted objects—"I guarantee you, with great authority, there is no archaeologist in the world who can say from a photograph whether a piece has been excavated now or earlier," he said. "In Italian museums there are a million pieces still encrusted with dirt. There is no money for restoration. And there are millions of pieces in storerooms—millions, not thousands, at Pompeii, in Florence, in the Villa Giulia—that still need to be restored. But from a Polaroid you cannot tell when it is dug up." He said that many pieces are kept for decades in the dirt-covered state in which they are found. "This is not proof," he insisted. Here Medici strains credulity. The Polaroids of dirt-encrusted artifacts included pieces thrown in the back of a trunk or wrapped in newspapers, suggesting that they had recently been unearthed. The photos did not show items with dirt from museum storehouses.

Medici also denied that he had sold a calyx being returned by the

Getty, though Watson published in his book a photo of the piece while under restoration and labeled it as from Medici. "I never sold that piece; I never even had it," he said. "Someone sent me the photo to ask if I could restore it, but I didn't do it. It was a private client from Geneva of Greek origin. I don't know what happened to the piece."

Medici claimed that politics was behind this prosecutorial zeal on the issue of antiquities. "I don't understand it," he said. "It's not about love of antiquity or history. It's for politics. The government that had been Christian Democratic for fifty years has changed, and they want to show that the Christian Democrats are finished and that the Socialists are in power. They want to attack the United States."

He accused Paolo Giorgio Ferri, a career criminal prosecutor, of being a Communist and anti-American. During questioning, he showed Ferri a picture of a statue of Apollo. According to Medici, Ferri responded: "I admire you. You can buy a piece of great value. But there are people in Italy who can't afford bread." This infuriated Medici. "I closed my file, I grabbed it, and I left. 'Thank you, Mr. Ferri, and goodbye.' This is the mentality of a judge? This is an extreme leftist, a Communist." But Ferri is not a member of the Communist Party.

Mainly, though, Medici said he failed to understand how methods of trading that were accepted for thirty years could suddenly be considered criminal. "Up to 1995, I never had an accusation or a trial. . . . I had a gallery in Rome near the Spanish Steps, with Greek vases, bronzes, marbles. I never had problems. Then came 1995, and General Conforti [of the carabinieri] . . . said that the antiquities trade is illegal. Okay—I agree. I don't like the idea of illegal commerce. Today many galleries sell antiquities. It's not drugs, after all. But we're talking about pieces from thirty or forty years ago. The Euphronios krater, the Getty pieces. What scared us all was that suddenly, all of us who sold at auction houses, out in the art world, we've all become bandits. Then, the Italian authorities never said a word. Now, they're upset. The policy has changed. It's not fair. I'm now in a position where I can't travel. I can't trade. It's like I'm dead. I wait. And what's really sad is the only proof are these photos. No witnesses, no declarations. Only photos."

The change that Medici referred to was very real. In 1998 he wrote a letter to *Archaeology* magazine protesting an article about him by

Andrew L. Slayman. In the letter he made some of the same points he would make in 2007: that no inventory was done during the raid, that he was not permitted to monitor the search, that internal documents from the police investigation had been leaked to the Internet. "The 'monster' who should have exported 10,000 items illegally does not exist," he wrote. Medici was supported by another letter in response to the article, from Frederick Schultz, the president of the National Association of Dealers in Ancient, Oriental and Primitive Art. Schultz wrote that he did not know Medici but was outraged that the magazine would publish photos of antiquities labeled as "probably smuggled from Italy," which in fact were from known collections, which he listed. "Instead of proving that Mr. Medici is the secret smuggling connection from Italy, however, your website proved exactly the opposite," Schultz wrote. But just a few years later, Schultz would himself be caught up in the rising tide of legal action against looted antiquities. In 2002 he was convicted in federal court in Manhattan of conspiring to smuggle and possess looted objects from Egypt. Unlike Medici, he went to jail.

At times during our conversation, Medici seemed to be driven to distraction, flinging arguments and justifications about. And strangely, under the arcane system of Italian justice, he may succeed in vacating at least part of his conviction on appeal. The law governing the statute of limitations had changed since Medici's verdict in 2004, and the period to prosecute him for illegal trafficking had apparently passed. This, too, could take years to decide. In the interest of ending his personal nightmare, Medici proposed a deal to the prosecutor: to give the state all of his sequestered artifacts, along with what he calls a "Greek, very important piece" owned by a friend, in exchange for the end of all proceedings against him. Medici insisted the piece was not his but would be donated by the collector friend. "I have family. I am old. I want to return to a normal life," he said. "Let's find a resolution." So far the prosecutor had shown no interest in the deal.

Italy cared too little for too long, and now it cares too much, Medici said. "The past is past. They were sleeping, all these governments. And justice must be done in source countries. Those countries must defend their objects," he said. "But for thirty-five years, Giacomo Medici was perfect. Now all of a sudden he is the devil. How is it possible?"

I asked Medici what he thought of Maurizio Fiorilli's remark that the Getty was full of looted antiquities. "I agree," said Medici. "If all the countries where the antiquities came from asked for their unprovenanced pieces back, the Getty would be empty. But not just the Getty. Most of the American museums would be empty."

# THE TRIALS OF MARION TRUE

*True . . . could go down in the annals of art as a heroic warrior against plunder and the Getty Museum as a defender of mankind's cultural heritage.*

—*Los Angeles Times*, November 12, 1989

WHEN MARION TRUE FIRST CAME TO THE GREEK ISland of Paros in the late 1970s, she thought she had found paradise: the startling color of the Aegean, the rolling verdant vineyards of the island, its shallow, sandy bays that hugged the shoreline in out-of-the way places. She loved the hidden swimming holes—blinking bright sapphire in some places, a placid liquid green in others—framed by primitive rock formations. True was hardly the first to be seduced by the Greek islands and the peculiarly bewitching light glinting off its sugar-cube houses. Half a century before, the writer Lawrence Durrell drank it in and let it pour out of him in a euphoric stream— "intoxicated by the white dancing candescence of the sun on a sea with blue sky pouring into it." After an island visit left him in a sensory daze, he wrote of walking around Corfu "with the feeling that the island is a sort of burning-glass. Later, sitting in a tavern . . . He thinks of other light drinkers in the past who have, like himself, suddenly felt that they were moving about in the heart of a dark crystal." About as long as there have been writers, there have been intemperate verses written about these scattered bits of land amid the boundless

blue of the Ionian and Aegean seas. Durrell digs this up from a Victorian traveler, Hugo von Hofmannsthal, who fell with similar passion.

> This light is indescribably keen yet soft. It brings out the smallest details with a clarity, a gentle clarity that makes the heart beat higher and enfolds the nearer view in a transfiguring veil—I can describe it only in these paradoxical terms. One can compare it to nothing except Spirit.

Paros is a gentle island at the center of the Cyclades, which Durrell called "the prismatic heart of the Greek sea. If a dolphin does not rise and wink at you, or a quiver full of flying fish swirl across your bows, you can ask for your money back." Like others who discovered this place, Marion True embraced and was embraced by its simplicity, the openness of the fishermen, the friendly shopowners who welcomed the blonde American curator speaking stilted Greek. She made a name and a reputation—the lady from the Getty Museum. She bought a house. She made friends with the locals, Greek high society, academe, and the small cadre of foreigners. Her circle included the archaeologists from the University of Athens who worked here; curators like Yannos Kourayos at the small local museum; and the Goulandris family, shipping magnates who had founded an antiquities museum with their private collection of (unprovenanced) Cycladic treasures and who owned a small island just off Paros. But mostly she reveled in the simple pleasures: sharing long meals late into the night, eating grilled fish caught that very day and drenched in locally made olive oil, accompanied by locally made wine. It was lazy days at the waterside, in Aliki, where she relaxed with friends away from the formality of the museum world. This was her paradise.

By the summer of 2007, True's paradise had become a living nightmare. Her house—once a place of peaceful retreat—had become a local curiosity and a point of contention in her slow, public savaging. The Greek police had raided it in 2006, confiscating what they said were seventeen unregistered antiquities scattered about the property. True rarely went out in public and no longer socialized—indeed, she no longer had many friends here. It had been close to two years since

the *Los Angeles Times* published a story in October 2005 saying that True had bought her house with a loan that breached the Getty's ethics policy. The loan came through a Greek lawyer who had been introduced to True by Christos Michaelides, a Greek art dealer who—together with his partner, Robin Symes—had sold many pieces to the Getty. The museum bars its employees from accepting favors from people with whom the museum does business. The revelation led to True's resignation, although the article also said the museum knew of the loan since 2002. But the loan was undoubtedly not the only factor leading to her resignation. Since July, True had been on trial in Rome on criminal charges of having received stolen goods and covering up the purchase of looted objects in the course of her acquisitions of antiquities for the museum. Quite a thing, and likely a first in museum history: a curator on trial for acquiring antiquities. Thus was ruined a scholar and a pillar of the museum community. Her reputation in tatters, her career over, her finances strained, the Harvard-educated curator was, at fifty-nine, an accused criminal, a symbol of Western arrogance and indifference to cultural integrity. The reigning image of Marion True was of her leaving a Rome courtroom in dark sunglasses and clutching a Hermes bag—an image that shadowed her, splashed continually in newspapers and on Web sites and television at any mention of the Getty and looted art. Even Paros could not hide her.

The downfall of Marion True is, by any reading of the known facts, bewildering and disturbing. Nothing in her past as a distinguished scholar of classical antiquities, in her twenty-three years as a curator at the J. Paul Getty Museum, suggested the swift, downward spiral that began in the spring of 2005. For most of her career, Marion True was a star in the world of classical studies and was in fact a champion of tightening acquisition policies at American museums. At the Getty, she helped reverse the museum's reputation for dubious acquisitions, funded archaeology abroad, and pushed for reform within the institution. It was True who had urged the museum to adopt a stricter acquisitions policy in 1995, which at the time was the most restrictive of any major U.S. museum. What happened? Did True change, or did the world in which she functioned shift? Did she lose her moral compass, overwhelmed by the desire for beautiful art?

*Marion True leaving a courthouse in Rome during her trial.* (Photo by Andreas Solaro/ AFP/Getty Images)

The Italian authorities had no doubt that True was a criminal. The paper trail that the police found in Giacomo Medici's warehouse linked True to him and to others with dirty hands—principally the dealer Robert Hecht and True's friends Symes and Michaelides. But the force of the attack against True by the Italian state was somehow disturbing, as was the viciousness of the public's turn against her. True did not buy antiquities for herself, nor was she personally enriched. And many other collectors were buying antiquities in that period of time, the 1980s and '90s, from those same sources, under the same rules. So by what strange turn of fate was it True, rather than the director of the Getty or the chairman of the museum's board of trustees, who was

facing charges? And why only the Getty, rather than the Met, for example, or the Ashmolean in Oxford?

True's prosecution raises questions of who is responsible, and who ought to be, for the purchase of antiquities that turn out to have been looted. In a two-page letter of protest to the heads of the institution where she'd worked for so long, True wrote that the Getty's silence was deafening in the face of charges that she criminally conspired to receive stolen goods. "No Getty colleague, supervisor, officer or legal representative has stepped forward to challenge publicly this distorted scenario," she wrote. The "calculated silence . . . has been acknowledged universally, especially in the archeological countries, as a tacit acceptance of my guilt." As she became a legal pariah, friends fell silent, and the void was filled by ugly invective. The Italian prosecution, while justified under its laws, smacked of extortion, a desire to bring the Getty to heel by humiliating its curator. The subsequent acts of the Greek government—particularly the raid on True's home in Paros with the confiscation of artifacts that turned out to have negligible value—felt like a piling on.

No one could mistake it. What happened to Marion True was a warning, a shot across the bow by source countries to the entire Western museum establishment. "Give us back our stuff," was the unspoken message, "or what happened to her will happen to you."

UNTIL THE FATEFUL events of 2005, there had been a logical arc to the career of Marion True, an upward line of achievement, recognition, and success. She was born in Tahlequah, Oklahoma, and graduated from New York University in 1970 with a degree in classics and fine arts. She went on to complete a master's degree in classical archaeology there before turning to Harvard to take up her doctoral work as a star pupil of Emily Dickinson Vermeule, the respected archaeologist. At the same time, she worked as a curator at Harvard's Fogg Art Museum and the Museum of Fine Arts in Boston, the latter under Cornelius Vermeule III, her professor's husband. True was a rising talent in the world of classical antiquities and was sought after by established institutions, according to her close friend the archaeologist Stella Admi-

raal. But she instead decided to take a position in Los Angeles with the J. Paul Getty Museum, still a relatively young institution, where she felt she could have an impact on shaping the collection. The Getty had gobs of money; and everyone knew the museum was in a mood to grow its holdings. She joined the Getty in 1982 as an assistant to the antiquities curator Jiri Frel, who had been hired in 1973 by J. Paul Getty himself. Two years later, Frel was demoted and subsequently resigned after it was disclosed that he had inflated appraisals of artifacts for tax purposes in exchange for donated antiquities. He also acquired a stunningly expensive statue, a kouros, that many believed was a fake.

As Frel's successor, True was meant to be a breath of fresh air, a rigorous scholar with a prodigious memory, an expert who read Latin, Greek, and Italian fluently and who would change the museum's tainted reputation in a new era of cooperation with source countries. She took over as the curator of the antiquities department in 1986, the same year she was awarded her doctorate from Harvard with a thesis on ancient Greek red-figure vases. She aggressively promoted scholarship, funding conservation all over the ancient world—the Sphinx, for example, in Egypt, and on the Acropolis in Athens. She awarded poorly paid Greek archaeologists grants to study at the Getty Research Institute. She and the Getty Conservation Institute sponsored a broad-ranging conference in 1995 on site management in Greece, Turkey, and Italy, and representatives from the museum traveled to those countries. She spearheaded a $275 million renovation of the Getty's signature building, its Roman villa in Malibu, a project she oversaw to the finest detail, but which she would not be present to enjoy at its reopening in 2006.

The most searing irony, in light of later events, was True's apparent devotion to improving the state of antiquities' provenance. "*Ironic* is too soft a word," said her friend Admiraal bitterly. True spoke openly of the need to improve the acquisitions policy at the Getty and of her intention to query source countries in advance of any purchase. Her acquisition decisions were reviewed by a scholarly steering committee, which included experts from leading museums in Britain, France, and Germany, and approved by the museum director. In 1988

True was offered a set of Byzantine mosaics by an American dealer for $20 million. She turned down the artifacts and reported the offer to the authorities in Cyprus, after telling the dealer that the mosaics were probably stolen. That information landed the seller in a civil case in U.S. federal court and got the mosaics sent back to Cyprus, whence they'd been stolen around 1974. In a deposition presented at the trial, True offered a heartfelt statement of the Getty's new policy: "We as an institution would not want to be buying art against the wishes of the country of origin." In an article for the *Los Angeles Times* Sunday magazine, the reporter Stanley Meisler wrote the following: "True, the Getty curator who alerted the Cypriot government, could go down in the annals of art as a heroic warrior against plunder and the Getty Museum as a defender of mankind's cultural heritage." He also wrote, "Museums make courageous decisions to stop plunder one day while making purchases that encourage it on another day. Hypocrisy reigns."

True also sought to settle professional whispering over the dubious kouros that Frel had bought. "It simply is not in the interest of any museum to have a work that isn't right," she told the *Los Angeles Times* in 1986. After consultation with a series of experts failed to quell the questioning, in 1992 the Getty convened a colloquium in Athens, held at the Goulandris museum, to debate the statue's authenticity. The conclusion of the experts at the conference was, ultimately, inconclusive. But not everyone came away impressed by how she handled the matter. Olga Palagia, the Greek sculpture specialist from the University of Athens, said that True invited her to Malibu to view the kouros and give her expert opinion a year before the conference. Palagia instantly decided that the statue was a fake because of its anachronistic mix of styles. "She sent me a letter saying, 'You're right. You had the courage to say so. We found the sculptor; he's in his eighties,'" said Palagia. But a year later when the conference convened, Palagia was not invited. She attended anyway and stood up in the auditorium to ask True why she changed her mind about the statue's authenticity. "She was angry and didn't answer," said Palagia. "We've never spoken since." (A lawyer for True disputed parts of Palagia's account, saying the Getty curator had never written to say that the Greek archaeologist was correct.) The kouros remains in the Getty museum galleries, labeled as "Greek, circa 530 BC, or modern forgery."

Perhaps the most important contribution True made to the cause of halting the looting of antiquities was persuading the Getty's board of trustees to adopt a policy barring the acquisition of antiquities that lacked clear provenance. The policy was finally adopted in 1995, which became the museum's cut-off date for purchases. "Marion True was the only one in North America who has been giving lectures about not buying antiquities for years," said her friend Admiraal. "None of her colleagues did this—not in Cleveland, in New York at the Met, or in Boston. She was so brave. About twelve or fifteen years ago, she told the trustees of the Getty that it was ridiculous to acquire more antiquities because they had so much, and they could only show the tip of the iceberg. She said, 'If we acquire more antiquities, it will generate more looting in the Middle East and the Mediterranean.' She said, 'We have to stop. Let's use this budget for restoration and conservation.'"

It was because of True's history that many in the field were bewildered when she was charged with trafficking in 2005. As True's trial got under way, Malcolm Bell III of the University of Virginia took up her defense. "Getty policy now excludes purchase of any antiquity unless documented by publication before 1995," he wrote in an op-ed article in the *Los Angeles Times*. "It is the strongest acquisitions policy of any major U.S. museum. By contrast, other museums, including the Met, do not exclude buying pieces without provenance. By all accounts, the sharp turn taken in 1995 on acquisitions is owed to True, who persuaded her institution to emerge from decades of unethical behavior and to regain respectability."

Admiraal recalls that the day after the policy was adopted True received several threats by phone and, later, an anonymous letter saying that the antiquities dealers would have revenge. Still, the Getty managed to continue collecting antiquities—buying 557 objects between November 1995 and early 2005, most of them antique glass from the Oppenlander Collection, the holdings of a German collector from the mid-twentieth century. After the serious troubles set in, and the Getty's acquisitions policies were tightened even more in 2007, collection almost halted entirely; from 2005 until the end of 2007 only one antiquity purchase was made, according to museum records, a bronze vessel

called a "balsamarium," in the shape of a boxer's head, bought from a European family that had owned it since the 1870s.

Before she found herself in the prosecutors' sights, True had seemingly excellent relations with Italian authorities. In 1999 she supported Italy's request for a five-year ban on U.S. imports of looted antiquities, and she testified in favor of it to the U.S. Cultural Property Advisory Committee, which advises the president on such policy. She was the only representative of a major U.S. museum to do so, and the policy was adopted. That same year the Getty voluntarily returned three works to Italy—a fifth-century terra-cotta drinking cup that was illegally excavated; a second-century torso of the god Mithra stolen from a private Italian collection; and a second-century Roman head taken from an excavation storeroom. In a press release at the time, True repeated what she had been saying for years: "Our antiquities collecting policy calls for our prompt return of objects to their country of origin should information come to light that convinces us that this is the appropriate action to take."

How does one square this image with the one revealed in the Italian courtroom, of a woman who exchanged letters over acquisitions with Giacomo Medici, the convicted looter, and protected the dealer Robert Hecht in deflecting inquiries from a Swedish journalist over a Roman relief that might have implicated him? Of her contacts with Hecht and Medici, there is no doubt. Among the many documents produced at trial was an April 1987 letter from Hecht's firm, Atlantis Antiquities: "Received in commission for resale from Giacomo Medici at the price of $2,000,000.—less 5% commission, payable to Mr. Medici after receipt of any payment from the J. Paul Getty Museum." This was for a one-year loan of twenty Attic red plates owned by Medici, which the Getty ultimately did not buy despite True's recommendation to do so. On another occasion she wrote to Medici to thank him for telling her that a certain piece, a wine jug, came from Cerveteri—a sprawling archaeological site outside of Rome where many artifacts had been looted—which she found "very helpful to the research of one of my staff members." In all, Italian investigators linked forty-two artifacts at the Getty to Medici, based on documents found in the dealer's warehouse. But some might wonder if similar

letters could be found in the files of other museums, signed by their curators, implicating them in the unsavory world of collecting.

In the first blush of news after her indictment, many took up True's defense. Employees at the museum, where she was popular, took to wearing lapel buttons that read: "True Love." In the summer of 2005 some three dozen museum directors and curators signed a letter to Barry Munitz, the president of the Getty Trust, attesting to "the absolute integrity and judgment of our esteemed colleague Marion True." Among those who signed were the leaders of the Museum of Contemporary Art in Los Angeles; the Hammer Museum at the University of California, Los Angeles; the director of the Los Angeles County Museum of Art; and the Fisher Gallery at the University of Southern California. That was before the court case began and details from the Medici archive began to leak, and it was before the loan for the Paros house became public. Soon enough, many of those friends fell silent. They weren't sure what to think. Many of True's contemporaries shuddered inwardly, fearing that but for the grace of God, they might themselves be under indictment. And some wondered: what really happened here?

Even now, across the range of the museological-archaeological world of collecting, reactions to the fate of Marion True remain tentative and confused. The question of fairness and balance seems to limn the lack of clear condemnation by her former colleagues and associates. Colin Renfrew, normally a thundering Jeremiah on questions of modern looting, is equivocal, even sympathetic. "Poor Marion True," he said in an interview, "a very well-meaning lady, but I think just a little bit schizophrenic," because her forward-looking policies seemed to contradict her backward-looking actions. He, too, wondered why she had been singled out. Asked if she deserved to face criminal charges, he said, "I don't think I want to comment on that until there's a verdict, although I've often thought if she *does,* then certainly John Walsh, who was director of the museum, and Harold Williams, who was chairman of the trustees, would belong beside her. I think it's amazing they're not in the court beside her."

At the other end of the spectrum, Giacomo Medici, the convicted smuggler whose photos formed the basis of the trial against True,

thought the curator had been too naive. He knew her predecessor, the ill-reputed Frel, and in an interview Medici said that Frel knew how to maneuver in a dirty world, the world of antiquity collecting. "Frel was like a bandit," Medici said. "He knew what to say to whom, to the police, to journalists. He'd send them on their way. Marion True—she was very sweet." Too sweet, Medici believes, and too willing to take up the question of dubious provenance and pursue it. According to Medici, she alerted the Italian authorities to a Pompeian fresco bought by the American financier Leon Levy, linking it to another fresco in an Italian museum. And she tried to build provenances for the unsourced pieces acquired by Frel. She wrote to Medici asking him about three Corinthian vases and whether he knew if they were looted. "I said, 'This style you describe sounds like it may correspond to an area in Cerveteri,'" Medici said he wrote her back. When the police found the letter, they used it as proof of her bad-faith relations with Medici. Medici said it was just the opposite: she was trying to learn of the actual provenance and queried Medici for an expert opinion, not as the dealer. "Marion True is the stupidest woman in the world," he said. "She's an idiot. She wanted to be too correct, too honest. She wanted to revolutionize acquisitions. The problems we have today are because of her. If she'd have acted like Frel, everything would have been fine." He shook his head ruefully. "They want to kill that woman," he said, of the Italian prosecutors. "She's a very nice woman. But stupid. The world is not a nice place."

THE TWENTY-FOUR ISLANDS of the Cyclades are their own storied haven—Mykonos, a magnet for the jet set; Santorini, a destination for crowded cruise ships; Kea and Andros for the yachters seeking a day trip from Athens. Paros, the largest island in the group, just a three-hour boat ride from Athens, has no grand Dionysian temples, no ruins like those on Delos, the center of the great alliance of the Athenian golden age. Still, it looms large in the mental landscape of any historian of the ancient world. Paros was the source for the most prized marble in ancient Greece, a pale translucent stone quarried in the very center of the island, famed for its luminosity and luster, allowing light to penetrate up to 3.5 centimeters (1.4 inches) deep. Parian marble was

used to create the Venus de Milo and the Winged Victory of Samothrace, among many other monuments. In ancient times, the island was home to famous marble workshops and a few cities and temples that have only begun to be excavated in the last century.

Marion True initially came to Paros to visit her best friend Stella Admiraal, a young archaeologist, and her husband, Koos Lubsen, a medical doctor. Lubsen had first come to the island as a student wandering south from his native Holland with a rucksack, and he kept coming back his whole life. Admiraal and Lubsen met True at Harvard in the early 1970s, while True was doing her doctoral work under Emily Vermeule and Lubsen had a fellowship to study at the Harvard School of Public Health. Admiraal was a budding archaeologist who audited courses in the same department as True, and the two women became fast friends. Both hardheaded, smart, blonde, and ambitious, they went on to work together at the Boston Museum of Fine Arts; they remain friends to this day. In the 1970s and '80s True would visit Admiraal and Lubsen in the summertime at their home, a sprawling, traditional Greek cottage on Paros, filled with photos of Lubsen as a skinny, young medic, of Admiraal excavating in Cyprus, and of their daughter, Gisele, who became a photographer. The mantel also has a photo of True's 1997 wedding on Paros to her second husband, Patrick de Maisonneuve, a French architect. In the photo she wears a yellow dress and an open smile. Bride and groom are flanked by the witnesses, Stella Admiraal and Angelos Delivorrias, the director of the Benaki Museum—another private collection endowed by a wealthy Greek family. Back then, "she had a sweet personality. She didn't have a new-rich mentality," said Ioannis Andreopoulos, a local lawyer who became True's good friend. "She was interesting; she spoke about history; you liked to be with her. She came here to find paradise, and she found paradise. Everyone liked to be with her. The mayor wanted to meet her." The Getty was her calling card, her power, and the largesse she could spread to deserving friends.

It so happened in the 1990s that the Lubsens' neighbors, a Swedish gay couple, decided to sell their house, a traditional cottage built in the nineteenth century on a one-acre plot of land. True wanted to buy it, though she knew that financially it would be a stretch. "She said, 'This

*Marion True's close friend Stella Admiraal and her husband, Koos*
*Lubsen, at their home on Paros, just down the road from True's cottage.*
*The photo behind Admiraal is of True's wedding to the French architect*
*Patrick de Maisonneuve.* (Photo © Sharon Waxman)

way, we can grow old together,'" Admiraal said in a conversation in
her kitchen, recalling her friend's determination to find a permanent
toehold just one hundred yards down the road.

As True suspected, the financing did turn out to be difficult. Admi-
raal and Lubsen loaned True $40,000 for a down payment on the
house, 10 percent of the $400,000 price. But it was the other part of the
loan that caused so much trouble. American banks turned her down,
since the property was overseas. True mentioned her quandary to her
good friends Robin Symes and Christos Michaelides, the partners who
had become successful dealers in the antiquities market in the 1980s
and '90s and who had been major suppliers to the Getty. They had a
house on Schinoussa, a nearby island, and were part of the circle of art

and antiquities friends who socialized in the summers. Michaelides referred her to Demetrios Peppas, an Athens lawyer who was willing to loan her the balance of the $400,000. The transaction went through, but the loan clearly made True feel uncomfortable because of the link to Symes and Michaelides; she was in a hurry to pay it back. Later it emerged that True repaid the loan from Peppas in 1996 with another ethically questionable loan, this one from Lawrence and Barbara Fleischman, major antiquities collectors who had donated pieces to the Getty and who had just sold part of their collection to the museum for $20 million. The loan followed the Getty sale by days, making the secret arrangement even more problematic.

It all seemed part of a toxic swirl of money, relationships, status, and prestige, a tangle of incestuous ties in the high-class world of museums and collecting. In this close-knit club, one hand shook the other, one person's interest served another one's need, and everyone covered for everyone else.

While they reigned through the 1980s, Symes and Michaelides were at the very nexus of the antiquities social network. Michaelides, a dashing young aesthete, came from big Greek money, and the older Symes, who had an established business as a dealer, thrived the more after he met Michaelides. Theirs was a love story; Symes left his wife and children for Michaelides, and the two became a couple, though there was always some strange insistence that the relationship was platonic. Regardless of their sexuality, their business partnership worked famously. Michaelides had the eye for quality, while Symes made the hard sell, convincing collectors that their latest piece was indispensable to a collection, a must-have. The pitch—to their good friends Shelby White, Lawrence Fleischman, George Ortiz, or Marion True—usually came over dinner at the couple's London mansion, where a stately indoor pool was surrounded by Roman marble busts. Or in their New York town house, designed by Philip Johnson and previously owned by a Rockefeller, with its massive library. "You pick an art dealer by his library," Symes once told a fellow dealer. The couple would fly the Concorde to New York for Christmas and be in Gstaad in Switzerland for New Year's Eve. On Schinoussa, where they relaxed in the summer,

their house was in the compound of Michaelides's relatives, the Papadimitriou family. "They had patina; they had savoir faire," said Barbara Guggenheim, a Los Angeles–based art dealer who knew them at the height of their reign. "They were so stylish. You wanted to have dinner with them. You wanted to *be* them."

But the success of Symes and Michaelides derived from the unregulated art market, most of it of illegal origin, laundered through the free zone in Switzerland and handed off to wealthy collectors or respectable museums who did not push very hard for more information when told the piece belonged to an unnamed "Swiss collector." Robin Symes would later acknowledge that what lay beneath his years of success was his naked disregard for laws about antiquities exports. "The business which ran so successfully for so many years is now virtually finished; for the reason that international law prohibits the export of [works of] art from most host countries and it is now not possible to flagrantly disregard them," Symes wrote in a revealing memo to the Inland Revenue service during a government investigation into his finances.

Such buying practices were widespread. As everyone in the art and museum worlds knew, antiquities for sale meant, for the most part, looted antiquities, since for decades no source country had allowed their export or domestic sale. The only legal source would be museums who were deaccessioning or collectors selling artifacts acquired before the 1970 UNESCO convention—and there were precious few of those. "From the beginning, we knew that there was the potential of being offered material that had been illegally excavated, or illegally removed from Greece or Turkey or Italy," acknowledged John Walsh, the director of the Getty Museum from 1983 to 2000, in a deposition in 2004. "This was a common problem. Everybody knew it in 1983; everybody knows it now." In the absence of interest by source countries and in the maze of varying international laws, the market became a gray zone of "don't ask, don't tell." And if museums were buying, well, at least the artifacts would be well cared for and open to public view, rather than hidden in the palace of a desert oil sheikh.

What changed was the discovery in 1995 of the documents and photographs in Giacomo Medici's warehouse and the raid on Robert

Hecht's home in 2001. Italian prosecutors now had a thread to trace from the work of the *tombaroli* into the halls of the Getty and other museums. Suddenly laws that had long been ignored were going to be enforced to the letter. The Getty's deep pockets and aggressive acquisitions policy meant that its name came up frequently in investigations. Italy began in 2000 by demanding the return of thirty-five artifacts from the Getty (later expanded to forty-two and eventually to fifty-two), though the list was never quite clear and became a running joke inside the museum. The Getty dragged its heels, responding to Italian demands for specific objects with broad, sweeping counterproposals that didn't touch the substance of the demands. Talks proceeded fitfully; the Italians grew restless and threatened criminal prosecution of Marion True and the board of trustees. The threats seemed serious, but everyone at the Getty seemed to believe that civil discourse was going to resolve the situation. They were shocked when, in May 2005, Italy filed charges against the curator. True had a lawyer, paid for by the Getty. But no one really understood why it was True in the crosshairs and no one else. After all, there were four levels of superiors above her in the Getty hierarchy: the associate director of the museum, the director of the museum, the president of the trust, and the board of trustees.

The trial started in July, an agonizingly slow list of witnesses called over more than two years, with the express aim of pressuring the Getty to cough up the pieces. At a certain point it didn't seem to matter much what True had done wrong, what her relationship was to the witness or the object being discussed. Some of the items being examined—such as Victorious Youth, the bronze sculpture from Fano that the Getty was refusing to return—had nothing to do with True. Meeting at the rhythm of Italian justice, one day every couple of months, parading in witnesses to make the case, the trial became an international showpiece with a shade of the baroque. True appeared only once, and she was besieged by reporters and photographers. Otherwise, she and her lawyers said nothing. Meanwhile the Getty trustees hired their own set of lawyers, Ronald Olson and Luis Li from the firm Munger, Tolles & Olson, who handled most of the negotiations in Rome.

The Greeks were next. The Italian prosecutors passed along information they had gathered to their Greek police counterparts, who followed with a list of four artifacts they demanded that the Getty return, including a magnificent gold wreath that was the prized possession of the museum's collection. In negotiations with the Getty in 2006, Greek prosecutors told museum representatives that the board of trustees and Marion True were all in their sights for criminal charges if compromises were not forthcoming. The Greek authorities also said that if the Getty was not compliant, they intended to go after numerous pieces in the Getty's storerooms unfamiliar to the public, not just the four pieces on display they'd initially announced to have been looted. They intended to bring this leading museum to heel.

Looking for evidence to help build a case, in March 2006 a squad of Greek police raided True's home on Paros, descending on the cottage in the morning hours and seizing seventeen pieces in the house that they declared to be looted antiquities. It seemed absurd on its face: what curator of a major institution would buy, much less keep in her home, looted antiquities? Greek law required that antiquities be declared to the authorities, unless the owner was a registered collector. True protested that the pieces had been there when she bought the house, and they were later found to be of little value. What police listed as a "classical column" was a piece of marble used to prop open a window. Another item listed as a Byzantine icon was a modern paper copy mounted on wood, brought as a present to a dinner party by Yannos Kourayos, the director of the Paros archaeology museum. Still another piece, listed as a sarcophagus, was a contemporary birdbath that sat on the roof. The police were not gentle; they hacked out of the fireplace a piece of antique marble installed as a structural element when the house was built a century earlier, though this was not unusual in Paros homes. The authorities were not happy when Kourayos told the press what was obviously true: the ancient things taken were of no particular value, the sort of thing found in gardens and homes around the Greek islands in general and Paros in particular. He subsequently lost his museum position and was transferred by the Culture Ministry to another region after a tenure of twenty years in Paros. From that point on, True became a public target in Greece, an object of scorn and derision in the place she

once loved and was beloved. Curiosity seekers broke into her house, taking photographs that appeared in the local papers. One trespasser was so bold as to steal True's address book from her desk. On continuing advice of counsel, True said not a word.

HAVING STONEWALLED ON Italy, when it came to Greece the Getty blinked. The museum agreed to give back the four artifacts, and it would serve up True as the expert who had recommended the purchases. The charges against the Getty board never materialized. Greece got back its four pieces, including the magnificent golden wreath. True was charged in December, within days of the return of the wreath, and protested vainly that the lack of any public statement of support from the Getty added to the impression of her guilt. In January 2007 she pleaded not guilty to the Greek charges and submitted a fourteen-page defense. She was released on bail of $19,500.

Was Marion True a scapegoat or a scofflaw deserving of her fate? Perhaps she was both. Certainly her conduct in accepting the loans for the Paros house seemed improper, over the line of ethical behavior for someone in her position. For that error she was made to resign, a year shy of retirement. But no one seems able to explain how the full weight of misconduct of antiquities buying in the world of museums has somehow fallen on her head. That was the source of her criminal prosecution, and Marion True was well and truly alone on that gangplank. Her friends were indignant. "The Getty should have said, 'This is an institutional decision. We acted with incorrect information, and as an institution we are responsible.' Like any normal company," said Koos Lubsen. "But you try to find a scapegoat. She's the scapegoat. The Getty chose to scapegoat someone, then not to fight the accusations."

A larger question is this: why did Marion True not cut a deal by handing over evidence against her superiors? "Every day we would ask ourselves: What do they really want? Why Marion?" recalled Barry Munitz, president of the Getty Trust, who did not find an appropriate moment to ask this of John Walsh and his predecessor, Harold Williams. The trustees wondered about this, too. John Biggs, the chairman of the board of trustees, would regularly say, "If this were the United States,

Marion True would have plea-bargained her way out of this within twenty-four hours and been on a beach in Rio."

But such speculation was disingenuous on the part of the trustees and the senior Getty officials. They knew perfectly well why Marion True never turned on her superiors: the Getty was paying for her legal defense. Everything was spelled out in a series of documents True signed as she resigned her position, according to one person involved. She signed what this person described as a "dramatic non-disclosure" in her separation agreement, though her lawyer has denied the existence of this document. The package included a joint defense agreement that tied True's legal confidentiality to that of the Getty, should the museum face charges. This required her to be cautious in revealing anything she learned in the course of preparing her defense. It also included a separate letter drawn up by the Getty's lawyers that if True were found guilty in her foreign trials, she would be liable to reimburse the museum for her legal fees—a sum that would easily rise to millions of dollars. This letter cut off the road to a plea bargain. If True were to admit even limited guilt and testify against her superiors—the quickest way out of her predicament—she'd have to pay. One Getty official described this as the "sword of Damocles" hanging over her, and the central reason for her to reject a deal.

In December 2007 Marion True finally broke her silence. The *New Yorker* magazine ran a long article about her plight, in which the curator gave her version of events. Even here, though, she didn't say much that wasn't already suggested by her circumstances. "Sometimes I think it is almost a case of mistaken identity," she said. "There is something horrifying about being accused as a criminal in two different countries that I spent my life promoting." As for her relationship with Giacomo Medici, she said that only in 2001 did she realize "he was working with people who were excavating. . . . I did not have a sense of Giacomo being shady." She said she learned this when, during a deposition, an Italian prosecutor showed her photographs of objects taken from the Geneva Freeport. But this response was disingenuous. Of course True knew that Medici had ties to the *tombaroli*; on several occasions Medici had sent her detailed information about the provenance of objects already held by the Getty for the very purpose of proving his proximity

to the authentic sources of the artifacts. This suggested his ongoing relationship with tomb raiders, which by accepted practice no one ever discussed explicitly. True was more credible when she spoke elsewhere in the article about the accepted etiquette of "don't ask, don't tell" in the museum world: "The issue of 'Where did you get this?' was not discussed."

The pressure on True had been unbearable, though she did not betray this. Her friends knew the truth. Said the lawyer Ioannis Andreopoulos: "It's a nightmare. It should not happen to you or anyone else. You could die from this stress." Stella Admiraal agreed, saying, "It has been very hard for her to survive mentally. I try to tell her: there will be a day that you will be truly exonerated. But she has been very close to leaving this world."

# THE GETTY MUSEUM

THE FOG ROLLED IN THICK AND WHITE, A HARD MILKY cover over the Santa Monica Mountain range where the J. Paul Getty Museum was perched, with its sharp edges and cube-shaped lookout points. It was November 2007, and the chilly fog seemed appropriate, a shroud to hide the museum's mournful duty that month. A half dozen miles up the road, millions of dollars' worth of antiquities, precious cargo, was being wrapped and prepared for shipment to Italy, among them the best-known and most cherished parts of the Getty antiquities collection. The battle was over. In August the Getty had finally come to an agreement with Italy over fifty-two antiquities that the Culture Ministry was demanding as having been looted and illegally exported from the country.

The Getty agreed to give up forty of its masterworks, including signature pieces like a massive cult statue (one used in religious rites) of Aphrodite, a startling marble sculpture of two griffins attacking a doe, and all manner of amphorae, calyxes, kraters, and lekythos. These were pieces that once adorned the covers of Getty catalogs, held out as the proudest of the museum's acquisitions. All gone or on their way out—the golden wreath, long gone to Greece; an Etruscan statue of

a man and woman dancing, donated by Barbara and Lawrence Fleischman, now on its way out; the griffins, donated by the American financier Maurice Tempelsman, found to have been dug up in a recent decade and sold through Giacomo Medici. The pieces would leave a gaping hole in the Getty's small but selective collection.

"To buy any object from [such] dubious sources is obviously risky," wrote J. Paul Getty himself in his book *The Joy of Collecting*, published in 1965. "To all intents and purposes, the modern-day collector of ancient Greek and Roman art must confine himself to buying from one or another of two sources—well-established and highly reputable dealers or other collectors. Even then, the wise collector will have the object he wishes to buy vetted by an outside expert, or even several independent authorities, if the purchase he is considering is important enough."

Prophetic words or ironic ones. At the moment of removal of its tainted objects, the Getty seemed resigned and desultory, if it's possible to assign emotions to an entire museum. No one there seemed to know anything about the latest in the Marion True trial in Italy or what was happening with the charges against her in Greece. In fact, on that very day—November 19—True's trial in Greece had begun over charges that she had conspired to illegally export the already-returned gold wreath. No one in the press relations offices at the Getty was aware of it; True had been amputated like a gangrened limb. Instead the museum was focused on getting through an unpleasant task—the return of the artifacts—and moving forward.

WHAT KIND OF place is the J. Paul Getty Museum? Is it some rogue institution—perpetually unable to contain its greed or to function within the confines of accepted museum practices? The question goes to its essential character and its culture from the start.

When judging the Getty, it is worth remembering that the museum set out to do something unique in modern times: to establish a world-class art and antiquities collection in the second half of the twentieth century. That alone sets it apart from its counterparts around the world, which assembled their collections during an era when laws were nonexistent or disregarded entirely, when colonial powers dug

at will and grabbed with impunity. When those older museums purchased antiquities, they bought from the Giacomo Medicis of their time: Henry Salt, Giovanni Belzoni, Bernardino Drovetti, Louis Palma di Cesnola. In that sense, all Western museums are flawed and too often acted out of greed to build their collections rather than the more noble, stated motivations of serving humanity. Museums have never been swift to acknowledge their past mistakes, usually choosing instead to cover them up and hide behind self-serving justifications. It is only as a result of media exposure, lawsuit, or other public embarrassment that policies change. In that sense, the Getty is no different than other museums.

But there is something about the place that has long given the Getty a whiff of scandal. Perhaps it is immaturity or the vast quantities of cash that have surrounded it from the start. The stories about the Getty, even within the Getty, are legion—tales of sex among the curators and researchers, of toga parties that ended in the pool at its stately villa overlooking the Pacific in Malibu, of political infighting and harassment lawsuits. "There was something sinister about the place," said Nicholas Turner, a former curator who worked there in the 1990s. "It worked in a way that I couldn't fathom."

Almost since its inception, the Getty seems to have been plagued by ethical challenges of one sort or another, following the tone set by its founder, the oil tycoon Jean Paul Getty. In 1957 *Fortune* magazine pronounced Getty the richest man in America and its only billionaire. (To which Getty famously responded: "If you can count your money, you don't have a billion dollars.") But he was a miserly billionaire. His seventy-two-room estate in London, Sutton Place—filled with millions of dollars' worth of art and antiques—had a pay phone for the use of guests. He notoriously refused to pay a ransom to the kidnappers of his grandson Jean Paul Getty III, in Italy in 1973, believing it was all a bluff by his family to squeeze money out of him. The kidnappers severed the teenager's ear and sent it in the mail to an Italian newspaper; Getty eventually paid, but not before negotiating the ransom down to $2 million from an initial demand for $17 million. Getty was a vain and acquisitive man, tirelessly competitive and surprisingly insecure. He was driven by a primal need not only to make money but to make more

than anyone else. He harked back often to the powerful men in classical history—the Roman emperor Hadrian was a favorite—and set out to acquire the objects that would make his superior power and wealth evident. Collecting art was one way of doing that.

With art, as with his other pursuits, Getty was led by his desire to pinch a penny. As he built a collection, the tycoon often chose on the basis of price rather than quality. Getty was sniffed at by connoisseurs, who considered him a rube who was unwilling to adopt the criteria required to create a great collection. He once sent back a sculpture because he thought it was too small for what he'd paid. "He was getting more for his money if he had a big picture," recalled Burton Fredericksen, a curator of the collection in the 1960s. Getty favored out-of-fashion categories like eighteenth-century furniture, carpets, or antiquities, where bargains were available, avoiding old master and impressionist paintings, which he thought were too expensive. Moreover, he did not let morality get in the way of his art collecting. After the Nazis seized power in Austria in 1938, Getty headed to Vienna and scoured the city to find objects that might be available at fire-sale prices from the city's persecuted, upper-class Jews. He stopped by the mansion of Baron Louis de Rothschild, not to see the baron—who was held prisoner by the Nazis—but to get a look at his furniture, which he thought might become available. It was. He later bought several pieces at a great discount.

Elsewhere, Getty was delighted to buy the Lansdowne Hercules, a magnificent marble colossus long celebrated for its beauty and idealized heroism, at a cut-rate price. The statue was first discovered in 1790 at Hadrian's villa near Tivoli in Italy and was bought in the nineteenth century by the Marquess of Lansdowne in London. But by the twentieth century tastes had shifted, and the statue was no longer so much in vogue. The family needed to sell it for cash, but the Hercules failed to sell at a Christie's auction. To Getty's "incredulous joy," he was able to purchase the statue at a bargain price—£6,600 (about $18,000 back then), which included, as he pointed out in his book about collecting, the 10 percent commission. He similarly crowed over buying three marble sculptures from Lord Elgin's personal collection: two steles and a marble kore from the fifth century BC. But many of

his purchases were not fine enough to be in a top-tier collection. Indeed, it was only after his friend Baron Thyssen of the German steel fortune exhorted him to "stop buying this rubbish and buy a good picture for once" that Getty started laying out serious cash for art, which he did at Christie's in 1971, spending $6 million on four paintings.

But what was perhaps strangest of all about Getty's penchant for collecting was that he showed no overt passion for the pursuit. He did not seem to love art at all. He would pepper experts with questions about the color of the paint or for proof of authenticity. But as Stephen Garrett, the architect who became the first deputy director of the museum, said, Getty showed "no joie de vivre. I never saw him stand in front of an art object and enthuse about it."

As the collection grew, Getty housed his art at the ranch he bought in Malibu in 1943, later adding a wing that served as an art gallery. And he placed the collection under a trust fund as the J. Paul Getty Museum, which was opened to the public in 1954. The Malibu collection included the landmark Persian "Coronation Carpet," eighteenth-century Beauvais tapestries, eighteenth-century French and English furniture, rock crystal, chandeliers, and fine examples of Greek and Roman sculpture. It was a hodgepodge of artifacts, not close to a proper museum collection. That would change.

In the late 1960s, as the collection grew, Getty decided to build a museum on the property and in doing so re-create a luxurious Roman villa from the first century BC, rather than "some tinted-glass and stainless-steel monstrosity," as he put it, to house the collection. His advisers—including Garrett—were horrified. Re-create a Roman villa? It was an invitation to be ridiculed by the mainstream of modernist-oriented architecture critics. But Getty, with an eye cast back to Hadrian, was insistent. He chose to replicate the Villa dei Papiri, a luxurious Roman-era seaside estate in ancient Herculaneum, which was believed to belong to Calpurnius Piso, Julius Caesar's father-in-law. The estate had been buried in the eruption of Mount Vesuvius in AD 79 and preserved for centuries under volcanic ash—furnishings, sculpture, and all.

Undoubtedly part of what motivated him to undertake such a

project was his rivalry with William Randolph Hearst, the newspaper tycoon whose Hearst Castle at San Simeon—an outlandishly sumptuous castle in a mix of Gothic and other styles, where he held epic parties—was already a legendary site in Southern California. Getty wanted to show that he had better taste and at least as much vision. He tapped Garrett to oversee the project and hired the architectural firm Langdon Wilson, who relied on drawings of the Villa dei Papiri made in the 1750s by a Swiss engineer who explored the ruins of the estate through a network of underground tunnels. They also consulted with Norman Neuerburg, a historian of ancient architecture, to reconstruct the villa. The two-story property is built around a central atrium, with a long reflecting pool, and gardens with small burbling fountains set around it. Rooms open up onto that central courtyard, which leads on one side to another central space arranged around a pool on the south end and continues into a colonnaded portico that overlooks a garden (now converted into an amphitheater). The west side has its own grand portico, overlooking a showcase, an outdoor reflecting pool, 210 feet long, surrounded by bronze statues, and bursting with fruit trees and flowers. The villa uses marble brought from the ancient world, and in the case of the stunning, geometric floor in a niche that contains the Lansdowne Hercules, one of the museum's most famous pieces, the architects used the design from the Villa dei Papiri itself.

Getty's advisers were right. The critics hated the Malibu villa when it opened in 1974. They described it as kitsch, vulgar, and "straight out of Disneyland." The *New York Times* called it "pretentious and somewhat sterile." The *Economist* couldn't decide whether the building was "merely incongruous or genuinely ludicrous." Getty was stung by the criticism. Nonetheless, he never regretted the decision. Ensconced in London and afraid to travel, though, Getty never once set foot in his Roman reconstruction.

In 1973, Getty appointed Jiri Frel as the museum's first antiquities curator with a mandate to build a collection to help fill the villa. Apart from the Lansdowne Hercules and the marbles from Lord Elgin, the collection assembled by J. Paul Getty was spotty at best and already contained the seeds of its future discontent. Getty, it seems, had bought some fakes. In the 1960s Rudolph Forrer, the antiquities expert at the

British dealer Spink and Son, disparaged Getty's judgment as a buyer. He recalled Getty asking his opinion about three Greek statues, which Forrer said were "covered with mud" and "made-up"—that is, fake. He added, "He's the most difficult of all our customers . . . a queer client: more interested in material than in the artistic qualities, perhaps because he studied geology for his oil business." As curator, Frel took up the cause of purifying the collection, pointing out numerous fakes among Getty's early purchases and returning them to the dealers—but the question of ethics in acquiring art apparently did not come into the equation for him either.

A wily and knowledgeable Czechoslovakian immigrant with a roving eye for the ladies, Frel was an expert in Greek tombstones and Attic pottery, and he bought hundreds of vases and shards for the Getty, also using them for scholarly research and teaching. He expanded the museum's classical holdings by aggressively buying artifacts and just as aggressively seeking donations. One former Getty official remembered an Egyptian head that had been smuggled into the United States from abroad in the purse of Frel's wife; when the museum director, John Walsh, was informed, the head was returned and reimported with the proper paperwork. But this was hardly an unusual incident for the adventurous Frel. He bought many pieces from Robin Symes and from Giacomo Medici, in the days when a "European collector" was quite acceptable as provenance and certainly good enough for him. Jerome Eisenberg, a New York antiquities dealer who studied under Frel and later did business with him, described him as a "quite a Byzantine character," charming and brilliant but also given to fits of rage. Symes told one journalist of an instance when Frel stomped into his gallery, threw his coat down, and began stomping on it.

Frel intimidated dealers and donors alike, calling wealthy collectors and begging them to give artifacts to the growing museum. His methods yielded some spectacular results; in his eleven-year reign, the collection grew to include $12 million worth of donations. It was Frel who hired Marion True, then considered a brilliant young scholar, as an associate curator. But Frel's methods also came to include tax fraud; he would inflate the stated value of antiquities that were donated by

private collectors, allowing them to claim tax deductions far in excess of what they had actually paid for the item. He ran this scheme with, among others, Bruce McNall, a rare coins dealer and sometime Hollywood producer in Beverly Hills. The donor would pay McNall his price as the dealer, send the antiquity to the Getty, and Frel would get a third dealer to appraise the artifact for many times the actual price. Or, in another scheme, Frel would get dealers to charge more than the desired price for an artifact and hold the extra money for him, which he would use as a private slush fund. According to a former Getty official with direct knowledge of the incident, an assistant curator once walked into Frel's office to find the secretary typing up inflated appraisals on the letterhead of an art dealer. "Why are you doing this?" he asked her. "Because Jiri asked me to," she responded. "And I sign it for the dealer."

Arthur Houghton, an assistant curator hired in 1982, observed Frel's behavior and was alarmed. He reported it to John Walsh, the director of the museum, in August 1983. It took four months for Walsh to inform the Getty board of trustees, according to a statement later issued by the museum. After an internal investigation, whose results were not released to the public, Frel was sent on a paid sabbatical to Europe. Houghton was outraged and continued to agitate for a more transparent response, which was not forthcoming. In 1986 he resigned and, in a five-page letter to Walsh, detailed his differences with the museum leadership over its approach to "ensuring the integrity of the collections." His concerns, the letter said, "involve my belief that you've chosen a path of self-imposed ignorance" and were "treating knowledge of the facts of a problem rather than the facts themselves." He warned that the "trail of fraud and deceit may have the most damaging consequences to the institution." Houghton's words were prophetic. In April 1987 Frel's tax fraud scheme was revealed in an investigative article in *Connoisseur*, the muckraking magazine run by Thomas Hoving that had revealed the network of smugglers in Turkey. It did not go unnoticed that Walsh was a former curator at the Met who had bitterly fallen out with Hoving.

Houghton's accusation that the museum was more worried about

the appearance of a problem rather than the problem itself resonated elsewhere at the Getty, especially relating to Frel. In 1983 Frel had persuaded the trustees to buy a rare sixth-century BC Greek statue of a naked youth—in a stiff, standing position that recalled Egyptian statuary, with long, even ripples of hair—called a kouros. A letter accompanying the kouros, written by the German scholar Ernst Langlotz in 1952, placed the statue in a Swiss collection, and the Getty bought it from a Swiss dealer for nearly $10 million. After its unveiling in 1986, however, a growing chorus of experts declared the kouros to be a fraud. In typical form, the Getty defended the acquisition, rather than investigate the suspicions, with Walsh telling the *Los Angeles Times* in 1987 that he was confident the kouros was genuine. But over time, evidence continued to stack up against the sculpture. It was not until Marion True held a conference in Athens about the kouros in 1992 that the subject was given a full academic airing. And by that point, Getty officials had learned that Langlotz's letter authenticating the kouros's provenance was a forgery; it bore a postal code that came into use only in the 1970s. The kouros was not the only forgery bought by Frel, but it was the most expensive one.

The ethos of "self-imposed ignorance" arose yet again in the lack of interest over provenance issues. Part of this stemmed from the personality of museum director John Walsh. "John was very remote," said George Goldner, a former Getty curator who did not get along with Walsh. "There were many things he didn't deal with expeditiously. . . . He's a rather indecisive man." The museum as a whole was not terribly different from its peers in its reluctance to look too closely at the origin of potential purchases, but the Getty was buying like mad in a quest to build a collection important enough to put in a new complex of buildings that was under construction in Brentwood and, later, to fill the Malibu villa with a stand-alone antiquities collection. When Houghton or another curator, for example, would inquire about the origin of a particular artifact that Robin Symes was offering, the dealer would say simply, "Thank you for your interest" and hang up the phone. "He was very professional," said one former Getty official who dealt with Symes and who declined to be identified. "He was not go-

ing to tell you dark secrets about the antiquities trade." But the curator would be left with the feeling that the artifact would be sold to a private collection. And the "don't ask, don't tell" realities of antiquities dealing was the rule throughout the profession.

Still, there was a glaring instance when the Getty had disturbing information about provenance and chose not to probe further. In 1985 Arthur Houghton wrote to Deborah Gribbon, the associate director of the museum, about a conversation he had with Giacomo Medici that suggested the museum had bought pieces that were looted. On a trip to Geneva that same year, Houghton had lunch with Medici, who wished to continue selling to the museum. As a gesture of showing his access to authentic pieces—an active concern at the museum—Medici told Houghton key details about three pieces at the Getty that had been bought by the museum from the collection of the New York financier Maurice Tempelsman. He mentioned that they had come from an archaeological site called Orta Nova, essentially making Houghton privy to the fact that the pieces were looted and illegally smuggled from the country. Houghton wrote to Gribbon, "Medici informed me that he had acquired the lekanis and Apollo in 1976 or 1977, and that both had been found at the same location, a tomb which included a number of vases by the Darius Painter." Houghton did not stir the waters by bringing up the matter to his bosses in person, but he thought it important enough to put in a memo. Yet he did not ask that any action be taken. The information was simply written down—perhaps to cover himself in case of future problems. The memo was filed away, and nothing further was done.

This institutional impulse to bob and weave, to avoid delving into potentially embarrassing areas, would play out with devastating consequences when it came to stolen antiquities.

ONE OTHER THING stood out about the Getty, and that was the sex. Numerous current and former Getty employees describe the atmosphere from the 1970s onward as convivial in the most carnal sense of the word. "It was like Peyton Place" was how one former employee described it. "Sodom and Gomorrah" was the phrase used by another. Peggy Garrity,

a lawyer who sued the Getty over a client's sexual harassment claim, put it this way: "They were fucking like rabbits behind the paintings."

To some degree, this was to be expected. The Getty was an elite institution, isolated on a hillside in Malibu, and later on a higher mountain in Brentwood, hosting academic stars and worshipful young researchers. Sex was bound to happen. But something about the Getty seemed to facilitate, if not exactly encourage, illicit sexual behavior.

The sexual shenanigans were not directly tied to the problems the Getty would later face over stolen antiquities. But they were not insignificant either, creating a backdrop of interpersonal drama and tensions that played out fatally when the museum faced substantive issues over acquisitions, governance, or finances. This had a pronounced impact on the functionality of the institution and its credibility within the museum world. Such was the case with Harold Williams, the president of the Getty Trust, who left his wife to marry in 1987 the second-in-command at the trust, Nancy Englander, widely reputed to be brilliant at her job. But Englander had to resign from the board as a result, and Williams was subsequently furious because of it. By the mid-1990s he and the board were barely on speaking terms, according to a well-placed official at the time. Jiri Frel, meanwhile, was known for his priapic tendencies; he had a three-sided desk useful for cornering research assistants against the window. (The research assistants did not always complain, it should be noted.) "There was a hazy smoke of sex in the atmosphere, of staff members sleeping with one another," recalled a former Getty official who arrived in the 1980s and experienced a culture shock when his complaints about unprofessional behavior were rebuffed. "People at a high level of the museum had a reputation for screwing around, for institutional misbehavior. The place was young, boisterous, ambitious. People didn't know how to behave." Another senior official, in the 1990s, was similarly shocked but was told by members of the board to lay off. "You're coming off as an incredible prude," he was told.

An affair between the associate director of the museum, Deborah Gribbon, and George Goldner, the curator of the drawings department, was notable enough to be mentioned in a sexual harassment lawsuit filed by another Getty employee; it led to rising tensions be-

tween Goldner and museum director John Walsh, who already shared a mutual dislike. (Some said Goldner coveted Walsh's job, but Goldner denied this, saying instead, "The truth is, we never liked each other from the beginning.") Goldner, an ambitious cut-up and skilled mimic, would entertain guests at London dinner parties by mocking Walsh's slow manner of speaking, lying on the table and mimicking his boss to general amusement. From a museum standpoint, the affair was awkward; Gribbon was married and had young children. Walsh instructed her to end it and arranged for the Getty to pay Goldner to leave quietly and work as a consultant in New York. Goldner ended up at the Met, where he became chairman of the department of drawings and prints. Goldner denied that the contract in New York was because of the affair, though he acknowledged that the relationship "annoyed" John Walsh because the director was "very fond" of Gribbon. Goldner said the Getty allowed him to move to New York because his then girlfriend, later his wife, was living there, and because he had "quite a strong record at the Getty." Gribbon, contacted through the Getty, and Walsh, contacted directly, declined to comment.

Ultimately, this culture of indiscretion burst into the public eye when a British-born curator, Nicholas Turner, sued the institution for sexual harassment and sexual discrimination in 1997. It was a modern twist on an age-old complaint. Turner, fifty and married, began a love affair with his assistant, Kathleen Kibler, in 1996, two years after he arrived at the Getty from the British Museum to be curator of the department of drawings. When he tried to end the affair six months later, Kibler wouldn't let him. The legal complaint details a lurid series of scenes; she pleaded with him, telling Turner, "Everyone in the Getty has affairs," citing Gribbon and Goldner, and she allegedly trapped Turner in his office and "got on her knees to embrace him." When none of that worked, she threatened to destroy him and then, he alleged, falsely complained that he was sexually harassing her. Turner said that he asked Gribbon and personnel director Kris Kelly for help and that they instead ordered him to give his ex-lover a favorable job review.

All of this happened against a background of Turner's agitating for what would be an embarrassing admission on the part of the museum; he believed that six of the museum's prized Renaissance drawings were

*Two former Getty curators whose sexual relationships with other staff members led to complicated public maneuvering by the museum's top brass: Nicholas Turner (left) and George Goldner.* (Photos by Jane Turner [left] and by Don Hogan Charles/The New York Times)

fakes. One was a portrait of an infant attributed to Fra Bartolommeo, whose most important work is the great altarpiece at San Marco in Florence; another was said to be the only surviving drawing by the Italian sculptor Desiderio da Settignano. The museum had paid more than $1 million for the drawings, and one of them hung in the hallway outside of Gribbon's office. They had been acquired by George Goldner, and Turner was convinced they were the work of a skilled British forger, Eric Hebborn. He had told the museum as much in 1996 in a meeting with Gribbon and Walsh. According to him, they did not respond. Fast forward to the extramarital affair and its aftermath. Turner was claiming harassment, while being accused of the same. He was still determined to expose the alleged fakery of the drawings. It had all gotten very messy. After an internal investigation, Turner was cleared of the harassment. But he was stripped of his authority, his budget cut. So in 1998 Turner sued for $5 million in damages.

Turner's lawsuit complained that the museum did nothing about his being harassed by a subordinate. To Turner and his lawyer, Peggy Garrity,

there were two reasons why the museum's top brass declined to do anything about Turner's allegations: they were afraid that Kibler would blab about Gribbon's affair with Goldner, and they were looking to quash Turner's forgery allegations. "The person I had an affair with was able to benefit from the fact that, for other reasons, the Getty wanted to get rid of me," said Turner. Whether true or not, the Getty settled the suit quietly for a six-figure sum and the promise that Turner would be allowed to finish publishing a catalog of the museum's drawings collection.

But two years after the settlement, the catalog had yet to be published. In the page proofs, Turner had stated his belief that drawings in the museum's collection were fakes. Meanwhile, Goldner was making threatening noises of his own. He had gotten wind of the fact that he was about to be called a dupe in a Getty catalog and had written to Barry Munitz, the new president of the Getty Trust, threatening to "protect his interests." The letter claimed that the Getty was allowing Turner to publish such calumny because Gribbon and Walsh were angry at Goldner. "They didn't care what happened to me or my reputation or even the collection," Goldner said. "What they cared about was getting out of a proximate problem, which was people knowing that she and I had an affair."

In 2001 Turner filed another lawsuit, this time for fraud, over the Getty having breached the confidentiality settlement and for failing to publish the catalog, harming his career and keeping him from his right to denounce what in his view were forgeries. The Getty in turn filed motions to keep Turner from discussing any of these issues, which the presiding arbitrator rejected. None of this reflected well on the institution, which had proved itself time and again prepared to shove problems under the carpet rather than examine and deal with them. The museum had to settle yet again, for more money, and the catalog was published in 2001, with the allegations of the forgeries reduced to footnotes. Asked about the incident in 2008, the Getty's spokesman, Ron Hartwig, declined to comment. "That's water over the dam," he said.

In a *New York Times Magazine* article in 2001 about the alleged

forgeries, the journalist Peter Landesman—who discreetly made no mention of the Gribbon-Goldner matter—observed, "By gagging the forgery claim of its own expert, the Getty reveals a museum culture defined as much by commerce, politics and academic provincialism as by a commitment to accurate art history. No one suggests that there is a conspiracy to purchase known forgeries. But once substantive challenges to authenticity are made, for a museum like the Getty to revert to a code of silence seems ill advised."

But by that point the museum's "code of silence" was very well established.

THE NEW GETTY Center finally opened its doors in mid-December 1997. It was a landmark moment in the civic and cultural life of Los Angeles. With its museum, Conservation Institute, Research Center, and the Getty Trust all united on a mountaintop in Brentwood, the $1 billion complex was greeted with celebration and, largely, worldwide praise.

Barry Munitz arrived to take the presidency of the Getty Trust in January 1998, just three weeks after the official opening. He was not an art historian, nor did he have any background in running a museum. Instead, Munitz was an executive from academia, having most recently run the California State University system, the state's sprawling network of twenty-two campuses that ran as second tier to the top-ranked University of California system. There he had won praise for having boosted Cal State's image, improved the quality of its education, and empowered its individual presidents. At the Getty, Munitz's mandate was to take the reins from an aging Harold Williams, a former tax lawyer, who moved into an emeritus position, and to give the Getty dynamic leadership as it opened its arms to the city of Los Angeles in the most public of ways. It didn't turn out that way.

From the start, Munitz set out to change some perceptions of the Getty and to tighten its administrative processes. The board of trustees feared that even with such a huge endowment, the free-spending Getty might some day run out of money, and so Munitz was directed to diversify the museum's revenue streams, to encourage private do-

nations, and to puncture the public perception that the Getty had an endless supply of cash. The opening of the Brentwood center put tremendous financial pressure on the endowment. Half of the $250 million earned annually off the endowment had to go to maintaining operations at the center: administration, security, the tram, landscaping. That left just $125 million or so for acquisitions, and when a single painting could go for $50 million, that posed a problem. "By the time I arrived," Munitz recalled, the impression of being flush "was completely, clearly, transparently wrong." So wrong, in fact, that Harold Williams had reduced the museum acquisitions budget from $46 million to $23 million in anticipation of the Brentwood opening. (The museum rarely hewed to this figure; when choice paintings became available, curators would go to the board and plead for more funding. They'd usually get it.) "I was already starting this debate, which obviously caused a lot of distress in some quarters, about, 'We can't do this by ourselves; we can't run this institution all by ourselves as wealthy as it is. We have to ask for gifts; we may even have to ask for money,'" said Munitz. "Everything that was absolutely 'Duh' to any other museum except the Getty."

Munitz fairly quickly managed to rub the Getty's veterans the wrong way. For one thing, he was an outsider. Second, he emphasized education over the Getty's artistic mission as a museum, anathema to the curators there, who were focused on building the finest possible collections rather than writing explanatory panels in the galleries. Munitz saw the Getty as a whole as an educational institution, with the museum serving that educational mission—the mandate under which, he says, he was hired. And while he promoted Deborah Gribbon to be the director of the museum, she chafed under his changed priorities and what she perceived as imperiousness. On one occasion Munitz overruled curators and insisted on bringing a seventeenth-century painting to a house on the Getty property to show off to his Hollywood dinner guests, the Paramount studio chairwoman Sherry Lansing and her husband, the director William Friedkin. This enraged curators. Meanwhile Munitz's cutbacks at the museum stood in contrast to his personal behavior, sowing suspicion among the museum staff. There

was whispering over his ostentatious personal spending, over first-class travel and trips with his billionaire friends Eli Broad, the real estate magnate, and Ron Burkle, the grocery store tycoon, both of whom were brought onto the Getty board. He earned about $1 million a year and drove a Porsche Cayenne SUV paid for by the Getty. This rankled at a place where the researchers and librarians toiled for low annual salaries on the order of $30,000 or $40,000.

Other interpersonal tensions were at play as well. As True worked frantically to prepare the Getty Villa for its reopening, delays set in and she clashed with Gribbon, whom True perceived to be unsupportive and slow to respond. Gribbon found True insubordinate and unwilling to accept her authority. True would complain to Munitz on long Sunday morning walks at the beach in Santa Monica, where they both lived. The board became divided between those who supported Marion True and those who supported Deborah Gribbon, and the two women stopped speaking. The board squabbled over their proxies. And a fatal set of interconnected circumstances had begun to be set in motion that would cripple the careers of Marion True, Deborah Gribbon, and Barry Munitz and strip the Getty of some of its most famous antiquities.

IN THE FALL of 2000 Barry Munitz was approached by Deborah Gribbon and a lawyer, Richard Martin, who had done work for the Getty in Italy. "We need to brief you about what is emerging in Italy around our antiquities and Marion True," they told him. Up to that time, Munitz said, he had no awareness of irregularities in the Getty's antiquities department. He hadn't heard, for example, of Jiri Frel and his fraudulent past. He didn't know of Arthur Houghton and his resignation. "Of all the things I was briefed about during my orientation, one of the topics was not 'There's a checkered history in antiquities; it's an open issue; there's a lot of intense debate.' The conversation only came up much later," he said. The Italians were asking questions about provenance, first concerning thirty-five artifacts, then forty-two. The list would change continually. Ron Hartwig recalled, "Sometimes we wouldn't have a clear picture of under whose authority [the artifact] was being requested," whether from the Culture Ministry or the cara-

binieri. Italian officials might buttonhole a Getty curator at a conference and whisper that "it would be better" if the Getty returned the cult statue of Aphrodite, for example, but no formal request would follow. Meanwhile, in 2001, a European lawyer informed a colleague at the Getty that Marion True had bought a house in Greece with a loan from Robin Symes. The lawyer told Munitz, who queried Peter Erichsen, the Getty's lead counsel, and Deborah Gribbon. Erichsen and Gribbon told Munitz that they had checked out this allegation, and there was no truth to it.

In fact, however, the old wink-and-nod culture was at work. Gribbon had never asked the right question, and True had not volunteered a full answer. Gribbon had approached True at a cocktail party to ask whether Symes had loaned her money for her home in Paros. True said he had not, and the conversation ended there. Gribbon did not probe further, and True did not mention that the loan came via a lawyer for Symes's partner, Christos Michaelides.

Pressure continued to come from the Italians, who sent multiple requests for information about artifacts in the museum's collection. In June 2001 Italian officials came to Los Angeles and, in an attempt to settle the matter, True allowed herself to be deposed for two hours by the prosecutor Paolo Giorgio Ferri. At that time she saw the Medici photographs and claims to have been shocked to learn of his close ties to the *tombaroli*. The Italians were not satisfied. In 2002 Italian officials again came to the museum to present their requests, and in June of that year Gribbon and Erichsen went to Rome to gauge the situation. But there was little progress and little cooperation. For one thing, the Getty believed that its objects were acquired legally and in good faith, a key measure when considering criminal charges. Erichsen said he did not believe that Italy had grounds to credibly accuse the Getty of a crime. For their part, the Italians considered the Medici photographs to be hard proof and wanted the Getty to prove that the pieces in question *weren't* looted. They clearly were serious.

But the Getty seemed at a loss to grapple with the issue. It did not help that every time the board of trustees broached the matter, one board member, Barbara Fleischman, had to recuse herself and leave the room. Fleischman had joined the board in 1998, two years after she

and her husband, Lawrence, sold and donated a large portion of their magnificent antiquities collection to the Getty for $20 million. At the time, given the Getty's tightened resources, the Fleischman collection was considered a great coup—"a miracle," said Munitz—demonstrating that the museum could solicit major gifts despite its reputed wealth. The Fleischmans, two New York–based collectors, were close friends with Marion True, and the Getty had exhibited their collection in 1994, publishing the works in an accompanying catalog. Lawrence Fleischman, a real estate tycoon, decided to sell and donate a large portion of the collection when the real estate market dipped, but he turned his back on the Met after the Fifth Avenue museum overplayed its hand and asked him for too much money.

Moreover, there were whispers about the Fleischman collection. In 1995 the Getty had changed its acquisition policy to accept only those artifacts that had published histories before that date. The Fleischman collection qualified, but only because the Getty itself had published the collection in a catalog the previous year. In archaeological and art circles, some called this a cynical move to permit the Getty to acquire the collection despite its new, more stringent rules, though both Munitz and True have denied this accusation. Nonetheless, a great many of the pieces in the Fleischman collection had been purchased from Robin Symes and Giacomo Medici. So when the board needed to speak about Italy's accusations over provenance, Barbara Fleischman could not participate. Even so, candid conversation was nearly impossible because the matter meant raising embarrassing questions about her and her close friend Marion True, at a time when the Getty Villa was undergoing a major renovation to showcase the very collection True had exhorted Fleischman to donate to the museum.

In 2002 the Italians opened a grand jury investigation into Marion True. "We were flabbergasted," said Munitz. "Everyone thought the issue was serious, but there was regular conversation going on. We were told by everyone, by our legal and political advisers, that they were trying to reach an agreement." According to Munitz, no one knew precisely why True was targeted and no one else. Why, for example, wasn't John Walsh, the museum director, considered to be re-

*Barry Munitz, the former president of the Getty Trust, who left amid harsh criticism of his spending practices and management style.* (Photo courtesy of the Munitz Family Trust)

sponsible? "This is a question that came up all the time, but I don't know the answer to that question, and no one has ever given me the answer to that question," said Munitz. Via e-mail, Walsh declined to respond to the question. Outside the Getty, people wondered, too. Nicholas Turner, the former curator who had become an independent art consultant, said that Walsh's penchant for pliability was on display in his handling of the True situation. "I can't understand how he's gotten away without being held responsible," he said. "Very plausible man. Very suave. Very charming. Fundamentally weak."

Meanwhile, relations between Gribbon and True had not improved. To mollify True and her ally on the board, Barbara Fleischman, Munitz made a fateful decision: he took responsibility away from Gribbon by having True report directly to him about the Getty

Villa renovations, the most important project on the museum agenda. To those who saw her at the time, Gribbon seemed wounded and angry. She was embarrassed. And pressure continued from the Italians; the curatorial staff feared a disaster on the eve of the villa's reopening. The board briefly considered an expedient solution to get rid of the problem—to just give everything back to Italy. Munitz ordered a mock-up of the catalog and site map being prepared for the reopening of the Getty Villa without the objects demanded by Italy. He and other board members felt that even a reduced collection would have as strong an educational mission as the current collection and would remove any shadow of taint. The curatorial staff and the Getty lawyers did not want to consider this option. "It's dangerous to even put it down on a piece of paper" was the attitude.

In September 2004 Gribbon resigned from the museum. To some, her resignation was expected. She was angry over her treatment by Munitz; she disagreed with his emphasis on education leading the museum's priorities and felt stymied at every turn. The staff supported her; on the day Gribbon left, they lined the hallways, applauding her. But Munitz clearly was less than thrilled with her leadership, having given her a negative job review the previous spring. Still, Munitz said he was shocked when she resigned. "We had a tough performance evaluation," he said, adding, "but that happens all the time. I wanted her to stay." He went on to note, "In the seven-plus years we worked together, I never once turned down an acquisition recommendation that she made. . . . We never fought about an exhibition; we never fought about an acquisition. I believed in her strengths. . . . I think we still could have built a great partnership." Gribbon saw it differently; she felt Munitz had made it clear that their priorities would never mesh. His emphasis on education ran directly counter to her commitment to collecting and scholarship. In her resignation letter she wrote, "It has become increasingly clear that we differ on a number of critical issues." She said she left the job "believing as passionately as ever that museums best serve the public by collecting, exhibiting and interpreting works of art of the highest quality." Internally, Gribbon accused Munitz of essentially forcing her to resign by making it impossible for her to do her job, something her lawyer referred to as "constructive discharge" and

threatened a lawsuit. The Getty paid her $3 million, a fact uncovered only later by the *New York Times*. She and Munitz never spoke again.

In December 2004 the first of a series of investigative articles about Munitz was published in the *Los Angeles Times*. The article involved the sale of a piece of Getty property that abutted another property belonging to Eli Broad, the philanthropist and board member. Broad had bought the parcel for $1.8 million, 10 percent below the appraised market price, which suggested that Broad had gotten a sweet deal because of his friendship with Munitz. For Munitz, things spiraled downward from there. Questions of ethics and overspending arose like a cloud over his head. He flew first-class. He used the staff for personal errands. He brought his wife on business trips. The ill will toward him within the institution was helping fuel an avalanche of internal documents being leaked to the *Times* reporters. The penetration of the institution was extraordinary. At one point a reporter showed Munitz a document from his own files about the Broad real estate deal, and Munitz asked if he could have a copy; his own had mysteriously disappeared.

Among the instances of questionable conduct uncovered by the reporters was a book deal given by the Getty to a former Getty Trust chairman who had helped Munitz renew a five-year contract. This was followed by an article laced with sexual innuendo: Munitz had apparently wangled institutional funds and travel money for a German doctoral student, Iris Mickein, who had interned at the Getty. There were similar favors, including a $200,000 Getty grant for a female Russian curator to whom Munitz took a shine. He had carelessly spread Getty largesse to friends and acquaintances, according to the *Times*: the institution paid $500,000 to a public relations firm promoting a White House education effort about Mars and spent $1,000 on custom-made gift wrap. The Getty launched an inquiry, but things didn't end there. Because the Getty was a nonprofit institution benefiting from tax-exempt status, the state government finally took notice. In July 2005 Attorney General Bill Lockyer undertook an investigation.

All of this coincided with the even more serious matter of Marion True and the Italian investigation over antiquities. Munitz had consulted with Colin Renfrew, the British archaeologist and restitution activist, and came up with a proposal to have a joint conference with

the Italians at the Malibu villa to debate the issue of legality and provenance, with an eye to a relationship in which the Getty would finance excavation and in exchange get first dibs on loans of artifacts. This proposal was supported by the Getty's research and conservation departments but rejected outright by the museum's curators, who considered it an invitation to disaster.

The Italians filed criminal charges against True in May 2005. She proclaimed her innocence, and the Getty vowed to defend her. In a last-ditch attempt to fend off the Italian prosecutors, the Getty agreed to send back three antiquities, a Greek urn, an Etruscan candelabrum, and a stone inscription. But it made no difference. In the late summer the dam broke. The *Los Angeles Times* was preparing a story that said True had bought her house on Paros with a loan obtained through Robin Symes and Christos Michaelides, and reporters called the Getty to ask about it. Munitz remembered the initial inquiry four years earlier, and this time he queried True directly, who said there had been such a loan, but a friend had helped her repay it within nine months. Who was the friend? True responded mysteriously, "I can't say."

On a Saturday evening in September 2005, the phone rang at Barry Munitz's Santa Monica home. He had just come back from a cocktail party at the Getty to welcome the newly hired museum director, Michael Brand. In between the cocktail party and going to dinner at a nearby restaurant, Barbara Fleischman called.

"Barry, I need to talk to you right away," she said.

"Barbara, I'm on my way out the door with Michael and Tina Brand," he replied.

"Well, you need to know that in terms of Marion and the loan, it was Larry and I who gave her the money to buy out the other loan," she said, referring to her late husband. This was why Marion True couldn't identify the source of the loan; she didn't want to implicate her friends. Immediately Munitz understood that this would be a serious problem. For one thing, the loan had occurred at around the same time as the museum bought the Fleischman collection, a clear appearance of conflict of interest. For another, neither True nor Fleischman had mentioned the loan in the annual "conflict of interest" statements that they were required to sign at the museum. This was a legal liabil-

ity and from the museum's point of view a more serious matter than the loan from Michaelides's lawyer. Three days later, the board held a special meeting and hired the firm of Munger, Tolles and Olson to represent them in their dealings on the loan, on antiquities, and on every major issue of public concern. After the story broke later that month, True resigned, striking the deal that had the Getty pay for her legal defense at the cost of tying her hands in any potential plea negotiations with the Italians. Fleischman ended up resigning, too, writing in her letter of departure that Marion True had been "wrongly accused and endured almost five years of battering." Reached by telephone in late 2007, Barbara Fleischman hadn't changed her mind. "It's been a travesty, a disgrace," she said.

Battered by the press, under siege from the Italians, and with True on trial, the Getty could not function. Barry Munitz was through. He had long ago lost the support of the Getty staff as a whole, and now he lost the support of the board. Physically exhausted and having lost twenty pounds during these months of stress, Munitz resigned in February 2006. The trust's top financial officer soon followed, as did John Biggs, the chairman of the board. Munitz admitted no guilt but paid the Getty $250,000 to cover any expenses that were misspent, which many took to be a tacit admission. And he agreed to forgo more than $2 million in benefits.

But in October the state attorney general issued the report of his investigation of Munitz, in which he cleared the disgraced president of substantive wrongdoing. He rapped Munitz's knuckles for taking his wife on trips and for overpaying the female doctoral student. But the state found that in most of the areas of inquiry, the Getty had acted properly; the Broad real estate deal—the allegation that started it all—had been handled "properly and for a fair price," and Munitz had "violated no clear rule" in his first-class travel and eating in expensive restaurants. Nonetheless, the *Los Angeles Times* led its report with the fact that the state found that "Munitz and the board of trustees misused organization funds on lavish travel, gifts and perks." The damage was complete. Munitz was undone not by having flouted the rules but by the unpopularity of his style—and by a fatal lack of judgment over the swagger that the Getty seemed to encourage.

Munitz, like True, like Gribbon, like Fleischman, feels scarred by the experience. John Walsh, for his part, became a Buddhist. The Getty turned out to be a small sandbox with very big egos, petted and pampered by a big endowment and lots of attention. "The staff were too refined for their own good. It made them vulnerable to the sort of things they got up to," said Nicholas Turner, the former curator. His nemesis George Goldner agreed: "They lived in a kind of dream world: 'Hand over some money and get it over with.' That was their attitude. Even when they could have made a deal with the Italian government, they didn't. They're not a group of mafiosi, but there was a sense of disconnect from the real world at the Getty. Too much money, it came too easily."

Munitz reached a similar conclusion, and nearly two years after his resignation he found that the experience still brought tears to his eyes. "I wasn't prepared for this institution," he said. "I understood it was going to be smaller, and I understood it was going to be much more private. I just wasn't prepared . . . for how spoiled and arrogant and self-involved and precious it was." The Getty, he said, had "too much money and was too spoiled for too long. Harold [Williams, his predecessor] used to call it the Getty Gold Standard. Some places clean up once a week. We had to pick up every leaf, every minute. . . . But the part of it that was just baffling to me was why, that precious sense of entitlement?" Even people who didn't like Barry Munitz might have agreed with that assessment.

# REPATRIATIONS

THE TRADE IN ILLEGAL ANTIQUITIES HAS SUCKED THE life out of Nikolas Zirganos. A wiry, intense forty-eight-year-old journalist who zips around Athens in a grimy sedan filled with papers, books, laptop, and extra shoes, Zirganos lives in a pleasant enough apartment with a view over the rooftops of the city. But it's tiny and narrow as a railroad car—that's because he lives here alone, an unwilling bachelor. His obsessive pursuit of the dark secrets of Greece's antiquities trade drove his wife away, and she took the kids with her. Zirganos hopes to get her back. He wishes desperately to separate himself from the story of the looting of his country by smugglers and middlemen.

But it keeps pulling him back in. He couldn't resist writing a splashy, front-page story for a local newspaper in March 2007 under the headline "The Kidnap of Terpsichore." It was about the looting of a beautiful statue of the muse of dancing from Ioannina in northern Greece. Zirganos reported that the statue had been purchased in 2000 by the Michael C. Carlos Museum in Atlanta, along with a Minoan bathtub and a geometric vase, but according to his police sources, it had been originally dug up in northern Greece and sold by

a smuggler. Zirganos was also in charge of research for *Network*, a Greek television documentary about the smuggling trade that aired in 2005. The program helped change the tone of the debate within Greece and quickly became a staple in university courses about cultural heritage. He wrote a chapter about Greek smuggling in Watson and Todeschini's book *The Medici Conspiracy* under his own byline. His living room is filled with files labeled "Medici," "Getty," "Symes," "Saarbrücken." He keeps his most important papers and photographs with him at all times, for safety's sake.

For five years, Zirganos has been up to his neck in the characters that inhabit the world of antiquities, often bringing evidence to Greek investigators from his travels in the smuggling underworld and urging them to launch criminal inquiries. His sources tell him the dirt even when they know he's a journalist. "You'd be surprised at how much smugglers are willing to tell you," he confided to me one evening, giving as reasons vanity, jealousy, and most of the other seven deadly sins. He spends his days and nights, weekends, and holidays thinking about dealers like Robin Symes, curators like Marion True, auction houses like Christie's and Sotheby's. He pulled out a sheaf of photographs. "Look," he said, displaying three pictures of the same item from three different sources. The first showed a Greek calyx, badly broken, from the trove of photographs taken by Italian police from Giacomo Medici. Medici sold the vase to Robin Symes, who sold it to the Getty Museum. The second photo showed the piece partially restored, and the third photo was the fully restored vase in the museum catalog. The photographs demonstrated the journey taken by the object—from looter to smuggler to buyer.

Many times he wishes he didn't have all this information, didn't know all these details. Like so many other journalists who have been drawn into the world of looted antiquities, Zirganos is a political reporter by training and inclination. Art and archaeology were not his thing. He is currently a journalist at the magazine *Elefthero Typia*, which means "Free Press," and he also freelances for the *Los Angeles Times* and the *Independent* in London. But the antiquities story had a way of taking hold of him, and he became consumed with following the trail that led from a farmer's field to the shelves of a museum. "I

started wondering: Where do they come from? How do people sell them?" he said. "You see the fresh pieces from the ground. I have thousands of photographs—from police, smugglers, dealers, Interpol. I'm not an expert, but it could be that 90 percent of these items are fresh from the ground. Practically speaking, you can't prove it's looted and that it came from your country, today. But you see it in Christie's. Where do I go, to squeeze whom, for a Minoan piece?" Over the years, Zirganos has uncovered the details of the whitewashing process in the modern antiquities trade, as an object passes from hand to hand in a chain of ownership that ends with wealthy collectors or a museum purchase from an unnamed "European gentleman." As he explored, he learned that the circuit of smuggling is vast and shadowy. It often involves powerful and rich people, both abroad and in his own country. And unfortunately, his material suggests many more avenues for research. Zirganos may think he is done with the looting story, but it is not done with him.

Zirganos believes that the modern-day smuggling trade undermines Greece's arguments for undoing the most famous incident of pillage in his country: the removal of the sculptures off the Parthenon by Lord Elgin. From his point of view, Greece has scant justification to demand the return of the Elgin Marbles until it does more to stop the ongoing looting within its borders, the theft from storage places, and the rampant sale of Greek antiquities in auction houses around the world—some of them to wealthy Greek collectors. After all, if the government doesn't care enough to clamp down on modern-day smugglers, why should it expect Britain to return sculptures taken two hundred years ago?

Zirganos holds his own government responsible, saying that there are too few laws to allow the police to clamp down on smuggling and not enough police to chase the criminals who smuggle antiquities. Greece bars the export of antiquities, but once a piece has left the country, proving where it came from becomes very difficult. In many countries there is a "good faith" clause that protects the buyer. And Switzerland has been a black hole where looted antiquities disappear and magically reemerge with provenance. "The law allows you to whitewash things because you can't prove something is looted," says

Zirganos. "You must prove that it's yours and that it's looted. But an artifact passes through one-two-three-four hands, and it's almost impossible to trace it back to the digger. There's a black area, that becomes gray, then becomes white. And there's a legal gap. We have laws that tell us where condoms come from, where milk comes from. But we have no idea of the provenance of antiquities, and that's ridiculous."

Zirganos sees a direct connection between the plunder of the nineteenth century and the high-society world of antiquity collecting today. "Buying and selling antiquities is the modern-day equivalent of the nineteenth-century upper classes who visited the ancient world and took what they wanted," said Zirganos. "Every dealer is a fence. They don't care to do a proper check. They close their eyes. They ask, 'Do you have provenance?' The answer is, 'Of course. But I can't reveal it.' Or, 'It's an American lady.' It's bullshit."

The thefts from Greece in modern times have been astonishing in their boldness. In the 1980s and '90s bandits took off with artifacts from museums all over Greece. The 1990 heist from the archaeological museum in Corinth was notable in its audacity. Robbers cleaned out practically the entire museum, 285 pieces, the largest such theft in Greece's history. Police suspected a crime family by the name of Karahalios, ethnic Greeks who were based in Venezuela, but police lacked the evidence to arrest them. The pieces disappeared until 1998, when they began to surface at auction—at Christie's, through an American collector with ties to the Karahalios clan. Jerome Eisenberg, the long-time dealer and owner of the Royal-Athena Gallery in Manhattan, was found to have bought three pieces from Corinth. He returned them, saying at the time, "It was an honest mistake." Some observers expressed skepticism, pointing out that Eisenberg had published photos of some of the stolen pieces in his magazine, *Minerva*, back in 1990, so he should have been familiar with the contraband. Police investigated Wilma Sabala, a Miami friend of Tryfonas Karahalios, and in 1999 FBI agents recovered approximately 265 of the objects sealed in twelve plastic boxes inside crates of fresh fish in a Miami storage facility. Sabala was arrested on June 2000 and sentenced to a year in jail after pleading guilty to interstate transportation of stolen property.

In 2001 Anastasios Karahalios was sentenced to life imprisonment in Greece after being found guilty of organizing the robbery. It was the harshest sentence ever handed down for an archaeology-related crime in Greece.

Modern-era looting within Greece has been equally tragic in its rapaciousness. Perhaps the most emblematic of the instances of self-destruction that the Greeks have wrought on their own heritage is in Aidonia, a small village in the Peloponneses on the Greek mainland. In 1976 a farmer with a donkey accidentally came across a tomb from ancient times, which turned out to be a trove of pottery and gold from the Minoan civilization, a 3,500-year-old, pre-Greek people. The villagers saw in this event a stroke of fortune: they would all be rich. The villagers dug day and night to empty that tomb and find any others in the vicinity. For six or seven months, they banded together—including the local authorities—and dug in secret, agreeing to divide the spoils. They emptied an entire cliffside of its Minoan riches, eighteen tombs in all, filled with treasures and each scoured clean of its contents until nothing was left but a hole in the ground. "It's not easy to describe what happened," said a mortified resident, in *Network*, the 2005 documentary. "It's a shame. They were digging night and day, summer and winter. All of the authorities were responsible." A local dealer paid them for most of the artworks.

In about 1978, an American archaeologist, Stephen Miller, heard about the looting from a dealer in Geneva and, along with officials from the Greek Ministry of Culture, went to the site to excavate and salvage what he could. But by then the tombs were all empty. Miller found a single burial pit undisturbed and salvaged three golden rings, beads, and other objects. The pieces went to a nearby museum in Nemea, but the rest had disappeared, and the cliff where they came from, rather than being an archaeological site, looked like the aftermath of a bombing campaign. Where did the artifacts go? No one knew. Thirteen years later, golden Minoan objects turned up at the Michael Ward Gallery in New York. Greece hired an American lawyer to bar the sale, and the collection was returned to Greece in 1996, in a compromise deal that allowed Ward to take a tax exemption. It was a great

victory for Greece, the first time the country had successfully demanded the return of what it claimed was looted art—and it came a year after the Turks reclaimed the Lydian Hoard from the Met.

All well and good, but there was an irretrievable tragedy in what happened to Aidonia, the small village that thought it would become rich. The village collapsed in rivalries and bitter disputes. Most of the residents left. Today it is a ghost town, with a handful of remaining hangers-on, while the history of Minoan life there has been utterly destroyed. Nikolas Zirganos imagines what might have happened if the villagers had shared their find with the Culture Ministry, built a museum, preserved the tombs, and built a thriving side business in tourism. "They could have lived off the tourism, earn legitimate profits, and be proud for their children and grandchildren," he said ruefully. "Instead they looted their own history and sold it for a piece of shit. They gained nothing." Meanwhile, the nearby town of Nemea exhibits finds from its Minoan tombs, which the residents did not plunder, in its museum. The residents live off the tourism and from selling the local wine they have made for centuries.

It has been only since about 2005 that Greece started to devote much attention to the question of looted antiquities, largely under pressure from journalists like Zirganos and with the encouragement of the Italian authorities, who have recently been the most aggressive in applying judicial pressure. The Greeks have signed bilateral agreements with the Italians over reclaiming antiquities, and police in the two countries have shared information and documents. But Zirganos is exhausted from all this effort; he has personally found neither glory nor riches, and he is not sure it has made a difference, overall. "You'll never stop the illegal antiquities trade," he declared, over a second glass of ouzo and grilled fish at an outdoor restaurant later that evening. "But you can diminish it. You terrify museums, you prosecute looters, and you change the laws, educate people, and give more money to the art squads. Then, in five or ten years, you'll have improvement."

It is such cooperation that led to the installation of a heart-stopping gold wreath in a spacious white marble gallery of the National Archaeological Museum in Athens. Macedonian, perhaps the property of Philip II (the father of Alexander the Great), it hangs suspended in a glass

case at the end of a row of marble friezes. The gold is lustrous under the spotlights, while a security camera dangles just above the case. In a hallway just ten yards away is a sensual bronze statue of a youth. Both pieces were offered in the 1990s to Marion True at the Getty Museum by the same dealer. True turned down the bronze because she thought it too suspicious, and indeed German police would later confiscate the bronze statue as looted and illegally smuggled and send it to Greece in 2002. But True bought the wreath, which also eventually came back to this place. Inside the glass case a label reads, "Repatriated on March 22, 2007, from Getty Museum, Malibu."

For fourteen years, the wreath was, literally, a crown jewel of the Getty's antiquities collection. At the villa overlooking the Pacific in Malibu, the wreath had been showcased in a backlit display built into the wall, in a niche just off the mosaic walkway through the ground floor. Acquired in 1993, the piece was an immediate star; crowds would line up to gaze at one of the most purely lovely pieces of the collection. With its thousands of tiny gold flowers, the gold leaf wrought in detail down to the tiniest stamens, the wreath is an evocative work of delicate artistic skill. Traces of blue enamel can be seen at the center of some flowers, surrounded by tiny petals and pistils of gold wire. In the context of the villa, the wreath was a revelation, conveying an entirely different sense of Greek culture from the kraters and calyxes, the marble busts and toga pins. And it made the Getty's other gold crowns look dim by comparison.

Where had it come from? The Getty was not in the habit of saying much. In its 1997 catalog, the museum boasted of having acquired "one of the most spectacular Macedonian gold wreaths ever found, a lavish miniature garden with leaves and several types of flowers, including myrtle, made of thin sheet gold and inlaid with blue and green glass paste. Spared from pillage by being buried in the tomb of its wealthy owner, it has survived beautifully." The full-page, full-color image gave no further notion of how the wreath came to be discovered, except to state that the piece dated from the late fourth century BC.

In fact, its journey to the Getty was not nearly so proper as to merit the dainty observation that it had "survived beautifully," as Nikolas

Zirganos found out. The story begins in February 1992, when Athanassios Seliachas, a young Greek painter of contemporary works, was having his first one-man show at a small art gallery in Munich. Friends and collectors were there, and Seliachas was surprised to be approached by three strangers bearing a cardboard cake box. They told him they had something for sale and showed him some photographs. Seliachas was no antiquities dealer and wasn't particularly connected to that world; he wasn't sure why the men had approached him except that he was Greek and an artist. Apparently that was enough. The strangers, two Greeks and a Serb, brought the box back to the gallery on a later day and opened it. "There was the most beautiful thing I had ever seen in my life," Seliachas told Zirganos. "It was a Macedonian wreath made of solid gold. *Solid gold.* I was so impressed, so shocked I could hardly breathe." Seliachas put the men in touch with Christoph Leon, a well-known dealer he knew by reputation. When Leon did not offer enough money, Seliachas suggested that the Getty Museum might be interested.

On March 13, 1992, a fax from Munich arrived at Marion True's office. Signed by a "Dr. Preis," the fax offered the wreath for purchase at the price of $1.6 million. She declined to buy from "Dr. Preis," whom she did not know. So the sellers went back to Christoph Leon. This time Leon raised his price and paid 400,000 deutsche marks (about $400,000) for the wreath. Then Leon contacted True himself. The Getty curator went to Switzerland to examine the piece, with "Dr. Preis" and the Serb present at the meeting, in a bank vault in Zurich. But the meeting disturbed the curator profoundly; she found the men's behavior bizarre and wrote as much to Christoph Leon. When she returned to Malibu, she wrote Leon that she would not be buying the piece, hinting that she suspected that the piece was smuggled. The Serb "and whoever was impersonating Dr. Preis have done tremendous damage to a great object," she wrote. "I hope you will find a possible buyer for it, but I am afraid that in our case it is something that is too dangerous for us to be involved with." Four more months passed, and True, apparently, changed her mind. What happened? That remains a mystery. Perhaps she was afraid that a singularly important art object would be destroyed at the hands of art imposters. Or perhaps the

thought of an ancient beauty about to disappear into some private collection became overwhelming. Either way, True could not resist. She wrote to Leon to say she wanted the wreath.

Following museum policy, True then informed the Greek and Italian governments of the museum's intention to buy the wreath along with an archaic kore, sending photographs of each. The Greeks protested at both. There was no way that an artifact as magnificent as the wreath could have suddenly appeared on the market, they said, without having been illegally dug up and smuggled from the country. The kore was similarly too important to have been unpublished if it were known to exist before export bans were in place. But they had no evidence that it might be theirs, other than the fact that neither piece had clear provenance. Leon claimed to be negotiating on behalf of one of those famously anonymous "Swiss collectors." The Getty was not convinced by the Greek argument and bought the wreath for $1.15 million, paying another $3.3 million for the kore.

As in so many other instances, there the matter lay, more or less, until 2005. German police had provided information about Athanassios Seliachas, but the investigation never went anywhere. Through a retired police source, Zirganos learned the story of how the piece was sold and published an exposé in *Epsilon*, a Greek magazine, in late 2005. A newly appointed special prosecutor, Ioannis Diotis, read the article and decided to take up the dormant matter. In January 2006 he went to Italy to meet the prosecutor working on the Medici and Marion True cases. For hours they talked and compared notes, sharing documents, including a photo of the wreath confiscated by Italian police from a known local smuggler, Gianfranco Becchina. Diotis looked up the earlier evidence in the case, which suggested that the piece had been dug up by a farmer in northern Greece in 1990 and smuggled into Germany by immigrant workers. He was convinced the piece was looted and determined to get it back.

In November 2006 Greek prosecutors filed charges against Marion True, along with Leon and the three alleged looters, in the case of the golden wreath. As a pressure tactic, this seemed to work. In December 2006 the Getty, now led by its new director, Michael Brand, announced that it would give up the piece, along with the marble kore. The hope

was that this would appease the Greeks and send a signal to the Italians. The museum was in the crosshairs of both countries, and a little cooperation seemed to be the way to proceed.

AS GREECE AND Italy have taken more confrontational stands against the museums and dealers who traffic in looted antiquities, there have been many unhappy endings. But not all have been at the hands of the state; some wounds have been self-inflicted.

The dominion of Robin Symes and Christos Michaelides, the dashing couple who were friends of Marion True and suppliers to the Getty and others, came to an abrupt end on July 4, 1999. On that evening, the American collectors Leon Levy and Shelby White gave a holiday dinner party at a villa in the small town of Terni, outside of Rome, and among their guests were Symes and Michaelides. At one point near the end of the dinner, Michaelides left the table and didn't return. When White's daughter went to find him, she discovered him in the basement, nearly dead. Michaelides had walked downstairs, apparently to get a bottle of wine, and seemed to have fallen and fatally struck his head on a small radiator. He died the next day at a hospital in Orvieto.

This sudden fatality was a crushing loss to Symes, the silver-haired operator who suddenly found himself without his companion of thirty years. But it was also a devastating blow to Michaelides's large and close-knit extended family. The personal loss was hard enough to deal with. But then there was the matter of finances: Who was entitled to Michaelides's assets? How to divide the business, given that Michaelides and Symes were domestic partners as well as business partners? Michaelides's sister, Despina Papadimitriou, had been involved in their business as well, providing millions of dollars in capital to finance antiquities purchases. In principle, the aftermath of Michaelides's death could have been handled privately and with good sense—the assets divided, future earnings totted up. But instead what ensued was a tale of ego and greed that resulted in the disintegration of the partners' accumulated wealth and a criminal investigation into their affairs.

Dimitri Papadimitriou, Michaelides's nephew, believed that his family was entitled to half the business of Robin Symes Limited. He proposed that Symes sell off the family's share over time, give them

the proceeds, and keep the rest of the business going forward. Symes saw things differently. From his point of view, he had founded the business, and with Michaelides gone he believed it should now belong to him entirely. But matters did not completely turn sour until after Symes went to Athens in 2000 for a family commemoration of Michaelides's death. Michaelides's mother asked Symes for some of her son's personal effects, including antique Cartier watches, a Rolex, and gem-encrusted cuff links. Symes took offense and reacted strangely. Later that year, he sent a small case with Michaelides's belongings to the Papadimitriou estate in Athens. Instead of watches and jewels, he had sent a collection of worthless baubles: a Swatch watch, refills for pens, a plastic cigarette lighter, Michaelides's birth cross, and some photos.

To the Papadimitriou family, such a slap to Michaelides's mother was tantamount to a declaration of war. And indeed, Symes was preparing for battle. In 2001 he sued the Papadimitriou family for interfering with what he claimed was his legitimate business. The lawsuit said that Christos Michaelides had been his employee, with no ownership stake in the company. Symes asserted that he could buy and sell any assets he pleased and was under no obligation to return any property to the Papadimitriou family.

This was insult and then injury. The Papadimitrious were prepared to counterattack with the full force of their clout and their considerable wealth. Robin Symes vastly underestimated how far their wounded pride would take them. They countersued for half of Symes's assets, hiring Ludovic de Walden, a prominent London lawyer well known in the art world, and set to work a team of private investigators, who would dog every step that Symes took, and damn the cost. The family's lawyers started by getting a court to freeze Symes's assets, raiding the dealer's office and seizing all the documentation they found there. This documentation included seventeen green photo albums, filled with photos of antiquities. Private detectives followed Symes in no fewer than six countries—Switzerland, England, Germany, Italy, the United States, and Japan—an extraordinary effort that ran into the millions of dollars. All of this was aimed at digging out every detail of his business dealings. As court papers later showed, the investigators learned that Symes stored antiquities at thirty-three

different sites around Europe and had a total of seventeen thousand items valued at £125 million.

The investigators sifted through Symes's trash, but he had been careful to shred almost all his paperwork. But by a fluke, private investigators were able to reconstruct a single shredded page from a yellow American legal pad, whose color stood out from the other white bits of paper. That single piece of paper turned out to be a memo written by Symes in which he made reference to financial help that the Papadimitriou family had given the business to fund purchases and guarantee bank loans. It referred to Despina Papadimitriou as a silent partner. This was damning evidence against Symes's claim that he alone ran this business, and it helped turn the momentum of the court case against him. At the same time Symes had managed to alienate the British judge by delaying the production of documents and lying about the proceeds of sales. In attempting to stave off a decision, he used an extraordinary series of switchback maneuvers—up to and including, in the fall of 2004, the claim that he was mentally incapacitated.

But by 2005, Symes was bankrupt. He had been living off the largesse of Leon Levy, and when Levy died in 2003, Symes was left without resources. Cornered by the evidence turned up by the investigators, Symes finally admitted in court that he had lied about his assets and the true sums earned through the sale of things such as his art deco furniture and a statue of Akhenaten (which the Papadimitrious claimed should have been shared with them). Furious, the judge convicted Symes of two counts of contempt of court and sentenced him in January 2005 to two years in prison.

The legal battle between Robin Symes and the Papadimitriou family knocked over a beehive that released a buzz storm of information and documents that flew right into the heart of the illicit antiquities business. In the documents that were unleashed in the lawsuit and countersuits, familiar names and objects popped up continually. The investigative journalist Peter Watson examined the documents from the case and tipped off Italian authorities to pieces he believed were looted that belonged to Symes and Michaelides. These included a life-size ivory figure from the first century BC, valued at £30 million, which was recovered by the Italian Ministry of Culture in 2003. The

ivory is now at the Museo Nazionale Romano in Rome, where it has a room all to itself.

The repercussions rippled into Greece. Having raided Marion True's house in March 2006, the Greek police got a tip from a local on Paros. The informer told them that if they were interested in unregistered antiquities, they should check out a nearby islet called Schinoussa and what was left lying around the property. Police captain George Gligoris descended on the Papadimitriou compound on Schinoussa while officers simultaneously searched the family's residence in Psychiko, a suburb of Athens. The villa in Athens yielded fourteen antiquities, mainly pieces of Coptic weaving from Egypt. But the Schinoussa property was something else. It was large and luxurious, with marble floors, an atrium and swimming pool, a passageway graced by a pillared colonnade—and dozens of antiquities everywhere. Police found Egyptian sphinxes made of pink granite, Roman fountains, marble lions. Strewn about the garden were a headless statue of Aphrodite, marble busts of Roman gods, Corinthian columns, Christian icons, and an Egyptian amphora. The dates of the objects ran from the early Hellenistic era to the post-Byzantine period. In the deep freezer police found shards of ancient pottery. In the linen closet were four Byzantine frescoes wrapped in bedsheets. The police also found a workshop that appeared to be used for making copies of sculptures. The raid took more than a week and netted some 280 artifacts—including an entire chapel, made up of segments that had come from Byzantine monuments all over the Mediterranean. Many of the items were in containers, some labeled as from the auction houses Sotheby's or Christie's, where they were bought between 2001 and 2005, the police said.

There were plenty of social photos found in the raid—pictures of dinner parties and social occasions that recorded the social whirl of Robin Symes and Christos Michaelides. And there was one more thing that police found and seized in their search of the house on Schinoussa: seventeen green leather-bound photo albums, filled with photos of antiquities.

Back in Athens, Nikolas Zirganos was covering this story when a police source mentioned to him what seemed to be the least interesting part of the raid, the seventeen photo albums. The police presumed the

albums were used for study and research in Symes and Michaelides's business of buying and selling antiquities. But Zirganos remembered that five years earlier, Peter Watson had mentioned seeing a similar set of albums at the office of the Papadimitriou family's lawyer in London and that these had come from Robin Symes's office. This set, then, was a copy of those albums, which Zirganos believed were not merely for research and study but were actually a photographic record of everything Symes and Michaelides had sold up to 1999. If so, it was an invaluable source for police investigators—and for Zirganos, who had begun a slow, painstaking process of cross-referencing the photos with items in collections at the Met, at the Getty, at the Museum of Fine Arts in Boston, at auction houses, and in published private collections. By the end of 2007 he had found 260 pictures matching artifacts owned by museums, including a bronze boy belonging to the Getty on loan to Minneapolis and a sculpture he found in a photo spread in *House & Garden* magazine from a private home in Pennsylvania.

The Symes story is far from finished. Having served the time for his contempt charges, the former dealer still faces possible charges in Italy and the remains of his lawsuit with the Papadimitriou family. There may be little left for them to claim. In November 2006 four leading family members—Despina and her three adult children, Dimitri, Alexandros, and Angeliki—were charged in Greece with illegally possessing more than $1 million worth of looted antiquities.

IN AN ALL-GLASS conference room at the Getty in Los Angeles in November 2007, James Wood, the new chairman of the Getty Trust, presented the new face of the institution. The former president and director of the Art Institute of Chicago and a respected figure in art circles, Wood had been appointed in 2006 to turn over a new leaf after the resignation of Barry Munitz. Shortly after the agreement with Italy, the Getty announced a new, more stringent acquisitions policy: nothing would be considered for purchase by the museum without clear provenance from 1970. This moved back the 1995 date that had previously been adopted and placed the Getty among those museums that hewed to the UNESCO guideline. Clearly, the Getty was looking to set new standards and send a message as an institution.

Yet with the wounds of restitution still fresh, it was hard to avoid the feeling that the museum, as an institution, felt beaten down and defeated, hesitant about its future. Wood wore a blue shirt and tie, and his broad face was pale as he discussed the uncomfortable issues that had preceded his tenure. But he could summon neither a ringing defense nor a clear condemnation of his institution's past practices. Indeed, he showed no strong emotion toward Italy, which had been dogging the Getty for years. Asked about Marion True, he demurred, insistently taking no position. "Were all the charges against the Getty totally groundless? No," he said. But, he added, "I think many of the charges against Marion True are not justified." He said he didn't believe that Marion True had been singled out but was quick to add, "I'm not defending the charges against Marion True. The Getty was a major buyer." Pause. "So was Boston." Has her treatment been fair? "The short answer is no. She has taken more of the brunt. But it wouldn't be fair if more people were there with her. There's a symbolic side to this."

Wood hadn't a clue why True's superiors—particularly John Walsh and Harold Williams, who made the ultimate decisions to buy the looted art—were not being prosecuted. "I wasn't here," he said. "I'd never know who said what to whom." The Getty essentially had a new crew in charge, and the response—"I don't know; I wasn't here"—was one that came back often to queries.

"You're looking for absolute answers, and they don't exist," he continued. "You have to put it in context. What was broadly accepted across the profession and thought to be adequate due diligence is no longer. It's an evolving perception of what is correct. Did I, fifteen years ago, think they [the Getty] were wrong and we [in Chicago] were right? We were all trying to calibrate the public good."

But the relinquishing of so many artifacts raises a different question about the future of this museum and other museums like it. Is it possible to continue collecting antiquities under current circumstances? Can the mission of museums remain the same? "It's possible, and we have a responsibility to keep collecting," he said. "We're a public institution, committed to showing the very best art we can. Obviously loans will be increasingly important. Our policy makes it very clear the kind of thing we would buy. Does it make it harder to do so? Yes."

He concluded: "At the end of the day, painful as this is, I hope we can set a precedent and move ahead." Is the future of the Getty bright? "Let's not use the word *bright*," he said. "Let's say *important*."

In his office across the broad, travertine-paved plaza of the Getty complex, Michael Brand, the museum's new director, was in a far better frame of mind. Brand had been on the front lines of negotiating the looted antiquities mess, up to his elbows in the dirty details of closing a deal with the Italians. An Australian with a Harvard Ph.D. who had most recently been director of the Virginia Museum of Fine Arts, he had a naturally optimistic style that chafed against the heaviness of the ongoing drama and against the Getty's austere aesthetic. The wall behind Brand's rustic wooden desk was vast and khaki green—and empty, since he hadn't had time to find a painting to put there. But the balcony outside his office was filled with bright planters overflowing with colorful flowers, a contrast to the monochromatic mass of white buildings that is the Getty's signature. Hired in August 2005, a month after Marion True's trial began in Rome, Brand set about to mend fences, strike agreements, and make the embarrassment go away.

That turned out not to be as easy as he'd thought. For one thing, the Italians were quick to leak information to the media but not so quick to offer detailed information about what pieces they wanted returned and why. Brand spent much of 2006 traveling to Italy in an attempt to strike a deal. He first went at the end of January 2006, shortly after taking up his position. He was prepared to give back objects. He'd read up on the issue; he'd spoken to colleagues. "I felt it was solvable," he said. He met the culture minister, Rocco Buttiglioni, and the prosecutor Maurizio Fiorilli. He believed that being a blank slate would help defuse the tension. "I went in with no background in antiquities, no history at the Getty, a neutral person. It might even have helped that I was Australian—who knows?" he said. "But I made it clear that we were out there to reach an agreement."

Even so, it took another year and a half to conclude one. The True trial marched along at its grinding pace, and the Italians felt they had the upper hand. They continued to insist on the return of the Victorious Youth bronze statue that had been fished from the waters near

*The Greek-era sculpture*
*Victorious Youth, now at the*
*Getty Museum. Italy seeks its*
*return; the Getty says there is*
*no basis for doing so.* (The
J. Paul Getty Museum, Villa
Collection, Malibu,
California)

Fano in 1964. Italy insisted it had a moral, if not a legal, right to the statue, saying it must have been exported illegally from Italy, even if technically it had not been recovered in Italian waters. The Getty said there was no proof of any illegal export, that the statue was Greek and not Roman, and that Italy had no claim on it. There things remained stuck. The Getty officials reached a preliminary agreement with Italian officials in Rome in October 2006 on many of the objects demanded by Italy. But when Brand went to Rome on November

17, the Italians went back to demanding the bronze. Frustrated, Brand flew home and announced that the Getty would unilaterally give up twenty-six antiquities and released the list to the media. Things stood at a standstill for months on end, with the Getty receiving no communications from Italy at all, save through the media. A new culture minister, Francesco Rutelli, stepped up the pressure, threatening to cut all ties with the Getty if the bronze did not return, but behind the scenes, quiet talks continued. By late July, an agreement in principle was reached, with the Italians agreeing to remove the bronze from the pool of artifacts under discussion. On August 1 both sides announced that forty pieces from the Getty's antiquities collection would be returned to Italy.

In a discussion in his office, Brand—a slim, graying, forty-nine-year-old academic wearing a tweed vest and skinny black jeans—seemed saddened but resolved. The artifacts being packed and shipped from the Getty Villa up the road did not make for a happy occasion. "Overall it's a good situation," he said, after staring down at his pen for a while. "But it's very, very sad giving up forty great objects. Our staff cared for them, cleaned them, built the displays, wrote about them, lectured. You feel sad. It's like sending away a family member." He paused to think about this. He was keenly aware of the awkwardness of the moment. "It's not what directors usually do—my job is to protect the collection," he said. "On the other hand, we're proud of what we've done with the objects. We are part of the history of those objects. They've been around for two thousand years and spent twenty years here. That's good."

Pragmatic to the core, Brand took the approach from the start that there was no tragedy in returning objects. It was not as if they were disappearing into a private home or a vault or being destroyed. They would simply go from one place of public view to another. But it was also not possible for him to snap his fingers and return everything Italy demanded, simply to break the logjam and give relief to Marion True. "This is a new situation that we're solving in the modern age," he said. "We have to be careful not to do something that has inadvertent consequences. Anything we do creates a precedent."

Brand got a full look at the Italians' evidence in January 2006,

when the government sent a complete list of the disputed objects and showed him the documents supporting their claim. It was the photographs that particularly convinced him. They were mainly Polaroids, which clearly dated them to after Italy passed an export ban in 1939, and they showed artifacts owned by the Getty encrusted in dirt, lying on the floor among half-crumpled newspapers, broken into pieces. About half of the photos used to identify the forty pieces came from the Medici trove. The largest grouping of objects, thirteen in all, came through the Fleischmans, by purchase or donation. The next largest grouping, six, came through purchase from Fritz Bürki, a Swiss antiquity restorer who worked with Robert Hecht, Giacomo Medici, and other dealers. Three major pieces came from Maurice Tempelsman, via Robin Symes and Giacomo Medici before that. Among them was the marble statue of Apollo, and the two winged griffins, still colored with hints of blue and red from antiquity, hungrily tearing at a fallen doe. The latter statue, once the base of a table, was carved from a single piece of marble. Brand was shocked to see a photo of the magnificent griffins in pieces, covered in dirt, thrown in the back of a car. "The griffins were the most distressing of all of them," he said. "That was not good. And that has been the big difference. Rather than it being theoretical, suddenly you had photographic evidence."

As to the fate of Marion True, Brand was more direct than Wood. Yes, he said, she's been paying for the mistakes of many. "The general feeling is that Marion has been used as a scapegoat. It's a legitimate comment," he said. "It's reasonable to say she has been scapegoated. The profession of curating has evolved. That's not to say that anybody would have done exactly the same as she did ten to fifteen years ago, but she kept trying to find better acquisition policies, and I believe sincerely so. She's a scholar, an educator. That's her motivation. She wasn't really doing anything that most other curators weren't doing. It's not as if everyone had sworn off vases and she bought them." Then he echoed what Giacomo Medici said about True: "You might say one of her problems was she was publishing and discussing acquisition policies." That, he meant, helped make her a target.

The success of the agreement that Brand struck with the Italians remains to be tested. In exchange for the return of the looted pieces,

*Michael Brand, the director of the J. Paul Getty Museum.* (Photo by Monica Almeida/ The New York Times)

the Italians have promised to provide long-term loans—four years at a time—of objects of similar value. At the time of the agreement, those objects were not discussed in specifics. The net result? A rich and powerful American institution was shamed. But in the process, its acquisitions policy has been vastly improved, and all other museums had been put on notice: do not make the same mistake as the Getty. Brand would like to salvage something from this defeat. He was headed to Rome in late November to work with Italian curators on selecting those objects for loan, including sculptures, paintings, and drawings by Bernini, among them some of the sculptor's finest pieces. As it happened, his trip came on the cusp of a major exhibit planned for mid-December in Rome. Within days of the arrival of the last of the Getty pieces, a grand showcase of the artifacts that had been returned in the

previous years from Boston, the Met, and the Getty was unveiled to the public. The title of the exhibit was *Nostoi*—the ancient Greek word for returning heroes—"Refound Masterpieces."

A FEW MILES up the coast from Brentwood, the Getty Villa in Malibu was quiet and flooded in the bright, abundant sunshine of Southern California. Curators and security guards wandered about the meticulously maintained grounds and well-polished marble halls. Visitors were sparse, and the bronze muses perched along a central fountain shone deep polished green in the sun. The ambitiously built, masterfully maintained property reopened in January 2006 after eight years of renovation. With its atriums and fountains and central pools and lush gardens, the villa is a delight and—in a rebuke to its early critics—must now be counted as an extravagant gift to the public by the penny-pinching oilman. The villa is a peaceful place, designed for reflection on ancient art. Indeed, it was no small irony that the re-opening was hailed with warm hugs from the critics, with nary a glance backward at the derisive "Disneyland" remarks from 1974. That may be because the villa is now stylistically of a piece with the art exhibited in its halls. There are few places in the world where one can see ancient art in a setting that re-creates the contemporaneous conditions in which that art was meant to be seen. The Getty Villa is one of them, and visiting the museum is like passing through an exceptionally gracious home, in another millennium. Today it also has numerous educational programs—you can make laurel wreaths here with your children—and hosts live performances of Greek theater in an outdoor amphitheater.

When the new Getty complex in Brentwood opened in 1997, changes were clearly needed to the villa, which was to be devoted exclusively to antiquities. Marion True was in charge of this $275 million undertaking, which caused the villa to close for eight years. The inside was cleaned, reorganized, and updated. Windows and skylights were added to allow in more light. Vitrines were made high-tech, to create microclimates in each of them, altered to suit different material such as glass or clay. The more obvious changes were made to the parts of

the property outside the villa. A café was moved to make room for the 450-seat amphitheater, and a new, larger café built farther away on the hillside. This was True's labor of love, and she traveled extensively to find the best marble for the renovation; she worked intimately with the architects Rodolfo Machado and Jorge Silvetti to get every detail right. But she wasn't there to see it open. By the time the Getty published the catalog of the renovation (which True cowrote with Silvetti), she was the former curator of antiquities. And she did not attend the opening.

By the last half of November 2007, reservations to the Getty Villa were booked through the end of the year. Visitors were as enthusiastic as ever. But the galleries were slowly being emptied of major objects. Holes were visible in many vitrines on the first floor as one piece after another was removed for the return to Italy. In the Dionysus room, a glass vitrine dedicated to comic actors had a gaping space next to several large vases. A similar gap could be seen in a vitrine across the room dedicated to actors in ancient art. There was no explanation or comment about the decision to return the forty objects, but the aura of their removal could be keenly felt. Surinder Kent, a security guard, was openly grieving. He arrived at work on this day and discovered that the six-foot statue of Apollo, which usually reigned from a central niche in the stunning marble gallery known as the basilica, was gone. "He must have left yesterday or the day before," said Kent. "What a shame. I tell you, without him, this museum looks very sad. This gallery will never be the same."

The basilica is a long, narrow space lined in rich variations of green and golden yellow marble. Along the wall there are carved marble muses and one empty pedestal, where a bronze Bacchus had been removed a couple of weeks earlier and sent back to Italy. At the end of the room the empty Apollo niche had faux green columns and panels of striped, tawny marble. Kent's own reaction surprised him. "I miss him like I was missing a person. You get emotionally involved," he said. "It's strange. It shook me up. They're nothing but stone. But are they?" Kent, who has worked at the Getty for a year and a half, keeps notes of his experiences at the museum. He said it is a job that has broadened and changed him inside. "The beautiful thing about work-

ing here is all the 'oohs' and 'aahs' you hear," he said. "Here you hear nothing but 'Oh, how beautiful. How marvelous.' You take it in, and you grow inside a little bit." Kent is a simple man with an Indian accent; classical art was hardly part of his upbringing. "Working here is overwhelming," he said. "You can't shut your mind to it. It's like a full-time college education." He led me past a room with silver rhytons in a case to the central gallery with the towering, seven-and-a-half-foot statue of a cult goddess, believed to be Aphrodite. She is perhaps the most important single piece in the entire collection, and she was most probably looted. Either way, she's going back to Italy in 2010.

Acquired in 1987, Aphrodite became an immediate star of the collection. With her placid gaze, and a dress carved from limestone as if it were a gauzy fabric sprayed with surf, she brought to mind elements of the Winged Victory of Samothrace at the Louvre and the windswept harpies of the Nereid Monument at the British Museum. In recommending its acquisition to the museum's board of trustees, Marion True wrote that the sculpture "would not only become the single greatest piece of ancient art in our collection; it would be the greatest piece of classical sculpture in this country and any country outside of Greece and Great Britain." The Aphrodite would command a commensurate price, $18 million, paid to Robin Symes. Symes said he had purchased it from the collection of an unnamed "supermarket magnate" in Switzerland. The Getty sent requisite letters to Greece and Italy asking if the piece was looted. But inside the museum, there was evidence that this explanation was for public consumption only, and that the attitude was not to push too hard for information. "We are saying we won't look into the provenance," said Harold Williams in a meeting with John Walsh, according to Walsh's notes of a meeting in September 1987. With no information coming from Italy about the statue, the Getty acquired the Aphrodite.

But the matter hardly ended there. Even without evidence, Italy was immediately on its guard—from where had this unpublished, massive statue suddenly appeared?—and launched an investigation. In 1988 Italy's art squad learned that there was talk among the tomb robbers of southern Italy that a statue had been dug up in Morgantina, a rich archaeological site in southern Italy. Giuseppe Mascara, the boss

of Morgantina's tomb-robbing circle, told the carabinieri that a large stone statue had been found at the site in the late 1970s. Shown a photo of the Aphrodite, Mascara said it was the same statue he had seen, without the head, in a looter's house in the town of Gela. In 1989 Mascara also told an Italian journalist for *La Repubblica* that looters had told him about a major statue that had been found in Morgantina, broken into three pieces for easier handling and driven across the Swiss border in the back of a Fiat truck filled with carrots. As for the head, Mascara said it had been found at the same time as two other marble heads in Morgantina and that a suspected looter, Orazio Di Simone, had joined it with the statue's body in Switzerland. Around the same time a Sicilian art collector, Vincenzo Cammarata, told Italian investigators that he had been offered two marble heads in 1979 by local tomb raiders. All interesting background material, but none of this was hard proof—although in fact the two marble heads ended up with Symes, were sold to Maurice Tempelsman, and were eventually returned by his family to Italy as looted art. The Italian police eventually charged Di Simone and two others with having looted and smuggled the Aphrodite, but the charges were dropped for lack of evidence.

In January 2007 the *Los Angeles Times* published its own four-month inquiry into the provenance of the statue. The reporters Jason Felch and Ralph Frammolino found Symes's "supermarket magnate," an eighty-five-year-old man who lived above a tobacco shop in Chiasso, Switzerland, just across the Italian border. He wasn't talking, but his relatives said they weren't aware of any statue long held in the family. "If there had been an expensive statue in my family, I wouldn't be working here right now," the man's niece said from behind the counter of his old tobacco shop, which she now owned. "I'd be home with my children."

What other evidence was there? Whatever the Italians showed the Getty officials, it apparently was convincing enough for the museum to agree to the statue's return without much of a fight once Michael Brand came into the director's office. A serious loss to the collection and another blow to the Getty's pride. The sign beneath the statue explained that this Aphrodite was probably used in cult worship, that the head may have come from elsewhere and was of marble, as were the arms. At

the bottom in small print it read, "Lent by the Republic of Italy." After surveying the Aphrodite, Surinder Kent walked me to the Hercules temple, where the thickly muscled statue of the warrior demigod stands majestically, a lion skin draped over one arm. The Hercules is a deserving centerpiece of the villa's crown jewels, and Kent drew the line at him ever leaving. "Without him, the museum will close," he said protectively. "If they come for him, we will call in the marines."

What will become of the Getty collection? Many believe that the museum can finally move into an era of transparency and self-respect as a collecting and research institution. The museum still is not in the habit of routinely revealing the provenance of pieces it acquires. But it was notable that the Getty's new antiquities curator, Karol Wight, did do so in an article about new acquisitions in *Apollo* magazine in 2006; she noted that a golden Roman beaker came from the collection of a nineteenth-century French noblewoman, the Comtesse de Behague; that two Cypriot bowls came from the collection of the zoologist Desmond Morris, via Christie's; and that a stunning marble Roman statue of a satyr was found in the late 1600s in a villa near Castel Gandolfo, went to Rome until 1728, before being bought by a Saxon leader who kept it in Dresden. It was there in East Germany until reunification, when restitution was made to the Saxon royal family, which sold it. One is tempted to call upon the Getty with a soothing, "Was that so hard?"

The losses of recent years will be keenly felt, however many pieces Italy chooses to lend in their place. For those who run the institution, the emptying of the Getty may be the right thing to do. But for those who live in Southern California, it is the undoubted diminishing of an institution that enriches the city's public life.

# CONCLUSION

In the dim light of a January morning in 2008, dozens of federal agents from the National Park Service, the Internal Revenue Service, and Immigration and Customs Enforcement swooped down simultaneously on four museums in Southern California. The agents were not after artifacts, at least not at that moment. Instead, they were after computer files, collection records, and tax documents related to hundreds of antiquities from Southeast Asia and pieces of Native American art. The agents had been staking out the Los Angeles County Museum of Art (LACMA) since 6:00 a.m. (the museum didn't open until 8:00), but the investigation had been going on for five long years, ever since an undercover agent with the National Park Service had uncovered what appeared to be a network that smuggled looted objects and donated them to museums in exchange for inflated appraisals used as tax write-offs. The search warrants told the story: museum officials and two antiquities dealers had been caught on tape in dozens of secretly recorded meetings and phone conversations and were revealed to be involved in handling artifacts smuggled mainly from China and Thailand.

The spectacular raid lit up phone lines and pinged BlackBerries in

museums across the country and quickly made the crawl on CNN. At the annual meeting of the Association of American Museum Directors in Austin, Texas, the news became a topic of heated discussions in the hallways and around conference tables. In addition to descending on LACMA, the agents searched three other small institutions—the Pacific Asia Museum in Pasadena, the Bowers Museum in Santa Ana, and the Mingei International Museum in San Diego—and carted off documents and hard drives. "This is the only case I can think of where the federal government went to the effort of a long-term sting operation," said Patty Gerstenblith, a law professor at DePaul University and the president of the Lawyers Committee for Cultural Heritage Preservation. "That's what you need to make a criminal case, to prove knowledge or intent, and it's very difficult to do."

But after a few days of inquiries, what looked like a major criminal ring on first blush seemed to be something less than the sum of its parts. The items in question were valued at less than $10,000 each; many of them were worth $1,500 but had been allegedly inflated to values of $5,000, the maximum for not having to provide supporting documentation on a federal tax return. This was hardly the stuff of an $18 million Aphrodite statue at the Getty or a $1 million Euphronios krater at the Met. Under scrutiny were a married couple, Jonathan and Cari Markell, who owned a boutique for Asian art in Los Angeles; they had donated objects each worth several thousand dollars to LACMA and had been taped forging inflated values from phantom appraisers. The other primary suspect was a dealer named Robert Olson, who had hardly become a jet-setter on his ill-gotten gains. The international smuggler was found to be a tired seventy-nine-year-old retiree watching television in a cluttered apartment in the nearby suburb of Cerritos, with a view of the parking lot. Far from denying his involvement, Olson openly described a network of dealers from whom he bought antiquities in Thailand, which he then shipped to the United States with "Made in Thailand" stickers on the relics, to make them appear recent. He said that he had sold "hundreds" of such items to the Bowers Museum and that he had sought to buy artifacts from the Ban Chiang dynasty, a culture that occupied Thailand from 1,000 BC to AD 200, all at the behest of the Bowers's chief curator, Armand

Labbé, now deceased. With no intended irony, Olson observed, "If it wasn't for people illegally digging up stuff, there wouldn't be museums."

This was a mentality that was clearly on its way out, and it remained to be seen what criminal charges, if any, would emerge from the splashy investigation. The director of LACMA, Michael Govan, sought to ratchet down the drama. He said that his museum possessed sixty pieces donated by the Markells, whom he described as "kind, regular, thoughtful supporters." The items, he said, were of fairly minor importance at an institution that accepted a thousand donated objects per year. And he noted dryly that most of the information sought by federal agents was available on the museum Web site or could have been provided with a single phone call. "I kept saying in disbelief, 'This must be much, much bigger.'" he said. "We'd be quite upset if people are falsifying information to the museum. But in the last decade, museums have been extra careful. The antiquities market has been shut down to zero."

Still, the warrants revealed the persistence of the "don't ask, don't tell" attitude within museums, despite their being "extra careful," in Govan's words. (No LACMA officials had been recorded making compromising remarks.) At the Pacific Asia Museum, Marcia Page, the deputy director of collections, and the museum's registrar, Jeffrey Taylor, had met with an undercover agent who said he wanted to donate objects from Thailand. Page told him that she was supposed to put up "token resistance" to accepting antiquities without proper paperwork, but a few months later she accepted the pieces anyway. At the Bowers Museum, Labbé accepted loans of objects looted from Thai and Native American graves and even solicited the donor to purchase objects from the Ban Chiang civilization for donation to the museum. The warrants also stated that the museum's current director, Peter Keller, had visited Olson's storage locker, where he kept smuggled objects.

The raid was a sign, if one were needed, that the battle over antiquities was not close to dying out.

ARE THERE SOLUTIONS to this raging conflict? Sometimes it seems not. There is an ethical betrayal in displaying an artifact in a museum

that has consorted with smugglers to possess it. But the viewing public loses when museums react out of fear of prosecution or when donors cease lending their works to museums because of the risk of legal jeopardy. There may be justice in returning plundered pieces that are sought. On the other hand, there is no benefit to returning a price-less artifact to a country that is not prepared to care for it. The artifacts themselves are at risk in countries where the local population is not educated about the importance of cultural patrimony and where the government is not equipped to protect it.

What is the answer? Shall we empty the great museums of the world because one source country after another seeks the return of trea-sures past?

In a conversation in his office several weeks after the raid, Michael Govan took a forward-looking perspective. His office had a Magritte-inspired carpet, clouds on a powder blue sky, and a ceiling wallpapered with the Los Angeles skyline, a piece by the contemporary artist John Baldessari. Just a couple of weeks after the raid, LACMA had opened its newest wing, the Broad Contemporary Art Museum—named for Eli Broad, the local billionaire whose land deal had caused Barry Mu-nitz such a headache. Broad had resigned from the Getty board when Munitz left and had financed a new building across town at LACMA, which was showcasing his art collection.

Govan argued that the past attitudes of museums had to change, and radically so. He noted that when he was an art student in the 1980s, the notion of an encyclopedic museum was considered passé. "Everything about the encyclopedic museum was outdated," he said. "It was Eurocentric—exemplified by the Greco-Roman temple fa-cade. And there's really no such thing as an encyclopedic museum. You can't be diverse enough to encompass the whole world, and those museums didn't usually deal with the twentieth century." Still, now that he is the director of just such a museum, Govan has modified his view, observing that a museum with such broad aims, seeking to en-compass the art of the world, need not fold its cards and give in to every restitution demand. Even so, it must justify its existence going forward, rather than hark back to eighteenth-century Enlightenment ideals. "In the twenty-first century, the encyclopedic museum has to

have new values," he said. "In a city like this one, where a hundred languages are spoken, every culture has its place. I'm a big believer in the relevance of culture to our everyday survival. Wars are fought over culture. We need to reconsider why we have these objects. We have to say why they have a future here, not why they have a past. We have to show that we use them in a way that is useful to society."

Govan has sought to back up his ideas with actions. He invited a Korean contemporary artist to install the museum's collection of Korean antiquities and a Los Angeles artist often working in Mexico to conceive an environment for the museum's installation of pre-Columbian art. "The great Western museums were built with a message of a hierarchy of cultures. That was always evident to me," he said, adding that this message had to change in a world where national boundaries have faded in importance. "We can't abdicate our involvement," he continued. "If we don't understand the origins of human history, we are nowhere. The question is how you do it. We need a new sense of awareness of how to rethink it. We can't change the past. But we can continually reconsider it."

There is a generational aspect at work here as well. Like the Getty's Michael Brand, who is also in his forties, Govan seems less attached than his older museum counterparts to ownership and the role of nationalism in general. But his perspective is a minority view. The antagonisms on display from countries like Egypt and Italy, and the defensive parrying by institutions like the Getty and the Louvre, risk making everyone losers: the museums, the source countries, the public, and the artifacts themselves.

I BELIEVE IT is possible to thread a path through the thicket of competing agendas. We can safeguard the artifacts that have survived through the millennia while still addressing the injustices and destruction that have resulted from extracting those artifacts from the ground. It will require changing attitudes and shifting paradigms. The four museums I visited have all behaved badly at one time or another. Most have resisted calls for transparency and accountability from outside challengers. The Met hid its illegal acquisitions for decades, while the Getty's insular culture contributed to blunders that led to a series of public humiliations. In the modern power struggle over ancient art,

the monolithic institutions of the West have betrayed a fatal weakness: an unwillingness to adapt to the changing mores of a shifting global culture. The politics of "us versus them" has to give way to a reaffirmation of the value of cultural exchange, and its real embrace by both sides.

The process must start with a fundamental reexamination by Western museums of their collections and the way they are presented to the public. Our great museums tell lies of omission about the objects they display within their walls. In this new era of owning up to the past, this state of affairs cannot continue. The history of plunder and appropriation must be acknowledged and aired for the public to understand the true origins of these great works of antiquity. No museum can legitimately claim to be a custodian of history if it ignores the history of its own objects for reasons of personal convenience. Neil MacGregor cannot be an effective cultural ambassador to the rest of the world if the British Museum continues to obfuscate the origin of its past plunder and subsequent blunders. The zodiac ceiling may end up remaining in the Louvre, but those who come to view it should know that it was brutally ripped from a two-thousand-year-old temple and that Egypt has asked for its return. The provenance of each ancient object is an integral part of its history, and it must be explained openly, in the galleries and the catalogs. And if necessary, apologies should be offered. It is past time for each artifact to be displayed with its full provenance (or lack thereof), especially in the most readily available databases for scholars and the general public: the museum Web sites.

Such actions do not address the question of restitution itself, but they would represent an enormous step in the right direction. Changes of this order would require an effort of scholarship, financial resources, and moral leadership. They would demand adjustments within the crowded displays of the great museums. But they would also be a gesture of enormous integrity and humility long missing from our great cultural temples. These actions would go a great distance in legitimizing the wounded pride of source countries and healing it.

On the other side of the equation, source countries also need to step up and look in the mirror. The history of the taking of ancient artifacts

is not altogether complimentary to them either, and their capacity for preservation is hardly reassuring. While the demands for restitution are not unjustified, they may well be premature—ahead of the source countries' ability to secure and preserve their objects. The theft of the masterpiece of the Lydian Hoard raises questions not merely of Turkey's regionalized system of museums but also of the wisdom of keeping artifacts near their findspots in general. Egypt, Turkey, Italy—countries with seemingly endless amounts of ancient culture—must acknowledge what is real and what is fantasy in their demands to take possession of their cultural patrimony. Are antiquities, once returned to their ancestral homes, displayed for the public or do they languish in storage rooms? Do objects go missing? Are they put on display in empty museums? As I learned in my travels, all of these problems exist. The conditions are variable not only from one country to the next but sometimes from one region to another. The uncomfortable realities that exist in many source countries must be discussed honestly and without embarrassment.

It is this perspective that is so often missing from the arguments of restitution activists like Colin Renfrew and Peter Watson. They have done an admirable job of pointing out the transgressions of those who have purchased smuggled antiquities for vast sums of money and fed the market for looting, which in turn has led to irreversible damage to archaeological sites. Understandably, these activists vociferously oppose the sale of antiquities in general and call for much-needed accountability.

But these positions do not get to the heart of the problem. There has to be a logical extension to the argument that the West simply must stop financing the destruction of history by buying antiquities. What will happen to antiquities if museums no longer acquire them? Will smugglers cease to smuggle? Will looting come to a halt? Or will looted pieces merely be sold elsewhere—to private individuals, who do not share them with the public? Will the source countries take steps to excavate and protect the sites that contain precious objects? It is entirely possible that prosecuting museums, shaming curators, suing dealers, and threatening donors will not end looting at all but will merely take the trade out of public view. In that case, the prosecutorial

approach is hardly an adequate answer. Looting may have ebbed in Italy, for example, but it is a rampant, unregulated problem in Bulgaria and Albania.

Because of all of these factors, there are no simple answers to the problem of stolen antiquities and no easy path to expiating the sins of cultural imperialism. Restitution is a balancing act. Many, like the Turkish journalist Özgen Acar, have suggested that the only realistic path forward is one of collaboration between poorer source countries so rich in patrimony and the wealthy industrialized nations that have the cash and expertise to preserve that patrimony. I agree with that view. There are calls to consider a reinstitution of partage or some softening of the export bans in source countries. Museums talk about long-term loans, and lawyers raise the possibility of transferring formal title to an object while leaving it in a Western museum or even having museums rent objects from source countries.

But what is required most of all is a desire to collaborate rather than excoriate, to take the measure of where a lack of collaboration has led and pursue a different path. It is possible that each side can win in this battle, without further loss to patrimony.

WITHOUT AN ACTIVE effort in a new direction, the patterns will continue. Demand will find its supply, licit or not. Beauty imposes its own imperatives, regardless of ownership. After several months of travel in the research and reporting of this book, I made my way, exhausted, to a friend's summer house in St. Moritz, Switzerland. On a stroll into town I found myself unexpectedly staring at a beautiful Roman marble bust in the window of Jean-David Cahn AG, a shop that had just opened on the square in the center of town, catering to the superrich residents of the area. The bust was not the only object of beauty for sale. Cahn had dozens of pieces on display: exquisitely preserved Greek vases, calyxes, and other pottery, along with glass jewelry, stone statuary, bronze objects, and even a mummy case propped behind a stairwell. The quality of the objects was astonishing. On the list that a saleswoman kindly provided, no provenances were listed, and a glossy promotional catalog that announced an upcoming auction featured the familiar, origin-erasing anonymity.

*Artifacts for sale at the gallery of Jean-David Cahn AG in St. Moritz, Switzerland.*
(Photo © Sharon Waxman)

Head of a nymph, Greek, late 4th to early 3rd century BC.
Former Collection B, Switzerland.

Red figure cup in the style of the Epeleios painter. Around
the figure the inscription, "The boy is beautiful." From a
German private collection, before 2001.

Statuette of standing Dionysos. Marble, Roman, about 160
AD. From a Belgian private collection, about 1988.

It was as if the debate raging in the world of art and archaeology
over provenance didn't exist. It was as if the legal histrionics going on
just a few dozen miles to the south—the prosecutions and headlines
and recriminations in Italy—were of no consequence. It was as if Jean-
David Cahn, from a famous family of antiquities dealers, had decided
that he could still live by the phrase that accompanied an exhibit of
antiquities at the Egyptian Hall in London in 1829: "They say it is
God's property, and he gives it to whom he pleases."

# NOTES

*Unless otherwise indicated below, all quotations and information are from interviews conducted by the author.*

## INTRODUCTION

1 "No one has a right to have an artifact": William Mullen, "Tut, Tut, Tut: As the Field Museum Unveils Its Lavish Show, Egypt's Antiquities Chief Takes a Dig at One of the Sponsors," *Chicago Tribune*, May 25, 2006; and "Say What?" *Chicago Tribune*, May 28, 2006.

2 Rowe . . . had been a major contributor to President George W. Bush: http://www.nndb.com/people/097/000123725/.

2 "This has been a very, very happy resolution": Author's notes for Sharon Waxman, "Antiquities in Office? Not While King Tut Rules Chicago," *New York Times*, May 26, 2006.

3 Hawass announced that Egypt would seek the loan: Lawrence Van Gelder, "Egypt Seeks Loan of Museum Antiquities," *New York Times*, May 1, 2007.

4 "Never before had one culture spread over the whole globe": J. M. Roberts, *The Penguin History of the World* (London: Penguin Books, 1987), p. 587.

8 in 2007 American deep-sea explorers in international waters: John Ward Anderson, "Will Finders Be Keepers of Salvaged Treasure," *Washington Post*, August 27, 2007.

8 "Given the present tempo of destruction": Karl Meyer, *The Plundered Past* (New York: Atheneum, 1973; rev. ed., 1977), p. 12.

## 1: ZAHI RULES

15 The news was the subject of a prominent article in the *New York Times*: John Noble Wilford, "Tooth May Have Solved Mummy Mystery," *New York Times*, June 27, 2007.

15 "the oldest human footprint ever found": " 'World's Oldest Footprint' Found in Egypt," Reuters, August 21, 2007.

16 Each of these objects left Egypt at different moments: Information on provenance of the statues of Hemiunu and Ankhaf from Zahi Hawass. See also Zahi Hawass, *The Treasure of the Pyramids* (Cairo: American University in Cairo Press, 2003), and Mark Lehner, *The Complete Pyramids* (New York: Thames and Hudson, 1997).

21 Egypt's per capita GDP is $4,200: The CIA's "World Factbook," at https://www.cia.gov/library/publications/the-world-factbook/geos/eg.html.

31 Cairenes lined the road: Alain Navarro, "Cairo Bids Joyous Farewell to Giant Ramses Statue," *Agence France Presse,* August 26, 2006.

## 2: FINDING ROSETTA

32 On the fifteenth of July, 1799: Biographical information on Napoleon Bonaparte is drawn from Flora E. S. Kaplan, *Napoleon on the Nile: Soldiers, Artists and the Rediscovery of Egypt* (New York: Dahesh Museum of Art, 2006); David G. Chandler, *The Campaigns of Napoleon* (New York: Macmillan, 1966); Correlli Barnett, *Bonaparte* (New York: Hill and Wang, 1978); Alan Schom, *Napoleon Bonaparte* (New York: HarperCollins, 1997).

34 "The day is not far distant": M. de Bourienne, *Memoirs of Napoleon Bonaparte Correspondence,* vol. 3, no. 2103 (London, 1836), p. 235.

34 "Europe is a molehill" Ibid., pp. 221, 230.

35 "Inhabitants of Egypt": Reprinted in *Columbia Centinel,* December 1, 1798.

36 his intellectual goals "succeeded wildly": Kaplan, *Napoleon on the Nile,* p. 5.

37 "The infidels who come to fight you": Captain M. Vertray, *Journal d'un Officier de l'Armee d'Egypte* (Paris, 1883), p. 64.

38 Local villagers resented his insistence: Chandler, *Campaigns of Napoleon,* p. 27.

38 "Pencil in hand, I passed": quoted in Brian M. Fagan, *The Rape of the Nile: Tomb Robbers, Tourists and Archeologists in Egypt* (New York: Scribner, 1975), p. 74.

39 "I reflected with a mighty excitement": Text of exhibition label, "Napoleon on the Nile: Soldiers, Artists, and the Rediscovery of Egypt," Dahesh Museum of Art, New York, June 8–December 31, 2006.

40 Shelley never visited Egypt: Some believe that Shelley was inspired by the bust of Ramses II that the British Museum acquired in 1816, but the poem was published before the statue arrived in England. The images of the poem correspond directly with drawings by the savants.

41 "Sooner than permit this iniquitous and vandalous spoliation": quoted in Kaplan, *Napoleon on the Nile,* p. 19.

42 "You can have it": J. Christopher Herold, *Bonaparte in Egypt* (New York: Harper & Row, 1962), p. 387.

42 Born in 1790 in the town of Figeac: Biographical information on Jean-François Champollion is drawn from ibid.

42 It was just after the revolution: Simon Schama, *Citizens* (London: Penguin, 1989), pp. 828–30.

43 He would tell Jean-François ancient stories: Daniel Meyerson, *The Linguist and the Emperor* (New York: Ballantine, 2004), p. 11.

44 Champollion came to the mayor's office: Ibid., p. 219.

45 "I have seen roll in my hand": www.ancientegypt.co.uk/turinpages/turn_royal_canon.htm.

46 Giovanni Belzoni came from his native Italy: Biographical information on Giovanni Belzoni is drawn from Stanley Mayes, *The Great Belzoni, Archeologist Extraordinary* (New York: Walker, 1961).

48 "They reached an unspoken gentleman's agreement": Fagan, *Rape of the Nile*, p. 90.

48 "It appeared to me": Giovanni Belzoni, *Narrative of the Operation of Recent Discoveries in Egypt and Nubia* (London: John Murray, 1820), p. 37.

49 "I instantly seized and disarmed him": Belzoni, *Narrative*, p. 47.

50 "If brought to England": Fagan, *Rape of the Nile*, p. 147.

50 One could easily imagine: Indeed, this happened a couple of years later, when Belzoni was trying to move an obelisk and watched, in horror, as it sank. It was recovered. He later wrote that "the obelisk in question has caused me more trouble and persecution than anything I succeeded in removing from Egypt. Indeed, it nearly cost me my life."

51 "The purpose of my researches was to rob the Egyptians": Belzoni, *Recent Discoveries*, p. 157.

51 "It is no uncommon thing to sit down near fragments of bones": Ibid., p. 282.

52 He took the few portable treasures that were there: Fagan, *Rape of the Nile*, p. 176.

52 "If any perfect tombs exist": Quoted in ibid., pp. 186–87.

56 "After my lunch break": Stephen Urice, "The Beautiful One Has Come—To Stay," in John Henry Merryman, ed., *Imperialism, Art and Restitution* (Cambridge: Cambridge University Press, 2006), p. 139.

57 "France . . . earns the right": E. de Verninac Saint-Maur, *Voyage de Luxor* (1835), quoted in Donald M. Reid, *Whose Pharaohs* (Cairo: American University in Cairo Press, 2002), p. 1.

59 "Do you know what I'm going to do one day?": Ernest Gill, "Nefertiti Now More German than Egyptian, Berliners Claim," Deutsche Press Agency, May 1, 2007.

59 "The moral and scientific responsibility": Hugh Eakin, "Nefertiti's Bust Gets a Body, Offending Egyptians: A Problematic Juxtaposition," *New York Times*, June 21, 2003.

59 "The ancient Egyptians were not disturbed by nakedness": Zahi Hawass, *Silent Images: Women in Pharaonic Egypt* (Cairo: American University in Cairo Press, 1998), p. 119.

60 "no longer safe in German hands": Eakin, "Nefertiti's Bust Gets a Body."

60 "The bust has been above ground and visible": Gill, "Nefertiti Now More German."

61 "The cultural connection between Nefertiti's Egypt and contemporary Egypt": Urice, "The Beautiful One Has Come," p. 153.

## 3: THE LOUVRE

64 The Cleveland museum had bought the statue in 2004: Rebecca Meiser, "An Ancient Apollo Statue Landed in Cleveland and Touched Off an International Outcry," *Cleveland News*, March 5, 2008; Steven Litt, "God of Mystery: Gaps in Apollo Statue's History Make It a Focus of Debate," *Plain Dealer* (Cleveland), February 16, 2008.

66 The building was first opened to the public: Information on the history of the Louvre and its current funding is drawn from the Louvre's Web site at http://www.louvre.fr/llv/commun/home.jsp?bmLocale=en; and Nicholas d'Archimbaud, *Louvre* (Paris: Robert Laffont, 1997).

67 From 1794 onward, France's revolutionary armies rounded up artworks: Francis Haskell and Nicholas Penny, *Taste and the Antique: The Lure of Classical Sculpture* (New Haven: Yale University Press, 1998), p. 108.

71 In his account of the discovery: Auguste Mariette Bey, *The Monuments of Upper Egypt* (London: Trubner, 1877), p. 119.

72 He had settled near the ruins: Mary Norton, "Prisse: A Portrait," *Saudi Aramco World*, November–December 1990.

73 "from vandalism . . . and from being removed by the Prussian Commission": Ibid.

73 "An object which 35 centuries had left unharmed": Ibid.

77 the museum's collection of 350,000 objects: Of those 350,000 objects, 180,000 are drawings, and some of the others are shards or series. The collection is so big, by the way, that its size was never actually tabulated until the advent of the computer, an innovation arriving in the museum only in the last decade of the twentieth century.

79 In fact the Code of Hammurabi was unearthed in 1901: For a history of the Code of Hammurabi, its discovery and removal to France, see Béatrice André-Salvini, *Le Code de Hammurabi* (Paris: Réunion des Musées Nationaux, 2003).

81 according to the *Manual of History of Art of the Ancients*: Charles Othon Frédéric J. B. Clarac, *Manual of History of Art of the Ancients* (Paris: Jules Renouard, 1847).

81 Another account states that a French sailor: Dumont d'Urville and Marcellus & Voutier, *Enlèvement de Vénus* (Paris: Editions La Bibliothèque, 1994).

81 At one point the statue was loaded: Etienne Michon, *La Venus de Milo: Son Arrivee et son Exposition au Louvre* (Paris: Revue des Etudes Grecques, 1900).

83 "Today I have just found, in my excavations": Marianne Hamiaux, "La Victoire de Samothrace: Découverte et Restauration," *Journal des Savants*, January–June 2001, p. 155.

83 They arrived, a curator wrote at the time, in a dozen bags: Ibid.

## 4: DENDERAH

88 So began the annual calendar: Interview with Rabia Hamdan, director of Supreme Council of Antiquities, Qena, Egypt.

101 the originals were thrown into the river: Fagan, *Rape of the Nile*, p. 270.

102 "These elaborate paintings, depicting kings and gods together": Sakuji Yoshimura and Jiro Kondo, eds., *Conservation of the Wall Paintings in the Royal Tomb of Amenophis III: First and Second Phases Report* (Paris: UNESCO and Institute of Egyptology, Waseda University, 2004), p. 3.

103 The Earl of Cavan pressed Mehmet Ali: Fagan, *Rape of the Nile*, p. 86. A general source on the transportation of Cleopatra's Needle from Egypt to London may be found in Reverend James King, *Cleopatra's Needle: A History of the London Obelisk* (London: Religious Tract Society, 1886).

105 the United States received its own "Cleopatra's Needle": Edmund S. Whitman, "An Obelisk for Central Park," *Saudi Aramco World*, July–August 1975.

105 "In desperation, the commander brought a Serbian crew": Ibid.

## 5: A TALE OF TWO CITIES

108 This is the Egyptian Museum in Cairo: For the history of this museum see Donald Malcolm Reid, *Whose Pharaohs?: Archaeology, Museums, and Egyptian National Identity from Napoleon to World War I* (Cairo: American University in Cairo Press, 2002).

109 A *New York Times* reporter who visited found the space: Michael Slackman, "Those Forgotten Mummies in the Cellar Must Be Cursed," *New York Times*, November 1, 2005.

## 6: CHASING THE LYDIAN HOARD

137 "A statue cannot have two navels": Özgen Acar, "Protecting Our Common Heritage: 3," *Turkish Times,* January 1, 2002.

137 "Like portly citizens who decry rich foods while gobbling them": Özgen Acar and Melik Kaylan, "The Hoard of the Century: Part I," *Connoisseur,* July 1988.

142 "The Turkish case of repatriation depends on a melting pot argument": S. M. Can Bilsel, *Zeus in Exile* (Princeton, N.J.: Princeton Center for Arts and Cultural Policy, 2000).

143 A report funded by the European Commission: Calimera Country Report: Turkey, p. 9.

145 "seemed to be hearsay fabricated around something": "Metropolitan Museum Queried by Turks on Smuggled Artifacts," *New York Times*, August 27, 1970.

146 had reportedly been bought for about $500,000: John Canaday, "Met Proud of a Rare Greek Pitcher, Calls Venders 'Traders' Left Native Poland," *New York Times,* February 26, 1973. This was later amended in press reports to the accurate figure of $1.5 million.

147 "You should ask Mr. J. J. Klejman that": Meyer, *Plundered Past*, p. 67.

148 "Turks Want the Lydian, Croesus Treasures Back": Ilknur Özgen and Jean Öztürk *Heritage Recovered: The Lydian Treasure* (Ankara: Turkish Ministry of Culture, 1996).

149 That one tomb held 125 pieces: Ibid.

150 "Dietrich von Bothmer asked what we should do": Thomas Hoving, *Making the Mummies Dance: Inside the Metropolitan Museum of Art* (New York: Simon and Schuster, 1993), p. 217.

## 7: LOSING LYDIA

161 "Many of the pieces have been corroded": "Treasures of Croesus Corroded," *Today's Zaman,* May 26, 2005.

162 They were also heard talking about taking the brooch to Japan: "Ten Charged in Missing Brooch Case," *Turkish Daily News,* July 14, 2006.

165 The *New York Times* reported: Sebnem Arsu, "Art Thefts Highlight Lax Security in Turkey," *New York Times,* June 13, 2006.

165 "Thieves have already made it into most of the museums": Ibid.

165 "would not be surprised if every one of them reported missing pieces": "Ten Charged in Missing Brooch Case."

167 The brothers believe that Akbiyikoglu was framed: They offered no proof for this view.

171 "Our museum possesses comprehensive security measures": "Nine Arrested Over Alleged Theft of Karun Treasure Artifacts from Museum," *Turkish Daily News,* May 30, 2006.

## 8: THE MET

175 A recent article in the *New York Times*: Elisabetta Povoledo, "Top Collector Is Asked to Relinquish Artifacts," *New York Times,* November 29, 2006.

178 The de Montebello family received its title: Danny Danziger, *Museum* (New York: Viking, 2007).

179 "I don't like controversy": "Personality of the Year: Interview with Philippe de Montebello," *Apollo in Array,* December 2003.

179 "The institution and I have totally merged": Danziger, *Museum,* p. 155.

179 "But we've lost, they've won": "Personality of the Year."

183 an institution that has tax-exempt status: According to the museum's 2006 annual report, nearly 10 percent of the Met's revenue came from the city of New York, $24.6 million.

184 "My Western civilization would never have arrived": Calvin Tomkins, *Merchants and Masterpieces: The Story of the Metropolitan Museum of Art* (New York: Dutton, 1973), p. 54.

184 "I have the pride of my race": Ibid., p. 55.

185 "We found by our excavations that the temple existed": "Dr. Richter on Di Cesnola; The Scientific World Grossly Misled, He Declares," *New York Times,* May 16, 1893.

185 "a mystery which cannot be cleared up": John Linton Myres, *Handbook of the Cesnola Collection of Antiquities from Cyprus* (New York: Metropolitan Museum of Art, 1914), p. xvi.

187 "She told me that Bob had been consigned a 'startling piece' ": Thomas Hoving, "The Hot Pot, I," *Artnet.com Magazine,* July 2001.

187 "Bob is the kind of guy who seems always stooped over slightly": Ibid.

188 "Regarding p. 14 of Jackie Dear's red": Ibid.

188 The curator was part of a wave of German intellectuals: For general information on Dietrich von Bothmer, see the Dictionary of Art Historians at http://www.dictionaryofarthistorians.org/bothmerd.htm.

188 "If the Italians don't look after their own things": Vernon Silver, "Met's Antiquities Case Shows Donor, Trustee Ties to Looted Art," Bloomberg News, February 23, 2006.

189 "I wanted the vase; I would have it": Hoving, *Making the Mummies Dance*, p. 317.

189 "We had landed a work that I guessed would be the last monumental piece": Thomas Hoving, "The Hot Pot, III," *Artnet.com Magazine*, July 2001.

190 he ordered up a glossy magazine piece about the Euphronios krater: Ibid.

190 In a series of front-page articles: Nicholas Gage, "Warrant Issued for Hecht in Vase Sale," *New York Times*, June 26, 1973; Nicholas Gage, "Farmhand Tells of Finding Met's Vase in Italian Tomb," *New York Times*, February 25, 1973; Nicholas Gage, "Dillon Stands by Vase; Met's Evidence Backs Vase, Dillon Says Affidavit from Restorer," *New York Times*, June 27, 1973; Nicholas Gage, "Met Withholds Photos of Vase; Refuses Request of FBI on Behalf of Rome Authorities," *New York Times*, March 11, 1973.

190 "They have abdicated responsibility": David Shirey, "Price Questioned: Museums Question Price and Secrecy in Purchase of Met Vase," *New York Times*, February 24, 1973.

191 The buyers were Leon Levy and Shelby White: Thomas Hoving, "The Hot Pot, VI," *Artnet.com Magazine*, July 2001.

192 "He appeared at our apartment with a Polaroid": Peter Watson and Cecilia Todeschini, *The Medici Conspiracy* (New York: PublicAffairs, 2006), p. 170.

192 "One is the fact and the other is a fancy invention": Jason Felch and Ralph Frammolino, "Italy Says It's Proven Vase at Met Was Looted," *Los Angeles Times*, October 28, 2005.

193 "Marion True had her own way of interpreting the law": Silver, "Met's Antiquities Case."

197 the museum should prepare for criminal prosecution: Interviews with Thomas Hoving and Maurizio Fiorilli.

198 "If you pile up enough circumstantial evidence": "Is It All Loot? Tackling the Antiquities Problem," *New York Times*, March 29, 2006.

198 "The whole process of how Italy prosecuted its case": Russell Berman, "Met Director Derides Italy's Efforts to Claim What It Calls Looted Art," *New York Sun*, March 7, 2006.

198 "We are told that the tombaroli of Italy 'went crazy'": Watson and Todeschini, *Medici Conspiracy*, p. 359.

199 "I see it as a sick collaboration": Susan Mazur, "The Whistleblower and the Politics of the Met's Euphronios Purchase: A Talk with Oscar White Muscarella," *Scoop*, December 25, 2005.

200 After much negotiation the Turks ceded ownership: For an account of international negotiations, see "Dept. of State, Division of Near Eastern Affairs: Memorandum of Conversation with Mr. Edward Robinson, member of the Executive Committee of the American Society for the Excavation of Sardis. May 8, 1924," and memo of same title for May 9, 1924. In State Department Archives. My thanks to Jack Davis for documentation.

203 84 percent first surfaced after 1973: Christopher Chippindale and David W. J. Gill, "Material Consequences of Contemporary Classical Collecting," *American Journal of Archaeology* 104, no. 3 (July 2000): 472.

203 In January 2008 Italian cultural officials announced: Elisabetta Povoledo, "Collector Returns Art Italy Says Was Looted," *New York Times,* January 18, 2008.

205 a glowing piece in the *New Yorker*: Hugh Eakin, "Treasure Hunt; The Downfall of the Getty Curator Marion True," *New Yorker,* December 17, 2007.

## 9: THE BRITISH MUSEUM

211 "He is the most flawlessly fragrant": Bryan Appleyard, "Behind the Scenes at the British Museum," *Times* (London), May 6, 2007.

211 "an extended hymn of praise": Ibid.

211 "high-minded to a fault": Maev Kennedy, "The Guardian Profile: Neil MacGregor," *Guardian,* May 11, 2007.

213 early visitors to the museum had to apply in writing: W. H. Boulton, *The Romance of the British Museum* (London: Sampson Low, 1930), p. 10.

216 "large and heavy packages": *Times* (London), May 1, 1843.

217 "Those were the great days of excavating": Fagan, *Rape of the Nile*, pp. 92–93.

217 "Budge's expeditions were models of illegal purchase": Ibid., p. 302.

218 "Agents of the museum": Geoffrey Grigson, *Art Treasures of the British Museum* (London: Thames and Hudson, 1957), p. 27.

220 divided among the Victoria and Albert Museum: Terry Kirby, "Hidden in a British Museum Basement: The Lost Ark Raided by Colonial Raiders," *Independent*, October 19, 2004.

222 "some benefit on the progress of taste": William St. Clair, *Lord Elgin and the Marbles* (London: Oxford University Press, 1967), p. 6.

224 "Take everything you can": Ibid., p. 63.

224 The first metope was captured during a seizure of the French boat: Cécile Colonna, "Les Sculptures du Parthénon Présentées dans la Salle de Diane," *Revue des Musées de France*, April 2, 2007, p. 9.

225 "The firman confers no authority": St. Clair, *Lord Elgin and the Marbles*, p. 89.

225 "I did not even mention my having presents for him": Ibid., p. 93.

226 "I trust they will reach England in safety": Ibid., p. 94.

226 "The very great variety in our manufactures": Ibid., p. 101.

227 "I had the inexpressible mortification": Edward Dodwell, *A Classical and Topographical Tour Through Greece* (London: Rodwell and Martin, 1819), p. 232.

227 "We saw this fine piece of sculpture raised": St. Clair, *Lord Elgin and the Marbles*, p. 103.

227 "I must do more still and I must want to try it": Ibid., p. 134.

228 "Each stone as it fell shook the ground": Ibid.

228 "He, too, was distressed": Ibid.

229 the influential critic Richard Payne Knight: Lionel Cust, "The Sculptures of the Parthenon," *Burlington Magazine for Connoisseurs* 21, no. 113 (August 1912).

230  "Never did the littleness of man": George Gordon N. Byron, *Childe Harold's Pilgrimage, a Romaunt* (London: J. Murray, 1837), p. 70.

231  "I opposed—and ever will oppose": Quoted in Roger Atwood, *Stealing History: Tomb Raiders, Smugglers, and the Looting of the Ancient World* (New York: St. Martin's Press, 2004), p. 131.

## 10: A GREEK TRAGEDY

238  56 of the 97 surviving sculptured blocks: The numbers do not add up because some sculptures from the Parthenon are scattered in other locations, including the Louvre, the Vatican, and the Munich Glyptothek.

242  "I truly believe that the day the museum is finished": Fred A. Bernstein, "Greece's Colossal New Guilt Trip," *New York Times*, January 18, 2004.

244  "as a constant reminder of this unfulfilled debt": "The New Acropolis Museum: Design and Original Exhibits from the Acropolis Collection," March 2005. http://www.helleniccomserve.com/acropolis_museum.html.

247  a radical "cleaning" of the marbles: St. Clair, *Lord Elgin and the Marbles*, pp. 281–313.

249  "From the appearance of the sculptures": Ibid., p. 344.

249  "a public statement need not be made": Ibid., p. 345.

249  "Unauthorized methods were being introduced": Ibid., p. 301.

249  "If any damage has been done": Ibid., p. 302.

250  "the British claim to a trusteeship has been forfeited": Ibid., p. 336.

251  "they're a bit, well, *colourless*, aren't they?": Trevor Timpson, "Fear and Fury Among the Marbles," BBC News, September 12, 2007.

## 11: HARD-LINERS

256  "To Lord Renfrew, every dealer is an anathema": Andreas Apostolidis, dir., *Network* (documentary film), Illusion Film Production, 2005.

268  "We should hold the revival of Grecian sculpture": Timothy Webb, "Appropriating the Stones: The Elgin Marbles," in Elazar Barkan and Ronald Bush, ed., *Claiming the Stones, Naming the Bones: Cultural Property and the Negotiation of National and Ethnic Identity* (Los Angeles: Getty Research Institute, 2002), p. 83.

270  In April 2007 MacGregor seemed to suggest: Martin Gayford, "Will Elgin Marbles Ever Make It Back to Athens?" *Bloomberg News,* April 17, 2007.

270  "any request for any part of the collection": See the official site of the British Museum, http://www.britishmuseum.org/the_museum/news_and_press_releases/statements/parthenon_sculptures/statement.aspx.

270  In 1998 a poll carried out in Britain by the well-regarded MORI organization [and a] more recent poll in 2002: "Support for the Return of The Parthenon Marbles," October 15, 2002, http://www.ipsos-mori.com/polls/2002/parthenon.shtml.

272  "I think that all the marbles would have to come together": Hugo Davenport, "Elgin Marbles Surprise," *Observer,* February 15, 1983.

## 12: REVENGE IN ROME

285 "The word here is '*malessere*'": Ian Fisher, "In a Funk, Italy Sings an Aria of Disappointment," *New York Times*, December 13, 2007.

286 "The works Italy wants returned": Federico Castelli Gattinara and Gareth Harris, "One Rule for the Getty, Another for Italy?" *Art Newspaper*, issue 182, July–August 2007.

287 "It is quite ironic for me": Christopher Reynolds, "This Could Be Monumental," *Los Angeles Times,* January 6, 2006.

288 during the previous year's telethon: Tom Kington, "Italy Resorts to Telethon to Protect Antiquities," *Guardian,* October 8, 2007.

288 higher than that of Buckingham Palace: Alessandra Rizzo, "Book Rips Cover off Corruption in Italy," *Chicago Tribune,* June 19, 2007.

290 "Some were wrapped in newspapers": Watson and Todeschini, *Medici Conspiracy*, p. 21.

295 an article about him by Andrew L. Slayman: Andrew L. Slayman, "Geneva Seizure," online article, *Archaeology*, May 3, 1998 (updated September 14, 1998), available at http://www.archaeology.org/online/features/geneva/index.html.

296 "The 'monster' who should have exported 10,000 items": Giacomo Medici, letter to the editor, *Archaeology*, May 3, 1998, available at http://www.archaeology.org/online/features/geneva/medici_eng.html.

296 "Instead of proving that Mr. Medici": Frederick Schultz, letter to the editor, *Archaeology*, June 16, 1998, available at http://www.archaeology.org/online/features/geneva/schultz.html.

## 13: THE TRIALS OF MARION TRUE

298 "intoxicated by the white dancing candescence": Lawrence Durrell, *The Greek Islands* (London: Faber and Faber, 1980), p. 5.

299 "This light is indescribably keen yet soft": Ibid., p. 11.

300 True had bought her house with a loan: Ralph Frammolino and Jason Felch, "Greek Officials Demand the Return of Getty Antiquities," *Los Angeles Times,* October 24, 2005.

302 She was born in Tahlequah, Oklahoma: General information on Marion True is from personal interviews and from Suzanne Muchnic, "A Career in Roman Art Tangled in Italian Law," *Los Angeles Times,* May 27, 2005.

304 "True, the Getty curator who alerted the Cypriot government": Stanley Meisler, "Art and Avarice," *Los Angeles Times Magazine,* November 12, 1989.

304 "It simply is not in the interest of any museum": William Wilson, "Getty Museum Reveals Ancient Greek Statue," *Los Angeles Times,* August 8, 1986.

305 "Getty policy now excludes purchase of any antiquity": Malcolm Bell III, "Better Late Than Never at the Getty," *Los Angeles Times*, October 4, 2005.

306 "Received in commission for resale": Watson and Todeschini, *Medici Conspiracy*, p. 96.

311 she was in a hurry to pay it back: Through her lawyer, True said she was in a

hurry to pay it back because the note was four years only, and bore a high interest rate of 18 percent.

312 "The business which ran so successfully": Ibid., p. 261.

312 "From the beginning, we knew that there was the potential": Jason Felch and Ralph Frammolino, "Getty Lets Her Take Fall, Ex-Curator Says," *Los Angeles Times*, December 29, 2006.

314 Greek prosecutors told museum representatives: Interviews by Anthee Carrassava, 2007.

316 "on a beach in Rio": Source anonymous.

316 a "dramatic non-disclosure" in her separation agreement: In a letter sent to the author shortly before this book went to press, a lawyer for Marion True stated, "She did not sign a separation agreement."

316 "Sometimes I think it is almost a case of mistaken identity": Hugh Eakin, "Tresasure Hunt," *New Yorker*, December 17, 2007.

## 14: THE GETTY MUSEUM

319 "To buy any object from [such] dubious sources": J. Paul Getty, *The Joy of Collecting* (New York: Hawthorn Books, 1965), p. 21.

320 His seventy-two-room estate in London: For general biographical information on J. Paul Getty, see: J. Paul Getty, *As I See It: The Autobiography of J. Paul Getty* (Englewood Cliffs, N.J.: Prentice Hall, 2006); Robert Lenzner, *The Great Getty: The Life and Loves of J. Paul Getty, Richest Man in the World* (New York: Crown, 1985); John Pearson, *Painfully Rich: The Outrageous Fortune and Misfortunes of the Heirs of J. Paul Getty* (New York: St. Martin's Press), 1995.

321 "He was getting more for his money if he had a big picture": Lenzner, *Great Getty*, p. 179.

321 He stopped by the mansion of Baron Louis de Rothschild: Daniel Yergin, *The Prize* (New York: Simon and Schuster, 1991), p. 440.

321 To Getty's "incredulous joy": Getty, *Joy of Collecting*, p. 18.

322 it was only after his friend Baron Thyssen: Lenzner, *Great Getty*, p. 184.

322 Getty showed "no joie de vivre": Ibid., p. 185.

323 "pretentious and somewhat sterile": Paul Goldberger, "Getty Museum's Styling, Once Criticized, Draws Crowds," *New York Times*, August 26, 1975.

323 "merely incongruous or genuinely ludicrous": Pearson, *Painfully Rich*, p. 156.

324 "He's the most difficult of all our customers": Ralph Hewins, *J. Paul Getty: The Richest American* (London: Sidgwick and Jackson, 1961), p. 140.

324 "quite a Byzantine character" . . . Frel stomped into his gallery: Ralph Frammolino, "Obituaries: Jiri Frel, Colorful Curator Who Left Getty Under a Cloud," *Los Angeles Times*, May 13, 2006.

325 the "trail of fraud and deceit may have the most damaging consequences": Letter from Arthur Houghton to John Walsh, April 1986, read to the author. Also, Houghton did not resign, as Watson and Todeschini state in *The Medici Conspiracy*, because he thought the Getty was "burying its head in the sand as far as illicit antiquities were concerned" (p. 286). Fraud was the concern, not looted art.

326 a rare sixth-century BC Greek statue of a naked youth: For information on the kouros and the controversy surrounding it, see J. Paul Getty Museum, *The Getty Kouros Colloquium: Athens, 25–27 May 1992* (Athens: Kapon Eds., 1993).

327 "Medici informed me that he had acquired the lekanis": Watson and Todeschini, *Medici Conspiracy*, p. 286.

332 "By gagging the forgery claim of its own expert": Peter Landesman, "A Crisis of Fakes: The Getty Forgeries," *New York Times Magazine*, March 18, 2001.

335 Gribbon had approached True at a cocktail party: A Getty official says this conversation took place in Gribbon's office.

336 both Munitz and True have denied this accusation: Could this have been a cynical move orchestrated by True? That is the accusation by the investigative journalist Peter Watson, citing the deposition of a Swiss antiquities dealer, Frieda Nussberger-Tchacos, with Italian authorities in 2002. She told them, "Every time I showed her something, she said to me, 'Beautiful, interesting, I can speak to Fleischman about it'" (Watson and Todeschini, *Medici Conspiracy*, p. 193). But Munitz, who was president of the trust when the accusations emerged in public, said he did not believe that this was a planned subterfuge, nor did he believe that Marion True had exhorted the Fleischmans to buy looted artifacts on behalf of the Getty. "I never saw or heard any evidence that this was a very clever ploy to backdoor objects to the Getty," said Munitz. "No one ever said this to me, nor did they subsequently say, 'I'm worried, because that's in fact what she had been doing.'" Asked if he believed it was a tacit arrangement, Munitz said he would have no way of knowing. The Getty's spokesman, Ron Hartwig, said merely, "This is people speculating and making comments" and pointed out that Nussberger-Tchacos was under arrest in Cyprus for antiquities theft when she made the statement. True, in a 2007 interview with the *New Yorker*, denied the allegation and said it made no sense. "By the time I met Larry Fleischman, he had a big collection and many things he bought from Symes," she said. "And I bought from Symes. So why did I need Fleischman to buy from Symes for me?" (Eakin, "Treasure Hunt").

339 The Getty paid her $3 million: Randy Kennedy, "Getty Trust Chairman to Leave by October," *New York Times*, August 5, 2006.

339 the first of a series of investigative articles: Jason Felch, Robin Fields, and Louise Roug, "Getty Deal Raises Questions," *Los Angeles Times*, December 20, 2004.

339 a book deal given by the Getty: Ralph Frammolino and Jason Felch, "Getty Book Deal Led to Questions of Conflict," *Los Angeles Times*, June 13, 2006.

339 Munitz had apparently wangled institutional funds: Jason Felch and Ralph Frammolino, "Investigators Secretly Mined Munitz's Records," *Los Angeles Times*, September 2, 2006.

339 He had carelessly spread Getty largesse: Jason Felch, Robin Fields, and Louise Roug, "The Munitz Collection," *Los Angeles Times*, June 10, 2005.

341 "Munitz and the board of trustees misused organization funds": Jason Felch, Ralph Frammolino, and Robin Fields, "State Names Monitor for Getty Trust," *Los Angeles Times*, October 3, 2006.

## 15: REPATRIATIONS

343 the statue had been purchased in 2000: The Michael C. Carlos Museum Web site accounts for the purchase of an exquisite sculpture of Terpsichore and the Minoan bathtub in 2002. No clue is given as to their provenance.

346 FBI agents recovered approximately 265 of the objects: Kristin M. Romey, "Corinth Loot Found Under Fresh Fish," *Archeology*, November–December 1999.

350 "There was the most beautiful thing I had ever seen in my life": Nikolas Zirganos, "Operation Eclipse," in Watson and Todeschini, *Medici Conspiracy*, p. 310.

350 On March 13, 1992, a fax from Munich arrived: Jason Felch, "Charges Are Dropped in Getty Case," *Los Angeles Times*, November 28, 2007.

350 "I hope you will find a possible buyer for it": Ibid.

351 In November 2006 Greek prosecutors filed charges: The court dropped the criminal charges against True on November 27, 2007, saying that the period of limitations had expired. Many of the charges against her codefendants were dismissed for the same reasons.

352 a tale of ego and greed: Information about the battle between Symes and the Papadimitriou family is from interviews, contemporaneous British press accounts, and Apostolidis, *Network*.

365 "We are saying we won't look into the provenance": Jason Felch and Ralph Frammolino, "Getty Had Signs It Was Acquiring Possibly Looted Art," *Los Angeles Times*, September 23, 2005.

366 "If there had been an expensive statue in my family": Ralph Frammolino and Jason Felch, "The Getty's Troubled Goddess," January 3, 2007.

367 a golden Roman beaker came from the collection: Karol Wight, "Ancient Art: New Acquisitions at the Getty Museum," *Apollo*, February 2006, p. 44.

## CONCLUSION

369 something less than the sum of its parts: Doug Irving, "Man in Bowers Probe Says He Did Nothing Wrong," *Orange County Register*, January 25, 2008.

370 "If it wasn't for people": Ibid.

376 "They say it is God's property": *Descriptive Account of a Series of Pictures: Representing Some of the Most Important Battles Fought by the French Armies, in Egypt, Italy, Germany, and Spain, Between the years 1792 and 1812: Painted by General Baron Le Jeune . . . Now Exhibiting at the Egyptian Hall, Piccadilly* (London: William Cox, 1829).

# SELECTED BIBLIOGRAPHY

Acland, Henry W., et al. *The History of Museums*. London: Routledge, 1996.

Andre-Salvini, Beatrice. *Le Code de Hammurabi*. Paris: Reunion des Musées Nationaux, 2003.

Apostolidis, Andreas. *Network* (documentary film). Illusion Film Production, 2005.

Archimbaud, Nicholas d'. *Louvre*. Paris: Robert Laffont, 1997.

Atwood, Roger. *Stealing History: Tomb Raiders, Smugglers, and the Looting of the Ancient World*. New York: St. Martin's Press, 2004.

Barkan, Elazar, and Ronald Bush, eds. *Claiming the Stones, Naming the Bones: Cultural Property and the Negotiation of National and Ethnic Identity*. Los Angeles: Getty Research Institute, 2002.

Barnett, Correlli. *Bonaparte*. New York: Hill and Wang, 1978.

Belzoni, Giovanni. *Narrative of the Operation of Recent Discoveries in Egypt and Nubia*. London: John Murray, 1820.

Bilsel, S. M. Can. "Zeus in Exile: Archaeological Restitution as Politics of Memory." Working Paper no. 13, Princeton University, Center for Arts and Cultural Policy Studies, Fall 2000.

Bogdanos, Matthew. *Thieves of Baghdad*. New York: Bloomsbury, 2005.

Bothmer, Dietrich von. *Glories of the Past: Ancient Art from the Shelby White and Leon Levy Collection*. New York: Metropolitan Museum of Art, 1990.

Boulton, W. H. *The Romance of the British Museum*. London: Sampson Low, 1930.

Boyd, Willard. "Museums as Centers of Controversy." *Daedalus* 185 (1999).

Brodie, Neil, and Colin Renfrew, "Looting and the World's Archaeological Heritage: The Inadequate Response." *Annual Reviews* (June 2005).

Byron, George Gordon. *Childe Harold's Pilgrimage, a Romaunt*. London: J. Murray, 1837.

Chamberlin, Russell. *Loot! The Heritage of Plunder*. London: Thames and Hudson, 1983.

Chambers, Neil. *Joseph Banks and the British Museum: The World of Collecting, 1770–1830*. London: Pickering and Chatto, 2007.

Chandler, David G. *The Campaigns of Napoleon*. New York: Macmillan, 1966.

Chippendale, Christopher, and David W. J. Gill, "Material Consequences of Contemporary Classical Collecting." *American Journal of Archaeology* 104:3 (July 2000).

Colonna, Cécile. "Les sculptures du Parthénon présentées dans la salle de Diane." *La Revue des Musées de France* (April 2007).

Cook, B. F. *The Elgin Marbles*. London: British Museum Press, 1997.

Cuno, James, ed. *Whose Muse? Art Museums and the Public Trust*. Princeton, N.J.: Princeton University Press, 2004.

Danziger, Danny. *Museum*. New York: Viking, 2007.

Départment des Antiquités orientales. *La nouvelle salle du Code de Hammurabi*. Paris: Louvre, 2003.

Dodwell, Edward. *A Classical and Topographical Tour Through Greece, During the Years 1801, 1805, and 1806*. London: Rodwell and Martin, 1819.

Fagan, Brian. *The Rape of the Nile: Tomb Raiders, Tourists, and Archaeologists in Egypt*. New York: Scribner, 1975.

Getty, J. Paul. *As I See It: The Autobiography of J. Paul Getty*. Englewood Cliffs, N.J.: Prentice Hall, 2006.

————. *The Joys of Collecting*. New York: Hawthorn Books, 1965.

Greenfield, Jeannette. *The Return of Cultural Treasures*. Cambridge: Cambridge University Press, 2007.

Grigson, Geoffrey. *Art Treasures of the British Museum*. London: Thames and Hudson, 1957.

Hamiaux, Marianne. "La Victoire de Samothrace: Découverte et Restauration," *Journal des Savants* (January–June 2001).

Haskell, Francis, and Nicholas Penny. *Taste and the Antique: The Lure of Classical Sculpture, 1500–1900*. New Haven: Yale University Press, 1981.

Hastings, Thomas. "Memorandum of Conversation with Mr. Edward Robinson, a Member of the Executive Committee of the American Society for the Excavation of Sardis." May 8, 1924, and May 9, 1924.

Hawass, Zahi. *Silent Images: Women in Pharaonic Egypt*. Cairo: American University in Cairo Press, 1998.

————. *The Treasure of the Pyramids*. Cairo: American University in Cairo Press, 2003.

Hellenic Ministry of Culture. *The Reunification of the Parthenon Sculptures*. Athens: Hellenic Ministry of Culture, 2003.

Herold, J. Christopher. *Bonaparte in Egypt*. New York: Harper & Row, 1962.

Hewins, Ralph. *J. Paul Getty: The Richest American*. London: Sidgwick and Jackson, 1961.

Hoving, Thomas. *Making the Mummies Dance: Inside the Metropolitan Museum of Art*. New York: Simon and Schuster, 1993.

J. Paul Getty Museum. *The Getty Kouros Colloquium: Athens, 25–27 May, 1992*. Athens: Kapon Eds., 1993.

Kaplan, Tobi Levenberg. *The J. Paul Getty Museum: Handbook of the Antiquities Collection*. Los Angeles: J. Paul Getty Trust, 2002.

King, Reverend James. *Cleopatra's Needle: A History of the London Obelisk*. London: Religious Tract Society, 1886.

Lehner, Mark. *The Complete Pyramids*. New York: Thames and Hudson, 1997.

Lenzner, Robert. *The Great Getty: The Life and Loves of J. Paul Getty, Richest Man in the World*. New York: Crown, 1985.

Linton-Myres, John. *Handbook of the Cesnola Collection of Antiquities from Cyprus*. New York: Metropolitan Museum of Art, 1914.

Manley, Deborah, and Sahar Abdel-Hakim. *Traveling through Egypt: From 450 B.C. to the Twentieth Century*. Cairo: American University in Cairo Press, 2004.

Mariette Bey, Auguste. *The Monuments of Upper Egypt*. London: Trubner, 1877.

Mayes, Stanley. *The Great Belzoni, Archaeologist Extraordinary*. New York: Walker, 1961.

McClellan, Andrew. *Inventing the Louvre: Art, Politics, and the Origins of the Modern Museum in Eighteenth-Century Paris*. Cambridge: Cambridge University Press, 1994.

Merryman, John Henry, ed. *Imperialism, Art and Restitution*. Cambridge: Cambridge University Press, 2006.

Meyer, Karl E. *The Plundered Past: The Story of the Illegal International Traffic in Works of Art*. New York: Atheneum, 1977.

Meyerson, Daniel. *The Linguist and the Emperor: Napoleon and Champollion's Quest to Decipher the Rosetta Stone*. New York: Ballantine, 2004.

Michon, Etienne. *Venus de Milo: Son arrivée et son exposition au Louvre*. Paris: Revue des Etudes Grecques, 1900.

Muscarella, Oscar. *The Lie Became Great: The Forgery of Ancient Near Eastern Cultures*. Groningen: Styx Publications, 2000.

Norton, Mary. "Prisse: A Portrait." *Saudi Aramco World* (November–December 1990).

Othon, Charles, and Frederic J. B. Clarac. *Manual of History of Art of the Ancients*. Paris: Jules Renouard, 1847.

Özgen, Ilknur, and Jean Öztürk, *The Lydian Treasure: Heritage Recovered*. Istanbul: Republic of Turkey, Ministry of Culture, 1996.

Pearson, John. *Painfully Rich: The Outrageous Fortune and Misfortunes of the Heirs of J. Paul Getty*, New York: St. Martin's Press, 1995.

Putnam, James. *Art and Artifact: The Museum as Medium*. New York: Thames and Hudson, 2001.

Reid, Donald Malcolm. *Whose Pharaohs? Archaeology, Museums, and Egyptian National Identity from Napoleon to World War I*. Cairo: American University in Cairo Press, 2002.

Renfrew, Colin. *Loot, Legitimacy and Ownership*. London: Gerald Duckworth, 2006.

Roberts, J. M. *The Penguin History of the World*. London: Penguin Books, 1987.

Rodenbeck, Max. *Cairo: The City Victorious*. New York: Alfred A. Knopf, 1999.

Rose, Mark, and Özgen Acar, "Turkey's War on the Illicit Antiquities Trade." *Archaeology* 48:2 (March–April 1995).

St. Clair, William. *Lord Elgin and the Marbles*. Oxford: Oxford University Press, 1998.

Schom, Alan. *Napoleon Bonaparte*. New York: HarperCollins, 1997.

Small, Lisa. *Napoleon on the Nile: Soldiers, Artists, and the Rediscovery of Egypt.* New York: Dahesh Museum of Art, 2006.

Tompkins, Calvin. *Merchants and Masterpieces: The Story of the Metropolitan Museum of Art.* New York: E. P. Dutton, 1973.

True, Marion. "Refining Policy to Promote Partnership." In Paola Pelagatti and Pier Giovanni Guzzo, eds., *Antichità senza provenienza II: Atti del colloquio internazionale, 17–18 ottobre, 1997.* Rome: Ministero per i beni culturali e ambientali, 2000.

Urville, Jules-Sébastien-César Dumont d', Marie-Louis-Auguste Demartin du Tyrac Marcellus, comte de, and Olivier Voutier. *Enlèvement de Vénus.* Paris: Éditions La Bibliothèque, 1994.

Vertray, Captain M. *Journal d'un officier de l'Armee d'Egypte.* Paris, 1883.

Vivant Denon, Dominique. *Travels in Upper and Lower Egypt in Company with Several Divisions of the French Army During the Campaigns of General Bonaparte.* 1803; reprint, New York: Arno Press, 1973.

Watson, Peter, and Cecilia Todeschini. *The Medici Conspiracy. The Illicit Journey of Looted Antiquities from Italy's Tomb Raiders to the World's Greatest Museums.* New York: PublicAffairs, 2006.

Ziegler, Christiane. *Le Scribe "accroupi."* Paris: Musée du Louvre, 2002.

# ACKNOWLEDGMENTS

The research and reporting of this book was one of the great adventures of my life, a journey of discovery into the past and through a dozen foreign cities and even more ancient civilizations. It was a crash course in archaeology and Greek history, along with a refresher in the cultures of Mesopotamia and ancient Egypt. In truth, when embarking on this book I had no idea what I was getting myself into, and that turned out to be a good thing. If I had, I would undoubtedly have thought the task impossible to accomplish.

That said, this book's completion is due to the many, many people across those countries and cultures who gave of their time, expertise, contacts, and most of all of their friendship. Through them, I was able to get my arms around a vast set of topics, historical figures, and controversies old and new. That said, any errors in this edition are solely my own.

The book originated in conversations I had with Zahi Hawass, secretary-general of the Supreme Council of Antiquities in Egypt, over his belief that Egypt needed to aggressively reclaim certain objects taken in past centuries. I am most grateful to him for his candor and his time, and especially for giving me full access to Egypt's magnificent monuments to better understand the history of colonial plunder and the modern quest for restitution.

My sincere thanks to the Getty Research Institute for granting me access to its formidable archives, resources, and special collections. I whiled away many fascinating hours on the Brentwood hilltop, assisted by its excellent staff. Similar thanks to the staff at the British Museum archive, ever helpful in aiding a pesky American reader who was never happier than when poring over crumbling texts on the creaky green leather–covered desks at which Agatha Christie once wrote.

A special thanks to the *New York Times* bureaus and my colleagues there across the old world as well as the ancient world, especially the able staffs in London, Paris, and Rome, who set up meetings, lent me equipment, and even took photos in a pinch. I particularly cherish the generosity of my fellow correspondents who shared their knowledge and friendship—Sabrina Tavernise in Istanbul, Michael Slackman in Cairo, Ian Fisher in Rome.

In Egypt, thanks go to Mustafa Wazery, Amr and Tabea Badr, Mona el Nagar, and Sahar at the *New York Times* bureau and to Essam Shihab, Rabia Hamdan, Sherif Hawass, Nigel Hetherington, Kelly Krause, Yousef Amr, Janice Kamrin, and Maggie, Colleen, and Katie—the "*khawaga* brigade."

In Turkey, my gratitude to the incomparable antiquities warrior and scholar Özgen Acar, along with new friends Amberin Zaman and Evrim Eral. I could not have moved an inch in that country without my indefatigable assistant Zeycan Sarihacioglu, who organized it all, traveling with me on overnight buses through the Turkish countryside and translating until she could barely speak. Zeycan, you are spectacular.

In Greece, the fabulous Anthee Carassava became a friend and was an invaluable resource. Thanks also to Smarot Toloupa, Nikolas Zirganos, and especially Chris Manoulis, the outstanding manager of the Grand Bretagne Hotel in Athens, one of the most beautiful hotels I have been privileged to stay at. Warm thanks to Koos Lubsen and Stella Admiraal for inviting me into their home, despite their initial skepticism.

In Rome, my thanks to Elisabetta Povoledo, Peter Kiefer, and Paola Nuvola of the *Times* bureau.

In London, sincere thanks to David Landau and Rosie Kahane for their generous hospitality, and special thanks to David for his counsel

and guidance in the planning of this book. In Paris, sincere gratitude to Ambassador Danny Shek and his wife, Marie, for their hospitality, as well as to Ruth el-Krieff and Claude Czechowski.

In St. Moritz, my thanks to Alexander Kahane for his hospitality and friendship; I wrote the proposal for this book at his home and debated the topic on long mountain walks with his stimulating circle of friends.

In New York, my thanks to the late and much-missed Joan Goodman and to my dear friends Kelly and Herve Couturier, who put me up, and put up with me, countless times.

And a very special thanks to Kevin Burns, of British Airways, for his interest in this book and his deeply generous support of the research effort.

To the communications staffs of all the museums in this book, my sincere thanks for your professionalism and courtesy, despite the sometimes sensitive subject matter involved. I must single out for thanks Harold Holzer at the Metropolitan Museum of Art; Hannah Boulton at the British Museum; Aggy Lerolle and Benedicte Moreau at the Louvre; and Ron Hartwig, John Giurini, and Julie Jaskol at the J. Paul Getty Museum. I came away from these great institutions ever more dazzled by what they offer the public—the artifacts and the quality of their presentation—even as I was writing about the debate over the objects' origins.

Thanks to my dear and indispensable friend Joel Bernstein for his sage advice and for books, maps, photo editing, and all-around moral support. Thanks to Tim Doyle for pushing the cover in the right direction.

My researcher Candace Weddle was a wonder, whizzing through the Getty library in search of sources, never complaining about the tasks at hand or the long hours. Thanks, Candace, and Godspeed to Turkey and your doctorate. Thanks to photo researcher Maggie Berkvist for her able assistance and to the *New York Times* photo archive.

My thanks to Alex Ward at the *New York Times* for his patient counsel and support, to Pearl Wu at Times Books for her dedicated efforts, and to my wonderful book agent, Andrew Blauner, who has shown me nothing but love and encouragement throughout this project.

A final word of tribute to my editor at Times Books, Paul Golob, a rare gem who grasped and loved this topic from the start and supported it with enthusiasm and calm dedication. Paul took my work and made it demonstrably better, without altering the tone or the character of the narrative. To me, he defines excellence in an editor; my thanks and everlasting appreciation.

Lastly, thanks to my husband, Claude, and my three beautiful kids, Alexandra, Jeremy, and Daniel, who understood my need to be absent for the entire summer of 2007 to investigate this book. Thank you for letting me follow my passion and for being my private cheerleaders.

# INDEX

Page numbers in italics refer to illustrations.

SHARON WAXMAN is a former culture correspondent for *The New York Times* and holds a master's degree in Middle East studies from Oxford University. She covered Middle Eastern and European politics and culture for ten years before joining *The Washington Post* and then *The New York Times* to report on Hollywood and other cultural news. She is the author of *Rebels on the Backlot: Six Maverick Directors and How They Conquered the Hollywood Studio System*. She lives in Southern California.